Women Making Art

W9-ATX-419

Women Making Art engages with complementary feminist thinking on history, subjectivity and aesthetics to rework those conventions which have occluded women's cultural agency and defined art made by women as a derivative version of a masculine norm. Rather than providing an inclusive survey of women artists, Marsha Meskimmon examines women's art practice across five continents and in a wide range of media at a number of key moments in the twentieth century to give an understanding of the intersections of history and culture, art practice, and theoretical issues.

Examining the ways in which women artists have reclaimed, expressed and defined personal and political histories, challenged conventional western notions of dichotomous sexed subjectivity, and opened out the relationships of pleasure/knowledge, word/flesh and space/time to new ways of thinking against the grain, Meskimmon discusses the work of artists such as Deborah Lefkowitz, Trinh T. Minh-ha, Cornelia Parker, Faith Ringgold, Mona Hatoum and Maria Helena Vieira da Silva, as well as other, less well-known artists from around the world. Focusing on historical, theoretical and aesthetic moments in the twentieth century such as the Holocaust, the Vietnam War, the African diaspora, Queer Theory and cyberculture, Meskimmon illustrates the importance of women artists in rethinking dominant traditions and assumptions at times of cultural, political and technological change.

Marsha Meskimmon is Reader in Art History and Theory at Loughborough University. She is the author of *The Art of Reflection: Women Artists' Self-Portraiture in the Twentieth Century* (1996), *Engendering the City: Women Artists and Urban Space* (1997), and *We Weren't Modern Enough: Women Artists and the Limits of German Modernism* (1999).

Women Making Art
History, Subjectivity, Aesthetics

Marsha Meskimmon

Routledge
Taylor & Francis Group

LONDON AND NEW YORK

First published 2003
by Routledge
11 New Fetter Lane, London EC4P 4EE

Simultaneously published in the USA and Canada
by Routledge
29 West 35th Street, New York, NY 10001

Routledge is an imprint of the Taylor & Francis Group

© 2003 Marsha Meskimmon

Typeset in Galliard by RefineCatch Limited, Bungay, Suffolk
Printed and bound in Great Britain by
St Edmundsbury Press, Bury St Edmunds, Suffolk

All rights reserved. No part of this book may be reprinted or
reproduced or utilised in any form or by any electronic,
mechanical, or other means, now known or hereafter
invented, including photocopying and recording, or in any
information storage or retrieval system, without permission in
writing from the publishers.

British Library Cataloguing in Publication Data
A catalogue record for this book is available from the British Library

Library of Congress Cataloging in Publication Data
A catalog record for this book has been requested

ISBN 0–415–24277–0 (hbk)
ISBN 0–415–24278–9 (pbk)

For Mark T. Shutes (1947–2001) – my beloved brother, my inspiring teacher and my trusted friend.

Contents

Illustrations

Acknowledgements

I have many people to thank for having helped me with this project and none to blame for any residual errors or inaccuracies. I have been delighted and surprised by the number of people who have supported the present project and I would like to thank everyone who has taken the time to engage so positively with its development.

I could not have completed the research and writing of this book without the support of Loughborough University, and especially the Faculty of Social Science and Humanities, who granted me study leave during the Autumn of 2001. This period of leave was matched by the Arts and Humanities Research Board who, through their Research Leave scheme, awarded me time away in Spring 2002. This gift of time has been of inestimable value and I thank both institutions for their generosity.

While on leave, I was able to take up two international Fellowships through which the research and writing of the project was nurtured, challenged and further expanded. I would like to thank the Directors, Administrators and other Fellows at the Center for Advanced Study in the Visual Arts (CASVA) at the National Gallery of Art, Washington, DC, where I spent September 2001 as Paul Mellon Visiting Senior Fellow for their encouragement of this work at a vital stage. While in Washington, I was also able to use the wonderful facilities of the National Museum of Women in the Arts and I would like to thank their staff, especially the staff of the library, who made my time there productive and very enjoyable.

I spent the first three months of 2002 as a Visiting Senior Research Fellow at the Humanities Research Centre (HRC) of the Australian National University in Canberra, and it was there that I was able to complete the final manuscript and to see, first-hand, the Australian material I had been researching. I want to thank the Directors, Administrators and Fellows at the HRC for their support and to say that the time I spent there was some of the most productive, intellectually rigorous and enjoyable of my research period; I am especially grateful to the staff of the Centre for helping me to meet so many scholars, artists and curators in Australia which enabled the time to become a seed-bed for new work.

There are many academic colleagues I must thank for reading the proposal and drafts of this project at various stages. This reading tends to be an invisible and

thankless task, but it has been of the greatest value to me and I would like to acknowledge and heartily thank these diligent critics, including: Amelia Jones, Karla Oeler, Megan Shutes, Ulli Sieglohr, Gen Doy, Rosemary Betterton, Paul Jobling, Martin Davies, Michelle Antoinette, and, especially, Whitney Chadwick.

Some of the most stimulating and productive engagements with the drafts of this text came from the artists who read, challenged and explored my approaches to their work with great generosity and skill. I want to thank Joan Brassil, Janet Laurence, Ann Hamilton, Elizabeth King, Rosy Martin, Deborah Lefkowitz and Anna Munster for their time and their creativity in making this a better volume than it would have been. Artists and galleries have also been extremely helpful with reproductions – from obtaining difficult-to-find work and ensuring that the quality of the photos, transparencies or digital files was high to waiving or radically reducing fees and transport costs, these individuals and organisations made this book possible and I owe them a great debt of thanks. In no order of preference, I would like to thank: Svetlana Kopystiansky, Mona Hatoum, Maya Lin, Amalia Mesa-Bains, Sokari Douglas-Camp, Trinh T. Minh-ha, Kathryn Wetzel, Kay Goodridge, Cathy de Monchaux, Faith Ringgold and Martha Rosler.

I am also grateful to the following institutions for generous help with illustrations: Williams College (MA), Sculpture at Goodwood, the Museum of Sydney, the British Film Institute, the Tate Gallery, Scalo Publishers (Andre Gstettenhofer), Frith Street Gallery, Sean Kelly Gallery, the Courtauld Institute (Melanie Blake), Anthony d'Offay Gallery, the Gemäldegalerie Alte Meister, Dresden, the Jersey Museum (Louise Downey), Lark Photography (Desiree Rinkel), Barbara Gladstone Gallery, Howard University Gallery, Marsha Mateyka Gallery and June Kelly Gallery.

Finally, and as always, I must thank my partner, Graham, for his encouragement and support throughout the planning and preparation of this project; he is like an anchor in a storm.

Introduction:
Women Making Art

Exhilaration and danger

Over the past thirty years, a substantial body of literature on the topic of women artists and their work has demonstrated clearly that women have played a significant role in the production of visual art for centuries. The present volume inherits from that empowering scholarly tradition its absolute confidence in the ability of women to make art which can change the way we think about the world.

For myself, and many other feminist scholars like me, researching women's unique cultural and intellectual contributions to both the past and the present is an exhilarating exercise and an important revision of those histories from which women's activities have been excluded. Linda Nochlin's recent account of her early feminist research, teaching and curatorial work, describes precisely her sense of excitement as the significance of long-forgotten women and their art began to unfold in scholarly articles, highly-charged classroom experiences and exhibitions:

> . . . it was no mere passive conjunction of events that united me to the history of that year [1969] and those that followed, but rather an active engagement and participation, a sense that I, along with many other politicized, and yes, liberated, women, was actually intervening in the historical process and changing history itself: the history of art, of culture, of institutions and of consciousness.[1]

When second-wave feminists sought out the women who came before them, they uncovered a substantial body of evidence confirming women's important political, artistic and historical presence in the cultural life of the past and this material changed the way in which they understood history and their place within it. However, this groundbreaking work has not yet fully changed the iniquitous dynamics of sexual discrimination in the present, in the art world or elsewhere. It is still perfectly possible, for example, for a major exhibition of a century's painting to be mounted by three national galleries without including a single work by a woman.[2] It is even possible, when asked about this omission, to hear that it had gone unnoticed by the curators and be referred to the work of a particularly 'feminine' male painter who made the inclusion of work by women unnecessary.[3]

In contemporary art, it is still a surprise, or possibly a 'fix', if the nominees for a major art prize are all women, but not even noted when they are all men.[4]

It is obvious that much work remains to be done before the art made by women is given the attention it deserves. Yet writing about women's art practices, historical or contemporary, is not a simple task; indeed, it is a dangerous one. In the first place, crude models of affirmative action – counting the number of works by men and women in a show, for instance – are both insensitive to the complexity of sexual difference as it informs visual culture and, frankly, rather ineffective in changing power dynamics in the art world. Moreover, the 'addition' of women to the current canon of 'masters', the simplistic production of an alternative canon (the 'great' women artists) and/or other forms of celebratory separatism, provide no critique of the prevailing norms by which women have been occluded from the histories of art and no tactics by which those histories might themselves be changed.

The problem is not one of recognising that histories need to be redressed, but of understanding how this can be done without recourse to reductive definitions of 'women artists' and 'women's art' as homogeneous categories of alterity. In other words, it is imperative that the significant and complex differences between women, and not just between women and men, are acknowledged and made to signify in any reconceived histories of visual culture, and that the vexing question 'what difference does it make that this art was produced by women?' be addressed in all its subtle and meaningful variations.

Nowhere have the dangers of reductive categorisation been better stated than by Griselda Pollock when she wrote:

> If we use the term *women* of artists, we differentiate the history of art by proposing artists and 'women artists'. We invite ourselves to assume a difference, which all too easily makes us presume that we know what it is. Furthermore, art becomes its deposit and expressive vehicle . . .[5]

Heeding the advice not to assume a difference (and then presume we know what it is) does not imply that difference is irrelevant or unable to be articulated. Indeed, the intellectual challenge presented by women's art practice is to mobilise radical difference and think otherwise; every intervention into this subject is strategic, exhilarating and dangerous, changing both what and how we know. As a critical form of epistemological enquiry, exploring women making art is invaluable. Since we cannot just add women's art unproblematically to the category of 'things known', we are obliged to reconceive the very processes of knowing in acts of experimental and creative thinking.

In considering the potential impact of Gilles Deleuze's thought on cultural studies, Ian Buchanan identified similar problems with the presumed known: '[c]ultural studies displays a common assumption that its object is ready-made and that theory is something one simply applies'.[6] By contrast, for Buchanan, a 'Deleuzian cultural studies', would 'begin with the question of the subject, but it would not ask, what is a subject? Rather, as we have just seen, it would ask, how

does one become a subject?'[7] What Buchanan so aptly argues is that a shift from object to process, from an ontology of being to one of becoming, is the crucial component of thinking beyond an economy of the same, of the already-known. If we ask 'what *is* a woman artist' or 'what *is* women's art', we fall back into the logic of objectification and marginality, but if we take the lead and enquire into how women's art comes to articulate sexual difference in its material specificity and at its particular historical locus, the potential to generate new answers, ideas and concepts is endless. In the present volume, I am embarking upon this dangerous and exhilarating path, engaging in an active dialogue with women making art.

The title of this book is precise and implies process; this is not a text about a category of objects defined as 'women's art', it is about the contingency of 'women' and 'art', coming together to make and re-make meaning in particular social situations and aesthetic encounters. To define women artists as an homogeneous cohort, irrespective of the dynamics of their histories, or to seek in women's art some monolithic 'female essence', preceding specific practices as their knowable 'origin point', erases differences between women and reinstates that exclusionary paradigm which rendered female subjectivity invisible, illegible and impossible to articulate. Moving beyond that logic to engage with women's art and radical difference interrogates traditional modes of historical enquiry, the nature of the artist, concepts of authorship, intentionality and the very definition of 'art'.

Indeed, the present volume is focused upon works of art, attending closely to their potential to signify differently and materialise female subjectivity otherwise. This does not presume that art made by women is a vehicle for some kind of eternal 'woman-ness', nor that there is any obvious, literal or uniform relationship between the sex of the maker and the work produced. Rather, I agree with Elizabeth Grosz's point in 'Sexual Signatures: Feminism After the Death of the Author', that:

> The sex of the author has . . . no direct bearing on the political position of the text, just as other facts about the author's private or professional life do not explain the text. Nevertheless, there are ways in which the sexuality and corporeality of the subject leave their traces or marks on the texts produced, just as we in turn must recognize that the processes of textual production also leave their trace or residue on the body of the writer (and readers).[8]

In this essay, Grosz argued that 'discursive positioning', or the 'complex relation between the corporeality of the author, . . . the text's materiality and its effects in marking the bodies of the author and readers',[9] provides the key to examining the practices by which sexual difference might be articulated in and through an individual text. The significance of such thinking resides in its double play between materiality and agency. The specific corporeality of subjects and works ('texts') in conjunction with their historical location and material presence in the world, are neither dismissed as irrelevant nor reified as the essential origin of their meaning. Corporeal specificity is, instead, implicated in relations, processes and practices

through which matter comes to *matter*, or becomes meaningful. The inter-relationship between an artist and a work, therefore, is both materially situated and in process, an effect of actions in the world.

Critics, theorists and historians also participate in this double play of materiality and agency; theory is not transparently applied to mute objects by disembodied, knowing subjects, but emerges from the positioning activities of knowledge projects. Following Buchanan, the questions we ask of women making art participate in the meanings which are produced – we are implicated in the productive relation. This is not a bad thing. Indeed, throughout this volume, I argue that engaging with women's art differently changes both what and how we know about histories, subjectivities and aesthetics, and that close attention to the double play of materiality and agency in women's art enables us to ask new questions of vital importance to the future. This locates me as a partner in dialogue with women making art rather than in the position of a privileged interpreter, explicating the inherent truths of women, art and cultural history. In an important sense, my task here is not to reveal the essence of female subjectivity expressed in art (even if this were possible), but to explore the *work* of women's art, the work it can do in articulating histories, subjects and sensory knowledges against the grain.

The *work* of art

It is important to begin an examination of the *work* of art with an instance. An exceptionally useful one is Cornelia Parker's 1996 piece, *The Negatives of Words (silver residue accumulated from engraving words)*, one of a number of Parker's works which focus on the traces left from processes of meaning production. In *The Negatives of Words*, tiny coils of metal, left from engraving, are carefully piled to form a delicate mound. Their treatment and display render them aesthetically provocative and visually absorbing. But this piece is compelling for a number of other reasons as well, including its resolute return of excised traces and residues to the focus of our attention, its emphasis upon the processes through which physical objects are brought forth and its strategic deployment of the 'in-between' of text, image and object. *The Negatives of Words* does not simply illustrate the concepts discussed earlier, it instantiates them, enabling us to grasp the work done by art at the interstices of materiality, subjectivity and agency.

If *The Negatives of Words* does not illustrate concepts, then what does it do? Mieke Bal's formulation of art as a mode of 'cultural philosophy' in which works act as 'theoretical objects', is instructive for thinking about practices such as Parker's.[10] That is, these works crystallise theory, they 'theorise', by forging a critical link between thinking and making, between the materiality of objects and the agency of artists and participant-observers. This locates the 'art' of these pieces in the 'work' that is done with them and again, requires us to ask different questions in our encounter. For example, asking what the 'negatives of words' *are* defeats the complex configuration of image, text, matter and idea in Parker's piece and simply reinstates the object: the negatives of words are the silver residue

Figure 0.1 Cornelia Parker, *The Negatives of Words (silver residue from engraving words)*, 1996, copyright, Cornelia Parker; photograph, Frith Street Gallery, London

accumulated in the act of engraving. I am arguing that here, the work of art does not reside in the visual image, physical artifact, suggestive title or descriptive parenthetical line, but emerges in their relational play, a play engendered by an embodied, corporeal subject.

For instance, one of the meanings which *The Negatives of Words* develops through this interplay concerns the effaced 'body' of 'text'. The body, deftly avoided in text-based knowledge regimes, commonly forms the base from which word differentiates itself to assume both transcendence and power over flesh, image and object.[11] Not coincidentally, the base matter from which words are engraved in the printing process is called the matrix. The links between matter, matrix and woman are definitive; by locating them as the negatives of words, the corporeal residue avoided as we ascend to text, Parker's work could hardly confront the gendered word/flesh dichotomy more explicitly. We can, of course, argue these ideas textually, but the modulation between the written word and the material object in *The Negatives of Words* engenders this meaning in a fully sensory, embodied connection with the work of art.

This, I am arguing, is one of the things art can do in terms of thinking; the *work* of art is the work of embodiment, of bringing us to our senses in cognition.

Clearly, the reconnection of bodies with knowledges is crucial to any project concerned with sexual difference and, for work focusing specifically upon women making art, it is imperative. This is not only because art and aesthetics have themselves been denigrated in favour of ostensibly disembodied knowledges (knowledges associated with pure rationality, freed from the deceit of the senses, corporeality and by extension, 'woman'), but because embodied thought is situated, perspectival, diverse and mobile. These wider ramifications reconceive the more deadly elements of universalising 'master' narratives within which female subjectivity is unable to be articulated and women making art are merely the negative shadow of their male counterparts.

An assimilative logic of the same supports the myth of transcendent, gender-neutral subjects, universal, homogeneous truths and *a priori* first principles in epistemology, ethics and aesthetics. Within such logic, difference is effaced, subjects not conforming to the normative centre are marginalised and knowledges become decorporealised as 'truths' beyond their material manifestation and effects in the world. Without labouring this point, there is no place within such a framework for women making art; their specific contributions to culture just cannot be seen in such a diminished ray of light.

Acknowledging the work of art as 'theory', as a fully sensory mode of cognition, reinstates the power of particular, located, corporeal meanings to emerge in encounters with difference. In a dialogue with women making art, this move is extraordinarily productive, enabling us to ask how female subjectivity was and is articulated in visual and material form, what meanings might have been signalled by the making of art by women in diverse historical circumstances and what such works might permit us to think and know now. These questions do not presume to define in advance what women's art can or might mean, they do not suggest that there is one, all-encompassing theory by which all women's art can or should be interpreted and they do not entail choosing, once and for all, whether to address women's art only, or to look at the art of women and men together. Such predetermined theories, methods and definitions are counterproductive in the case of women making art and can only curtail the potential it has to form new epistemes.

The challenge, rather, is to write *with* women making art and to create specific configurations of ideas, objects, images and texts, which address the questions we ask. And, while these do not set limits on what else might be asked of the work, they can be examined for their efficacy, rigour and persuasive explanatory power. In this volume, I am asking what new knowledges women making art can produce in terms of history, subjectivity and aesthetics. For that reason, I am focusing only on women's art practices and yet, in some instances, I am bringing together work from very different geopolitical and chronological contexts in order to think through particular issues and ideas. Without preempting the introductory comments at the start of each Part of this text, it is worth considering here how the geographical and chronological choices made in the case studies connect with the intertwined themes of history, subjectivity and aesthetics as they are used throughout this book.

New epistemes

In considering what difference it makes when art is produced by a woman, it is impossible not to confront the problems of conventionally defined histories, limited concepts of the subject as an autonomous 'I' and understandings of art which reinforce canonical exclusions and evaluate women's work negatively. Indeed, such conceptual frameworks are interdependent. Moreover, as feminist philosophers and theorists have demonstrated, the 'postmodern' and poststructuralist critiques of these meta-narratives have not always provided better or more useful models of female subjectivity, nor paradigms of histories or aesthetics which can account for sexual difference. In instances where poststructuralist theory itself ascends to the summit of presumed sex-gender-'race' neutrality and takes on the mantle of universal, abstract meta-discourse, it only serves to reinforce the very system it initially critiqued.

There are two intimately interconnected points established here: first, that the conventions of history, subjectivity and aesthetics which marginalised women's art practices supported a very particular geopolitical situation, one which is now disintegrating, and second, countering this conventional logic neither replaces it with a new meta-theory, nor refutes meaning altogether in some form of radical relativism, 'after' the subject. The rise of the modern, bourgeois, Euro-centric individual and the progressive, linear historical models which complemented his autonomy and power in the world, was the corollary of European colonial expansion and imperial domination as well as the so-called scientific and industrial revolutions. The geopolitical dominance of the 'west' over its 'others', the rise of the modern nation-state and the systematic assimilation or destruction of difference are related phenomena. Women's art did not just happen to be rendered marginal; associated with the feminine, the decorative and the facility (but not genius) of women, it became the negative 'other' of men's art, which could then transcend its corporeal trace to become simply 'art'.

Disentangling these complex strands to investigate the cultural legacy of western imperialism and its effacement of difference is difficult but possible. However, it is not all that needs to be done. We might be able to see how the work of women artists came to be less valued and less well known than that of many of their male contemporaries generally, but this general point does not address the astounding range of art which women made nor the extraordinary variations in their modes of practice and sophisticated negotiations with social norms and constraints. To explore these things is to engage productively with difference and to attend closely to the historically located and materially specific contingencies of women making art. This neither replaces the exclusionary logic of the same with a new, meta-theory of women's art (e.g. 'all women's art is . . .'), nor does it accede to the utter rejection of the subject and meaning, simply because these cannot be universalised as one.

This latter point is more pressing for feminist theorists concerned with female subjectivity and women's agency, since the critique of both the autonomous 'I' and the truth claims of, for example, history, philosophy and science, have led

some scholars to reject the subject of knowledge altogether. As many feminist and anti-colonial thinkers have rightly claimed, this rejection of the subject comes just as women and non-white, non-western subjects have claimed their voice. Dispersing subjectivity is easy when you have long since held the position of empowered subject; female subjectivity and women's agency (and, of course, the agency and subject-position of all those who had been denied as 'others') are not relics of a now-discredited social system, but important emergent conceptual structures. In my engagement with women making art, I am committed to both of these productive concepts, formulated not as the antiquated 'I' of the same, but as intersubjective modes of articulating difference.

In the chapters which follow, a series of close case studies are used to open debate on the three, intertwined themes. These cases are diverse – the artists and works range geographically from North, Central and South America, Europe (including the former Soviet Union), Africa, the Middle East, Southeast Asia and Australia and, chronologically, from the seventeenth century to the present. This geographical and chronological span is not, nor is it intended to be, an all-inclusive survey and there are many more regions and historical moments which might have been discussed at length. Moreover, it would be wrong to say that the cases are representative of the full range of women's artistic practices internationally; I was not attempting to give a cursory account of, for example, cultures in which the category of 'art' is utterly divergent to our own, albeit contested, understandings. In what follows, there is a focus upon diverse, international instances of practice by women which resist, reformulate and reconceive the central, western-normative paradigms described above. These instances, therefore, are actively engaged with or informed by the embeddedness of Euro-centric discourses (dramatically extended in the twentieth century by US power politics) in the international sphere, but they do not simply accede to this dominance. Their articulation of radical difference acts both as an anti-colonial force and as a means by which the 'international' might be redefined and positioned otherwise.

Additionally, the emphasis given to the articulation of female subjectivity in all its complex and sophisticated difference, refutes any essential or authentic claims concerning woman. The works considered throughout this volume were produced by women – diverse, heterogeneous and mobile subjects, constrained but never fully contained by their historical and material circumstances. Privileging the specificity of sexed subjectivity as it emerges in and through the visual arts, the works discussed deploy varied media and were made to be seen in a wide range of contexts. Some of the works are public monuments, some private self-images, designed to be circulated amongst friends; some of the artists are well known, others less so and there is a definitive mix of contemporary with past practice. This diversity demonstrates not only that women making art have been experimental and innovative for centuries, but that their interventions bear the valences of their material form and particular, practical development. There is no one type of women's art, yet women's art resides at the nexus of materiality, subjectivity and agency and bears the traces and residues of its discursive positioning. It provides us with an exceptionally apt means by which to create cross-cultural dialogues in

and through difference and to exacerbate the crisis points in conventional meta-narrative, so to deconstruct their rigid economy of the same.

Not surprisingly, in exploring the varied work within this volume, overlapping themes emerged, such as the significance of cartography and mapping practices in formulating new concepts of the knowing subject, the role of pleasure in thinking through difference, a shift from object to process and from representation to articulation, the intertwining of text with image and of the individual in and with the collective and, of course, the power of corporeality and the senses to engender new epistemes. While these appear with regularity in this work, and are abiding concerns of mine, I do not imagine that they are eternal truths of women's art or that they will necessarily remain key features of women's art practices in the future. Moreover, there is no sense in which these broad conceptual constellations produce any particular form of artwork or theoretical structure, rather, they are formed by the negotiation of the kinds of parameters set in place by the 'modernity' of the past three centuries.

In the future, these parameters may alter and, consequently, the insights of this book will become a description of the past. I hope, however, that its determination to ask new questions and to acknowledge the vital significance of women making art, past, present and future, will be its legacy. At a moment when the institutional structures surrounding contemporary art seem bent on consuming the valuable work of feminism around, for example, the body, materiality, performativity and the sexualisation of space and time, without so much as noting their indebtedness to the intellectual, political and artistic interventions of generations of women, ensuring this legacy is all the more urgent.

Part I
History

Introduction

Any investigation of women making art by necessity addresses history. The very fact that the work of women artists is still less well known than that of their male counterparts raises questions concerning women's historical role in cultural production and in the construction of art's histories. The phenomenon of women making art intervenes at this juncture, severing any seamless link between 'history' as a series of past events, people and observable facts, from 'history' as the process of recounting such events, evaluating the facts, and bringing them forth in the present. Both the conventional historical record and the recording process fail at the point of women's art, the very point at which they would need to recognise and account for difference.

There was a time in the recent past when it might have been thought that women were not very often active as artists, historically, or were unsuccessful in the artworld. However, some three decades' worth of scholarship on historical women artists now makes such a contention seem nonsensical. Women were active in all areas of cultural production in the past, despite the (sometimes extreme) opposition they faced personally, socially and professionally. In fact, many women artists, over at least the last five centuries in the west, were highly successful and gained notice and patronage from their contemporaries. Yet their historical legacy has not equalled that of their male counterparts, and this is a fact which requires an explanation. Were these noteworthy and successful women really making art of lesser quality than the men of their generation or were the women who made art excluded from the historical practices by which artists were assured a legacy?

To examine questions such as these, it is imperative to break with any lingering historical positivism and refute linear, progressive narratives of the past and the trope of the 'objective', disinterested historian, rendering bygone events transparent to reveal their inherent truth. In itself, it is hardly novel to challenge such monolithic models of history; indeed, it is possibly more difficult to sustain the fiction of history as a unilateral and stable explanatory force, than to acknowledge the multiple perspectives and located interests which constitute histories. But for subjects and materials which have been marginalised by mainstream, historical meta-narrative, reconceiving histories is a political as well as scholarly act. Women artists and women's art are not benefited by any adherence to the exclusionary

logic of the canonical traditions of art history which forever cast them as second-rate, peripheral and of little lasting value. The challenge to the historian is to critique those paradigms which marginalise women artists and their work, while, at the same time, finding alternative structures through which to configure histories otherwise.

Structures which emphasise the embodied situation of historical subjects, the material processes, rather than universal principles, of history, and the perspectival practices of historians in evaluating the past are useful to this task. Placing the emphasis upon embodiment, process and praxis does not just reverse the positions of the centre and its margins, creating, for example, an 'alternative canon', a separate but equal list of 'great' women artists. Working with histories as multiple, perspectival and dialogic, dismantles the centre–periphery paradigm, enabling women's art to be seen and heard in its own right, sometimes for the first time.

One key insight derived from understanding subjects as embodied and historically situated is negative – there is no universal 'woman artist'. Simply put, a 'woman artist' in Victorian England was not the same as a 'woman artist' in Russia at the time of the Third International. Women making art negotiated diverse socio-cultural, economic and temporal contexts, combining the complex categories of 'woman' and 'artist' in many different ways. Indeed, women's access to art, and success within its remit, often depended upon contingencies of class, age, economic status, urban or rural locus and national, 'ethnic' or 'racial' origin – factors which could brutally distinguish between women in terms of power and privilege. Histories which articulate corporeal specificity mobilise differences between women, not just between men and women, and these differences are critical to any project designed to explore the multi-faceted histories of women's art.

Stressing these multi-faceted histories dismantles both progressive teleologies and *a priori* principles of historical development. In the case of women artists, for example, there is no evidence of an inevitable, uni-directional advance; women's participation in the arts did not simply 'increase' in any obvious, chronological manner and women artists today are not at the pinnacle of a slow march toward equality. Similarly, women's historical involvement with the arts demonstrates no uniform relationship between gender, aesthetics and history. The micro-histories of women making art can neither 'prove' nor 'test' the existence of a universal macro-history of women and art. Rather, it is the material specificity of micro-historical instances of women's art practice which constitutes the wider, macro-historical field. Understanding the processes by which polyvalent micro-histories construct what we understand as the macro-historical frame, acknowledges that patterns emerge across historical accounts of women's art-making without occluding the significant differences these also evince.

To recognise the historical interventions made by women's art means taking art's address to history seriously, expanding our relationship to material and visual practices as configurations of historical knowledge. To explore art-making as a form of historical agency means more than asking what past event or figure is pictured by an artwork, who or what is commemorated by the work or what set of circumstances led to the production of the piece. These might all be important

elements in taking an historical approach to a work, but they are far too literal to delineate the full potential art has to reconceive histories. In this stronger sense, I am arguing that the visual and material arts can address history in ways that writing and speaking cannot; this is not to privilege art over other forms, but to recognise the specificity of its intervention. Acknowledging that art works in particular and powerful ways, especially in terms of mobilising the senses and the imagination as significant cognitive faculties, means that our modes of writing with, to and about its effects have an important part to play. If there are no objective, disembodied historians and no transparent, immaterial histories, then art, and the writing of and with art, are themselves formative of the histories of which they speak.

In the three chapters which constitute the Part of the present volume devoted to 'History', these insights have been crucial. The material addressed within the chapters is highly selective, and the particular historical moments covered are certainly not inclusive, yet neither are they random. Each chapter takes as its central pivot a double crisis point between history as the events of the past and history as the record of those events. The Holocaust, with which the volume opens, epitomises this double break. As an historical fact, the brutal genocide of millions of Jews, gypsies, political dissidents, homosexuals and others defined as non-human by the obscene logic of National Socialism, destroyed whole generations, the very fabric of historical continuity. And the corporeal loss of the Holocaust was so great that history, as a sense-making of the world, faltered; many scholars simply declared the Holocaust beyond history, unable to be conceived, addressed or represented.

The second and third chapters, focusing on the anglophone African diaspora and the decolonisation of Viet Nam, also examine extreme forms of conflict which have led to crises in historical explanation. The African diaspora is steeped in the brutality of the colonial practice of chattel slavery and its near-complete destruction of familial genealogy for the generations of those descended from slaves. Yet one of the most striking aspects of black feminist interventions into this history is its emphasis upon survival – and a survival of more than just the bodies of women subject to inhuman treatment, the survival of beauty, creativity and strong bonds between women across generations and over time. The long process of decolonisation in Viet Nam also marks a crisis point in historical narrative, particularly the narratives engendered by the developed west. Unable to represent Viet Nam within the singular logic of east and west or the Cold War bi-polar pair of communism and capitalism, the power of representation itself came to be questioned and the answers were not always easily consumed. Significantly, all three points of crisis which focus the chapters of this section have been pivotal points for the construction of alternative forms of history which legitimate location, perspective, embodiment and difference.

If the cases examined in the chapters each challenge a seamless historical paradigm, they also interrogate the complex relationship between aesthetics and sexual politics. The injunction not to aestheticise the Holocaust, typified by Theodor Adorno's rejection of lyric poetry in the wake of Auschwitz, has been mirrored by

a strong opposition to feminist explorations of the event, argued to trivialise or marginalise its significance. By contrast, black feminists have stressed frequently that the reinstatement of African diasporan women as significant subjects of history relies on a wide variety of practices, from academic scholarship to political activism, and that art-making is key amongst these. An extraordinary body of art and theory has been produced by African diasporan women drawing together new and renewed aesthetic forms of historical inscription which operate at the nexus of racial and sexual difference. The problem of 'representation', as both political and aesthetic, is taken up by the third chapter by focusing on Viet Nam. Since the conventions of representation speak of political bodies and the body politic, articulating sexed subjectivity provides a counterpoint to assimilative liberalism and neo-classicising figuration.

Crucially, none of the three chapters asserts a separate 'women's history' of the Holocaust, African diaspora or Viet Nam conflict; rather, they present histories as partial and perspectival, arguing that the multiple, differently inflected positions of women can yield significant insights into these events and mobilise histories otherwise muted. The chapters are micro-histories, detailed examinations of particular conceptual tropes such as exile, covenant, gesture, cartography and representation, designed to realign expected meta-narratives by shifting our attention to an overlooked feature, an under-considered idea or a response not yet included in the dominant accounts.

This historical realignment is an effect of history-making in the present, of mediation, reinscription and reconfiguration through materials, ideas and images. The works which form the basis of each chapter's argument intervene in the production of historical knowledge. These works do not comment upon or merely reflect histories which exist beyond them and it is their visual, material, spatial and conceptual intervention in the processes of constructing histories which is at stake in the chapters. For that reason, the chapters never take histories or works of art as self-evident or as transparent vehicles of truth, but rather focus upon the ways in which women making art negotiate historical parameters, engendering meanings in materiality.

In writing with these works, rather than about them, I am seeking to mobilise a few particular interpretations and ideas which are resonant with the artworks and histories being explored, but I am not attempting to determine and assert the full meaning of these complex pieces once and for all. Indeed, I do not even think such a task is possible. The chapters are structured to emphasise the writing/making of histories in the present, the material mediations through which histories are constructed and the significance of the detail or fragment in the wider, macro-historical frame. It is a deliberate strategy to use two works from the recent past as a lens through which to explore earlier events, comparing and contrasting these to elicit a theme which connects gender, history and aesthetics. However, as the chapters unfold, the themes take on variations as the works are brought into contact with other practices and ideas – as does history itself. In the end, the macro-historical field is reconstituted by the extraordinary work of women artists at the micro-historical interstices between embodiment, location and practice.

1 Exiled histories: Holocaust and *Heimat*

> In addition to the 'intervals of silence' that I made visually palpable, there are the omissions of time – both narrative time and chronological time – that I recorded in my interviews. . . . The significance of these narratives thus lies in the very fact of disruption. What remains unsaid cannot simply be pieced together, or adroitly bridged.
>
> > (Deborah Lefkowitz on her film *Intervals of Silence: Being Jewish in Germany* (1990))[1]

> Buchenwald
> shaven dome of a skull
> the cerebral execution machine camouflaged inside a height scale
> neck bone oracle
> no birds upon the hill, no sound
> the dead are joined in fear
> forming a leaden skin belljar suspended over Weimar
> even trees refuse to grow here
> the energy absorbed from inside the earth
> weighing down with stones the camp's perimeter
> > (Rebecca Horn, from her work *Concert for Buchenwald* (1999))[2]

What address can be made to the Holocaust which does not contend with absence, exile and loss? Holocaust survivors live in an exilic condition, past and present permanently inscribed by an inexorable abyss. Those of us who come after the Holocaust live in a history scarred by the extreme evidence of inhumanity. Both Deborah Lefkowitz's film *Intervals of Silence: Being Jewish in Germany* (1990), and Rebecca Horn's Weimar installation, *Concert for Buchenwald* (1999), worked within the conditions of exile and loss, engendering history against the grain of a forgetfulness seeking to 'unlearn' the terrible lessons of the past. *Intervals of Silence* did not shrink from evoking the traumatic void expressed by silence and temporal discontinuity and *Concert for Buchenwald* intoned an ashen, voiceless performance. But if these works acknowledged the magnitude of the exilic chasm which was and is the Holocaust, they never implied that such devastation stands beyond history, a *tremendum* which leaves us mute and helpless. Arguing against the possibility of recovering what Jürgen Habermas termed

a 'conventional' history or identity,[3] *Intervals of Silence* and *Concert for Buchenwald* offered the potential to reconstitute history and identity by other means. The work of this art enacts what Geoffrey Hartman called 'a counterforce to manufactured and monolithic memory',[4] materialised by an attention to location, corporeal specificity and coextensive difference.

Exile is constitutive of the Holocaust; the Third Reich created exiles throughout the world as political dissidents, homosexuals, left-wing artists and intellectuals joined Jews, gypsies and other 'undesirables' in a mass exodus from Germany and its occupied territories. The millions murdered in the death camps, and the smaller number who survived, created a generation torn by exilic trauma, pain and longing, and for those who stayed, yet remained in opposition to the Nazis, the period has commonly come to be figured as one of 'inner exile', a painful loss of community, agency and subject-hood. Yet exile cannot be conceived as a blanket term. Thinking exile refutes fixed, abstract theories and universal subjects – exile demands specificity. As Hamid Naficy put it, exile is not a 'generalized condition . . . Exile discourse thrives on detail, specificity and locality. There is a there *there* in exile.'[5]

Refusing to universalise exile finds its parallel in the rejection of monolithic historical narrative in the post-war period. Simply, an unwavering faith in progress and the coherence of history could not withstand the Holocaust. As Ronnie S. Landau put it: 'The Holocaust shattered Western liberal dreams of reason and culture as forces which necessarily humanise us and which promote genuine tolerance of difference.'[6] Landau's emphasis upon tolerance and the recognition of difference does not stand alone. Indeed, it is the dialogue with difference which many historians and cultural theorists argue is the most crucial element missing from monologic histories of the Holocaust and their purposeful 'forgetfulness'.[7]

Forgetful accounts polarise the Holocaust as *either* beyond history *or* as an easily contained, indeed inevitable, result of reasonable historical processes. This is too limiting a paradigm; it is a paradigm born of conventional historical dualism which views the diverse, individual experiences of the Holocaust, and its universal significance, as mutually exclusive rather than complementary. In resisting forgetfulness, it is imperative to resist reductive binary thinking as well and to address the Holocaust as simultaneously universal and specific, both a breach of historical certitude, yet utterly within our histories. The work of memory, history and art in the wake of this cataclysmic rupture falls precisely at this point, enabling the connections between the general and the particular, contradictory motives and actions, to emerge through negotiations with difference.

Intervals of Silence and *Concert for Buchenwald* each support the dynamic interaction between incommensurable differences as a way of making histories anew. In Lefkowitz's film, the dynamic emerges in the interplay of silence and testimony, suggesting that coming into voice in post-Holocaust Germany is a function of both presence and absence at once. In Horn's installation, the tension between German high culture and the technical barbarity which was the Final Solution demonstrated their simultaneity as well as their irreducibility.

Both works made distinctions between the universal and the specific seem arti-ficial; close attention to particular materials, contexts and ideas was the mechan-ism by which the vast historical chasm which marks the Holocaust came into view.

Intervals of Silence takes no singular point of view on the problems of history, knowledge and community in post-Holocaust Germany, yet the voiceless inter-vals which speak so eloquently within these personal stories mirror the exilic chasm created by the Holocaust and the destruction of the very possibility of unified historical narrative. The film's premises are straightforward: Lefkowitz juxtaposed (in narrative voice-over) her experiences as an American Jewish woman getting to know her German (non-Jewish) husband's family and home town in Westphalia, with the varied voices of the residents of the town discussing their own histories, the significance of history in the present and their understand-ing, as Jews and non-Jews, of being Jewish in Germany. While the voices might be addressing similar themes, they do not correspond in tone, intent or position. The visuals, consisting of both 'straight' footage of the town and heavily worked replays of this footage (negatives, slowed motion, overlays, fragments) no more readily reveal a coherent historical narrative. As Hartman wrote of testimony, '[e]very story or testimony . . . is and is not like every other'.[8] These intervals of silence are like and not like every silence which attends the reconstitution of European history after the Holocaust.

Horn's installation, *Concert for Buchenwald*, was in two parts, located such that they inscribed an arc over the city of Weimar, home of Goethe and cultural capital of the German Enlightenment. The significance of Weimar was critical to the meaning of Horn's double installation which sited a ghost-like concert in the vacant White Salon of Schloss Ettersburg against a desolate dirge in an abandoned factory depot in the city below. The transportation to the death camp, barely beyond Weimar's city limits, was repeatedly reimagined in the depot by a mech-anised skip truck from Buchenwald running ceaselessly between a brick wall and a heaped pile of discarded stringed instruments. The concert in the castle was an empty, mechanical repetition of two bowed notes on a bass, played to the sound of bees in their hives, reflected by rotating, sometimes shattered, mirrors on the floor. Light and darkness, sound and its absence, hope and its loss, were brought together in this concert played for the contradiction of Weimar and its camp, Buchenwald. The counterpoints of cultural power Horn invoked do not inform a singular historical narrative, but coexist as the central problem of western history 'after Auschwitz'. Horn's double installation attends to the specificity of location and material to articulate coextensive differences as a history-making process in the present.

Significantly, both *Intervals of Silence* and *Concert for Buchenwald*, are prem-ised upon corporeal specificity. In interviewing for the film, Lefkowitz noted that silence, the failure of voice, usually accompanied the narrative break at the point of deportation and that this pattern was especially pronounced in women's testi-monies. Noting the prominence given to silence in feminist literary theory and, increasingly, in feminist scholarship on the Holocaust, Lefkowitz wrote:

Several years after completion of my film, I am struck by the possibility that my interviews with women may, in fact, have influenced my thinking about the material I collected as a whole, as well as inspired some of the specific visual and structural ideas I employed in presenting this material.[9]

The film was not intended to take the positions of women as formative of its structural logic, but their address to silence was too compelling to be ignored. It could be argued that Lefkowitz's own position as a woman engaged in a process of cross-cultural translation and communication, made her more receptive to the voices of women which resonated with her own. Whether or not this is the case, the film's interplay of presence and absence, (mis)communication of multiple differences and signification through silence, were determined by women's stories and amplify feminist perspectives on female subjectivity and voice.

Similarly, Horn's installation was not designed to privilege a woman's viewpoint, yet its powerful evocation of corporeal loss, in addition to its critical take on both Enlightenment high culture and modernist technology, are common themes in feminist philosophical work seeking to undermine dualism and the privilege of the masculine centre over its marginalised others. Horn had a long history of feminist practice behind her by the time she produced *Concert for Buchenwald* and its resonant connection of Weimar with paradigms which eradicate difference, would not be misread as a feminist gesture.

Holocaust scholarship and feminism, however, have not formed an easy alliance. Not surprisingly, some feminists have been accused of trivialising the Holocaust by attending to the banality of misogyny,[10] of marginalising the event by looking at women's experiences, or of setting women against men, suggesting for example, that women were 'better suited' to the rigours of the camps or had better chances of survival.[11] Such arguments assume that women's perspectives upon, and experiences of, the Holocaust must be taken in opposition to those of men, that there is here posited yet another binary choice between a universal or specific account. This choice is itself wrong-footed. In a moving passage from one woman survivor's remembrance of her liberation, Sara Horowitz contends that the gender-specific testimony of subjects is inseparable from the wider picture of devastation in the Holocaust. To further my argument here, it is worth quoting the testimony at length:

> All on earth that I had left after liberation from Malchow, Germany, was my skeletal body minus all my hair, minus my monthly cycle, a tattered concentration camp shift dress without undergarments, a pair of beaten up unmatched wooden clogs, plus my 'badge of honor', a large blue number 25673 that the Nazis tattooed on my left forearm on the day of my initiation to Auschwitz inferno. I was homeless, stateless, penniless, jobless, orphaned and bereaved.[12]

Following Vivian Sobchack, I would argue that corporeality and embodiment are also crucial concepts for exile, since the body (*a* body) is the first 'home' of the

subject and the productive locus of both history and knowledge.[13] Moreover, women's embodied experiences of the Holocaust are not opposed to those of men, but are as Myrna Goldberg described them, 'different horrors, same hell'.[14] Their voices give us access to histories formed through attention to difference, specificity and location.

These critical connections inform my thinking about women's art and the Holocaust. Looking carefully at exile and female embodiment brings new perspectives to our understanding of the Holocaust, while the negotiation of female exilic subject-positions through the materiality of art reiterates the significance of corporeality to theory. Women's art thus offers a unique praxis through which to consider the connections between embodiment and articulation, beyond the legacy of universal representation and monolithic history. It is not a separate or oppositional 'women's history', but a nuanced intervention into those singular narratives which so easily permit us to forget.

To develop these ideas of exiled histories and women's art further, I would like to take the cipher of *Heimat* as a theme. In German, *Heimat* can evoke both 'home' and 'homeland', a critical nexus for considering the Holocaust as exilic, as a loss of home in the widest sense. Lefkowitz's film explores the deep meanings which reside at the heart of the domestic and the everyday, while Horn's installation connects spirit and matter in a negotiation of high culture and homeland. In the German context, which both *Intervals of Silence* and *Concert for Buchenwald* use as their principal framing device, there can be neither a simple return home, nor an easy reconstitution of the identity of the homeland after the breach inscribed by such corporeal devastation. As James E. Young has argued elsewhere, German memorials for the Holocaust almost always focus upon absence and the problem of national identity.[15] I would suggest that thinking this identity at the point of connection between home and homeland, while attending to corporeal specificity, exile and difference, enables *Intervals of Silence* and *Concert for Buchenwald* to intervene in the processes of inscribing histories in the present. These artworks do the work of history, memory and mourning in allowing voices to be heard, and covenants formed, for the future.

Home, covenant and the profundity of the everyday

Intervals of Silence is a meditation on the very possibility of home and community after the Holocaust. Combining images of the small German town in which her husband was raised with taped interviews of its residents, Lefkowitz produced a thoroughly local nexus from which to examine the wider phenomenon of post-Holocaust social fragmentation. While the film is in many ways a personal portrait of the artist and her ambivalent[16] relationship with this community, it is also a structured dialogue with memory, history and the inscription of the past in the language and material substance of the present. In this sense, I am invoking the term *Heimat* in connection with *Intervals of Silence* to signify both its focus upon local, even domestic, detail and its attention to the practices by which community comes into being. In the case of post-Holocaust Germany, explorations of

Heimat thus imply more than a return to a prelapsarian homeland; as exilic histories, they do not return to, but reconstitute, home itself.

One of the tactics *Intervals of Silence* uses to reconstitute home is to amplify the gap between the spoken and unspoken, the seen and unseen, within the histories of its subjects and their local environment. In the second half of the film, for example, there are a series of key image-text passages which concern death, mourning and remembrance. Directly following a woman's declaration that the Final Solution destroyed the Jewish presence in Germany, 'We actually no longer exist',[17] we see women's hands tending a grave, placing beautiful orange marigolds as a marker. In the next passage, footage of the council-tended Jewish cemetery is overlaid with varied comments, ranging from pleasure in being reminded of the former strength of the region's Jewish community, to concern that Jews have become a cipher for death, loss and victimisation, and the pointed remark, 'We are not a cemetery culture.'

After strategic breaks to scenes of a carnival and excerpts telling of the unimaginable horror of seeing the documentary images which emerged from the death camps after liberation in 1945, a voice declares that the incessant coverage of the Holocaust has made it 'forgettable' and another longs for the imagery onslaught to cease, saying 'maybe grass would grow up over some of this'. At this point, the visuals change to a long-shot of an idyllic, sunlit scene of children in a playground, while Lefkowitz's voice-over explains the pleasure she took in filming this place. We are only then told that this was the site of a Jewish cemetery before the war; the grass has indeed grown up.

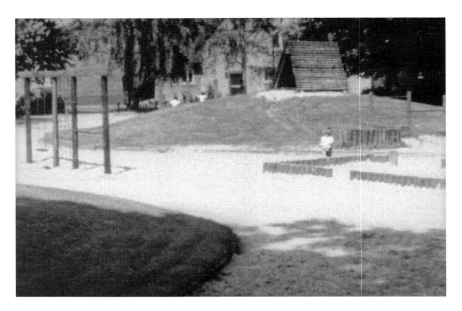

Figure 1.1 Deborah Lefkowitz, still from *Intervals of Silence: Being Jewish in Germany*, 1990, courtesy of Deborah Lefkowitz

In attempting to précis the film above, it may sound as though the work made an over-obvious point about the devastation experienced by the Jewish community and their absence from key sites of remembrance, mourning and history. That is the effect of my brief account only; the film makes no such unsubtle connections, developing these ideas instead through layered effects of sound and image, or what Matthew Bernstein astutely termed filmic palimpsests.[18] It is especially significant that such meaningful historical insights emerge in and between filmed images of the everyday. Recasting these, Lefkowitz realised the fuller potential of the ordinary to eloquently express historical knowledge. As the artist put it, 'Eventually I realized that the images of everyday life I was filming embodied both meanings simultaneously, were at once both profound and trivial.'[19]

The profundity of the everyday is crucial to the film's dynamics, and it is hardly surprising that so much of the material in the film, and of course, its structural logic, are drawn from the domestic. Women cleaning homes, caring for children and tending graves, do the everyday job of recording familial histories, making times and places significant. In *Intervals of Silence*, not only do we learn to hear the unvoiced intervals which typified women's accounts of the Holocaust, but we orient our vision by entering into the local and the domestic. The most deliberate break in the temporal progression of the film, the interval of silence which marked the moment of deportation in the female survivor's narratives, is a case in point.

While the film's visual sequence consists of slowed, negative footage of cables passing above a tram-line, a woman speaks:

> Being taken away, that was not the worst of it. For years one had been waiting, knowing it would happen . . . One evening I was preparing dinner and about to slice some tomatoes. And my husband said to me, 'Why are you trembling? Why are you cutting the tomatoes so thick?' And I said, 'Please, you cut. I can't anymore.' I was waiting for the things which were to come.

Her story, and the incessant negative images, continue to the inevitable knock on the door: 'I didn't say a word. I was just waiting for the things which were coming. I knew then that I would be taken away.' At this point, the film becomes utterly silent for a whole minute, while we watch factory smoke stacks, clearly reminiscent of the terrible chimneys of crematoria, yet located within the local narrative as I.G. Farben, the chemical plant founded in the district in 1936. That the most profound and meaningful silence of the film ensues from a story of cutting tomatoes, in the voice of a woman, should not be underestimated. Nor should the fact that the voice of this same woman breaks the silence with the continuation of her narrative of disrupted, impossible homecoming after internment:

> How happy we were – just knowing that we were coming home. . . . I was given a big welcome. . . . The women were delighted and had already opened a bottle of wine. And I thought, dear God, where have you ended up? The

loud talking and laughing and merrymaking – and they were happy that the war was over. But they really didn't have to go through much, just a few nights in a bunker. Then I said, 'Please.' I folded my hands and said, 'Please leave me to be alone.'

The negative visuals, articulate silences and signs of corporeal absence within the film, materialise the incomprehensible differences between survivors and those others who lived through the war years unscathed. Communication cannot be resumed, what remains unspoken cannot be 'adroitly bridged'. Lefkowitz made the brave move not to veil what she understood in the subjects' voices, as 'speaking not to each other, but in the absence of the other'.[20] In so doing, she addressed a central paradox – one just does not come home after Auschwitz, yet one does. The question remains how to move forward through this profound disjunction.

To consider this, I want to turn to a fascinating text written by Griselda Pollock on the potential of feminist art to reconceive covenant and begin the work of mourning and communication in difference so needed in the wake of the Holocaust. In 'Gleaning in history or coming after/behind the reapers', Pollock examined the art and theory of Bracha Lichtenberg Ettinger, raising particular points about the reinvention of history painting following the corporeal loss of the

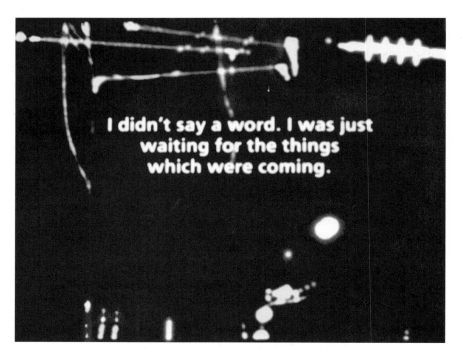

Figure 1.2 Deborah Lefkowitz, still from *Intervals of Silence: Being Jewish in Germany*, 1990, courtesy of Deborah Lefkowitz

Holocaust. Yet her text's concerns with history and art, '*after history*' and '*after painting*',[21] are equally resonant with the problems Lefkowitz faced in constructing a documentary concerning the loss of community and the very possibility of communication in/after exile.

Significantly, Pollock takes as her key figure of covenant the relationship between Naomi and Ruth, a mother- and daughter-in-law, who make their bond in and through differences of culture, generation and experience. This figure of covenant in difference is not a form of easy pluralism, forgetfulness or silence; it is the work of mourning and memory in reconfiguring histories against the violent eradication of the other by the one. I want to suggest that Pollock's insistence on the significance of feminism, art and female agency to such reconfigured histories is a powerful strategy to think otherwise and one which parallels Lefkowitz's filmic tactics. As Pollock wrote:

> The violence of the foreclosure of the feminine . . . can be associated with the violence of Christian western culture towards the Jews as strangers, as one of Europe's intimate, structuring Others. . . . There can only be a future through alliance, through covenant, through what the artist [Lichtenberg Ettinger] calls a coexistence in difference.[22]

Some of the parallels between Pollock's text and Lefkowitz's film are quite literal; as a daughter-in-law from another culture, Lefkowitz's first, formative dialogues across this historical gap were with the women in her husband's family.[23] This surface link with the Naomi and Ruth story, however, obscures the more significant sense in which women's words, stories, voices and actions underpin the structural logic of both Lefkowitz's film and Pollock's text in far more sophisticated ways. Indeed, I want to argue that the most compelling forms of covenant enacted by the film and the text do not reside in any explicit content, but in the modes of address they so skilfully deploy. That is, Pollock's text writes *with* the story of Naomi and Ruth, the work of Lichtenberg Ettinger, psychoanalysis and the concept of the matrix, to come after/behind the Holocaust and envisage the possibility of covenant. Never obscuring the material differences between these diverse sources, Pollock interweaves them with her own distinct voice to form a kind of heteroglossic constellation; the text is a work of covenant-in-difference in its own right. Lefkowitz's film similarly moves next to its sources, allowing the resonances and dissonances to emerge through material connections between the texts, images, words and sounds.

In *Intervals of Silence*, the coexistence of difference reveals painful rifts between individuals and in the fabric of community, but there is also hope. This hope comes precisely in the form of tentative, but decisive, communication between individuals. During the production of the film, Lefkowitz considered including a highly personal segment about her husband coming to learn Hebrew songs and Jewish celebratory customs with her family. In the end, she found this part of the narrative too intimate for inclusion, but continued to work with the concepts of song, celebration and memory in the constitution of home and community. The

final words spoken at the close of the film mark the hesitant but positive reconstruction of a sense of 'home' after exile in the place of her husband's birth:

> When I come to this city, I don't have the feeling that I cannot be Jewish here, although there are other cities that are more comfortable for me as a Jew. Sometimes the presence of other Jewish voices here or the singing of a melody familiar to me from my childhood is enough to give me the feeling that I am home.

The sequence finishes with the joyous song *Adon Olam*, which often closes Sabbath services. Arguably, both the explicit content of this filmic sequence and the process of its composition, through tentative inclusions, excisions and careful editing, perform the kinds of creative work necessary for building bonds through communication and love in the wake of terror.[24]

Lefkowitz's powerful evocation of the profundity of 'home' as a mechanism by which to enact a covenantal bond is nowhere more strikingly mirrored than in the work of Kitty Klaidman and her daughter Elyse. Kitty Klaidman was born in Czechoslovakia in 1937, survived the war in hiding and later emigrated to the United States where she now lives. Like many survivors, it took Klaidman nearly four decades to confront her experiences at mid-century directly; in the 1980s, she travelled with her daughter to look at the building in which she and her family had hidden from the Nazis for a year, and in 1991, the attic store became the subject of Klaidman's triptych *Hidden Memories: Attic in Humence*. In three large paper panels (the whole triptych measures over a metre high and three metres in length), this barren space in the eaves was transformed into a highly evocative image of loss and restitution.

The spartan composition of the piece cannot but express the traumatic experience of this place and the noticeable joins between the panels is an effective metaphor for the break in personal and historical continuity signified by hiding and exile. Yet the whole scene is made palpable through light – light from windows at the end of the store and an ambiguous atmospheric light where the floor would be found. This light is crucial to the meaning of the work, both for Klaidman personally and for viewers. As the artist said:

> In each of these works, I have introduced a seemingly paradoxical fusion of light, which may represent the remarkable reality that my immediate family survived intact. What it surely represents, however, is that the existence of people like Jan Velicky, the man most responsible for saving us, serves as a beacon of hope in the most desperate times.[25]

This ordinary storehouse, infused with light, becomes both a space of catharsis and covenant, a marker for the work of memory, mourning and connection across difference. In a mirroring act of covenant for the future, Elyse Klaidman also painted the attic store in which her mother remained safe long before she was born. These reflecting works are a dialogue between mother and daughter,

Figure 1.3 Kitty Klaidman, *Hidden Memories: Attic in Humence* (triptych), 1991, copyright, Kitty Klaidman; photograph, Marsha Mateyka Gallery, Washington, DC

despite the incommensurability of their experiences, the pervasive logic of silence and the terrible possibility of forgetfulness. Like the bonds described by the artist's narrative in *Intervals of Silence*, these works offer hope for the future through the reconstitution of 'home'.

High culture, assimilation and modernity

As a non-Jewish German born in 1944, Rebecca Horn has a personal, as well as aesthetic, investment in the reconstitution of *Heimat*. In *Concert for Buchenwald*, Horn engaged in a dialogue with the internal contradictions of post-Holocaust German culture from Enlightenment to modernity. The installation's two parts/ sites, Part 1: Tram Depot and Part 2: Schloss Ettersburg, unfolded their stories like two acts in a play, inextricably connected, yet self-contained. In this defining gesture, Horn demonstrated the interdependence of oppositions within the assimilative logic of dualism, as well as their limits. In *Concert for Buchenwald*, 'civilised' high culture is saturated by brutality, the Enlightenment and modernism are parts of a whole, the spirit connects with the machine and any simplistic division of the one from its 'others' is shown to be fatally flawed.

The correspondence of opposites is typical in Horn's work and accounts for much of its dynamism.[26] In *Concert for Buchenwald*, these dynamics effect a particularly concise critique of German high culture and its exclusions. The Tram Depot of Part 1 is Taylorism gone mad, the monstrous potential of technological modernity to make even the most horrific acts of genocide a mere matter of machinic efficiency. The skip truck travelling back and forth on its deadly journey, the broken bodies of violins, guitars and mandolins, heaped on the track, and the walls of the depot, formed by layers and layers of ash, bear witness to the

inevitable tragedy caused by eradicating 'others' in a desperate attempt to maintain a self-same, monolithic culture. Yet the Tram Depot was not the only scene of devastation; the White Salon too was derelict. This was a different form of dereliction, one which wrought its destruction from within. There was no concert intoned in Schloss Ettersburg, just disembodied sound reverberating within an evacuated shell, itself cracking from the pressures of abandonment and self-induced devastation.

It is in the White Salon that we come to understand the internal destruction of an assimilative culture gone wrong. 'Assimilation' is doubly valent here; there is the important historical issue raised by the fate of assimilated Jews in Germany, Austria and other German-speaking European regions, and the theoretical problem of assimilative epistemes which homogenise, rather than recognise, differences. I am suggesting that these two features of 'assimilation' are connected and have important ramifications for addressing history and making art after the Holocaust, especially when those histories and art are made by women.

As we now know, the assimilation of Jews into German culture did not save them from the Holocaust; none of the extraordinary contributions of generations of Jews to German literature, art, philosophy, music, politics, economics, science, medicine or psychology mattered when biology became destiny. It is more than a brutal irony that the very culture which Jews helped to forge was mobilised against them and so many diverse 'others', it is a feature of the terrible inability of reductive, self-same thinking to acknowledge the motor-force of change and development which resides in difference. In this sense, assimilative logic and the historical conventions which depend upon it, need to be resisted in order to move forward and reconfigure histories as covenantal, dialogic and mindful of the past. This is why I find Horn's reconfiguration of *Heimat*, of high culture and its internal dynamics of difference, so compelling.

Take again the damned performance in Schloss Ettersburg. Signalling German high culture through classical music, the 'concert' further hearkens to the significance of music as a motif within European Jewry expressing assimilation while, at the same time, remaining transportable.[27] Moreover, the trope of the deconstructed 'concert' was not new in Horn's *œuvre*; her 1987 installation in Münster, in the former Hitler Youth headquarters, used as a prison/execution chamber by the Nazis during the war, was entitled *Concert in Reverse* and consisted of a cacophony of mechanical noises and diametrically opposed visual devices. And, in 1994, Horn installed the *Tower of the Nameless* in Vienna, a series of ascending ladders punctuated by violins playing their discordant notes as a memorial to both the Yugoslav refugees pouring through the city at the height of the Bosnian War and their nameless predecessors, the thousands who fled the Third Reich prior to Vienna's occupation. These projects brought together the corporeality of the instruments, as 'bodies' whose 'voices' sound a tragic chorus, with the corporeality of memory itself, through which culture and history are transmitted, or, of course, lost.

As the site of a concert of remembrance, mourning and madness at the destruction of the other within, Schloss Ettersburg could not have been better chosen.

Figure 1.4 Rebecca Horn, *Concert for Buchenwald*, 1999, Part 1: Tram Depot, copyright Rebecca Horn, DACS; photograph from the book *Concert for Buchenwald* by Rebecca Horn, Scalo Publishers, Zürich

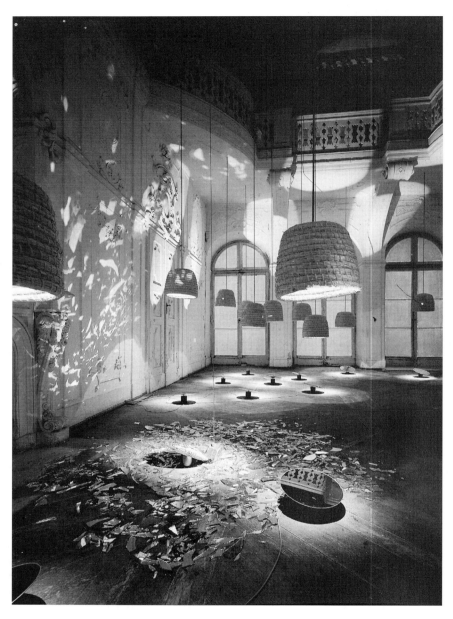

Figure 1.5 Rebecca Horn, *Concert for Buchenwald*, 1999, Part 2: Schloss Ettersburg, copyright Rebecca Horn, DACS; photograph from the book *Concert for Buchenwald* by Rebecca Horn, Scalo Publishers, Zürich

Schloss Ettersburg was where Goethe first performed his *Iphigenie*;[28] the story of Orestes, whose guilt and madness were brought on by an act of matricide. The self-induced tragedy of destroying the (m)other, upon whom life, culture and the self depend, is a mythic rendition of male autogenesis and the attempt to assimilate difference into the same. Reading Goethe's invocation of Orestes through the work of Horn, emphasises the role of sexual difference in western knowledge systems and has powerful ramifications for exploring the dereliction of European culture in the brutal eradication of Jews and all others whose difference singled them out for destruction during the Holocaust.

The fact that Horn interrogated elite culture through the space of the salon is significant. As a crossing point between public culture and private life, European salons were one of the sites in which women could and did participate readily in the cultural life of the community. Horn was not the only woman artist to invoke this spatial trope to explore sexual difference, bourgeois culture and history; in a fascinating parallel, British artist Rachel Whiteread drew these very strands together in her design for the *Holocaust Memorial* (1996–2000) in Vienna.

Sited in the Judenplatz, Whiteread's work is based on an inverted library,[29] whose books have been shelved in reverse, so that their spines are hidden, and whose doors remain permanently locked. Invited to bid for this prestigious commission on the strength of her only other public work, *House* (1993), Whiteread was already practised in materialising domesticity's negative spaces to trigger powerful social memories. Whiteread read the Judenplatz itself as a domestic space, a vast room with doors and hallways running from it, and scaled the memorial to the typical dimensions of a bourgeois salon in the square, including domestic architectural details such as a ceiling rose and panelled doors.[30] The Vienna project, intimately tied to the salons of the Judenplatz, linked home with homeland, to remember the 65,000 Jews from the city who were killed and their important public presence, as part of bourgeois Viennese cultural life.

Beneath Whiteread's 'library' lay the remains of a synagogue, destroyed in a mediaeval act of anti-semitism. The present memorial, therefore, refuses to forget a much longer history, and beyond the simple equation of the Jews with the book, key sites of historical record, articulation and knowledge are invoked materially and spatially. There is a traditional precedent for linking the work of memory with envisaged spaces/objects in rhetoric. To train the memory for connective, rhetorical thought, subjects imagined ideas 'stored' as objects in rooms; to 'retrieve' the ideas, they envisaged moving through the spaces of the rooms and bringing the stored memories back to the present. The memory-training of rhetoric connects the individual's imaginative powers with a collective knowledge-base and a system designed to operate in analogy, rather than the effacement of differences.[31] I would argue that Whiteread's locked library, and the evocative 'rooms' of Horn's *Concert for Buchenwald*, draw upon just this sort of embodied, situated memory-work, producing a form of cultural mnemonic which materialises spaces and objects against forgetfulness.

It is almost too obvious to note that both Whiteread and Horn frequently conduct dialogues with the legacy of modernism in their work. However, one

Figure 1.6 Rachel Whiteread, *Holocaust Memorial*, 1996–2000 copyright, Rachel Whiteread; photograph, Anthony d'Offay Gallery, London

particular element of this troubling legacy, its tendency to be used as a justification for the elimination of difference and the construction of a monolithic form of history and art practice, is of interest to me here. Suzi Gablik, following her colleague Patricia Catto, has termed this evacuated legacy 'bad modernism',[32] a mode of alienated, distanced, self-referential praxis which encouraged the violent objectification of others to sustain its privileged, individualistic autonomy. It is this facet of modernity and modernism which is challenged by the unflinching installation in the Tram Depot, yet Horn's work does not simply negate or reject modernism wholesale.

The Tram Depot articulated the inhuman, mechanical progress from transport to death, recalling Hartman's question, 'How fatal has administrative and instrumentalized reason become in the modern era?'[33] Many critics have been quick to note that Horn here, and in other machinic work, stressed the loss of individual responsibility in systems of technological power and industrialised violence.[34] I would agree that the Tram Depot expressed with extraordinary force the technical brutality of the factory death camps and the way in which such nameless violence stripped human beings of their individuality so to group them more definitively as 'non-human' and available for disposal. I would also agree that Horn's factory of annihilation is derived from the dark and destructive

fantasies of modernism, as they came to such a bitter conclusion in the crematoria at Buchenwald, Auschwitz and elsewhere.

However, Horn's machines, as they animate objects and inhabit rooms, enter into a productive dialogue with modernism, technology and corporeality, which enables them to defy their absorption within the paradigm they cite and body forth their critique in their material specificity. In the Tram Depot, for example, the piles of discarded instruments are anything but devoid of human referents or lacking in individuality. They call to us as reminders of lives lived and voices heard, their contours, like bodies, bear the marks of individual journeys and, at the same time, they bring us back to our senses, 're-mind' us, of the exilic longing expressed by simple objects separated from their owners, by accident or design. As the skip truck impacts with the far wall, a small spark travels up Jacob's Ladder, releasing a charge, an immaterial force, into the sky. Horn imbued this with hope; the spirits of the tortured finally ascending beyond the factory of death.

I am not the first to argue that Horn's machines and objects are corporeally significant. Mina Ronstayi referred to them as objects with 'souls', citing Horn's interest in alchemy and animism, rather than high-tech modernism, as the origin of their particular calls to our own bodies.[35] Bruce W. Ferguson noted the polyvalence of Horn's machines, both cold and articulate of human desires, motives and hesitant attempts at communication.[36] I would suggest that Horn's machines play with the contradictions of the modernist project itself, invoking both its incredible dynamism and its terrible destructive power. We should remember, for instance, that the inter-war years in Europe and America were the scene of a flourishing women's culture,[37] some of the earliest acknowledgement of the rights of gay men and lesbians and an intellectual/political climate in which Jews played an absolutely vital role. Modernism could embrace difference, but its more powerful appropriators could not. Like the White Salon, the Tram Depot speaks again of the devastation suffered by a culture which attempts to eliminate difference from within. Yet, taken together as interconnected sites, the two parts of *Concert for Buchenwald* make corporeality and coexistent difference a locus of potential connection, or covenant. As Horn wrote, 'They meet in human beings/ as a catalyst/connecting the above and below of the mind./Through the process of transformation/cautiously writing the language of new signs.'[38]

Lefkowitz's *Intervals of Silence* and Horn's *Concert for Buchenwald* acknowledge the devastation they address, but make covenants-in-difference in ways which echo Gablik's concept of 'connective' aesthetics, the kind of praxis which can redirect bad modernism. Her words nearly describe Horn's double installation:

> Connective aesthetics strikes at the root of this alienation by dissolving the mechanical division between self and world that has prevailed during the modern epoch. World healing begins with the individual who welcomes the Other.[39]

Intervals of Silence and *Concert for Buchenwald* do not suggest the impossibility

of culture, aesthetics or political agency in the wake of the Holocaust, but demonstrate the reinvention of art as a significant social force. Facing the void, communicating in and with difference, creating strategies by which to articulate exilic histories of home and homeland, Lefkowitz and Horn do not forget the past or negate the future. It will suffice to end with Pollock's hopeful words:

> Within modernity, both woman and the Jewish people stand for a recalcitrant 'difference' from, or 'strangeness' within, what appear to be the dominant norms. They have come to represent a troublesome ambiguity which has often led to discrimination and persecution. Yet we must grasp the possibility, offered by that very dissidence, for a model of society that could genuinely celebrate and value difference.[40]

2 Corporeal cartography: women artists of the anglophone African diaspora

> It is important, when redressing history as I am doing here, not to be too literal or historical. It will spoil the magic . . . That is the real power of being an artist. We can make it come true. Or look true.
>
> (Faith Ringgold, on *The French Collection* story quilts (1992))[1]

> There is a strange type of humor to many West African theatrical performances . . . It's not a straight view, it's not a square picture. There has to be a twist to it. I think my electrical stuff adds that spice.
>
> (Sokari Douglas Camp discussing her kinetic sculptures (1988))[2]

Faith Ringgold's *French Collection* story quilt series opens with *Dancing at the Louvre* (1991), in which the fictional central character, Willia Marie Simone, her friend Marcia and Marcia's three daughters, finally reach the gallery in which Leonardo's *Mona Lisa* hangs. On arrival, the three girls break into a spontaneous dance of joy; in the space reserved for paying hushed tribute to a Renaissance masterpiece, the canonical tradition of western fine art is reinscribed by this dance. Exploring the work's subversive address to history, Marcia Tucker writes, 'After all, culture belongs to each and every one of us, right? And we're allowed to celebrate it anyway we'd like.'[3] But the culture represented by European fine art has not always belonged to everyone. Ringgold's work is a retort to this history, a history which violently excluded people of the African diaspora, and especially black women.[4]

Sokari Douglas Camp's kinetic sculptural figure of 1986, *Small Iriabo (Clapping Girl)*, also used dance to reposition women within the cultural traditions of their community. Camp's figure of a young girl enjoying the dance at a festival is semi-autobiographical; the artist's Kalabari figures all refer to masquerades she has attended in her village, Buguma, in southern Nigeria. Though Camp is Kalabari, she was educated in England and the United States, completing her under- and postgraduate Fine Art training in London, where she lives and works today. Her work's double focus (upon Kalabari masquerade and Euro-American kinetic installation practices), is part of her negotiation of the cross-cultural histories of the African diaspora, and particular to her experience as a woman. As she explained, her work resides at this nexus: 'The major influences are the Kalabari

festival and the fact that in the West women are allowed to make sculptures. . . . being Kalabari is my work. [yet] . . . The word *art* and being an artist are things that have to do with the West.'[5]

The work of Ringgold and Camp demonstrates the power of art to invent and intervene at the level of history itself. Not just 'literal', or a 'straight view', their histories are made, performed, imagined, 'twisted' and 'redressed', such that the multiplicity of black female subjectivity and African diasporan geography can be materialised. I would argue that their work is a mode of corporeal cartography, an art which examines the processes by which histories are formed at the interstices of bodies and geographies. And, while these bodies/geographies are never fixed or homogeneous, nor are they merely dispersed, absent or phantasmatic. As Stuart Hall argued, 'Cultural identities are the points of identification, the unstable points of identification or suture, which are made within the discourses of history and culture. Not an essence, but a *positioning*.'[6]

Shifting from essence to positioning, or from object to process, is also crucial to feminist reconceptions of female subjectivity. Feminist theorists have argued convincingly that the structural logic of western metaphysics and epistemology privileges the masculine subject at the expense of an objectified 'woman/other'. In the case of women doubly inscribed by sexual and racial difference, the problem of objectification and the inability to attain an empowered subject-position is all the more pressing.[7] Thus, the process of positioning embodied black female subjects against the grain of historical and theoretical marginalisation is an act of corporeal cartography which reconceives western knowledge systems as it rewrites monolithic historical formations.

For women artists of the African diaspora, moving from object to subject requires a critical engagement with art's histories and with the ideological and institutional structures which negate black women's creativity. In a cartographic encounter with this negation, significantly titled 'Mapping: A Decade of Black Women Artists, 1980–1990', Lubaina Himid singled out art history for particular criticism: 'European/American art history has at best done us a great dis-service, at worst we are being stifled and smothered . . .'[8] Similarly, Adrian Piper described the 'triple negation' of 'colored women artists', through race, sex and the denigration of innovation, agency and a sustained tradition in the arts. Piper cited these as the key features of the contemporary, Euro-American dominated, art world and its fellow-traveller, a criticism premised upon the kind of 'postmodernism' which denies the very possibility of creative, female subjects and meaningful artwork.[9]

Countering this negation, distinctive forms of 'Afrofemcentrist' or 'Black womanist' theory and criticism have developed to deal with what Frieda High W. Tesfagiorgis calls the 'simultaneity-multiplicative construct of race, class, gender and sexuality fundamental to understanding the lives, thought, production and interventions of black women artists'.[10] Arguing that black feminist art is 'incommensurable' or demonstrates 'variations on negation', Michele Wallace astutely locates its power in its ability to critique and create histories simultaneously. Such work reconnects bodies and geographies through the material

legacy of histories, or as Wallace wrote, the '. . . tropes or gaps in the dominant discourse become a kind of road map of where the bodies – the bodies of those who have been ignored or negated – are buried'.[11]

The French Collection is precisely one such corporeal cartography, exacerbating the tropes and gaps of modernist art history to reinstate embodied black women as culture makers, rather than the negated bodies on which culture is made. In the series, Ringgold works through a fictional character (Willia Marie) to stage not 'too literal' encounters between historical figures ranging from the 'founding fathers' of European modernism (Vincent van Gogh, Pablo Picasso, Henri Matisse), to leading African-American writers, artists and radicals (Harriet Tubman, Zora Neale Hurston, Langston Hughes), contemporary feminists in the art world (Moira Roth, Johnetta Cole) and members of her own family. This deliberate configuration of historical presence through artistic licence brings to mind Audre Lorde's well-known dictum, 'the master's tools will never dismantle the master's house';[12] Ringgold re-maps the master's house, defying the principles, and recycling the very materials, of a history which would violently excise black women from its midst.

Camp's *Small Iriabo* is itself a corporeal map; its particular combination of media, display and subject-matter would not exist were it not for the complex geopolitical processes of decolonisation currently being negotiated by contemporary African women. It counters the myth of an essential subject or an easy alliance between 'race', gender, nation and culture, manifesting the productive interstitial spaces between bodies and geographies which can be delineated by art. The significance of art to the making of histories through aesthetic mapping should not be underestimated; Camp's work does not simply reveal the 'truth' of diasporan female subjectivity, it engenders participatory encounters with the maps through which we are all interpellated.

To take these ideas further, I want to distil from Ringgold's *Dancing at the Louvre* and Camp's *Small Iriabo* one distinct trope – that of dance. In so doing, I am not suggesting that dance is an essential theme in all African diasporan art, nor that it is the only way to think bodily mapping practices. Rather, I am using it as a resonant motif to examine some of the ways Ringgold and Camp interrogate histories in these particular works.[13] And, while dance may be a specific trope, it has an astounding depth. With an ambivalent historical relationship to African diasporan culture in the west, dance has suffered from an association with 'primitivism' and been denigrated as a popular or 'low' form of sensual expression, demonstrating a less developed cultural sensibility. Yet the very fact that dance has been allied with the low, the corporeal, the feminine and the culturally marginal, makes me take it all the more seriously. As in the case of performance art, such multi-sensory, boundary-crossing forms have the potential to disrupt fixed categories of knowledge and articulate embodied subjectivity in new and startling ways.[14]

The reclamation of dance by African diasporan feminist artists, writers, filmmakers and theorists is a strategy designed to reinvigorate occluded traditions and reconnect the body and mind in an empowered subjectivity. Ntozake Shange,

whose haunting *for colored girls who have considered suicide/when the rainbow is enuf* was produced in the form of 'choreopoems', eloquently put it thus:

> Knowing a woman's mind & spirit had been allowed me, with dance I discovered my body more intimately than I had imagined possible. . . . I moved what waz my unconscious knowledge of being in a colored woman's body to my known everydayness.[15]

Shange here spoke of a kind of bodily knowing, a corporeal memory and history inscribed and described by gesture, movement and an intimate interrelationship between body and mind. In this sense, Shange was asserting the significance of embodiment to subjectivity and of dance to experiencing and articulating that embodiment. Such thinking has been taken up by an increasing number of critical theorists for whom bodies and knowledges are understood to be intertwined.[16] These insights remind us that dance is participatory, it invites intercorporeal exchanges between viewers and works and establishes the pleasure of bodily mapping as one of its powers. It is not just coincidental that many women artists have used elements of performance in their work to develop greater audience participation. Indeed, Lowery Stokes Sims made the important point that African-American women artists had often turned to performance in order to interact more with their audiences, so to engage with political issues in ways which would affect, touch or move, their viewers.[17]

 In each of these ways, dance is an effective trope through which to explore the work of corporeal cartography performed by *The French Collection* and *Small Iriabo*. As Ringgold quilted the narratives of modernism to include African-American women who speak, dance and make art, she crossed the boundaries between 'high' and 'low', literal facts and magical truths, to redress histories written in the singular. So too Camp's sculptures, constructed from multiple materials and able to move, are in transit, challenging static notions of cultural and gender identity in works which are objects, performances and installations at once. These works invite us to join in their stories and move us to rework the histories they invoke.

Dancers, mothers and modernity

Taken as a group, the twelve story quilts which comprise *The French Collection* are an extended meditation upon the history of European modernism reviewed and retold through the eyes and voice of an African-American woman. In an important sense, the series is highly personal; it reinvents Ringgold's own struggle to forge her practice through modernist influences and was done in remembrance of the artist's mother, Willi Posey Jones, a fashion designer and textile artist. Ringgold's family members take important roles in *The French Collection* and inspire the fictional characters, most notably Willia Marie herself and the three children in *Dancing at the Louvre*, said to be based upon Ringgold's grandchildren, who were 'always in motion'.[18] Willia Marie's attempts to find her place as an artist

within this tradition, set in the charged sites of the Louvre, the studios of Picasso and Matisse, the salon of Gertrude Stein and the Café des Artistes, hearkens to Ringgold's own tour of European cities and museums in 1961 where, accompanied by her mother and two young daughters, she made the final decision to pursue art as a career.

We should, however, be wary of reducing the extraordinary historical intervention of *The French Collection* to simplistic psychobiography. As I have argued elsewhere,[19] this is a common tactic used to nullify the work of women artists by casting it as purely personal, intuitive or emotional, while venerating art which is public, universal and edifying. Piper's earlier warning about the 'triple negation' makes the similar point that the politics of difference have been mobilised against the work of black women artists precisely by focusing on the 'otherness' of the artist to the exclusion of any serious discussion of the practice. In this way, Piper suggests, innovations within the work are explained away as peculiarities of an individual (read insignificant) personality.[20]

While it is important to explore the biographical sources of the series, it is equally important to remember that Ringgold's fascinating work is not 'just personal'. Its strength resides in forging a powerful bond between the personal and the historical, fiction and fact, to delineate the complex exchanges between individuals and the society which they make and which, in turn, makes them. In *The French Collection*, the combination of texts, images and materials, fashioned through the connective aesthetics of quilting, enables black female subjectivity to emerge as a fictional/factual dialogue between an African-American woman artist and the histories of early twentieth-century European and American art, culture and colonial fragmentation. This is corporeal cartography and it is lyrical and uplifting even as it is deadly serious.

In a description of *The French Collection*, Ringgold's daughter, Michele Wallace, wrote what might also summarise her mother's cartographic practice of self-mapping through composite, even contradictory, mentors:

> Instead, she drew on a willy-nilly hodgepodge of role models, some of whom certainly didn't deliberately choose to be her inspiration (such as Pablo Picasso, Henri Matisse and Vincent van Gogh); others from black history (such as Sojourner Truth, Harriet Tubman, Mary McLeod Bethune, Fannie Lou Hamer and Ella Baker) who had no apparent ideas about how to be a visual artist; and still others from the family, in particular, her great-great-grandmother Susie Shannon and her great-grandmother Betsy Bingham, both of whom were slaves and quilters, and her mother Momma Jones, who had wanted to be a dancer and who settled for being a Harlem fashion designer – a more practical choice than being an artist, given her historical moment, and not entirely unrelated.[21]

This 'willy-nilly hodgepodge', brought together in a formidable act of creative agency, refutes unidirectional historical accounts which exclude or objectify African-American women. As Ringgold said of the series, 'My process is designed

Figure 2.1 Faith Ringgold, *Dancing at the Louvre*, Part 1, no. 1, from *The French Collection*, 1991, courtesy of Faith Ringgold

to give us "colored folk" and women a taste of the American dream straight up. Since the facts don't do that too often, I decided to make it up.'[22] 'Making it up' is, in *The French Collection*, a highly sophisticated, politically radical and historically informed cartographic practice which acts, as Moira Roth put it, 'in the service of reinterpreting African American history and celebrating the bonds between diverse black women'.[23]

Dancing at the Louvre opens the quilted series and first materialises the theme of dance in *The French Collection*. Dance is addressed directly in two other quilts: the fifth, *Matisse's Model* (1991) and the tenth, *Jo Baker's Birthday Party* (1993). Though the quilts are very different, their sequencing as first, fifth and tenth, ensures that dance, dancing and dancers become a persistent thread which stitches the series together. *Dancing at the Louvre* uses the celebratory dance of the children in the hallowed halls of High Art to invoke pleasure in cultural presence. *Matisse's Model*, opening on Willia Marie's words 'Every little girl wants to be une danseuse. I still do.', explores the more problematic relationship

between black women, high culture, beauty, desire and subjectivity. *Jo Baker's Birthday Party* places the famous African-American woman dancer back into the frame of 1920s' modernism, but here makes her the model and muse to our central character, the woman painter Willia Marie.

In all three works, the traditions of western fine art are both desired and somewhat elusive; African-American women dance between the positions of subject and object, charting a new history as they go. In *Matisse's Model* for instance, the narrator maps the beauty hierarchies within the African-American community of her youth, 'dark skinned girls at school knew we were not the top priority', her desire to incarnate the female nudes of western art, 'I love playing the beautiful woman, knowing that I am steeped in painting history', and her awareness of her own role as model, maker and interpreter of this cultural legacy, 'There is a certain power I keep in the translation of my image from me to canvas.' The central painted panel of the quilt quotes Matisse's work, *The Dance*, while acknowledging the pivotal role played by the nude female model in the studio-based art of male modernists.

The critical link between the female body, masculine creative/sexual energy and so-called 'primitivism' in the histories of European modernism, is also at stake in the series, not surprisingly coalescing around the woman as dancer.[24] *Jo Baker's Birthday Party* particularly contends with this conjunction by focusing on Josephine Baker, the urban, African-American dancer who so successfully manipulated sexual stereotypes of the 'primitive' to forge an unprecedented celebrity in Paris and Berlin during the 1920s and 1930s. Willia Marie's narrative recognises the ambivalence of Josephine Baker's fame, 'How did she become une grande dame française? I don't know how, but I do know why – She had no other choice . . .', but she is still moved by the dancer's beauty, power and charismatic presence, 'And she is very strong, aussi forte que belle. I feel honoured to paint her picture . . . just to be in the same room with her would have been enough.' In the painted panel, Baker appears as one of Matisse's *Odalisques*, yet his vast array of nameless, exotic nudes (set in North Africa, yet usually modelled by white, French women) are reframed by the mythic collaboration between the two empowered African-American female subjects, the famous dancer Baker, and the artist, Willia Marie.

The three quilts, most decidedly focused on dance, stage Willia Marie as an African-American expatriate in Paris, a model and 'primitive' muse, and an artist, a subject who makes the culture of modernism at the nexus of bodies and geographies. *Jo Baker's Birthday Party* is an especially apt signifier for this act of corporeal cartography. Baker's body is acknowledged in both the text and quotational visual as the site of the conflicting desires which mapped her, 'There are too many black women in America for any one of them to be rare. . . . There are only a few black women in Europe. So Europe wants to see Josephine nude.' At the same time, the beauty, power and presence of her body are the prerequisite for the narrator's reinscription of the negation/objectification of the black female subject, 'Unlike the artists I pose for, I want to see her beauty not as a kind of vulnerability, but une force.'

The French Collection thus recognises the African sources of European modernist 'primitivism', even as it reinstates the importance of African-American expatriate artists in Paris and the significance of the Harlem Renaissance in New York. It further displaces the 'founding fathers' of modernism by bringing forth its 'mothers', figures such as Gertrude Stein, Zora Neale Hurston and Meta Vaux Warrick Fuller, and by having contemporary women artists and critics renegotiate its most privileged spaces – Emma Amos, Michele Wallace and Lowery Stokes Sims are among a group who sit on the grass in a new *Déjeuner sur l'Herbe* (Picasso is the nude). Significantly, the 'mothers of modernism' are joined in the series by a whole network of women; Ringgold's family members, the friends and family of Willia Marie and historical African-American women activists, artists and writers who form a matrilineal support system through which black female subjectivity comes into view.

Motherhood itself, however, is not rendered simply in the series. Beginning with *Dancing at the Louvre*, we are led to understand that motherhood can be an obstacle to the kind of freedom necessary to pursue a career in art. Willia Marie's two children live in the United States with her Aunt Melissa so that she can remain in Paris and work as an artist. The joyful dance of Marcia's girls in *Dancing at the Louvre* is narrated in epistolary form to Aunt Melissa, and is an occasion for Willia Marie to refuse her friend's advice to bring her children back to Paris to live with her. The figure of Aunt Melissa is part of *The French Collection*'s maternal address. Though we never see this character, seven of the texts are written as letters to her and three others refer to her influence on Willia Marie. Thus, only two 'scenes' are without her; no single character is more fundamental to the series except Willia Marie herself. I would suggest that the framing device of a present and absent 'Aunt Melissa' is crucial to the kind of history *The French Collection* maps, dealing as it does with African-American women's histories marked by both incommensurable loss through deportation, slavery, rape and racism as well as by unbreakable, intergenerational bonds between women who survived.

Two story quilts make this point very clearly, both linked to Aunt Melissa – the sixth, *Matisse's Chapel* and the fourth, *The Sunflowers Quilting Bee at Arles* (both 1991). Matisse's chapel in Vence is the scene of Willia Marie's dream, related to Aunt Melissa in a letter, of all of her departed family members joined together in a reunion. The deceased family members are Ringgold's own, from great-great-grandmother Susie Shannon to mother Willi Posey and a host of grand-parents, aunts, uncles, cousins and siblings. The visual family tree is accompanied by a story of slavery told by Susie Shannon, herself a slave and quilter. This juxtaposition is profound; as Geoffrey Hartman argued, the loss of some 60 million Africans in the Middle Passage, in addition to the brutal form of chattel slavery which destroyed familial histories and replaced them with bills of sale, was a 'suffering that allowed no development of person, family or ethnic group'.[25] Hence, visualising the corporeal presence of this family network, wrought in slavery, yet surviving to flourish in its wake, is a powerful form of history-making, enabling individual women's voices to speak back to all master narratives.

The Sunflowers Quilting Bee at Arles invokes yet another kind of maternal

legacy, one which unites women across generations in their struggles to change the world for their own daughters. The premise of the story quilt is 'fictional history': Aunt Melissa asks Willia Marie to arrange a quilting bee in France for the National Sunflower Quilters Society of America. Willia Marie takes the group, all historical African-American women freedom fighters, to Arles, where they quilt in a sunflower field as Vincent van Gogh collects the blooms he will make famous in paint. Van Gogh approaches, Willia Marie explains that he is a great artist and he is summarily dismissed by Harriet Tubman: 'Make him leave. He reminds me of slavers.'

While this invocation of racism and the historical fact of slavery counters the white male genius, he is really relocated by the creative work of these women, by the fantastic sunflower quilt they make in the field, together, as they work toward freedom.[26] With the figure of Aunt Melissa, this quilting bee constitutes a creative maternal lineage for Willia Marie and, by extension, for African-American women struggling to find a history in which their creative agency counts. In a vital exchange, Sojourner Truth says to Willia Marie, 'We are all artists. Piecing is our art. . . . That was what we did after a hard day's work in the field to keep our sanity and our beds warm and bring beauty into our lives. . . . Now we can do our real quilting, our real art: making this world piece up right.'

The imperative to reclaim creative mothers is a persistent theme in African-American women's writing, not least in the work of Alice Walker and Toni Morrison. As Morrison put it, Euro-American racism is premised upon the destruction of the mother–child bond through slavery: 'slave women are not mothers; they are "natally dead", with no obligations to their offspring or their own parents'.[27] Walker's famous text, 'In Search of Our Mothers' Gardens', counters this foundational logic of racism with a beautiful, personal and political testimony to the ability of generations of African-American women to maintain their creativity against all odds, and to pass this, with love and freedom, to their children.[28] Walker's writing is very well known and Ringgold has made work in the past which cites her as an influence, but I am not suggesting that *The Sunflowers Quilting Bee at Arles* is a literal illustration of 'In Search of Our Mothers' Gardens'. Rather, the subject-matter, the women figured and the very use of the quilted form, drawn from African-American women's creative and political histories and linked, directly, back to Ringgold's own mother, suffice to make *The French Collection* a testament to black female subjectivity and agency in history.

In *The French Collection*, Willia Marie responds to the Sunflower Quilters by promising that she will make them proud of her work and pass this to her daughter, creating a link between herself and this hard-won maternal legacy of freedom. In the penultimate quilt in the series, Willia Marie honours this promise by issuing her 'Colored Woman's Manifesto of Art and Politics' and secures her legacy in the final work in the series, *Moroccan Holiday* (1997), when she passes the torch to her daughter, Marlena, who reminds us all of the debt owed to Aunt Melissa as well.[29] From the children's first dance at the Louvre, to the bond forged between mothers and daughters, *The French Collection* refashions histories at the locus of

bodies and geographies such that black women might become the subjects, rather than objects, of historical knowledge and artistic practice.

Dancing: place and ethnography

Sokari Douglas Camp's kinetic sculptures devoted to Kalabari masquerade themes are also concerned with the intersection of bodies and geographies as they materialise the histories of black female subjects. Camp's practice explores the correspondence between viewing and making which situates her in two connected, but different geographies, that of her birthplace in Buguma, Nigeria and that of the country in which she became an artist, England. The simultaneity of her positioning is made manifest in the works by an ostensibly seamless union of competing cultural traditions and material practices.[30] The harmonious syncretism of these kinetic, multi-media dancers and spectators, belies their address to the complexity of identity and history in the contemporary African diaspora, defined as it is by increasingly mutable definitions of race, gender, nation and community.

I want to suggest that the particular combination of motion (kinesis) and multi-media assemblage in Camp's *Small Iriabo (Clapping Girl)*, allows us to explore the kinds of histories being engendered by contemporary African diasporan women as they move beyond conventions premised upon 'authentic' identities and stable cultural boundaries. In a certain sense, I am questioning the now commonplace invocations of nomadism and hybridity in terms of historical processes and products. That is, instead of simply saying that Camp's work combines the African with the European, demonstrating its hybridity, or that the sculptures represent the nomadic subject positions typical of diasporan experience, I am seeking to understand *how* a work such as *Small Iriabo* does this and what effect such a materialisation of these theoretical concepts might have for rethinking histories to address changing bodies and geographies.

The mechanical kinesis of Camp's Kalabari sculpture operates as more than a literal transcription of the movement of dancers or audience members, clapping along with the rhythm of the performance. In *Small Iriabo*, the movement of the figure invokes a participant spectatorship in which the young girl enters into the practices which delineate the terrain of her community through rituals, songs and dance. The involvement of the audience is as significant as the performance of the masqueraders; the community is constituted anew each time the dances are enacted between these constituencies. This kind of participant engagement is crucial to conceiving histories and cultures in process and acknowledging that subjects are both mapped by social structures and rules which precede them, yet capable of negotiating these maps through their own creative agency.

To explore the ability of art to develop historical knowledge as corporeal cartography and participation, it is useful to turn briefly to the installation *The New Charleston* (1991)[31] situated in the Avery Center for African-American History in Charleston, South Carolina. *The New Charleston* is the result of a collaboration between the poet and activist Estella Conwill Májozo, her brother, sculptor

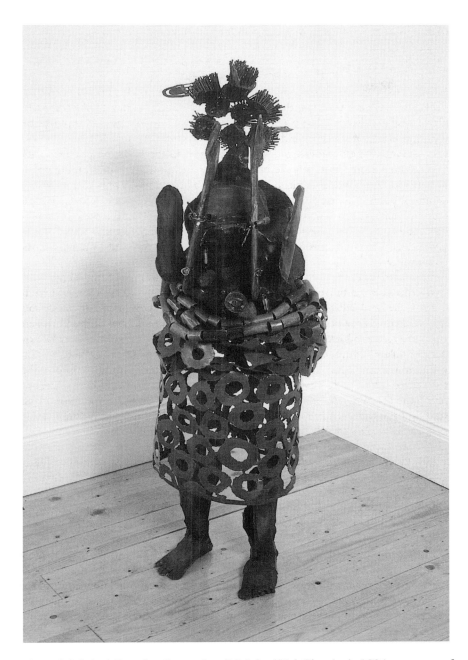

Figure 2.2 Sokari Douglas Camp, *Small Iriabo (Girl Clapping)*, 1984, courtesy of Sokari Douglas Camp

Houston Conwill, and the architect Joseph de Pace and takes the form of a 'cosmogram', a word coined by the artists to describe a form of interactive, map-based installation. *The New Charleston* is a floor-piece, combining visual, textual and spatial elements to chart the Middle Passage and the arrival of forcibly trans-ported Africans into South Carolina by means of directional story-lines and a series of dance instructions layered over a water and land-mass map. By walking through the map and doing the famous 1920s' dance, the 'Charleston', visitors are brought into the histories of the African diaspora and its impact on this particular location.

The New Charleston was designed originally as a temporary installation (for the Spoleto Festival), but it has been so successful as part of the Avery Center's teaching and exhibition programmes that it has remained on permanent display since 1991. It was conceived as an intervention into histories and a demonstration of the artists' commitment to interactive public art and political activism. Estella Conwill Májozo has written eloquently of the power of art to re-map histories in the present and change the future, using the metaphor of the three part blues structure (call, response, release):

> The call is incited by experiences we have with the world, by the human conditions . . . within our terrain that arouse our interest or consciousness. Next comes the response, the artist's creation – the attempt to name, recog-nize, and instigate change . . . The process continues as members of the community experience the release, the inspiration that allows them to enflesh the message and begin activating change in their own terrains.[32]

The Charleston is a tactical mechanism within this particular cosmogram and one which reiterates the fact that dance, as a participatory practice, can engender a corporeal knowledge which is both individual, within one's own body, and social, expressive of the trajectories of culture and history in process. Dance manifests, and to some extent literalises, a wider point here – namely, that knowledges which affect knowers, which 'move' them, change their understanding of themselves and their relationship to the world. Such corporeal knowledge is at the heart of social change and activism.

Camp's *Small Iriabo* was not intended to be a direct intervention into the histories of contemporary African diasporan subjects, yet its ability to engage spectators though a mode of kinaesthetic performance bears a striking resem-blance to the 'call, response, release' structure delineated above by Conwill Májozo. For example, Camp acknowledges that there is no complete understand-ing of the cultural conventions which map the Kalabari, either by the 'insiders' who perform the masquerade (male members of the Sekiapu cult), or by their audience, the wider group of Kalabari (mainly women) who attend the festivals.[33] Kalabari come to understand themselves as a part of this culture by 'responding' to its 'call', by participating in the dances, telling and listening to the stories and reaffirming the group's history and connection with the past. The repetitive phys-ical gestures of the sculptures mirror this 'response', but their material presence as

'art' in contexts which differ dramatically from the village festivals in Buguma, take them into a new realm.

I would argue that the 'release' comes in the form of laughter – the most diverse audiences are amused, entertained and engaged by the Kalabari sculptures and this is not an accidental element of the work. Indeed, Camp is at great pains to stress the significance of inducing laughter with her pieces and I would go further to suggest that this strategic use of humour brings spectators into an unfamiliar territory and enables them to communicate across cultural differences. Camp's addition of the kinetic elements to her sculptures is neither a gimmick nor an extraneous feature of their meaning; movement, and its ability here to reinstate the corporeal locus of memory and knowledge, and physically engage a widely diverse audience, is a way of thinking through the shifting cultural landscape of African diasporan women making art.

By engaging a cross-cultural audience in this way, Camp's work refuses to posit an 'authentic' or originary notion of cultural identity and instead suggests a dynamic hybridity. This is reinforced by the material assemblage of the works and their multiple and varied sources. Camp's sculptures invoke the physical presence of her figures through clothing, pose and gesture, yet the sculptures are neither simple likenesses nor even produced from materials associated with flesh, dress or costume. *Small Iriabo*, for instance, is a composite figure, consisting of wooden arms and hands, metal legs, an indication of a patterned skirt and beaded belt in heavily wrought copper and steel, and the suggestion of a head, mainly formed by a shock of 'hair' made from nails. None of these materials are 'traditional' and Camp's Kalabari figures are not rendered so to recreate the masks or costumes of the festival-goers literally. They are an interpretation of the event and they are, at the same time, recognisable within the conventions of contemporary western figurative sculpture.

Camp's most direct sources for this work are similarly multiple and dynamic hybrids. For example, *Small Iriabo* is semi-autobiographical, but it refers to the transitional moment of adolescence as masquerade: 'I am dressed for my role but my body is still in puberty.'[34] Moreover, some of Camp's research for the Kalabari works was undertaken in British ethnographic museums, where she combined the detailed material analysis of objects otherwise unavailable to her (such as *duein fubara*, ancestral screens) with a hearty scepticism concerning the methods of display typical of these institutions. As she put it, '[a] lot of ethnographic museums show a very fragmented view of African art which seems quite peculiar to Africans - like trying to explain to foreigners what the Queen means to the British by just showing her shoes'.[35]

This point about ethnographic museum display and fragmentation is important in understanding the historical intervention staged by Camp's work. Ethno-graphic museums were formed within the context of western imperialism and the cultures whose artifacts were displayed within their galleries were subject to a peculiar form of dehistoricisation. Understood as sacred objects and fetishes per-taining to ancient, unchanging myths and rituals, the materials housed within these collections were essentialised, homogenised and cast as beyond history as

we understand it in the ('civilised') west. However, Camp's use and critique of ethnographic sources, in addition to her decidedly historical exploration of the festivals and masquerades of her village through contemporary art, challenge the conventions of the ethnographic museum and its a-historical rendering of Africa.

Dance and ritual performance have been particularly subject to the processes of dehistoricisation by Euro-centric accounts which perpetuate their association with exoticism, magic and superstition. Yet the festivals of Buguma are constantly changing in response to wider socio-economic developments in Nigeria; in fact, one of the festivals Camp used as subject-matter was in honour of the centenary of the village. Even the nature of the dancers and spectators is subject to historical variation and this is another crucial element of Camp's work. A key example of the changing historical climate of the Kalabari is found in the lifestyle of the priestess whom Camp studied as an undergraduate and it is worth quoting the artist at some length:

> I studied a Kalabari priestess, Amonia Horsfall, in the third year of my BA course. . . . She danced by combining male dance steps and female dance steps. That's very unusual . . . So I was quite interested in her and the fact that she wasn't just a lady who had babies and looked after her husband. She had a business. . . . Because I got into a very good relationship with her, I made spirit objects that, I suppose, I imagined because of the way she danced.[36]

There is an extraordinary parallel here between Camp, as a Nigerian student in London, who both studies Horsfall as part of her course and yet makes spirit objects from this encounter, and the priestess herself, a woman steeped in the traditions of her group, yet combining this with an independent life as a businesswoman. Expressed through the co-mingling of the male and female dance steps, what Horsfall epitomises is the historical, hybrid, African female subject.

I am emphasising the decidedly historical African female subject here as a counterpoint to the pervasive objectification of the black female body as a signifier of essentialised racial and sexual difference in European and US-dominated knowledge systems. The colonial domination of Africa, as well as its diasporan subjects, was attended by both scientific and aesthetic scopic regimes which produced a knowable sexual and racial body – black women have inherited the most damaging legacy of these assimilative encounters with difference. As Charmaine Nelson compellingly argued, neo-classical figurative sculpture was painfully inscribed by the question of determining racial identity and this was most pronounced in imaging the bodies of black women.[37] Rather than examining art as a means by which 'race' is represented then, I am in agreement with Nelson that it is far more productive to examine art as a performative site through which 'race' (and sexual difference) are materialised.

Camp's Kalabari sculptures are one such site and, as an African woman sculptor making figurative work in England, her investment in articulating black female subjectivity, rather than objectifying black female bodies, is obvious. Like the

fictional redress to modernist primitivism staged in *The French Collection* when Willia Marie paints Josephine Baker, Camp's collaboration with the empowered female subject, Amonia Horsfall, locates creative agency firmly in the hands of African women. Moreover, their multiple and shifting subject-positions, articulated in dance steps, art practice and in the kinetic sculptures themselves, demonstrate that hybridity is a process of cultural negotiation, not a fact of the body. That is, these subjects are not hybrids in some fixed biological sense, but as situated subjects adapting to the ever-changing social, cultural and political geographies in which they live.

In this sense, *Small Iriabo* is again significant; any sense of hybridity is performative, engendered by the complex material, spatial and kinetic conjunctions of the piece and not by imaging or representing an *a priori* 'hybrid body'. Indeed, we are not given access to any singular body at all, but rather to the processes and encounters through which corporeal subjects map their changing world. *Small Iriabo* is a charged site for the meeting of bodies and geographies which can articulate African diasporan female subjects as historical, creative and empowered. Like *The French Collection*, the sculpture is a form of corporeal cartography which takes seriously the processes and practices through which histories have been made, might be questioned and will be redressed in the future. These works reinstate the black female subject as a significant force in histories, but their powerful address to the articulation of difference at the nexus of bodies and geographies concerns every historical subject and all of our futures.

3 Re-inscribing histories: Viet Nam and representation

> Let's take the example of my latest film, *Surname Viet Given Name Nam*. . . .
> the film works simultaneously at different levels on the intersection of nation
> and gender; on the problems of translation within a culture as well as between
> several cultures; on the politics of interviews with its emphasis on oral testi-
> monies and its 'voice-giving' claims; and finally on the fictions of
> documentary.
>
> (Trinh T. Minh-ha, interviewed by Pratibha Parmar, 1990)[1]

> The point is to see yourself reflected in the names.
> (Maya Lin, on her design for the *Vietnam Veterans Memorial*, 1983)[2]

Both *Surname Viet Given Name Nam* (1989) and the *Vietnam Veterans
Memorial* (1982) address conflict – within and between nations, across differ-
ences of language, culture and identity and as a dynamic interaction between
politics and aesthetics at the level of representation. The fact that representation is
called into question by these works is not surprising; challenges to nation, identity
and cultural unity were embedded within the very processes of decolonisation in
Viet Nam. Investigating the ramifications of these events by necessity asks who
represents whom, by what authority and to what effect. However, what interests
me here is how these artworks re-inscribed those histories, through what mechan-
isms they were able to expose the practices of representation and, concomitantly,
what new historical and political perspectives they have configured. I would argue
that Trinh's film and Lin's public memorial offer an extraordinary opportunity to
examine connections between nation, political agency, difference and representa-
tion in the wake of Viet Nam's struggle against international imperialism[3] and,
moreover, that the feminist praxis embodied and developed by these works is
crucial to their intervention.

Concepts of nation and representation are not simple, so it is useful to clarify
the perspectives I am taking on these terms briefly here. In thinking about nation-
alism, Benedict Anderson suggested that the nation is 'an imagined political
community' and that it is imagined as both 'inherently limited and sovereign'.[4] In
stressing the 'imagined community', Anderson was not underestimating the sig-
nificance of economic power, ethnic affiliation, linguistic or social bonds to define

the limits of the nation-state. Rather, Anderson's emphasis upon imagination helps to explain the function of ideas, discourses and material practices, such as art making, in forming a concept of national identity which is political, cultural and subjective at once. Anderson's double play of a limited community (the boundaries of the nation and the internal comradeship between its members) and its sovereignty (the power to rule 'others'), enables us to envisage a dynamic exchange between inside and outside in the continual re-inscription of nation.

It is this charged sense of a 'nation-in-process', the constant iteration and negotiation of cultural norms, forms and boundaries, both individually and collectively, which is at stake in the work of Trinh and Lin discussed in this chapter. Neither artist took the limits of nation, nor the role of representation in constructing political subjects and national identities, for granted. Representation is a multi-faceted term, which can, for instance, refer to a likeness or be defined as a person or object standing in for, or speaking on behalf of, another person/object. In these variants, aesthetic and political representation is at its most conservative, signifying the reflective, objectifying construction of a representative norm. However, representation can also be dynamic and enabling, as a strong argument designed to sway opinion or as a clearly defined idea or concept.[5] In other words, representation can be participatory as well as objectifying. I want to suggest that *Surname Viet* and the *Vietnam Veterans Memorial* reformulate representation such that intersubjective participation becomes a political and aesthetic force for considering the problems of nation, conflict and history in Viet Nam and beyond.

Trinh has spoken often and eloquently of the difficulty of representing 'others', arguing especially that 'speaking about', 'speaking for' and 'speaking as' reduce the complexities of subjectivity to an ostensibly unmediated and monolithic identity politics.[6] Countering this mode of assimilative representation, she emphasised 'speaking nearby', practices designed to constitute an embodied and relational interaction between subjects. 'Speaking nearby' is not just a theoretical ploy for Trinh. Her own position is profoundly interstitial – born and raised in Viet Nam, educated in the United States and France, living and working in both the United States and Africa and writing and making films which concern the changing dynamics of post-colonial subjects.

The cinematic devices Trinh deployed to demonstrate the 'fictions' of documentary in *Surname Viet*, stress the 'nearby', repositioning viewers against the grain of representational objectivity and locating Vietnamese women as creative, political agents. The film combined conventional guarantors of authentic representation (first-person interviews, documentary footage, 'factual' voice-overs, sub-titles), such that they were rendered unstable. We quickly find that the first interviews are staged, scripted in English from French translations of interviews conducted in Viet Nam (in Vietnamese) with women whom we never see. The later, 'real' interviews with these actors are, of course, equally staged, as the women re-present themselves to the camera. The documentary footage itself is montaged, replayed and interleaved with other visuals which disrupt its characteristic reportage. Even the name of the country is subject to scrutiny when its multiple historical variants appear on-screen and are read aloud in the diverse

accents of natives, colonisers and combatants.[7]

This excessive reiteration of the cinematic form created a space for difference, or what Trinh termed an *interval*:

> If we put aside the fact that the popular use of the interview is largely bound to an ideology of authenticity . . . or facile consumption, I would say that the interview is, at its best, a device that interrupts the power of speaking, that creates gaps . . . and invites one to move in more than one direction at a time. . . . It is in the *interval* between interviewer and interviewee, in the movement between listening and speaking . . . that I situate the necessity for interviews.[8]

Yet if the competing translations, voices and images in *Surname Viet* challenge an easy equation of documentary, testimony and figurative imagery with definitive meaning or representational truth, they never suggest that political subjects or creative agency do not exist.

Indeed, *Surname Viet* specifically addresses women as social and political agents, delineating its manifold narrative of cultural change in Viet Nam through female voices and women's resistance, endurance and survival as they adapt to new regimes of power within the nation and beyond its borders. But while Trinh's film is structured in and through female subject positions, these are never essentialised or homogenised. The film does not evince a singular or unified

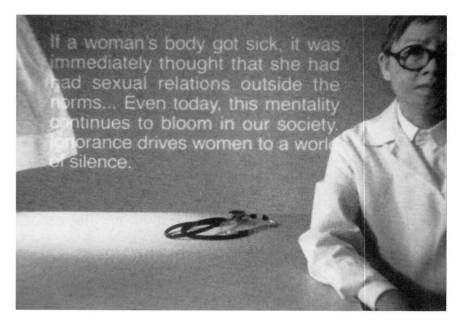

Figure 3.1 Trinh T. Minh-ha, still from *Surname Viet Given Name Nam*, 1989, cour-
tesy of Trinh T. Minh-ha

feminist/feminine aesthetic nor suggest that there is a separate but equal 'women's history' of Viet Nam's conflicts, national identity or cultural representation. Rather, its power resides in demonstrating that political crisis, nationalism and cultural change are themselves materialised by the complex exchanges which take place between subjects already marked by multiple differences – of which one critical component is sexed specificity.

The *Vietnam Veterans Memorial* demonstrates a similar attention to exchanges between subjects and locates meaning in the interval between the work and its participant-viewers. Naming and mirroring in the memorial act to represent diverse historical subjects without occluding their differences. The project was always intended to include some 58,000[9] names of those US servicemen and women who died or went missing in action in Viet Nam. Lin took that representational parameter and expanded it by ordering the names neither alphabetically nor by rank, but by the date of their loss. The physical inscription thus bears witness to the temporal frame and the monumental scale of the human sacrifice, without reference to hierarchy. There are no images of soldiers in uniform, yet the clusters of names and dates suggest missions which were ambushed or patrols who never returned to their unit. As we read the names, the figures and spaces we see reflected in the polished surface of the black granite are ourselves and others at the memorial, seeking to come to terms with this overwhelming corporeal absence, made present, tangible and timely by name and date alone.

The form of the memorial, a massive, 'v-shaped', horizontal rift in the earth of the park, presents the historical period of the Viet Nam conflict as a scar, a break, which must be encountered physically in the present. The first year of US engagement, 1959, is placed at the top right-hand panel at the vertex of the work; the yearly losses run along the wall as it descends into the ground on the far right and they begin again where the wall emerges from the earth at the far left, concluding such that the 1975 panel meets that of 1959 at the central vertex, omega to its alpha. This scale of the losses can only be experienced and understood by moving through the space, tracing with your own body this broken and restored time-line.

Lin's memorial reinstates the significance of multiple responses in a participatory public space and, by extension, in a participatory democracy, constructed to enable all of its citizens to engage in the political process.[10] This constitutes a substantial challenge to those forms of civic representation premised upon an economy of the same, a singular, representative 'citizen' who is by default, white, male, middle-class and otherwise normative. It does not, however, simply reverse the paradigm and place a normative woman at the privileged locus of representation; its feminism is neither so blunt nor so unilateral. Yet Lin was fully aware of the difference between the *Vietnam Veterans Memorial* and the overt masculine language of public monumental sculpture in Washington when she designed the work. Asked if the memorial had a 'female sensibility', Lin responded 'In a world of phallic memorials that rise upwards, it certainly does. I didn't set out to conquer the earth, or overpower it . . .'[11] The very fact that the memorial explored

site, power, nation and identity through difference linked it with a well-defined feminist practice, typified by the work of Nancy Holt, Elyn Zimmerman and Lita Albuquerque.[12] Like *Surname Viet*, Lin's memorial neither posits an ideal nor singular feminist form of public sculptural aesthetic; its strength resides in opening representation to diverse subjects who would otherwise be excluded by its normative codes.

To explore further the aesthetic mechanisms by which *Surname Viet* and the *Vietnam Veterans Memorial* reformulated representation around the concepts of nation, gender and participation, I want to move in two directions. First, it is useful to examine the role of documentary and mass media in the constitution of a nation's sovereign right to represent 'others'. Second, the connection between monuments, memorials and civil rights activism queries the delineation of internal bonds between civic subjects within the nation. In the case of Viet Nam, and the US military conflict which played a part in the longer process of deccolonisation there, both the media and public space were renegotiated as subjects sought access to representation in the widest sense. From this conflicted arena representation was reformed, in the cases here, by women making art.

Mass media, documentary and reportage

Toward the end of *Surname Viet*, the following is heard as a voice-over:

> War as a succession of special effects; the war became film well before it was shot. . . . If the war is the continuation of politics by other means, then media images are the continuation of war by other means. . . . Nothing separates the Vietnam war and the superfilms that were made and continue to be made about it. It is said that if the Americans lost the other, they have certainly won this one.[13]

As these words are spoken, we see a cinematic montage of western documentary photos of the Vietnam conflict; tiny children standing over their dead mothers, women and children forced into a ditch, refugees fleeing a village, protesting Buddhist monks setting themselves alight in response to the brutality of the war. The photographs are filmed in fragments and, in a striking visual sequence, we see three isolated photographs of fatalities, woundings and refugees which are then placed into their original context on the cover of a 1975 edition of *Time* magazine. While we review the media war in pictures, the sound of helicopters accompanies another fragmentary dialogue: 'These images call for human compassion toward countries in war', 'They can change the way you think', 'These images are very painful'.[14]

The effect of this sequence is powerful in its familiarity. As Carlo McCormick said, 'What cannot be overlooked in any discussion of the Viet Nam war and its cultural impact . . . is that it was first and foremost a media war.'[15] Voted the biggest world story of the year in 1967 by the Japanese press,[16] the events were

reported globally and images of the devastation filled the pages of newspapers, magazines, TV news and documentary programmes throughout the next eight years. Arguably, the coverage of particular events actually changed the course of the military action – the success of the Tet Offensive in January 1968 and news of the atrocities committed by US soldiers in the village of My Lai reported in November 1969, are cases in point. Particular visuals have now become synonymous with the conflict: the monks' self-immolation; Nik Ut's photo of the naked child Kim Phuc running along the road on fire from napalm; the execution of a Viet Cong prisoner by a bullet in the head, photographed by Eddie Adams.

Cinematically recomposing these pictures to connect with the ubiquitous helicopter noise, a critique of media and film images of the conflict and their reception by Vietnamese women who speak over them, was an effective deconstruction of their initial aim. The mass media coverage of the military action in Viet Nam (indeed, of any war) was intended to distinguish between home and away, 'us' and 'them', so to shore up national sovereignty through distance and a clear sense of purpose. As we now know, this went horribly wrong in the case of US representations of the Viet Nam conflict; the mechanisms by which war would ordinarily be kept at bay failed, and the war came home.

Women artists in Europe, Australia and the Americas responded swiftly to the influx of information and photographs from Viet Nam and used the power of the media against itself. Australian artist Ailsa O'Connor recast the image of Kim Phuc as an emotive political statement in the style of Käthe Kollwitz in *Napalm* (c. 1970), Nancy Spero's work turned US helicopters into ugly, phallic monsters of death and Yoko Ono conducted a media campaign against the war with John Lennon, using their honeymoon in Amsterdam as a bed-in and taking a billboard in Times Square to 'advertise' their 1969 Christmas song/message 'War is over, if you want it.' As early as 1966, Carolee Schneemann linked militarism with the pornography of mass media depictions of violence in her film *Viet-Flakes*, which combined photographs of atrocities in Viet Nam with a soundtrack of Bach, Mozart, the Beatles, Vietnamese and Laotian songs. In performance, the film was projected while actors struggled on-stage to the overlaid sounds of trains and orgasms.[17]

While these women artists' responses to the media onslaught were diverse, the refusal to divorce anti-war work from feminist and civil rights activity was a feature most had in common. This is an important point, since there remains a tendency in the literature to view women's anti-war activism as 'political', while relegating their involvement with civil rights and feminism to the realm of the social, moral or ethical. The now-famous dictum 'the personal is political' meant, as the artist May Stevens put it, 'My social life, my political life, and my studio life were the same.'[18]

Martha Rosler was already involved with civil rights and anti-nuclear activism in New York when an increasing engagement with feminism and the anti-war movement mobilised her to politicise her art practice.[19] As Alexander Alberro argued, for Rosler '. . . feminism clarified the direct links between everyday life,

anti-war work, and struggles for civil rights and political and social transform-
ation'.[20] Moving to San Diego in 1968, Rosler's work adapted mass media
imagery through collage, photomontage and low-tech video production. This
mode of practice utilised a Brechtian dialectic of appropriation and recontextuali-
sation to demystify seductive media forms and encourage political consciousness.
Rosler's comment that television tended to make its viewers 'audience spectators
rather than citizen participants'[21] is telling in this context and her choice to recon-
figure, rather than reject, the media makes her work an interesting precedent to
Surname Viet. But it was Rosler's critical ability to link nation, gender and partici-
pation in her media-based work which most powerfully addressed the issue of
representation at stake here.

From 1967 to 1972, Rosler produced twenty photomontages as a series
entitled *Bringing the War Home*.[22] These works were composed from newspaper
documentary photographs of the Viet Nam conflict combined with images of
domestic interiors from style and design magazines. The finished montages were
not intended for gallery display, but were published in underground anti-war
journals, thus returning the recontextualised images to the media and popular
dissemination. The photomontages literally 'bring the war home', locating the
ubiquitous pictures of soldiers, dead bodies and maimed refugees in the very
spaces of the American show-home. *Balloons* (from *Bringing the War Home:
House Beautiful*) for instance, montages the figure of a frightened Vietnamese
refugee holding an injured child in her arms onto the stairway of a chic, middle-
class, suburban split-level. Any definitive sense of dividing 'us' from 'them' is
shattered as the prosperity of the first world is linked incontrovertibly to the
violent maintenance of its sovereignty abroad.

Rosler's series brought the conflict close to viewers while estranging them from
commonplace imagery and an over-familiar, naturalised reading of it. This is a
tactic dependent upon an 'intimate distance',[23] an active, yet critical, engagement
which transgresses the boundaries between insider and outsider, subject and
object, such that these can no longer be maintained. *Bringing the War Home*
challenged the sovereignty of the western media to depict its 'others' through
simplified stereotypes designed to keep the war at a safe distance from its passive
audience spectators. Encouraging instead a participant citizenship, Rosler's series
troubled her viewers' own status as knowing subjects by examining the conven-
tions through which familiar images constructed the fictions of stable gender,
national and cultural identities.[24]

In speaking with Isaac Julien about *Surname Viet*, Trinh made the parallel
point that national identity is no more easily defined from within a culture than
from beyond its limits:

> The film, structured by multiple strategies of cultural identification, is very
> much about how, even and especially for insiders, the naming of their own
> culture (the national narrative) remains plurally unstable. Vietnam cannot be
> homogenized or subsumed into an all-embracing identity.[25]

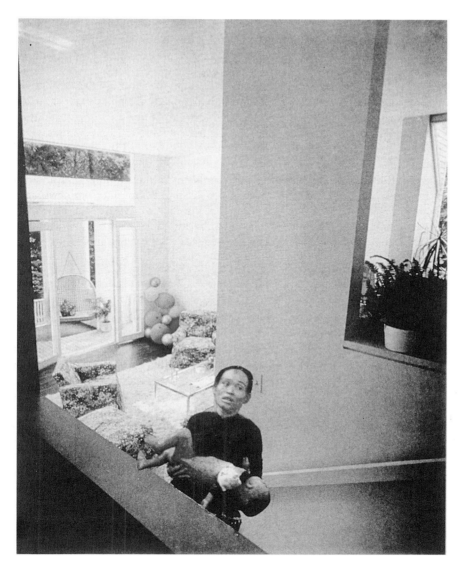

Figure 3.2 Martha Rosler, *Balloons*, from *Bringing the War Home: House Beautiful*,
1967–72, courtesy of Martha Rosler

Trinh's deployment of the US media war sequence, as but one short segment
within *Surname Viet*, challenges the right of the first world to construct Viet
Nam's national narrative or cultural identity from outside its borders. Trinh's
film refutes an homogenised picture of Viet Nam and resists particularly the
stereotypes of Vietnamese women as victims, so frequently displayed in, for

example, US documentary images of the military conflict. However, the film does not simply reverse this expression of sovereignty such that we are granted access to a singular, Vietnamese 'insider' story of nation and identity or to an essential Vietnamese 'woman'. The problems of translation within the culture are as marked as those which come from outside and, to approach these issues, the film produces what Homi Bhabha termed 're-inscriptive histories'. Re-inscriptive histories operate like a cinematic palimpsest, manipulating conventional representational forms to articulate differences and hybridity.[26] In *Surname Viet*, the intersection of nation and gender is re-inscribed in women's voices, images, narratives and memories. There are no singular or stable narratives of female subjects or their interaction with the changing configurations of nation at any point in the film. Documentary material ranges from footage of women in Viet Nam under French colonial rule walking together on the street or riding bicycles, to women working in markets and on riverboats, participating in revolutionary marches and demonstrations and, inevitably, fleeing villages as refugees. The symbolic structures which constitute ideal womanhood are seen to be equally diverse, dynamic and subject to historical mediation. Confucian rules of ideal womanhood and the national poem of Viet Nam, the nineteenth-century *Tale of Kieu*, link female self-sacrifice and endurance with the concept of the nation-state. These are played against ancient tales of women warriors and more recent Maoist conventions of female comradeship which held sway after the Fall of Saigon. The staged and 'real' interviews with women focus on their diverse experiences of colonial disintegration, military invasion, communist rule and emigration; while no experience is paradigmatic, each adaptation to this changing political climate enacts a gender-specific negotiation of ideals, ideologies, traditions, and the necessities of practical life.

In one fascinating sequence centred on a 'Miss Vietnam' pageant held in the immigrant community within the United States, 'woman', women, national identity and the translations in and across cultures come together. While we see Vietnamese women gliding across a stage in western evening wear, playing traditional instruments in the 'talent' section of the competition and coming to the microphone to introduce themselves or answer judges' questions, we hear the following exchange: ' ". . . please tell us what characteristics of Vietnamese culture we should preserve in American society?" ". . . as far as women are concerned, we should preserve our Vietnamese heritage and the four virtues Cong Dung Ngon Hanh" '.[27] The four virtues, being skilful in work, modest in behaviour, softly spoken in language and faultless in principles, are here translated, literally and figuratively, into another set of cultural conventions. The women we see on film, and those whom we have heard interviewed, watched as activists and mourned as victims of foreign aggression throughout Trinh's work, are not static objects of an ancient dictum or passive recipients of a culture beyond their control. They are active mediators of this culture, political agents participating in all and every competing concept of nation which might be formed.

Surname Viet makes its most powerful intervention into the logic of cinematic

representation and national sovereignty at just this point. Trinh's own thinking on a documentary form 'aware of its own artifice', which 'constitutes' rather than 'advocates' political agency[28] is instructive in this sense. The film constitutes Vietnamese women, those subjects least often granted the power to define the nation within the near-hegemonic field of external reportage, documentary and cinematic super-film, as the central mediators of meaning. Yet they are never homogenised, essentialised or disconnected from the complicated histories of which they speak nearby. Rather than choose between the polarities of a totalising form of meaning or the wholesale rejection of meaning, political engagement and the subject itself, *Surname Viet* reformulated subjectivity around the question of the participant-citizen.

As we move to consider the *Vietnam Veterans Memorial* and the conventions of representation in and of the public space of the body politic, Michael Renov's comments on feminism, subjectivity and the politics of documentary seem particularly apt:

> But what makes this new subjectivity new? Perhaps the answer lies in part in the extent to which current documentary self-inscription enacts identities – fluid, multiple, even contradictory – while remaining fully embroiled within public discourses.[29]

Figure 3.3 Trinh T. Minh-ha, still from *Surname Viet Given Name Nam*, 1989, courtesy of Trinh T. Minh-ha

Nation, difference and *bodies* politic

The long struggles to control Viet Nam, politically and culturally, threatened the international sovereignty of more than one imperial power. But nowhere did these struggles damage the internal cohesion of a nation more than in the case of the United States. When Maya Lin's design for the *Vietnam Veterans Memorial* was first unveiled, the controversy it caused centred on representation itself. As Victoria White put it, 'the selection of her design ignited a public battle, with loud claims that the memorial was inappropriate and did not represent who it was supposed to represent'.[30] But just what does 'represent' mean in this context? Is it the literal question of representational (figurative) versus non-representational (abstract) art, the problem of representing the ethnic, racial and gender mix of the veterans themselves, the choice of a pro- or anti-war position or, whether it is viable to represent the body politic?

A brief look at the terms in which the debate over Lin's design was pursued is instructive. The first major public objection to the work came from Viet Nam veteran Tom Carhart, whose concerns were, for the most part, merely amplified later. In the open hearing on the design held in 1981, Carhart said:

> One needs no artistic education to see this memorial for what it is, a black scar. Black, the universal color of sorrow and shame and degradation . . . There are presently three monuments that could be called black in Washing- ton. – But those are all heroic images. . . . And then we come to the shameful, degrading ditch that Vietnam veterans are given – a black gash of shame and sorrow . . .[31]

New Right politics became more pronounced in later oppositional comments; anti-feminist Phyllis Schlafly and conservative columnist Tom Wolfe referred to the memorial as a 'monument to Jane Fonda' and Wolfe further argued against its elitism, calling it art from the 'Mullahs of Modernism'.[32] Frederick Hart, the artist eventually commissioned to design the compromise figurative addition to the site (at some distance from Lin's piece), made offensive comments about both the memorial and the artist. He called her memorial 'art that is contemptuous of life', accused Lin of 'egocentricity and arrogance' while also condescending to her as 'an ingenue' and a 'little girl'. In mentioning his own credentials as a representa- tive of the Viet Nam veterans' opinions, he said, 'I became close friends with many vets, drank with them in the bars.'[33]

That the language deployed by opponents to Lin's plans for the site had racist and sexist overtones was not lost on contemporary politicians, critics or the artist herself. The problem of the black granite, for example, was put to rest by General George Price, an African-American military official, who countered with 'Black is not a color of shame. I am tired of hearing it called such by you. Color meant nothing on the battlefields of Korea and Vietnam.'[34] But Lin found that being a young, Chinese-American woman did mean something on the battlefields of Washington's public art scene:

Figure 3.4 Maya Lin, *Vietnam Veterans Memorial*, 1982, copyright, Maya Lin; photograph, National Parks Service, Washington, DC

In the academic world where I grew up, my femaleness, the fact that I was Oriental, was never important. . . . When I first came to Washington my biggest shock was that no one would listen to me because I had no power – no masculinity.[35]

In her incisive work on the memorial, Marita Sturken not only noted the sexism and racism embedded within the texts and sub-texts of the debate on Lin's design, but the implication that the work emasculated the military men, the practices of war and, by extension, the nation. Sturken argued that its 'antiphallic' presence opposed 'the codes of vertical monuments symbolizing power and honor' and that the 'battle over what kind of style best represents the war was, quite obviously, a battle over the representation of the war itself'.[36]

Nicholas Mirzoeff suggested that the *Vietnam Veterans Memorial* interrogated the representative function of the body politic at the end of the twentieth century, arguing that 'the possibility that the Body politic might at once represent all the citizens of a nation and a sense of new possibilities for the future no longer seems open'.[37] To Mirzoeff, Lin's memorial is a fundamental challenge to what has become the fiction of the unified body of the nation, forged through the legacy of neo-classicism in state-sponsored art and the founding myths of republican political ideals. A crucial dimension of his discussion concerns the long association of state-sponsored violence (such as war) with 'fraternity', or those horizontal bonds between citizens which, to paraphrase Anderson, constitute the limits of the nation.

Moira Gatens echoed this turn by pointing to the conventions of corporeal forfeit or sacrifice required of the bodies who enter into covenant to form the body politic.[38] Gatens argued convincingly that the concept of the body politic relies on two forms of representation – the metaphorical, or the construction of an image based on an ideal body, and the metonymical, the 'representation of a complex body by a privileged part of that body'.[39] In political, legal and artistic terms, the ideal body is not in fact neutral, but masculine and, concomitantly, masculinity and male bodies form the normative conventions of politics, law and art. Gatens further contended that, although the body politic is archaic and has been weakened by successful claims for access by marginalised 'bodies' such as women, the working classes and people of colour, its exclusions still underlie many socio-political inequities.

It is my contention that the *Vietnam Veterans Memorial* offers the possibility of providing a space in which the *bodies* politic might be represented in participation and difference. For concepts of nation, gender and representation, this configuration of the memorial reinscribes the histories of the site, the corporeal ideal of the liberal nation and the participant-citizen. The *Vietnam Veterans Memorial* is a crossing, a chiasmus, where subject and object, here and there, past and present meet and reformulate histories in their exchange. The arrangement of the names, for example, links servicemen and women from many different backgrounds together. This does not hide the fact that a disproportionate number of the

soldiers were African-American, Chicano, Latino or native American, yet it marks their 'position' as where they fell together, rather than where they stood at home, divided by racism, power and privilege.[40]

D.S. Friedman argued that the reflection of the viewers in the polished surface of the memorial produced another form of chiasmus.[41] This important feature of the memorial defies the necessity for figurative imagery by linking the participant-viewers' own bodies with the sculptural form. Thus, the memorial enables diverse groups to come into representation in the modulation between reflection and engagement. A negative demonstration of the success of this strategy came in 1990, when women veterans petitioned to create a sculptural group dedicated to their lost comrades. As they argued eloquently, it was the addition of Hart's figurative group to the site which so pointedly materialised their exclusion, as women, from representation in the discourse of the conflict; in Lin's design, they said, they had had a presence.[42]

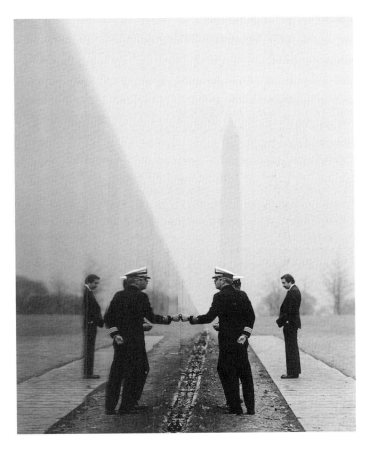

Figure 3.5 Maya Lin, *Vietnam Veterans Memorial*, 1982, copyright, Maya Lin; photograph copyright Christopher Lark

A further chiasmus materialised by the memorial is the crossing of past and present. In part, this is a function of walking through the broken time-line of the conflict and in finding yourself reflected in the long list of names. But the work also inscribes an historical crossing as it points to the Washington Monument and the Lincoln Memorial, key symbols of the narrative of federal unity and the legacy of neo-classical aesthetics. Many commentators have noted the siting of the work and its interaction with the two extant monuments. Some features are obvious; the Washington Monument and the Lincoln Memorial drew upon classical Greek and Roman precedents associated with civic unity. Washington, the first President of the United States, symbolises the founding narratives of US democracy and Lincoln, the Civil War President, held the disintegrating union together and upheld the human rights of enslaved African-Americans by legislating for their emancipation.

But these works inscribe less obvious historical narratives as well. The construction of the Washington Monument was begun in 1848 as an active attempt to reanimate the space of the Mall as a symbolic site for the federal government.[43] This was necessary for a number of reasons, including the developing threat of states' rights to federalism, the relative provincialism of Washington and increasingly vocal opposition to the use of the Mall as a market for re-selling escaped slaves captured in the north. If federalism was to have any representative force, the Mall needed to be re-designed. The Washington Monument was the centrepiece of this new building programme, but its progress was halted during the period of the Civil War (1860–1865). It was only begun again in 1876, when federal unity and emancipation had won the day.

The Lincoln Memorial more directly symbolised the unity and emancipation won during the US Civil War, but was not produced until 1922, following the First World War. The First World War signified the end of US isolationism and the start of a long series of conflicts waged on foreign soil. It also marked the extension of suffrage to women. By the beginning of the twentieth century then, neo-classicism had become the standard stylistic language of United States federal representation, international sovereignty and of the homogenised body politic of the liberal nation-state which included women and people of colour, yet did not recognise their differences.

Lin's *Vietnam Veterans Memorial* marks a treble temporal trajectory; it is steeped in the formation of a representative political and aesthetic construction of the body politic after the Civil War, it invokes the challenges to this national narrative waged by feminist, civil rights and anti-war activists during the 1960s (not least as they marched on the Mall) and it has played an important role over the past two decades as a place of reconciliation and renegotiation of civic identity. The historical moments which provide the frame for the *Vietnam Veterans Memorial* were moments of representational conflict centred upon access, identity and the national narrative. In echoing these through the materiality, site and strategies of the present memorial, Lin's design reconfigured the body politic by examining the inevitable fissures in the over-determined construction of federal unity.

The introduction of neo-classicism into monumental sculpture and the corollary development of public memorial spaces were not seamless. The US Civil War was the first conflict to elicit such commemoration and while the Mall was being landscaped, markers were being laid in battlefields. I would suggest that the battlefield memorial at Antietam in particular is an important precedent for the participatory, temporal naming devices of the *Vietnam Veterans Memorial* and helps to explain spectatorial responses. The battle of Antietam was fought on a single day in September 1862, resulted in the greatest number of casualties in one battle of the Civil War and was the event which impelled Lincoln to issue the Emancipation Proclamation in January 1863. By the middle of the 1870s, the Department of the Interior marked battlefields so that the huge number of visitors travelling to these sites, might be able to 'walk' the battles themselves. The majority of these markers provide simple textual notes of the time, date and names of the soldiers at the very places in which they camped, charged, killed or died on the field. Thus, from the earliest period of commemorating wars on home soil, there were conventions for participant engagement in the practices of representation itself. Moving through the names and dates of the *Vietnam Veterans Memorial* is far more like the corporeal participation involved in walking through Antietam than along the Mall; these were places where citizens from both sides came together to trace the fate of the civil union.

Similarly, the sculptural language of nineteenth-century classicism was not hegemonic. In 1867, Edmonia Lewis produced *Forever Free*, a figural group depicting an African-American man and woman breaking the chains which have shackled them and rising upward in a gesture of emancipation. This work was well received in its day as both a naturalistic form of neo-classical sculpture and as a clear statement of the rights of all people regardless of race. Additionally, it directly referenced Lincoln's Emancipation Proclamation and, indirectly, the famous image of the kneeling chained slave from the Wedgwood seal of the Society for the Abolition of the Slave Trade (designed 1788). Subsequently, the sculpture has become famous both for being the work of a successful woman artist of mixed native and African-American parentage and for being one of the most definitive anti-racist works of art produced in the period. It is also a fascinating negotiation of the parameters of the political and aesthetic representations of the body politic. It engendered neo-classicism as a style which could voice difference and yet not fall foul of the prevailing standards of art criticism. It acknowledged the embodiment of racial and sexual difference without recourse to misleading stereotypes or an assimilative generality. We find here that the paradigm of neo-classical representation itself was re-inscribed as participatory and multi-faceted by an artist positioned in and through difference.

Similar re-inscriptions of the interconnected body/bodies politic in and through art practice occurred in the work of another African-American woman a century later. In 1968, Elizabeth Catlett produced *Homage to My Young Black Sisters*, a sculpture in wood which conformed to a modernist syntax while revealing its hidden reliance upon 'primitivism'.[44] Again, this work articulated difference and claimed the right of representation for marginal subjects by negotiating

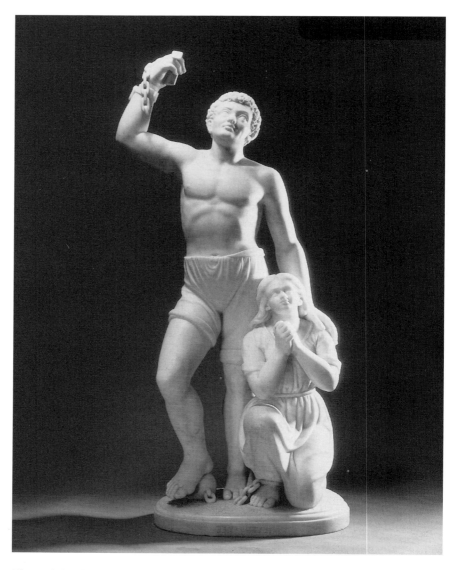

Figure 3.6 Edmonia Lewis, *Forever Free*, 1867, courtesy of Howard University
 Gallery, Washington, DC

the parameters of contemporary aesthetics, politics and participatory citizenship.
Catlett's sculpture combined contradictory, yet powerful codes: that the figure is
female typified modernist tropes, but its pose, giving the black power salute,
marks the female figure as a cipher of contemporary, political agency. The
emphasis upon black sisterhood challenged the masculine biases of both main-

stream American politics and the black power movement itself, while the aesthetic reworking of the legacy of non-western ('primitive') motifs by an African-American woman artist was a purposeful statement of reclamation and adaptation in the diaspora.

I would argue that the strategies which Catlett and Lewis used to confront the exclusive image of the body politic at its borders, edges and limits, are resonant with Gatens's argument that '(f)or these "others", who have never experienced

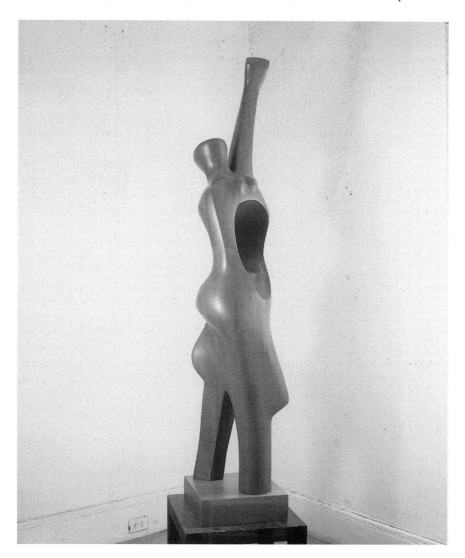

Figure 3.7 Elizabeth Catlett, *Homage to My Young Black Sisters*, 1968, copyright, Elizabeth Catlett; photograph June Kelly Gallery

the satisfaction of having their image reflected back to themselves "whole" or "complete", the fascination with this dream is not so binding.'[45] And, of course, the partial and perspectival 'reflections' offered by the *Vietnam Veterans Memorial* similarly frame the body politic through *bodies*, diverse, multiple and participatory. In this sense, these works both used and critiqued the conventions of representation and the body politic, rather than simply abandoning them as useless fictions. However, in their alternative formulation, they lose their transcendence and unchallenged power to unify or 'to represent' through assimilation.

The *Vietnam Veterans Memorial* has been called a 'screen';[46] a shield and an open space for projection, it enables both intimate contemplation and public expressions of grief to emerge. And these have emerged. Since its unveiling in November 1982, hundreds of thousands of visitors have left offerings at the wall, taken tracings of the names of their loved ones and written letters directly to the dead. The space is remarkably participatory, indeed, unexpectedly so. It is also corporeal without being figurative; the bodily interaction with the site animates it and reinvents the national narrative in each interaction.

Some critics have pointed to the fact that there is no similar space in which to recognise the far greater losses sustained by the Vietnamese, or even to be able to garner an accurate number of the dead (estimated at 3,000,000) or their names. In this sense, they seem to be arguing that the *Vietnam Veterans Memorial* is yet another instance of cultural imperialism. I think differently about this point. Although the namelessness of the Vietnamese casualties is a function of the imperialist project of their annihilation, it is in subsequent attempts to represent Viet Nam in monolithic stereotypes that we find the legacy of the effacement of their legitimate claim to representational authority. This will not be challenged simply by naming the dead; if western conventions of representation are not altered from within, there will be no chance of creating real dialogue and genuine acknowledgement of differences in the future. In the wider remit of nation, gender and representation, both the *Vietnam Veterans Memorial* and *Surname Viet* re-inscribe histories otherwise, inviting such dialogues with diversity and beginning the longer processes of cultural exchange beyond the logic of assimilation.

Part II
Subjectivity

Introduction

A sense of 'self' and an ability to articulate in the first person, as an 'I' through which authority and identity are constituted, are the privileges of unified subject-hood, privileges which, in the west, accompanied the historical preeminence of individualism. But the centrality and empowerment of this individual 'one' were bought at the expense of its 'others', defined through excluded modalities of difference. Culturally, this had significant ramifications for the development of concepts of authorship and creative agency. Simply, the authoritative 'I' who authored texts, the intellectual subject capable of rational thought and the genius who created high art, was not a neutral subject, but masculine, heterosexual, white, Euro-ethnic, middle-class and able-bodied – the normative subject of western epistemology and ontology.

Women making art interrogate these conventions of the subject since 'woman', allied with the feminine position, is structurally defined beyond the bounds of articulate subjectivity. Within this logic, woman is the mark of difference, the 'object', rather than the 'subject' and thus mute, unrepresentable and unknowable. However, women do speak, they write and they make art. The question this raises so pointedly is just what sort of subjectivity women articulate when they come into voice or materialise ideas in the visual sphere. I would argue that they neither assume a masculine subject-position in some form of mis-identification, nor slip into the passive role of the object; female subjectivity confounds the very opposition between self and other, subject and object, which typifies the normative 'I' of the ostensibly universal, gender-neutral individual.

However, the fact that female subjectivity cannot be conceived through such normative paradigms does not oblige us to entertain extreme theoretical man-oeuvres designed to deny subjectivity altogether or to embrace a fragmented, dispersed subject, devoid of agency, responsibility or political potential. Rather, the existence of articulate, creative and intellectual women asks us to reconsider the parameters of the subject in new and productive ways such that difference and process might inform more nuanced concepts of subjectivity. Feminist philosophers have been at the forefront of this project and their work has had a far-ranging impact upon academic theory, aesthetic practice and political activism. Significantly, this work has identified and critiqued the limits of western philosophical constructions of subjectivity while, at the same time,

positing alternative conceptions of the female subject which are articulated otherwise.

Many of the key concepts developed by thinking differently about the interpellation of female subjects have significant implications for aesthetics and art practice as well. For example, the renegotiation of mind–body dualism refutes the logic through which 'woman' is objectified and emphasises the crucial role of corporeality and embodiment to thinking, making and knowing. Clearly, work which confronts the scopic objectification of woman has much to contribute to the reformulation of visual culture in our society, but even more subtly, reiterating the bodily locus of subjectivity emphasises the role of the senses in knowledge production, thus connecting aesthetics with sexed specificity and difference. Similarly, the shift from object to process in addressing radical difference speaks both to the interpellation of new modes of subjectivity and to the development of art practices which acknowledge making itself as integral to meaning.

What I am suggesting is that the insights developed in reconceiving female subjectivity against the grain are imperative to any project exploring difference and that art-making, with its decisive link to visuality and materiality, has the potential to expand the limits of this project in unique and vital ways. Women making art therefore have a particularly important role to play in reconceptions of female subjectivity in and through radical difference. This point is crucial; women's art does not materialise the essence of woman or presuppose an *a priori* subject which only needs to find a voice through which to emerge. Rather, I am arguing that the particular conjunction of 'woman and art' is contingent and that female subjectivity is bodied forth by these diverse interactions with visual and material culture across varied historical circumstances.

The three chapters which comprise the second section of this volume, 'Subjectivity', take a closer look at three particular constructions of subjectivity through difference: embodiment, performativity and becoming. These three concepts are not taken as definitive theories and applied to artworks, but are themselves seen as configurations of intersecting ideas, practices and materials, mobilised in various contexts to help think through the multiplicity and mutability of female subjects. The three themes are not the same, nor do they do represent every possible interrogation of subjectivity which might be useful to a feminist project concerning women making art, yet they do address the key problems of dualism, corporeal objectification, stasis and monadic individuality. In this sense, they work well as a set of interrelated concepts, designed to open the connections between female subjectivity and art practice to further debate.

In exploring embodiment, it is crucial not to conflate the idea of the body as a site of competing desires, definitions and discourses with any conventional sense of the body as a known and determinate object. Embodiment moves beyond subject and object to stress the bodily coordinates of subjectivity as well as the materiality of knowledges. Embodiment relies upon interactions between subjects and objects in the world, or what has come to be termed 'intercorporeality'. There are a number of important and interrelated insights which are derived from working through the ramifications of embodied subjectivity, particularly in

relation to space, knowledge and sexed specificity. If 'the body' is the first locus of subjectivity, then this subjectivity is produced through an encounter between the body and the social systems which articulate corporeality through difference, whether sexual, 'racial', generational or otherwise. That is, bodies matter, but not as fixed essences – as the very potential of signification in and of the world. Moreover, the situation, the physical and discursive location of sexed subjects, is critical to the knowledges which they make. Hence, the fourth chapter examines bodily knowledges and the spaces in which female intellectual and creative agency are formed, literally, by looking at studios, studies, libraries and galleries, and metaphorically, by engaging with women's art as a perspective on history and female creativity. Art is taken in this chapter as one of the parameters of intercorporeal exchange, as a critical component of embodiment for women artists, and not just as the representation or the picture of these exchanges and bodies.

The fifth chapter of this volume turns to the concept of performativity as an especially apt counterpoint to biological determinism and the fixed sex/gender/sexuality nexus so commonly assumed to underlie identity. In addressing the visual arts, however, it is less the word- and text-based idea of the performative which occupies my attention and more its development through the linked concept of materialisation. The chapter unfolds around the potential of art to *matter*, to make meaning and to do so in substantial, physical form, and the significance this has for women artists working through questions of desire and agency. Female sexuality, when confined to compulsory heterosexuality and a form of biological certitude which uniformly associates sex with gender, is conceived as passive and mute. The works in this chapter, however, mobilise female sexuality and desire as powerful creative forces, materialised in their diversity through art-making as a performative mode of subjectivity. These materialisations are not *erotica*, some kind of objectification of female pleasure and desire on display to a masculine-normative viewer, but they are *erotic*, in the fullness of that term as a form of empowering sensual articulation and knowledge.

The final chapter in the 'Subjectivity' section moves on to consider becoming. Here, two crucial points are connected – the mutable nature of the subject and integral relationship between individual and collective. Becoming, as opposed to being, stresses mobility and change as fundamental to subjectivity and this fact necessitates finding ways to think and demonstrate process. Art provides unique opportunities in this respect since its materiality bears the trace of its production and can be mobilised as part of its meaning. Additionally, art is intimately linked to collectivity; the multiple, the hybrid and the assemblage formed from different elements can be expressed with particular efficacy through the visual and material arts. In terms of materialising female subjectivity, both process and multiplicity suggest a more active encounter between the 'self', or individual 'I', and the wider social body. In the sixth chapter, this interaction unfolds as a form of 'trans-individuality' made manifest through the historical and physical play of the arts and sciences.

Two final points remain to made about the structure of these chapters and their interrogation of the issues they raise about women's art and female subjectivity.

First, these chapters take as read that subjects inscribed in and through difference will not be universal or transcendent, and may very well be described as 'de-centred', hybrid or nomadic, yet they can be empowered, articulate agents in the world. Furthermore, art has a real role to play in the materialisation of female subjectivity otherwise and this role is not as the illustration of abstract theories or as the object of their interpretation.

In each of these chapters, works of art play a central role in defining and delineating concepts; they act no less theoretically than any of the textual material with which they are interwoven. In order to emphasise how art can be vital to emergent forms of female subjectivity, the chapters are configured in and around particular works, using these micro-historical case-studies as incisive focal points for ideas. In every instance, the specificity of the practice, its media, form, historical location and mode of address, are explored as part of its ability to make a meaningful contribution to the theoretical debate at stake. The micro-historical focus of the chapters leads to the second point which must be made here, namely, that the diverse cases brought together within these chapters are part of a deliberate strategy to think critically about the relationship between female subjectivity, art and history.

Within each chapter, the case-studies are drawn from very different historical contexts and brought together around their conceptual address to female subjectivity. This is not meant to imply that female subjectivity is transhistorical or that the specific histories of these works and their artists are immaterial. On the contrary, the historical framework and the specificity of the artworks are absolutely crucial to the arguments. The differing histories and material conditions through which these works came to be made are not occluded by the theoretical perspectives on female subjectivity which form the focus of the chapters, nor are these theories intended to act as an interpretive grid, forcing the historical differences into a false unity or homogeneity.

The chapters centre upon artworks and their engagement with female subjectivity *within* their historical moments, so to reinforce the fact that subject positions are interpellated differently in diverse contexts. The constitution of female subjectivity, materialised in art, changes in response to the changing climate in which it is formed and of which it is formative. In a productive encounter between women making art and concepts of female subjectivity we can attend to such differing historical circumstances, recognising patterns which emerge over time, without seeking a universal explanatory structure or theorem. The chapters' multi-temporal and multi-local cases do suggest patterns and develop configurations of concepts and practices which go toward rethinking female subjects, but they do not collapse the exciting and creative work of women making art into a monolithic absolute.

4 Embodiment:
space and situated knowledge

Embodying the woman artist

In 1857, Emily Mary Osborn exhibited the modern-life painting *Nameless and Friendless* at the Royal Academy. Osborn was an experienced exhibitor at the RA and this work was the second painting she showed in this venue to focus on the roles of contemporary women. Over the next decade, she would produce many modern-life paintings exploring the lives of women and their struggles for independence in the wider arena of socio-economic and political life in mid-Victorian England.

Nameless and Friendless centres on the figure of a woman artist, legible as young, respectable and middle-class, who ventures into a West End art dealership to sell her work. Osborn's picture makes clear that this is a difficult situation; the figure's discomfort is emphasised by both her awkward pose and position, beholden to the sharp judgements of the dealer on her work and beheld by the close scrutiny of the men in the shop. This work, now taken as paradigmatic of women's differential access to sites of power and representation, was one of the few works by women artists in the mid-nineteenth century to explore the gendered topographies of modern London; as Deborah Cherry eloquently put it, 'this is a painting about the sexualised encounters and economies of the modern city, its spaces of pleasure, exchange and consumption'.[1] The troubling encounter in this work is located at the nexus of the body and the city, or more specifically, the problem of embodiment and situation around one particular 'body' – that of the woman artist.

The meaning of the work relies on the paradox of woman as subject and object; viewers must at once be aware of the central figure as an object seen (of the dangerous and unpleasant objectification of woman) and as a subject who sees, a creative female agent, an artist. Her depiction as white, middle-class and very much clothed, in addition to the title of the work, made her an object of sympathy for a contemporary Victorian audience. While there is little disagreement about these broad lines of interpretation, how the work encodes the body is more complex. I want to suggest that thinking through the notion of embodiment, rather than any particular definitions of body types or painterly tropes of 'woman' in the period, is a more useful move to make in exploring the

ways in which women's art can address sexed subjectivity, situation and knowledge.[2]

Embodiment refutes the division of 'mind' from 'body', arguing that what we call subjectivity is the effect of human, corporeal existence in the world. Moving from mind–body dualism to embodiment has been especially productive for those subjects most decidedly objectified and positioned negatively within the former logic as 'all body': women and subjects marked by 'racial' difference. Where an attainment of subjecthood relied upon the assumption of transcendence and a definitive rejection of corporeality, any sign of immanence, especially as 'bodiliness', was eschewed. The corollary of this divisive logic was that the masculine (and white, middle-class, able-bodied – i.e. 'normative') subject position became disembodied, and, as Donna Haraway argued, this demonstrates iniquitous power structures: 'Only those occupying the position of the dominators are self-identical, unmarked, disembodied, unmediated, transcendent, born again.'[3]

But embodiment stresses the corporeal roots of subjectivity itself and hence the embodied locus of all subject positions. Moreover, embodied subjectivities are relational, formed through corporeal encounters with other bodies in the world. Developing the ideas of Maurice Merleau-Ponty, Gail Weiss described this enworlded sense of embodiment as *intercorporeality*:

> . . . the experience of being embodied is never a private affair, but is always already mediated by our continual interactions with other human and non-human bodies. Acknowledging and addressing the multiple corporeal exchanges that continually take place in our everyday lives, demands a corresponding recognition of the ongoing construction and reconstruction of our bodies and body images.[4]

I want to argue that the dynamics of embodiment as intercorporeality are visualised in *Nameless and Friendless* and that this play of imaging within the frame has wider ramifications for rethinking female subjectivity outside its bounds. As discussed earlier, the central female figure is placed at the nexus of a series of connected looks which establish her body as a paradox: woman as subject *and* object. But the paradox of female subjectivity is here located within a particular historical framework, one in which the social, political and economic interests of the dominant male subjects are served at the expense of the central figure's claim to independence within the narrative and visual structures of the painting. That is, the problem of the figure's embodiment as a sexed subject cannot be configured in a vacuum; the female figure disrupts the ostensible neutrality of the visual exchange and thus *embodies* the masculine figures as well. The dynamics of looking within the painting only make sense as corporeal interplays; there are no self-identical or unmarked positions. By these means, *Nameless and Friendless* reinstated sexed specificity and interestedness as inherent to the act of looking, opening masculine-normative subjects and spatial relations to critiques focused upon differential power, access and control.

In this sense, the female figure in *Nameless and Friendless* describes embodi-

ment as a process which takes place between subjects and not as a thing which can be represented. This is a very subtle, but significant shift of meaning. I am arguing that embodiment is manifest through processes of exchange, that it is an effect of these processes and not an *a priori* essence, object or thing. Hence, embodiment, and indeed, embodied subjectivity, cannot be represented as kinds of things, as bodily objects for instance, but rather, embodiment can be materialised in the visual by setting up the parameters for an intercorporeal exchange. The central figure in *Nameless and Friendless* therefore, is not a representation of an embodied woman artist, if by that we mean a reflection of a 'real' woman prior to the work's mediated configuration of body, space and vision. Rather, her figure is a site of negotiation, a set of potential bodily coordinates, which are realised within the spatial structures of the work and as those interact with embodied viewers in the world. As Pamela Gerrish Nunn has argued, *Nameless and Friendless* can be seen as a 'generic self-portrait'; not a simple likeness of Osborn, but an image through which Osborn strategically positioned the problematic exchange between women, art and the politics of Victorian social regulation.[5]

Examining the pose of the central figure in *Nameless and Friendless* makes this point more clear. The female figure stands demurely, hands nervously twisting the cord of her purse, body closed, head tilted downwards and, importantly, gaze averted. These bodily signs marked the figure as 'respectable' – not making a spectacle of herself or inviting unwanted sexual attention. But, as the work of Iris Marion Young suggests, female body comportment is a complex, corporeal exchange between the lived bodily power of the subject and the external pressures, physical and social, exerted upon her.[6] In order for this figure to make sense in the scene as depicted, we have to imagine a prior narrative in which the woman made art and travelled through the city to this dealer's shop; we have to imagine a far more active female body, indeed, a very determined female subject, being made self-conscious and self-protective by the particular economy of this intercorporeal encounter. The figure of the woman artist in *Nameless and Friendless* is thus less a picture of a kind of woman (respectable), or of the natural/essential qualities of femininity revealed by the body, than it is a description of the specific historical conditions through which woman was bodied forth in the highly charged spaces of middle-class Victorian society.

Nameless and Friendless had, and continues to have, powerful ramifications for thinking productively about female subjectivity. Simply, it shifts our focus from the issue of the objectification of women's bodies to the potential of art to materialise female embodiment as a process of location, power, vision and corporeality. This is why I find Cherry's recent account of this work's significance for contemporary audiences so convincing. In *Beyond the Frame*, Cherry connected the spaces of art practice to female subjectivity in diverse, complex and compelling ways. Rather than see the social conditions of the period as a form of background context, or the 'real' against which images are judged for accuracy, her work insists that spaces, bodies and visual imagery interacted to produce female subjectivity. While Cherry refers explicitly to the 'intertextuality' of these interactions, I

Figure 4.1 Emily Mary Osborn, *Nameless and Friendless*, 1857, Private Collection.
Photograph: Photographic Survey, Courtauld Institute of Art

would suggest she also describes the intercorporeality of embodied encounters
within and beyond the frame.[7]

Nameless and Friendless deployed visual and spatial devices to emphasise the
inequalities between the sexes in this particular historical moment while reinstat-
ing the corporeal locus of the subject positions it depicted. But, if we take the play
of intercorporeality seriously, we must contend with the stronger assertion that
the painting itself is one of the 'bodies' in the world with which we interact as
corporeal subjects. Its mid-Victorian viewers were themselves implicated within
the embodied logic of the work, just by taking up a viewing position within the
gallery which paralleled the internal visual and spatial construction of the piece.
Moreover, the wider questions of women's access to education and the profes-
sions, not to mention the controversies surrounding definitions of 'obscenity' in
the period, further interpellated the audience of *Nameless and Friendless* in their
corporeal specificity. There were no 'outside', unmarked positions from which
this work might be consumed to avoid implication within its strategic devices and
there are none now as we re-view it.

Furthermore, *Nameless and Friendless* set into place a double play of embodi-
ment and situation for contemporary viewers since the artist who produced it was
by no means 'nameless'. As the work of a known woman artist, the painting was

itself an intervention into a masculine-normative power structure – that of the art world. Osborn was a successful professional practitioner who travelled widely, exhibited in major shows throughout her life, won awards, attracted wealthy patrons and maintained studios in London and Glasgow. Significantly, she was engaged in the political struggles of women artists to gain access to the Royal Academy Schools, not just to further their training, but to increase their professional status. For women artists to be understood as educated, intellectual and professional practitioners meant taking up a place at the centre of institutional power, and of course, to situate sexed subjects within the Academy threatened to shatter the universalising myth of 'Art' itself.

Osborn's own career was negotiated in and between the sexualised spaces which characterised the mid-Victorian art world and her artwork, therefore, was a strategic articulation of sexed subjectivity within the charged arena of visual culture in the period. *Nameless and Friendless* did not illustrate her experiences as an artist, express an inner essence or depict a monolithic female condition, yet the fact that its maker was a woman did situate the work in significant ways. It claimed a strategic position for women within the political debates of the period, particularly as they centred upon women's intellectual and creative agency. Women seeking access to education, political representation and the professions were challenging the myth of transcendent, masculine rationality and male intellectual superiority. Moving beyond the logic which equated 'woman' with 'body' was crucial to this endeavour. Osborn's negotiation of embodiment and position in and through the languages of art, instantiated the power of intercorporeality to materialise the body as situation, rather than as object, a fact which draws together explorations of female subjectivity and reconceptions of knowledge, power and meaning.

As Judith Butler has argued, the body as situation has at least two meanings:

> . . . the body is a material reality which has already been located and defined within a social context. The body is also the situation of having to take up and interpret that set of received interpretations. No longer understood in its traditional philosophical senses of 'limit' or 'essence', the body is a *field of interpretive possibilities*.[8]

In an interesting parallel with Butler's double reading of the body as situation, Rosalyn Diprose revisited the etymology of 'ethics' from *ethos* – 'dwelling'. Diprose's wider project was to develop an ethics which would take sexual difference and embodiment seriously, thus rejecting universal or transcendent first principles in favour of creative agency and intercorporeal exchange. Stressing the simultaneity of 'dwelling' as a noun (material locus), and as a verb (taking a position), Diprose posited the ethical subject as embodied, as already located and able to interpret their location: 'From this understanding of ethos, *ethics can be defined as the study and practice of that which constitutes one's habitat*, or as the problematic of the constitution of one's embodied place in the world.'[9]

Understanding the practices which constitute one's embodied place in the

world conjoins questions of female subjectivity with ones of ethics, aesthetics, power and knowledge. It is this conjunction which is of interest to me here and, specifically, how women's art plays a crucial role in configuring this nexus. Looking at this is a matter of examining strategies for articulating female embodiment as situation in the visual and material practices of art and not an issue of defining a style or representational mode which either reveals the truth of the body or illustrates 'embodiment' in some literal way. Moreover, practices which connect bodies with situation provide a means through which to examine the significance of corporeality to both subjectivity and epistemology under specific material conditions. This further connection makes embodiment a crucial component in any attempt to establish women as intellectual or creative subjects; obviously, this is imperative in thinking about women artists.

Donna Haraway's work on situated knowledges provides important insights into the relationship between embodiment and intellectual objectivity and is useful here. To put it very briefly, Haraway is concerned with the ways in which epistemologies borrowed from the natural sciences have constructed 'objectivity', or rational, intellectual rigour, as a neutral, disembodied mode of knowing. She sees this reductive scientism as problematic in two senses: first, it occludes the significance of desire and interestedness within scientific research and second, it banishes embodied knowledges, such as feminism, to the realm of discredited, subjective thinking and radical relativism. Unlike some feminist theorists, however, Haraway does not wish to dispense with a concept of intellectual objectivity, but to re-cast this as originating in embodiment and situation: 'So, not perversely, objectivity turns out to be about particular and specific embodiment . . . feminist objectivity means quite simply *situated knowledges*.'[10] Haraway's re-casting of objectivity as situated is meant to reconnect engagement and responsibility with intellectual and creative insights – it is an epistemology in which ethics, aesthetics and female subjectivity might converge.

If Haraway's work speaks to the question of feminist knowledge and articulate female subjects, so too did Osborn's painting. Women artists were especially important figures in first generation feminist struggles for access to education, professional rights and an independent political voice.[11] As we have seen, Osborn herself played a part in these struggles and the fact of her independent and successful practice, in addition to her association with the Langham Place circle centred around Barbara Leigh Smith Bodichon, a founder of Girton College, make explicit the connections between women, art, feminist knowledge and power in the period. *Nameless and Friendless* participated in this conjunction, not just by figuring a woman artist but by emphasising the embodied nature of vision in intercorporeal exchanges of power. It is at this level that Haraway's thinking on situated knowledge, Osborn's painting and the potential of art to envisage and engender knowledge as position converge.

Haraway argues against vision as a 'conquering gaze from nowhere' since

> [t]his gaze signifies the unmarked positions of Man and White, one of the
> many nasty tones of the word *objectivity* to feminist ears in scientific and

technological, late industrial, militarized, racist and male dominated societies.[12]

Instead, 'an optics is a politics of positioning'[13] and practices which re-embody vision can construct usable conventions of knowledge, based upon creative agency, rigour and responsibility. These insights into embodiment and situation suggest that intercorporeal exchanges produce conditions by which female subjectivity may emerge as fully embodied and also as knowing, creative agency. In this sense, art has the potential to play an especially important role by emphasising the corporeal roots of cognition and insisting upon perspective as the very premise of feminist objectivity.

Embodied vision: situation(ism), the library and the studio

Haraway was not alone in suggesting that embodied vision could provide an important counterpoint to subjects and knowledges which base their authority on a universal or all-encompassing viewpoint. Elizabeth Grosz similarly critiqued the conceit of transparent knowledge systems, premised upon 'perspectiveless' position and disembodied (masculine-normative) subjectivity.[14] Gail Weiss took this in yet another direction by considering the visual mechanisms of intercorporeality as intersubjective rather than objectifying. Suggesting that we might conceive of a gaze which immerses us in light and colour, she refuted the definition of vision as disembodied, distancing and forged in a violent separation of self from other.[15]

Concepts such as embodied vision, the 'look' of intersubjectivity and the significance of partiality and perspective in the creation of knowledges, again link aesthetics with ethics and politics around female subjectivity and intellectual agency. In relation to these ideas, the work of Maria Helena Vieira da Silva offers a fascinating parallel. In her long painting career, Vieira da Silva constantly examined and reinvented the highly charged sites of the city, the studio and the library while interrogating space and perspective through the play of optical immersion. In this way, her works act as a critical intervention into both the paradigmatic modernist sites of intellectual and creative agency and the deployment of space and vision to underpin a distanced, disembodied, objectification of the world.

Born in Portugal, Vieira da Silva trained and worked in both Lisbon and Paris during the 1920s and 1930s, moved to Rio de Janeiro during the Second World War (1940–46), and finally settled in Paris in 1947. By the end of the 1940s, she was an established part of what came to be known as the international School of Paris, a loose collection of artists ranging from Pierre Soulages and Hans Hartung to Alfred Manessier and Wols. Vieira da Silva's fame rested on interpretations of her works as a middle path, a viable stylistic and thematic engagement with the polar extremes of modernism – abstraction against realism and, within abstract modes, 'hot' versus 'cold', or gestural, emotive excess and expression against distant, geometric formalism. In this sense, Vieira da Silva's paintings were a successful negotiation of the dualism inherent in modernist theory, yet locating

her work within the shifting parameters of the post-war Parisian art world neither explains nor contains her practice in any simple way.

Vieira da Silva's consistent deployment of the spaces of cities, studios and libraries was neither a simple affirmation of their pivotal role in avant-garde art and literature, nor a rejection of the power of these spaces to demarcate intellectual, cultural and creative agency. For example, while Vieira da Silva frequently imaged cities, she refused the modernist cliché of the city as 'woman', known through the visual mastery of the artist/*flâneur*. This was a persistent trope even after the Second World War, manifested, for instance, in the pictorial emphasis upon speed and disembodiment in the work of Soulages and Franz Kline or by Situationist International linguistic turns such as 'raping the city' or 'I came in the cobble-stones'.[16] Rejecting the masculine conceits of the historical avant-garde, Vieira da Silva's work reinterpreted cities as relational sites of corporeal exchange, thus enabling an optical politics of perspective for the female, urban subject to emerge.

In addition to cityscapes, Vieira da Silva often painted libraries and studios, further exploring the connections between spaces whose power, whether academic or artistic, was forged through a disembodied paradigm of the knowing/seeing subject. Vieira da Silva's repeated imaging of libraries and studios worked otherwise, delineating these spaces as a critical locus for embodied vision and female, knowing subjects. What interests me about Vieira da Silva's paintings of libraries and studios is that they both acknowledged the power of these sites in forging intellectual and creative subjects and refuted the logic of disembodied visual objectification in their structure. In an important sense, rejoining the studio to the *studium*, or the artist's work-space to the space of the library, reiterated the Renaissance origin of the studio as part of a wider cultural and intellectual community and reaffirmed this legacy in the twentieth century.[17] Both historically and theoretically, this link was vital to women; we should not forget the conceit involved in rejecting academic training when it is readily available or the significance of both libraries and studios to women during the first half of the twentieth century as they sought to expand their access and status within professional circles.

But it is the intimate relationship between female subjectivity and situated knowledge which makes Vieira da Silva's cities, libraries and studios converge as experimental geographies which enworld our vision and situate knowledge claims. Cities, studios and libraries, as they figured in Vieira da Silva's practice, can be seen to have involved a mode of knowing which acknowledged the importance of the observer and embodied vision. In an excellent essay on the studio 'as an instrument', rather than an iconography, Svetlana Alpers developed some ideas which are remarkably resonant with the spatial interventions in Vieira da Silva's works.[18] Alpers described the studio as '. . . the very condition of working. . . . the constraints under which knowledge is achieved'.[19] Drawing upon phenomenology, Alpers suggested we think about vision in the studio as a rehearsal of 'how we come into an experience of the world'.[20]

The links with intercorporeality are absolutely clear; if the studio can be understood as an instrument of phenomenological subjectivity in the world, this is

because our embodiment is premised upon what Merleau-Ponty termed 'revers-ibility'.[21] Reversibility, in this sense, refers to the mutually constitutive agency of the self/other, or self in/of the world. At the micro level, reversibility is what links the senses together, especially sight to touch and vice versa; embodied vision is the demonstration of the intertwining of self and other in flesh. As Merleau-Ponty wrote:

> Since the same body sees and touches, visible and tangible belong to the same world. It is a marvel too little noticed that every movement of my eyes – even more, every displacement of my body – has its place in the same visible universe that I itemize and explore with them, as, conversely, every vision takes place somewhere in the tactile space.[22]

In 1949, Vieira da Silva painted *The Library*, a work which explodes the last vestiges of those two key visual schema formulated to disembody subjectivity and render vision universal – one-point perspective and the grid. The visuals invoke the ostensible objectivity of the grid, yet reformulate it against both the post-Renaissance legacy of linear perspective and the structural sensibilities of modern-ist formalism. The space of *The Library* is multiple, shifting and inviting, yet it does not conform to any geometric conventions from beyond the frame. As her admiring critics from the 1960s and 1970s would have it, her fascinating 'hypo-thetical geographies'[23] were 'mysterious horizons', 'vistas that exist nowhere but have become real because Vieira da Silva has brought them into being'.[24] In an excellent revisionist account of the transgressive elements of Vieira da Silva's work which were ignored by contemporary critics, Serge Guilbaut argued that she:

> . . . proposed a different point of view. What was missing in the unique eye of Cartesian perspective was a certain emotional component unable to surface under the technology of the grid. The bodies of the painter and viewer were forgotten in the name of an allegedly disincarnated, absolute eye.[25]

I want to suggest that *The Library* is more than just a hypothetical geography, and press even further Guilbaut's points concerning the forgotten bodies of the Carte-sian logic of visual disincarnation. The visual immersion of the viewer in the colour and space of *The Library* makes the intercorporeal encounter between bodies in the world the project of this work. As Martine Arnault wrote, it is in 'noting the vanishing points, learning the different deformations of perspective, mastering the play of intersections, appreciating the subtlety of the tones'[26] that the work emerges for the spectator. The quality of the visual encounter is embodied and the corollary ramifications for subjectivity are powerful. The sheer scale of this painting, with its fascinating mobile and mutable formations, envisages perspective and agency as part of a process of exchange, or, as Haraway argued:

> Accounts of a 'real' world do not, then, depend on a logic of 'discovery', but on a power-charged relation of 'conversation'. The world neither speaks itself

Figure 4.2 Maria Helena Vieira da Silva, *The Library*, 1949, copyright DACS; photograph L'Agence Photographique de la R.M.N., Paris

nor disappears in favour of a master decoder. The codes of the world are not still, waiting only to be read … the world encountered in knowledge projects is an active entity.[27]

Haraway's insights into the agency of the world in bringing forth embodied and situated knowledges could almost describe the visual intersubjectivity of Vieira da Silva's painting. The world is neither available to be mapped by the instrumental gaze of the subject from beyond its limits, nor is its 'real' underlying structure being revealed by the objective vision of the artist. Instead, the work of art is a 'knowledge project'.

This makes Guilbaut's assessment that 'Vieira da Silva offered not so much a radical critique of Mondrian's utopian grid as an enrichment of it, more tactile, less visual'[28] all the more telling. Vieira da Silva's paintings concern precisely these acts of vision in 'tactile space'; the corporeal exchanges she envisaged as the very work of her art are the marvellous movements of the embodied eye in the world. The interpellation of subjects in connection with the world and, as Weiss argued, the very possibility of perception, thought and language, are premised upon this reciprocal, intersubjective reversibility.[29] Vieira da Silva's immersive optical effects not only break apart the false 'objectivity' of universal systems of perspective,

modernist formalism and the post-war avant-garde reinvention of the tran-
scendent artist trope, they embed the visual in the tangible and perspective in
embodiment. In so doing, they materialise the chiasmus, the crossing of self
and world. While Merleau-Ponty's notion of this intertwining has been critiqued
for assuming a universal, sexual body, rather than working through the asym-
metries of sexed subjectivity in the world, the crucial interconnections between
embodiment, situation, knowledge and vision described by the chiasmus are
clearly significant to feminist reconceptions of subjectivity and new models of
'objectivity'.

Vieira da Silva reconfigured painterly visual tropes and charged sites in ways
which enabled her work to explore space and subjectivity as mutually constitutive.
That these investigations made sense of the situation of a woman artist in the
post-war Parisian avant-garde is hardly surprising, nor should be Vieira da Silva's
determined interrogation of the connections between cities, studios and libraries.
The body as situation was evoked powerfully by the combinations of site and
vision which Vieira da Silva's work brought forth and these, in turn, suggest that
an optical politics of embodiment can interpellate a knowing, creative female
subject.

Skin, borderlands and *mestiza* knowledge

At the end of her essay on situated knowledge, Haraway turns briefly to the
problem of boundaries:

> Boundaries are drawn by mapping practices; 'objects' do not pre-exist as
> such. Objects are boundary projects. But boundaries shift from within;
> boundaries are very tricky. . . . Siting (sighting) boundaries is a risky
> practice.[30]

Haraway's text points to two, interrelated, phenomena of boundary-siting; first,
that boundaries are arbitrary, shifting effects constituted by intercorporeal rela-
tions in the world and, second, that establishing boundaries is risky, since power is
not distributed evenly across and between different subjects and our borders are
commonly produced through domination, seizure and control. For these very
reasons, thinking through the ramifications of embodiment, situation and risky
boundaries is imperative to developing a politics of/for subjects who have not
been privileged in the prevailing economies of knowledge and power.

Questioning how intercorporeal boundaries are established between bodies has
led to insightful work on 'skin', described by Sara Ahmed and Jackie Stacey as a
'boundary-object'; not simply the covering of the body but a form of 'inter-
embodiment, on the mode of being-with and being-for, where one touches and is
touched by others'.[31] Thinking the skin in this way expands the significance of
process in intercorporeal embodiment and refuses to fetishise the body as an
object by insisting upon understanding subjectivity as mediated by contact within
the world. Like Haraway, Ahmed and Stacey see boundaries as relational and their

work similarly points to the difficulty of siting/sighting borders between bodies which are always themselves unstable and crossed by differences.[32]

Nowhere could the risks associated with the boundary or the significance of skin as the effect of intercorporeal practices, have been more attenuated than in the borderlands feminisms of radical Chicana scholars, activists and artists. The insights of Gloria Anzaldúa, Cherrie Moraga and other Chicana feminists on the problem of siting boundaries, emphasise that for *mestiza* subjects, thinking through the skin is always a confrontation with geopolitical borders, sexism and racism which limit the power of women of colour and reduce them to the objects of knowledge. Combining this compelling materialist analysis with a sophisticated use of metaphor and allegory around the boundary and the multi-faceted Chicana subject, borderlands feminisms deconstruct iniquitous intellectual paradigms while insisting upon the formation of new knowledges.[33] This double position interpellates the new *mestiza* as a multiple locus of subjectivity, knowledge and critique.

Indeed, Chicana feminists have been especially critical of Anglo-American, liberal feminists who, under the joint banners of equality and sisterhood, all too easily acceded to the position of central, knowing subjects over their 'others', including non-western, non-white, 'Third World' and working-class women. These criticisms are convincing; taking seriously the political ramifications of embodiment, intercorporeality and situation means acknowledging differences between women, based on their material circumstances, access to resources and the ideological structures which map their bodies at the point of their skin. The *mestiza* subject materialises the very processes of 'inter-embodiment' which mark the skin as a 'boundary-object' and, moreover, points to the historical specificity of articulating female subjectivity and knowledge. Moreover, borderlands subjectivity is a process, not an object, and one which reiterates the power of perpetual negotiation.[34]

The challenges to thinking about subjects and knowledge wrought by exploring the border subjectivity of the new *mestiza* are not simply confined to a small, marginal group. The risk is just the opposite; we are all implicated by difference, location and the intersubjective production of our own bodily boundaries. To take this point further, I want to turn to an installation by the Chicana artist Amalia Mesa-Bains, *Venus Envy Chapter II: The Harem and Other Enclosures, The Library of Sor Juana Inés de la Cruz* (1994). This work is multi-layered in its references and in its implications, but I want to explore just one particular aspect of its aesthetic and political dynamic, namely, the way it materialises borders and interstices as active sites for the emergence of the Chicana subject of knowledge. This is not meant to limit the work, but to engage with Mesa-Bains's own assertion that 'cultural transformation requires an expansion of aesthetic language'[35] and her use of what she has termed *domesticana* as a means by which to develop a 'personal and collective narrative of Chicano/Mexicano history'.[36]

Domesticana is Mesa-Bains's term for a feminised form of *rasquachismo*,[37] a type of Chicano sub-cultural, popular aesthetic.[38] *Rasquache* is manifest in the decoration of cars and homes, styles of dress, and, significantly, as a gestural act, a

way to 'put forward your body and person as a style'.[39] It is also commonly misread by Anglo-US cultural norms as a kind of *kitsch*. As Mesa-Bains pointed out, neither *rasquache* nor *domesticana* should be assumed under the blanket heading of *kitsch* for two reasons – first, they are not just empty play with the remnants of commodity culture, but are produced with an oppositional 'attitude' and, second, they are not the appropriation of 'low culture' from outside, but the affirmation from within of the materials to hand.[40]

In the art of Mesa-Bains, *domesticana* connects the tradition of the home altar, most often the preserve of the matriarch of the family, with the conventions of contemporary installation practice. In so doing, her work critically links spaces with materials, constituting embodied subjectivity as an ethical, political and aesthetic problem of position:

> Spatial ambiguities and metaphors can function to shake the foundational patriarchy in art through challenging works. *Domesticana* begins to reposition the *Chicana* through the working of feminine space.[41]

In *The Library of Sor Juana Inés de la Cruz*, repositioning the Chicana/Mexicana is explicitly an issue of materialising the processes by which history, memory, art and ritual combine at the interstitial figure of the intellectual woman in/of the border. Sometimes called 'the first feminist of the Americas' or 'the Tenth Muse', Sor Juana Inés de la Cruz was one of the most influential scholars of the seventeenth-century Hispanic world. She wrote poetry and epistolary texts on theological problems, was knowledgeable on the subjects of astronomy, music and the natural sciences and, not inconsequentially, was a nun in New Spain (Mexico). *The Library of Sor Juana Inés de la Cruz* reconfigures Sor Juana's study as an installation/altar in the present, using a constellation of objects, images and texts to explore the Mexicana intellectual as both an historical figure and an important contemporary archetype of *mestiza* self-knowledge. That the 'site' interrogated by this work is the studio/library of a woman, re-imagined in the present at the nexus of the gallery installation and home altar, emphasises again the significance of female subjects occupying those spaces through which intellectual, cultural and artistic authority are forged.

The objects and the space of the installation corporealise this border of past and present, of history and memory, of site and knowledge. The centrepiece of the installation is a large table (the scholar's desk) covered with objects associated with Sor Juana's learned pursuits – musical and scientific instruments, books and writing implements. These share space with typical elements of the *vanitas*, such as a skull, an hourglass and extinguished candles, as well as with contemporary objects akin to *domesticana*: framed photographs, bundles of herbs and small decorative ornaments. Such objects imply the passage of time, its lived experience as history and its record, symbolised in allegories. The globes, pre-Columbian artefacts and the chair emphasise the impact of the past upon the present, politically, materially and conceptually, in the form of the colonisation of the Americas.

In her fascinating discussion of the works of Mesa-Bains as a form of

'autotopography', Jennifer A. Gonzáles argued that these sorts of collections of objects displayed in cabinets, on altars, in *retablos* or *nichos*, can form 'a compendium of symbols and indices that represent personal links to other times, locations and individuals'.[42] Taking this even further, Gonzáles made the following salient point:

> Thus objects and memory are found once again to inhabit the same space – a space that includes not only the latest 'scientific' find, but also a material history, a personal memory, . . . a representation of that which is knowable and indeed, an entire cosmology of relationships, both human and divine. Memory becomes a process of *situating*.[43]

Emphasising the process of situating, rather than the fixity of situation, reiterates the practices through which subjects are embodied, those practices which take place as intercorporeal relationships between bodies, both human and non-human. The richly evocative objects in *The Library of Sor Juana Inés de la Cruz* are a field of such bodies through which the multi-faceted subjectivity of the intellectual, creative Chicana might be glimpsed at the interstices of many layered ideas and meanings. Moreover, these bodies are brought to bear on the diverse bodies of participants within the installation as they move, read, look and are brought into an awareness of their own embodied situation by the work. In this particular sense, I would argue that *The Library of Sor Juana Inés de la Cruz* is an especially significant way of thinking through the implications of both embodiment and situated knowledge as they pertain to women and female agency.

In the wider space of the installation, the table is framed by a number of texts, images and objects which include transcriptions by hand (in Spanish and English) of some of Sor Juana's poetry and framed mirrors, imprinted with, for example, Velasquez's *Rokeby Venus*, the portrait of Sor Juana and saintly female intercessors. These texts and images hearken to yet another risky boundary as they simultaneously inscribe the empowered 'first voice' of the Mexican scholar, while locating her at the epicentre of the visual and ideological structures which render 'woman' a silent object of knowledge (literally, by siting her self-portrait in the central panel of a mirrored triptych whose glass has shattered at her image). It is important to bear in mind that the situation of Sor Juana as an intellectual woman in Golden Age Spain was as a colonial, Catholic woman. While she was able to use her interstitial position to her advantage, becoming a nun rather than marrying, having servants and a slave within the privileged space of her convent, entertaining aristocratic patrons and being published in Spain, these borders also led to her eventual downfall. Toward the end of her life, after a brutal rhetorical battle of words with powerful ecclesiastical enemies over her right, as a woman and nun in a colony requiring missionary zeal rather than intellectual prowess, to forge her independent scholarly life, Sor Juana eventually sold her library, renounced her scholarly pursuits, renewed her vows and died a few years later in 1695.

What is at stake in Mesa-Bains's installation as it sites the boundaries which interpellated the seventeenth-century female knowing subject in her own

Figure 4.3 Amalia Mesa-Bains, *Venus Envy Chapter II: The Harem and Other Enclosures, The Library of Sor Juana Inés de la Cruz*, 1994, Collection: Williams College Museum of Art, Williamstown, Massachusetts; reproduced courtesy of Amalia Mesa-Bains

historical locus and in ours? Sor Juana was not the first historical Chicana/ Mexicana to figure in the work of Mesa-Bains; for example, in her *Grotto of the Virgins* (1987), she made three temporary altars (*ofrertas*), one to Frida Kahlo, one to Dolores del Rio and one to her grandmother. Sor Juana, too, invoked a

litany of women in her famous response to Sor Filotea (her former advocate Manuel Fernández de Santa Cruz, bishop of Puebla), *La Respuesta* (*The Answer*, 1691). The text, designed to justify her right as a woman to pursue and voice her knowledge, strategically located its author as one in a long line of virtuous, yet powerful, vocal and intelligent women; to this end, she included not only the Virgin Mary and Sts Catherine and Paula, but Isis and Hypatia. Neither Sor Juana's litany of women, nor Mesa-Bains's invocation of a female legacy are simple rehearsals of a linear, progressive narrative history. Both are tactical devices designed to situate themselves and other women in positions of authority, by asserting the significance of women's creative agency and intellectual genealogy.

Yet their tactical devices do not, in themselves, define a 'type' of intellectual or creative female subject and, indeed, they develop very different constructs of the articulate woman, specific to their historical moment. That is, for Sor Juana, it was important to argue for women's ability to rise above the limits of sex and ascend to rationality, rhetorical skill and knowledge.[44] By contrast, contemporary Chicana feminists are concerned to address the material locus of difference, so to reassert the significance of embodied perspectives against the privileged abstractions common within Anglo-American theory. Mesa-Bains has herself both asserted the significance of education to a new generation of Chicana activists and reinstated the fact that these ideas must remain relevant and intelligible to the whole of the community, whether they have had the privileges of higher education or not.[45] This contrast of position emphasises that concepts of knowing female subjects are not static, but are processes of negotiation in particular circumstances.

Looking back to Emily Mary Osborn's delineation of the woman-as-artist in *Nameless and Friendless*, and Maria Helena Vieira da Silva's painting, *The Library*, we are confronted with a similar dynamic of intercorporeal process, embodiment and site. In mid-Victorian England, the social and political challenges for access and education made by white, middle-class women helped to construct a particular model of the female knowing subject while in the middle of the twentieth century, the tactile modernism of Vieira da Silva has negotiated the limits of creativity from within a nationalist, masculine-normative climate. None of these works simply produced the *same* trope or image of the intellectual female subject, each engaged with the very conditions of embodiment and creative agency in the visual and material languages of art. Moreover, each took on the risk of materialising the boundary as an intercorporeal exchange and each occupied the critical spaces of art and knowledge – the city, the dealer's shop, the studio, the library, and the gallery – otherwise, to empower female knowing subjects.

This is why I find the dual concepts of embodiment as intercorporeality and situated knowledge as feminist objectivity so compelling. By shifting the idea of the body from object to process, they enable the many and various modes of female creative and intellectual agency to emerge as particular and located, rather than fixed or monolithic. In the varied examples of women's art explored within this chapter, such diversity is both powerful and strategically useful. The intellectual woman is interpellated not as a stereotype, but as a site, as responsible, yet not fixed, as an aesthetics and a mode of knowledge, not abstracted from the world.

5 Performativity: desire and the inscribed body

From the performed to the materialised

In 1930, Claude Cahun published *Aveux non Avenus*, a lengthy collection of diverse texts and photomontages. Taken together, these poetic verses, succinct aphorisms, fragmentary statements and complex images operate as a form of autobiography under erasure, articulating an active, desiring female subject and yet never finally determining 'her'. Transgressing genre borders, as this work does, is a common strategy in women's erotic writing, since established literary forms are not usually conducive to the enunciation of women's desire as positive and particular.[1] Cahun was ideally placed to utilise such a transgressive strategy to interpellate her desiring 'self' between texts, images, body and discourse in *Aveux*, given the wider remit of her artistic practice during the 1920s.

Cahun's literary connections were extensive; many of her middle-class Jewish family were authors, editors or publishers, she worked with a number of Surrealist writers when she moved to Paris in 1922 and was linked to the circle of the salonists Adrienne Monnier and Sylvia Beach, friends of Cahun and her partner Marcel Moore throughout the inter-war years. Additionally, Cahun was involved in experimental theatre in Paris throughout the 1920s, both performing and designing costumes and sets, and she collaborated with Moore in the period to produce an extensive body of unpublished self-portrait photographs, the work for which she has now become best known. Cahun and Moore were also part of the radical left, becoming particularly active during the 1930s and into the war years. They were members of the Association des Écrivains et Artistes Révolutionnaires and later, Contre-Attaque.[2] In 1934, Cahun published a treatise on the role of aesthetics in political life, *Paris Sont Ouverts*, dedicated to Trotsky. Cahun's cross-genre practice and the circles in which she moved are thus intimately connected with her exhaustive focus upon articulating female subjectivity and desire as positive aesthetic and political forces.

Cahun's work did not express a universal or essential woman-ness, but was specific to the leftist, Parisian avant-garde and lesbian underground of her day.[3] As Elizabeth Meese suggested, the 'lesbian self' can best be thought as a process, an interaction between the body and the text or between what she eloquently called 'the literal and the letteral'.[4] Arguably, articulating any mode of desiring

female subjectivity takes place at the interface of the literal and the letteral, bringing together bodies and texts within specific historical formations. Thus Cahun's manoeuvres in *Aveux* were both particular to her situation as an avant-garde artist, writer and performer in Paris in the 1920s and have wider ramifications for exploring the manifestation of women's desire generally.

Aveux non Avenus refuses to fix female subjectivity along the singular axis of sex–gender–sexuality, yet it constructs a powerful and desiring female voice. This fact makes it resonant with contemporary feminist philosophical thinking around performativity. Judith Butler's work on the role of the performative in reconfiguring sex-gender structures is well known, but it is useful here to reiterate her explication of the performative subject:

> Where there is an 'I' who utters or speaks and thereby produces an effect in discourse, there is first a discourse which precedes and enables that 'I' and forms in language the constraining trajectory of its will. Thus there is no 'I' who stands *behind* discourse and executes its volition or will *through* discourse. On the contrary, the 'I' only comes into being through being called, named, interpellated . . .[5]

The 'I' of *Aveux non Avenus* is interpellated as the effect of competing definitions of female subjectivity; in evading final definition, however, the subject is neither demonstrated to be 'behind' language (exercising resistant volition) nor absent altogether (an empty sign, evacuated by all-encompassing discursive power). To think *Aveux* as constitutive of performative subjectivity is not to imagine it to have posited a transhistorical or universal 'woman', but precisely to have articulated a female subject through and within the constraints and conventions specific to its moment. Cahun's call to the recognisable languages of gender, sexuality and aesthetics – from terms popularised by the sexology of her day to the linguistic gestures common amongst her avant-garde colleagues – constituted her as a particular subject while pointing to the limits of the very discursive structures by which she was called forth.

Jeffner Allen's lucid reconception of the subject as 'fiction' rather than 'illusion' is helpful in this context. Allen wrote of 'the body as an event', arguing that occupying fictional positions speaks the subject without implying that there is (or should be) a core truth of body/identity.[6] *Aveux* is constructed through just such useful fictions; it performs self-revelation and then negates it, names and authors its texts and images, later to confound the very authenticity of the name. The title of the volume, for example, can be translated as *Confessions Null and Void*,[7] suggesting the most intimate self-revelation and then cancelling this in impersonal, legalistic tones. Connecting 'confessions', redolent of both the personal case-studies common in sexology of the period and the guilty recitation of sin, to 'null and void', legalistic jargon which threatened to render the confession beyond the 'grid of cultural intelligibility'[8] or outside the frame of social validation, was a complex tactical enunciation of the self as a problem and a process.

Aveux was published under the name of Claude Cahun, which was the

pseudonym Lucie Schwob most used during her lifetime and the name by which she is best known today. It was not her only pseudonym and it was not one created randomly; she also published under the name of Daniel Douglas, in honour of Oscar Wilde's lover, and as Claude Courlis. 'Claude', as many commentators have noted, can be either feminine or masculine in French and thus permits its bearer to shift between gendered pronominal positions. 'Cahun' was a family name which referred to Claude's great-uncle Leon Cahun, an orientalist artist and curator and, as Rosalind Krauss has pointed out, deliberately emphasised her Jewish origins.[9] Cahun's life-long lover Suzanne Malherbe was also better known by her chosen pseudonym, Marcel Moore, 'Marcel' a reference to Cahun's uncle Marcel Schwob, a symbolist writer in the circle of Oscar Wilde. Marcel is also a play with gender, since, written it is masculine, yet spoken could be feminine. Not surprisingly, the initial letters of both women's pseudonyms are alliterative doubles.

Cahun and Moore took the project of self-naming seriously, multiply citing historical and literary precedents while exposing the fragile grammatical connections between sex and gender. This performative naming was exacerbated further by *Aveux*'s collaborative authorship. If Cahun's identity and authority were vexed by her pseudonym and shifting textual voice, the attribution of the visual elements of the work to Moore (whose name appears on the first photomontage without explanation), 'after ideas from the author', constitutes another problem of naming and authenticity. In these collaborative textual/visual pages, any autobiographical certitude collapses as the 'author' posits the ideas, figures in many of the fragmentary images, but does not become the executor or signatory of the work. These name games countered the construction of an authentic self, yet they did so in terms which were easily legible to their contemporaries. Performative language relies upon citation and reiteration, taking its power from historical precedents rather than universal axioms.

Indeed, the contingency of history is crucial to the politics of performativity and has determined its theoretical trajectory. It is significant that performativity's potential to destabilise sex-gender structures was first demonstrated in lesbian feminism and queer theory as scholars worked to refute historical and theoretical constructions of homosexuality as wilful perversion, biological error or psychological deviance. The theory both critiques oppressive histories, exposing their repetitive attempts to stabilise the gender–sex axis, and carries with it a pervasive political valence derived from its own history. While I am not seeking to define a lesbian or queer aesthetic in this chapter, neither do I wish to occlude the political imperatives which underlie any question of desire, aesthetics and female subjectivity. Nor do I wish to forget that explorations of these questions are historically located; the naturalisation of the heterosexual norm as a function of the sex–gender axis (male/masculine therefore object-choice 'woman') is the effect of historical processes which labelled, limited and defined bodies, desires and identities. As Elizabeth Grosz wrote:

> My problem is how to conceive of desire. Particularly, how to think desire as a 'proper' province of women. The most acute way in which this question

can be formulated is to ask: How to conceive lesbian desire given that it is the preeminent and most unambiguous exemplar of *women's* desire (for other women)?[10]

To conceive women's desire is to explore the interface of the body and discourse, acknowledging that desire acts as a process between sensuality and sentience, well beyond the limits of normative heterosexist descriptions of 'woman' as the mute object *of* (masculine) desire. This move from object to process is also a critical component of Butler's work on materialisation – which asserts that bodies *matter* and that materiality is significant to meaning:

> To speak . . . of *bodies that matter* is not an idle pun, for to be material means to materialize, where the principle of that materialization is precisely what 'matters' about that body, its very intelligibility. In this sense, to know the significance of something is to know how and why it matters, where 'to matter' means at once 'to materialize' and 'to mean'.[11]

If we are to take seriously this move from matter (as a mute object upon which subjects act) to materialisation (as the process of bringing forth meaningful materiality), then we are obliged to go beyond abstract, universal modes of thinking subjectivity toward experimental practices which articulate the subject in the fullness of its desiring, embodied and sentient agency. Given the potential which performativity and materialisation have to enable explorations of female subjectivity and desire as positive and productive forces, the shift from object to process seems imperative. I would argue further that materialisation has an intimate connection with, and powerful ramifications for, feminist aesthetics and women's art.

Concepts of materialisation do not simply act as interpretive frames by which art might be 'explained' more effectively, nor do artworks merely provide useful 'illustrations' by which complex theories might be made more accessible. It is within the realm of the visual and material arts that the articulation of desire at the interface of body and discourse, the connections between the senses, the sensual and the sentient, the reconfiguration of corporeality beyond the logic of the subject-object divide and the critical recast of representation find their most acute and attenuated form. Art practices not only demonstrate what materialisation can offer in thinking female subjectivity, they have the potential to actualise and extend the theoretical frame itself by direct confrontation with matter, meaning and desire.

I want to argue for one further connection between 'materialisation' and 'materialism' at this point, since the uses of performativity, as a conceptual structure, often move toward idealism or abstract, apolitical theorising. Gen Doy has been particularly critical of this tendency, and her comments on the performative readings of Cahun are instructive:

> In terms of disguise, masquerade and performance, Cahun's self-portraiture does not reiterate the performance of 'the feminine' in order to conceal what

is unconscious and opaque, thereby preserving the façade of gender stability. Her self-portraits, on the contrary, continually reinvent Cahun, in collaboration with Moore, as a multi-faceted subject in control of her own image, desired by her collaborator, yet not phallicized/fetishized.[12]

I agree that these works do not perform 'the feminine', reinstate gender stability or fetishize Cahun; indeed, what is suggestive about performativity and materialisation is the fact that difference emerges in and through repetition/reiteration. In what follows, I am not suggesting that materialisations are disconnected from matter (bodies), materials (art), materialism (the locus of social and historical conditions) or mattering (making meaning). Instead, I am taking materialisations as located and concrete negotiations of difference in repetition which have significant effects for subjects in the world, particularly for those subjects whose positions are not performed by the dominant patterns of (re-)iteration.

It is here that the visual elements of *Aveux non Avenus*, the ten photomontages produced by Cahun and Moore, come into their own. These montages (each of which acts as a frontispiece to a section of the text), are an integral part of the volume as a whole and participate in the production of the shifting signs woman/lesbian/artist. What concerns me here, however, is not just identifying the visual signs and symbols which Cahun/Moore cited (and re-cited) in the images – such as the mirror, the eye/I and the mask – but exploring how these signs and symbols were configured to materialise resisting desire in the particular context of European modernism in the inter-war years. In this sense, I am interested less in how art forms 'objects' and more in the ways aesthetics might instigate processes; processes which, while situated within very particular frames of meaning historically, might also expand our contemporary perspectives on sexed subjectivity.

Examining Cahun's deployment of the self-portrait is a useful way of working through some of these ideas. From the mid-1920s until Cahun's death in 1954, she and Moore collaborated to produce an extraordinary body of photographic 'self-portraits', featuring Cahun costumed and posed in a wide array of disguises and settings, some drawn from her work in theatre, others more explicitly engaged with cross-gender masquerade.[13] During Cahun's lifetime, the photographic portraits were not shown or published in their own right, but they did circulate privately and were known within the salon and theatre circles in which Cahun and Moore moved.[14] Cahun also began her project *Heroines* in the 1920s, publishing a few sections in 1925 and circulating others privately. *Heroines* consisted of a series of short, fictional, 'biographies' of powerful women from myth and history – specifically women who were seen to have rejected passivity and patriarchal order in their sexual or political exploits, such as Sappho, Judith, Eve and Delilah.[15] The repeated stagings of the 'self' in the Cahun/Moore photographs operated in the same way as the textual play with historical and biographical 'fact' in *Heroines* – they performed falsehood as the very premise of coming into visibility. In this way, they established a visual and material grammar of 'imitation', or the strategic occupation of the counterfeit, as an aesthetic

experiment with identity. This experiment required repetitious, collaborative production and the relative safety of a private network of like-minded friends to survive and develop to the point of *Aveux*.[16]

Since the portraits made in the 1920s were not so much objects in themselves as a grammar of 'self', it is not surprising that they reappeared, reconfigured by the processes of montage, in *Aveux non Avenus*. The Cahun/Moore montages used photographic material, snippets of typed or printed text, hand-written fragments and drawn images as part of a graphemic aesthetic, one which mobilised the interface between writing and drawing, the machinic and the gestural.[17] Using this mode of graphemic photomontage emphasised the conceptual structure of the Cahun/Moore images by undermining the association of photography and print with the 'real' through strategic recontextualisation. The Cahun/Moore works did not formulate an aesthetic of self-revelation, premised upon an underlying truth, but an aesthetic of the self as staged, mediated, composed and composing – like photomontage itself. Such an aesthetic had much in common with feminist responses to sexology in the 1920s.

By the time *Aveux* was produced, Cahun had written numerous articles on the question of female sexuality, including a translation of Havelock Ellis, a defence of individual sexual freedom for both homosexuals and heterosexuals (in the radical gay journal *Amitié*) and an article concerning the homophobic trial of Maud Allan for her performance of Wilde's *Salome* in 1918.[18] Cahun's own sympathies lay with concepts of a radical sex–gender continuum, in which there was no absolute male or female, masculine or feminine, nor could there be any fixed relationship between sex and gender determination. These were not unique positions to hold and variations of these ideas circulated widely, especially within the European avant-garde in the period, exemplified by journals such as *Urania*.[19] Women artists frequently explored the visual and textual possibilities of sex–gender fluidity – from the famous transhistorical gender-crossings of Virginia Woolf's *Orlando*, to the images of Berlin's underground lesbian scene produced by Jeanne Mammen in the 1920s.

The montages in *Aveux* materialised the fluidity of female desire in and through specific visual structures which confronted the subject/object divide. For instance, the second montage from *Aveux* becomes meaningful through counterpoints of looking, reflecting and imaging.[20] Fragments from the 'self-portrait' photographs establish both Cahun's look and her 'looked-at-ness';[21] within the fragments, the artist's gaze is directed outward, toward the viewer, yet her likeness is set within mirrors and eyes. The visual constitution of the 'other' as 'object' is both imaged and re-imaged by this montage – the mirror does not adequately 'reflect' or capture the body it seeks to reveal and the eye holds its subject inverted, as if in the lens of a camera. And of course, the first eye to see Cahun's self-stagings was that of her lover Moore, looking through the camera lens. The drawn eye thus replicates this first materialising look, calling forth the subject through an exchange of desire, vision and agency between women. Titled 'Moi-même', this second montage could be read as 'myself' or 'self-same'; the collaborative interchange between Cahun and Moore (to whom Cahun

Figure 5.1 Claude Cahun and Marcel Moore, *'Moi-même'*, Montage II, from *Aveux non Avenus*, 1930, Éditions du Carrefour, Paris

tantalisingly referred as 'the other me') implies an intimate intersubjectivity, a desirous interpellation of selves through visual and material forms. The montages are executed by Moore, after Cahun, photographed by Moore, directed by Cahun. Whose self-portrait are we seeing – who is myself and who self-same? Reconceiving the act of looking in this way materialised desire as an aesthetic force able to destabilise the sharp boundary between the subject and the object.

Montage IX in *Aveux, N.O.N.*, exacerbated the self-portrait form even further, materialising the body beyond the conventional limits of mimetic representation and the frame. The piece is comprised almost wholly from two 'self-portrait' photographs, multiplied, reversed and overlaid as a fascinating composite portrait. This 'portrait', however, uses conventional visual codes against themselves, revealing their instability while materialising a subject against the grain. For example, the multiplication of the portrait fragments does not reinforce a central or unified 'I' through repetition, but rather heightens difference and dissonance so to disperse the subject. Where the work sets up the expectation of mimetic representation or mirroring, such as at the central, horizontal 'fold', the body fragments do not match or replicate, but diversify, engendering their subject as an effect of visual construction rather than an object captured by it.

Similarly, there is a significant break with the logic of the frame in this montage. Framing, of course, is a divisive visual mechanism by which the privilege of the subject over the object is maintained. Moreover, the conventional power of the frame has an intimate connection with the history of the female nude, objectified as the marker of sexual difference and the very cipher of western fine art.[22] *N.O.N.* challenges the frame, refusing its capacity to divide inside from outside, object from subject, in any final way. In this montage, the most dispersed and fragmented portrait elements reside within the rectangular 'frame' while the most legible, 'complete' photograph of Cahun's body breaks the frame, residing neither inside nor outside its limits. That Cahun's body breaks the frame interpellates her otherwise; the montage acts as a complex deception, repeating without reiteration, defying mimesis and the frame and materialising desiring female subjectivity as integral to its visual strategies.

Inside/outside

While the Cahun/Moore photomontages extended performative female subjectivity and desire into the visual/material languages of avant-garde modernism, they did not form a model of ideal art practice. Materialisation has no ideal model – each instance is particular. Women artists addressing desire as a positive visual and material force may perform female subjectivity against prevailing masculine norms, but each performance will be specific and different.

Examining differences within the work of one artist makes this point clear. Two photographic projects, separated by some twelve years, were undertaken by Rosy Martin specifically to address female desire and sexuality beyond externally-imposed and debilitating stereotypes of passivity, objectification and/or deviance. Significantly, in each set of photographs an encounter between the letteral and

Figure 5.2 Claude Cahun and Marcel Moore, 'N.O.N.', Montage IX, from *Aveux non Avenus*, 1930, Éditions du Carrefour, Paris

the literal was staged as a direct confrontation between texts and the body of the artist. Yet in these projects, the body matters very differently, developing a complex political and philosophical interaction between inside and out through an aesthetic modulation between interior and exterior.

In 1988, Martin produced (with Jo Spence) the two-image phototherapy work entitled *Unwind the Lies that Bind*. The visuals are relatively straightforward; the first image in the series shows Martin's body and face bound by bandages on which words such as 'pervert', 'predator', 'evil', 'disease' and 'dyke' are written and the second image sees the artist breaking free of her text-laden bondage, like a chrysalis emerging from a cocoon.[23] As a pair, they were produced in response to Martin's coming out to her mother and the homophobic legislation passed by Thatcherite conservatives under the heading of Clause 28.[24] *Unwind the Lies that Bind* has subsequently been shown and reproduced widely,[25] and its definitive narrative, combined with legible and emotive visuals, make it an accessible and evocative representation of the personal as political.

'Coming out' offers both potential empowerment and further ghettoisation; its immense individual and political significance for many gay men and lesbians is a function of its dangerous transgression of the boundary between inside and outside.[26] Coming out demonstrates what Eve Kosofsky Sedgwick has famously called the 'epistemology of the closet', which, in an important sense, describes an exclusionary theoretical border between those 'in' and those 'out'.[27] Performing the self as 'out' can thus reinforce the privileged status of the heterosexual/homosexual binary as a 'natural' or authentic locus of identity even as it interpellates a resistant and alternative subject. Neither Sedgwick nor any of the theorists who have described the dangers of the inside/outside paradigm suggest that the route through these treacherous waters resides in forceful self-deception ('there is no problem') or in resigned acceptance of invisibility, marginality or oppression. Rather, the task is to steer a course between invisibility and fixed definition ('in' or 'out' once and for all), engaging in what Tamsin Wilton called 'the necessary fiction' of naming.[28]

Unwind the Lies that Bind steers this course, powerfully rejecting the names which defined lesbian sexuality negatively, without simply replacing these with a new, 'positive' set. *Unwind* thus keeps the future open to change and development, signifying lesbian desire as a perpetual process and, moreover, one which remains responsive to changes in the historical conditions in which lesbians live. In materialising desire at the locus of body and text, however, its path is more precarious. There is a sense in which *Unwind* could be seen to posit a 'real' or natural body as the antithesis to oppressive external discourses – visually, the narrative liberates the body which lies intact beneath the languages which confine it.[29] And while that liberating visual is empowering for many viewers, it can reinforce an ontological conception of the body as an origin point for the truth of the subject beyond discourse.

I would argue, however, that this ontology is complicated by the wider mechanisms which structured phototherapy and its circulation. As a collaborative, therapeutic practice, phototherapy provides a safe space for subjects to

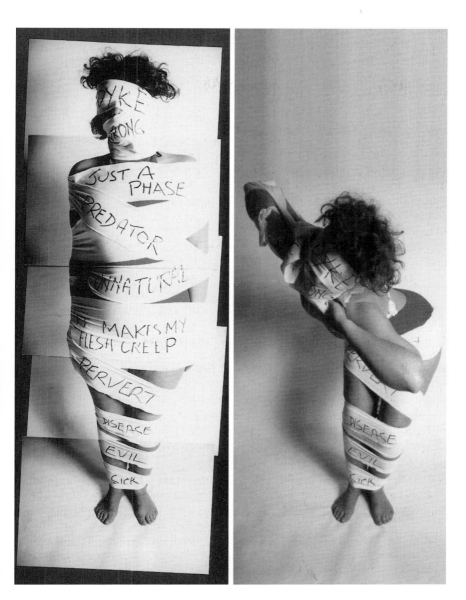

Figure 5.3 Rosy Martin (with Jo Spence), *Unwind the Lies that Bind*, 1988, courtesy of Rosy Martin

experiment with staging themselves within and through competing visual tropes.[30] In other words, phototherapy is premised upon the power of visual images to construct, not reveal, their subjects and viewers aware of phototherapy come to *Unwind* already questioning any form of biological essentialism. The phototherapeutic experience is premised upon a relationship between subjects, discourses and the historical conditions through which they come to make and interpret their images. Additionally, phototherapy is dialogic, a communicative process undertaken between the therapist and analysand and, in the rare instances where phototherapy images are published or exhibited, they circulate in association with contextual information. By definition then, phototherapy interpellates a speaking subject, rather than a mute object.

Attending to the circulation of visual and material practices is important in understanding them as performative processes. What might in one space act to objectify the body can, in another frame, articulate its difference eloquently. This is why I am interested in looking at a later project by Martin in which imaged bodies and textual definitions of sexuality collide, but in a very different way. A series of ten black and white photographs of bodily fragments, illuminated by texts projected on their surfaces, formed one part of the collaborative installation *Outrageous Agers* which Martin developed with Kay Goodridge during 1999– 2000. *Outrageous Agers* used photography and video to explore the processes, and explode the myths, surrounding female sexuality and aging. The remit of *Outrageous Agers* was far more encompassing than the direct expression of 'coming out' in *Unwind*. Taken together, however, the two projects suggest significant, yet very different, materialisations of Martin's embodied, desiring agency over time. They demonstrate that desire acts as a mutable force and that performing female subjectivity is more about what bodies can *do*, than what they might *be*.

Like the earlier work, the scripted body series from *Outrageous Agers* calls the boundary between inside and outside into question by interrogating the interface of body and text in visual and material form. However, the later series sets up a repetitive visual relay across and between ten images, rather than a directed narrative progression from one to the next, and the fragments of the bodies imaged do not lend themselves to any straightforward visual reconstruction of the whole. The voices of the texts are similarly multiple, from excruciating definitions of women's aging ('The vagina begins to shrivel, the breasts atrophy . . . gradual baldness completes the tragic picture'[31]) to the empowering language of the manifesto ('The real threat posed by older women in a patriarchal society may be . . . sharp judgement . . . which pierces male myths and scrutinises male motives . . .'[32]). The texts neither construct a singular nor wholly negative discursive field which must be rejected for the body to be liberated. On the contrary, the multiple exchanges between the voices in these texts and the bodies they materialise, make it clear that inside and outside are not adequate terminology by which to think this textual/bodily interface or, echoing Elizabeth Meese, that 'language is like a skin, both on the side of the body and out-side the body, between the body and the world, but also of the body, in the world'.[33]

Martin's series enacts this skin in particularly visual, aesthetic formulations,

materialising the bodies and the texts as the effect of light and shadow. The skin's surface is the very premise of visibility for the text and the bodies emerge in the works through their scription. Each is interpellated, indeed, made to matter, at their point and process of contact. Moreover, their materialisation is particular to the photographic process itself which draws/writes with light. These photographs are not *of* objects, but are the condition by which this text/body exchange can take place. As viewers, we are invited to engage actively with this materialisation, working to read the bodies, envisage the texts and make their interface meaningful. For example, the seventh photograph of the series casts a text by Elizabeth Grosz across the undulating surface of a woman's torso – we see/read each as a function of the other, the contours of the body reframing the very shape of the text. I would argue that this powerful aesthetic performance of the text makes its meaning more fully material and sensually viable than any printed version could: 'The body . . . as a site of social, political, cultural and geographical inscriptions . . . is itself a cultural, *the* cultural product.'[34] As these words describe and inscribe the sensual surface of a woman's skin, literally and letterally, they materialise female desire and subjectivity as embodied, sentient knowledge.

Grosz is a key reference point for Martin's project, since she has examined the concept of the inscribed body in great detail in her work, arguing that no inscribed surface is neutral and no two acts of inscription can ever be identical. *Outrageous Agers* extends this insight and, additionally, demonstrates that the locus of body and text might be troubled and resisting. The third photograph of the series voices alterity as a critical dislocation between visual citation and text. These are Sigmund Freud's words on post-menopausal women transforming from 'charming girl, . . . loving wife and tender mother', to 'quarrelsome, vexatious and overbearing, petty and stingy' after they have 'lost their genital function'.[35] This text materialises a body which defies it by being a voluptuous, but resisting nude; in a pose reminiscent of the famous *Venus pudica*, the hand by the pubis is a fist.[36] It is also the body of an older woman, strong, beautiful and sensuous and it towers over us. The changes wrought over time have not placed this body beyond what the text describes as women's 'period of womanliness', but begin a challenging process of re-defining what empowered 'womanliness' can mean.

Outrageous Agers treated the body as an aesthetic project in order to articulate female desire as a creative process which continues throughout women's lives. In this way, Martin's work bears a marked similarity with Joanna Frueh's development of the concept of *monster/beauty* as aesthetic/erotic self-development and materialisation – a practice and not a thing. Her words take us toward a reconception of the erotic, which will occupy me for the rest of this chapter:

> Monster/beauty eroticizes the midlife female body, develops love between women, embraces without degrading or aggrandizing bodies that differ from one's own in age, race, sex and shape. Monster/beauty is artifice, pleasure/ discipline, cultural invention, and it is extravagant and generous . . .[37]

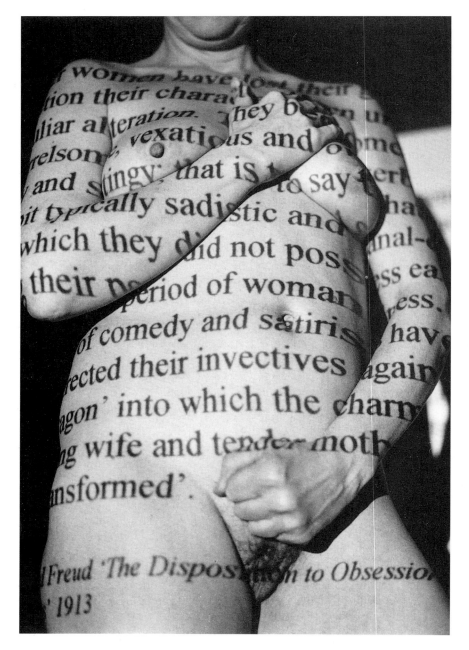

Figure 5.4 Rosy Martin (with Kay Goodridge) *Outrageous Agers*, 2000, courtesy of Rosy Martin and Kay Goodridge

Erotic surfaces

It is clear that when Frueh explores the terms of the erotic, she does not simply refer to genital sexuality, but to the whole range of embodied pleasures, powers and desires through which subjects are materialised in their full sentience. Hence Frueh connects the reconceived erotic to aesthetics, thinking bodies and subjects as mobile projects.

Not surprisingly, *Monster/Beauty* made explicit its relationship with the groundbreaking work of Audre Lorde on the erotic.[38] Lorde's work acknowledged pleasure and desire as significant elements within the whole range of women's creative and affective lives, and refused to limit women's involvement in the erotic to their negative role as objects of masculine desire. Indeed, Lorde both uncoupled the erotic/desire from any form of objectification, calling it the 'life force of women', and conceived it as a mode of coextensive difference, rather than assimilation.

Thinking desire as positive, beyond the satisfaction of lack, enables a very new logic of the erotic and alterity to emerge – one which has had radical implications for feminism. Specifically, it explores desire as a multifaceted force working at the level of 'surfaces and intensities', making connections across differences and moving beyond the binary of subject and object. Elizabeth Grosz suggested:

> . . . a model or framework in which sexual relations are contiguous with and a part of other relations – the relations of the writer to pen and paper, the body-builder to weights, the bureaucrat to files. . . . sexuality and desire are part of the intensity and passion of life itself.[39]

Such a statement emphasises the significance of sexuality and desire to the formation and articulation of subjectivity, but neither suggests it is an immutable, foundational truth of the subject nor that it can be limited to sexual acts, *per se*. As a creative and sensual force, desire is intimately linked to aesthetics; explorations of the erotic as power in women's art pose fascinating questions of materialisation, subjectivity and the dissolution of the opposition between surface and depth.

Cathy de Monchaux's sculptural installations are related intimately to the body and especially to notions of the erotic, the sexual and the seductive. Clearly, her work appeals to viewers in a direct and corporeal way – the supple leather materials she folds, twists, stitches and girdles into forms reminiscent of, yet not identical with, limbs and organs, call to the flesh of her audience. De Monchaux recognises and has spoken of the corporeality of her work, but, even more interestingly, she frequently characterises the practice as a linguistic construction: '[the work] builds up a kind of vocabulary . . .', 'the syntax that has been built up to that point . . .', 'a body of work that is like the build up of a narrative . . .'[40] In this suggestive conceptual conjunction between flesh and word the interface of body and text is again the nexus of desire. Yet neither 'body' nor 'text' are literalised by de Monchaux's practice, allowing the works to materialise the body/text

exchange, difference, desire and the erotic without representing them. We are invited into the intersubjective process between sense and sensuality as they materialise in this work. Indeed, I would argue further that its specific combinations of visual, material and spatial strategies perform subjectivity as an emergence through and in flesh, desire and difference.

Visually, de Monchaux's installations play with repetition and difference in ways which are not representational, but excessive in their effects. The bodily texts of bliss described so compellingly by Roland Barthes in *The Pleasure of the Text* are a useful way of thinking the flesh-words de Monchaux inscribes.[41] In one particular passage, Barthes characterised two excessive modes of erotic word play – repetition (which does not represent) and the single word which 'glistens'.[42] These are the very excessive pleasures which de Monchaux's installations materialise; *Cruising Disaster* from 1996, for example, is an extraordinary collection of near-replicas placed one after the other in a long repetitive sequence, while *Evidently Not* (1995) is absolutely singular – glistening. The effect of these repetitive and singular gestures is not to yield a meaning, but to write the body of bliss as more than a textual premise.

Works such as *Cruising Disaster* and *Evidently Not* call attention to their surfaces physically, through overall patterning, contrasts of shine and matt finish and the powder which clings to their 'skin'. Combined with their staging in patterns and singular marks, de Monchaux's works challenge the logic of surface/depth as traditionally conceived in western fine art. The conventions of this binary are premised upon the ability of the surface to reveal depth – both spatially, through linear perspective, and theoretically, by moving beyond the mere face of a work toward its underlying truth.[43] Countering this paradigm has had radical implications for artists over the past century, not least in terms of rethinking the relationship between visuality and truth; significantly, the move to the surface has been seen as a loss of stability and certitude at the same time that it has opened the potential of representation to marginal subjects.[44]

In thinking the body, flesh and desire, attention to the surface has equally powerful ramifications. Once art is released from its duty to reveal the truth of a unified 'I' residing beneath the veil of surface appearance, it can assume the freedom to move fluidly across such surfaces, articulating the changing dynamics of an ever-mobile subjectivity. The body/text interface becomes a process of materialising the erotic, rather than an inscription *of* desire *on* the body. Alphonso Lingis took this turn in his work on the tattooing and scarification practices of tribal cultures, refuting the conventional assumption that the tattoos and scars mapped the interior significance of the body on its surface, and instead arguing that the processes of tattooing and scarring produced the body itself as the mapping of fluid erotogenic intensities.[45] There is here no underlying depth or truth of the desiring subject being expressed on its surface, just the power of the surface and its valences, attractions and repulsions. This is the power of de Monchaux's erotic as it visually materialises across the attenuated surfaces of her pieces, sometimes repeating, sometimes holding us enthralled within a single word of flesh.

If de Monchaux's installations set up a visual relay across and between the

Figure 5.5 Cathy de Monchaux, *Cruising Disaster*, 1996, courtesy of Cathy de Monchaux

Figure 5.6 Cathy de Monchaux, *Evidently Not*, 1995, courtesy of Cathy de Monchaux

surfaces of works, so too do they enact a modulation between vision and the other senses in their materiality. *Evidently Not* epitomises this; at once a highly complex visual pattern and an extraordinarily tactile object, the work confounds simple distinctions between two- and three-dimensionality, images and 'things', interpellating us as fully sentient participants rather than distanced viewers. Such a call to the senses complicates our involvement with the work, materialising intersubjectivity as the very locus of the erotic. Our empowered subject status is destabilised as the 'objects' of our desire compose, decompose and recompose across sense-boundaries and spaces. We are called forth as subjects-in-process within this modulated sphere of difference, and, to paraphrase Merleau-Ponty, it is our dynamic body spatiality itself which yields a meaningful world.

Given the intimate connection between the bodies of participants and the flesh/word of the works themselves, it is hardly surprising that de Monchaux considers the scale and movement of bodies when she installs her shows.[46] But her spaces are more than just well-orchestrated places in which to hang the work; arguably, de Monchaux's installations materialise what Emmanuel Levinas termed 'voluptuous' spaces, or what Luce Irigaray referred to as 'porosity'.[47] De Monchaux's work writes the body's bliss as a surface-intensive space in which we are involved, interpellated as desiring subjects, without any absolute direction. That is, we participate in the play of attractions and repulsions, the materialisation of flesh and the erotic, without having any absolute objects/others to whom we direct our desire in search of a definitive outcome, resolution or assimilation. This is a non-teleological space, following Levinas, a place in which we experience the voluptuousness of absolute otherness without any intention. Moreover, the undecidability of the 'others' with which we connect in de Monchaux's aesthetic nexus, makes it impossible to assimilate them – their difference is part of the surface modulation of desire and pleasure itself.

Lingis wrote of the erotic and flesh: '. . . the carnal itself appears in the equivocation of vulnerability and exorbitant materiality, and it has become formless, non-functional, uninformative by excess'.[48] This does not make it unproductive or inconsequential in relation to subjectivity. If de Monchaux's installations materialise the erotic such that it flows across fixed boundaries of subject and object, masculine and feminine, then its intensities can mobilise difference and desire as constitutive of the subject-in-process, rather than as the limit of the subject-as-object. Interestingly, in a different context, Krauss recognised the 'formless' as a crucial component of self-articulation in the work of Claude Cahun as she engaged otherwise with surrealism:

> Cahun's deconstructive stance on the position of the subject is continuous with the subjective *blurring* I have been attributing to much of surrealist production and discussing under the concepts of 'formless', 'alteration' or 'declassing'.[49]

That Cahun's articulation of her 'self' as a desiring female subject should deconstruct stable, unified constructions of subjectivity, blurring boundaries and

intensifying pleasures across the surfaces of her texts and montages does not simply render her work the same as that of de Monchaux or Martin. Their very different performances of desire and aesthetics across the text/body interface articulated specific subjects and particular loci of the erotic. Materialisations occur at the interfaces of very different material conditions, use varied material strategies and matter in many diverse ways. Yet, their resonances are audible – these visual and material enunciations of female subjectivity demonstrate the intimate relationship between aesthetics and desire as they mobilise alterity and articulate difference across a wide range of forms.

6 Becoming: individuals, collectives and wondrous machines

Flower painters and feminist figurations

In 1699, Maria Sybilla Merian travelled from Amsterdam to the Dutch colony of Surinam. Over the course of the next two years, Merian studied the insects native to the region and, with the help of her younger daughter Dorothea Maria, documented their growth, metamorphosis and environmental constraints in detailed drawings and watercolours. Merian's images and notes, taken from careful observation and discussion with the local population, formed the basis of her volume *Metamorphosis insectorum surinamensium*, published in 1705 in Amsterdam. This work confirmed Merian's reputation as an artist-entomologist throughout Europe; the expensive volume sold well among scientists and collectors, its images and text were cited extensively by Carl von Linné [Linnaeus] in his work on naming species, and nearly two hundred of her original illustrations were purchased by Peter the Great for his collections.[1]

Metamorphosis was not Merian's first illustrated publication or her first foray into the natural sciences. Born into a family of artists in 1647, she trained as a flower painter, first with her step-father, Jacob Marrel, and later, with his student Abraham Mignon. Although being a woman excluded her from the guilds in both Frankfurt and Nuremburg, Merian produced extraordinary images of local flora and fauna, eventually publishing two well-received folios: the three-volume pattern-book *Neues Blumenbuch* in 1675 and *Der Raupen wunderbare Verwandelung und sonderbare Blumennahrung [The Wonderful Transformation of Caterpillars and their Singular Plant Nourishment]* in 1679. For *Der Raupen*, Merian collected and bred the insects she depicted and included detailed texts describing the processes of metamorphosis shown in each image.

The intimate relationship Merian developed between art and science in her work underlines the importance of the visual arts within the wider contexts of commerce, trade and colonial expansion in the early modern period. Scientific experimentation flourished throughout Europe in Merian's day and Merian herself prepared specimens, used magnifying glasses and bell-jars, referred to the work of other entomologists such as Jan Swammerdam and Johannes Goedaert and consulted material in the famous collections of Cornelius van Sommelsdijk and Frederick Ruysch. Merian's letters too, reveal her awareness of the

commercial value of her painting and prints and of the new plants, animals and commodities which flooded the markets in Northern Europe during the seventeenth century. Indeed, the success of the *Blumenbuch* was based on the wide appeal of detailed floral images to scientists, artists and connoisseurs alike.

The Surinam project lets us glimpse the complex networks women artists could develop within this vibrant visual culture. Although Merian had seen specimens of plants and animals from India and the Americas before the 1680s, her interest in species particular to Surinam was aroused when she joined a Labadist community in West Friesland between 1685 and 1690.[2] The Castle of Waltha in Wieuwerd, where Merian, her step-brother, mother and daughters lived with the Labadists, was owned by the Sommelsdijks, a powerful Netherlandish family with interests in the Dutch West Indies – Cornelius van Sommelsdijk became a Governor of Surinam in 1683 and the Labadists founded a community there shortly after. Without speculating on Merian's religious convictions,[3] it is clear that her time with the Labadists provided her with opportunities necessary for the eventual production of *Metamorphosis*, since at Waltha, Merian studied the Surinam material in the cabinet of curiosities, separated from her husband (by appealing to the Labadists' dictum that only marriages between believers were valid) and made contact, through the Sommelsdijks, with scientists and collectors in Amsterdam who became her patrons. In 1690–1, she left West Friesland with her younger daughter and settled in Amsterdam as an independent artist-scientist.

Arguably, Merian's two most important supporters in Amsterdam were Caspar Commelijn, the Director of the Amsterdam Botanical Garden who later provided Latin names for many of the plants in *Metamorphosis*, and Frederick Ruysch, the most influential figure in the medical and scientific circles of northern Europe in the period. Ruysch's connections were voluminous; he was Praelector of the Amsterdam Surgeons Guild, Doctor to the Court and held a host of other official positions as a scientist during his lifetime. Moreover, he was internationally famous for his public anatomical dissections, his inventions in embalming, his interventions into midwifery and obstetrics and, not least, his astounding *Wunderkammer*.

Ruysch's cabinet was actually a whole property in Amsterdam, filled with books, objects, instruments and, most notably, a wide array of embalmed animals and humans (the human specimens were mainly children or miscarried foetuses). Many of these were displayed in complex 'still-life' *tableaux*, consisting of allegorical arrangements of the bodies and body parts with bits of drapery, beads and text, meant to encourage spectators to contemplate mortality.[4] From at least the 1680s, Ruysch was assisted in his *Wunderkammer* by his eldest daughter Rachel who prepared specimens, sewed ornaments for the embalmed bodies, participated in the final composition of the twelve *tableaux* and taught her father to draw. The ability to depict specimens should not be underestimated; published images were a crucial means of disseminating scientific knowledge throughout Europe in the period and Rachel's contribution to this facet of Frederick's practice was quite valuable. She also worked with her father on the reorganisation of his cabinet at the end of the decade, was one of the first artists to make extensive

use of the specimens in the Botanical Gardens within her own painting practice and met Maria Sybilla Merian when she arrived in Amsterdam.

If Ruysch was well connected to the scientific circles of the city on her father's side, on her mother's, she was equally well affiliated with artists and architects. Ruysch's mother was from the Post family; her grandfather was Pieter Post, architect to the Dutch stadholder and her great uncle was Frans Post, the landscape artist now best known for his paintings of Brazil, undertaken as part of a government-sponsored trip to gather information about its colonies. As a young woman, Ruysch trained with the flower painter Willem van Aelst, eventually entering the Guild in the Hague and rising to the post of Court Painter to Johann Wilhelm, the Elector Palatine in Dusseldorf. The fact that Rachel Ruysch became one of the most celebrated still-life painters of the eighteenth century and, like Merian, worked at the interstices of science and art throughout her career, is not a mere coincidence.

Like many artists of their time,[5] Merian and Ruysch drew upon the complex exchanges between science, art, European colonial expansion and bourgeois mercantilism to make innovative visual work. In the longer-term however, their work was divorced from these multifaceted contexts to their detriment. As standards for scientific imaging became more rigidly defined, Merian was marginalised as a curiosity – a female entomologist and traveller whose science was too artistic. Yet her work was equally anomalous within the conventions of floral still-life painting, focused upon allegory, and she came to be seen as that strange breed, the 'exceptional' woman.[6]

By contrast, Ruysch's reputation reached a high point in the latter half of the eighteenth century, despite the fact that her work was also disconnected from her extensive knowledge of the natural sciences. In an excellent exploration of the scientific roots of Ruysch's early work, Marianne Berardi argued that this separation was manifest first in the biography of Ruysch published by Jan van Gool in *The New Theatre of Dutch Painters* in 1750. In his biography, van Gool makes no mention of Ruysch's father or her detailed work within his cabinet and in the scientific institutions of her day. As a prestigious biography and a major primary source for later Ruysch scholarship, van Gool's text presaged the eventual separation of the artist's flower painting from scientific discourse.[7]

The separation of the work of these women artists from developments in the natural sciences poses in striking form what Sandra Harding called 'the science question in feminism' or, more specifically, what Evelyn Fox Keller described as the problematic of the 'science–gender system'.[8] As the sciences came to prominence over the course of the seventeenth and eighteenth centuries, they were increasingly conceived and expounded as universal, objective and rational discourses. This tended to place them in opposition to what were seen as subjective, irrational forms of imagination, from poetry to the fine arts. More insidiously, scientific epistemologies, premised upon gender-neutral, universal and disinterested modes of observation, occluded their masculine, ethnocentric interests within their own structural logic. To put it simply, there was no way that women

painting flowers and insects could be conceived as engaging in a valid scientific pursuit – yet clearly they were.

The work of Merian and Ruysch was produced at that moment of historical transition which disconnected the arts from the sciences, privileging 'culture' over 'nature', rationality over intuition and, by extension, the masculine over the feminine. Hence, relocating the work of Merian and Ruysch within their complex historical trajectory not only reiterates the importance of women as agents of cultural change at that time, but provides a mechanism by which we might begin to reposition female subjectivity as a mode of connective making and thinking against the grain. To examine this mechanism more closely, it is necessary to draw together a number of disparate strands of thinking on the relationships between art, science, cognition, sexual difference and subjectivity.

A useful place to begin is with Barbara Stafford's concept of 'visual analogy'.[9] Stafford's evocative terminology is precise; she argues for the visual as a constructive form of connective cognition and describes analogy as 'a metamorphic and metaphoric practice for weaving discordant particulars into a partial concordance'.[10] Thus, visual analogy neither assimilates nor effaces difference; empathy and affinity, the motor forces of analogy, allow productive, temporary coalitions to emerge in their diversity. Significantly, Stafford located the high points of visual analogy in the *Wunderkammer* and in Gottfried Wilhelm Leibniz's concept of the *Ars Combinatoria*, each a manifestation of what we might now call a Baroque or early modern world-view, premised upon the same complex exchanges between the arts, sciences, colonial expansion and practices of collecting which enabled the work of Merian and Ruysch to flourish.[11] Indeed, the modes of visual analogy deployed by Merian and Ruysch engendered productive cognitive connections to be made across diverse materials, concepts and forms; their work brought the arts and sciences together in addressing processes of change and metamorphic ecologies. Moreover, the connective aesthetics of Merian and Ruysch underpinned both their creative and intellectual interventions into the production of knowledge in early modern Europe and their emergence as empowered, articulate female subjects.

In Merian's case, for example, the 'work' of her art is to demonstrate metamorphosis – literally, in subject-matter, and figuratively, through the nature of her visual effects. Her approach can be seen in both *Raupen* and *Metamorphosis* where Merian insistently imaged ecologies-in-process, connecting the stages of transformation characteristic of each species with the food plants and local animals in its environs.[12] Thus, in the 1705 illustration of the *Manihot* (the plant whose roots are cassava), a whole ecosystem is at work: the eggs, larva, pupa and winged butterfly make use of the foliage, stalks and root of the host plant while another insect and snake continue their life-cycle in the same arena. The illustration yields both accurate information and sensual delight in its colours, curves and clever compositional devices, drawing us into the wonder of an ever-changing nature.

Merian's assemblage of art and science, a heterogeneity of differences made visual, confounded any simplistic division of knowledge from sensual participation; this fact placed her at odds with many of her male contemporaries, such as

Figure 6.1 Maria Sybilla Merian, *Manihot* from *Metamorphosis insectorum surinamen-sium*, 1705, photograph and copyright, British Library, London

Jan Swammerdam, who isolated insects from their environs, numbered or labelled their images and relied upon dead and/or dissected specimens, rather than observe or depict them in life. Indeed, Merian was so out of synch with the kind of scientific illustration which dominated eighteenth-century entomology that James Petiver, who planned to translate and revise the unique material in *Metamorphosis* for an English audience, sought to reorganise, or 'methodise' it, so that it would conform more fully to the standards of the new taxonomic texts.[13]

The innovative flower painting of Rachel Ruysch operated within a similar logic of analogy and assemblage. Her choices of flora and fauna, manner of arrangement and painterly style neither conformed simply to the predominant conventions of allegorical floral still-life in the period nor to those of scientific illustration, yet participated in both. So, for example, it is possible to trace some of her compositional motifs directly to the work of Maria van Oosterwijk and her teacher van Aelst, yet also demonstrate that she used a Roman numeral dating form derived from scientific documentation and was one of the earliest painters to include cacti and an example of a Surinam 'midwife' toad in her work, thus confirming an extensive familiarity with natural science and the commodities entering northern Europe from its colonial domains.[14]

Her work has been noted especially for its unusual, eclectic ecologies; Ruysch combined animals and plants in ways which went beyond the pattern books of her day, defied known allegorical conventions and suggested a knowledge of the growing seasons of plants and the habits of animals in life. Her *Woodland Still-Life with Milk Thistles, Flowers, Insects, a Frog and a Lizard* (1694) worked in this way, taking traditional still-life elements found in the pattern books and still-lives typical of the period and connecting them with observation from the life (in the particular depiction of the milk thistle), the ecology of the woodland setting and a scientific acquaintance with less well-known species (lizards and frogs). Ruysch thus produced an analogous combination of elements which admits of various, mobile readings across multiple visual sign systems. The 'art' of her science was to combine this extensive horticultural knowledge with compelling visuals and stunning qualities of paint. We should not reduce the importance of this active engagement and re-combination of elements from the work of other painters and pattern books. As Frances Borzello has argued in relation to seventeenth- and eighteenth-century self-portraits by women, demonstrating an intimate knowledge of the conventions of your genre, while making strategic changes in your own work, was an important and ambitious tactic commonly deployed by women artists.[15]

This art of heterogeneous connection, produced by women keenly aware of the most advanced work in the natural sciences, the conventions and innovations in flower painting and the expansion of trade, commerce and the colonial project, suggests a way of knowing the world and negotiating a meaningful position within it. The analogous sensibility of Merian and Ruysch not only reinvigorates our historical understanding of women artists' integral role as mediators of science, art, imperialism and bourgeois mercantilism in the early modern period, it demonstrates an epistemology based on visual analogy which can go beyond the

Figure 6.2 Rachel Ruysch, *Woodland Still-Life with Milk Thistles, Flowers, Insects, a Frog and a Lizard* 1694, courtesy of the Gemäldegalerie Alte Meister, Dresden

deadlock of the science–gender system so devastating to articulating female subjectivity.

The work of Rosi Braidotti on the epistemological problem of the female feminist subject provides productive strategies through which to think about visuality, consciousness and heterogeneous connection – precisely the configuration of

ideas which I wish to expand around the topic of female subjectivity throughout this chapter.[16] Braidotti's project, to conceptualise nomadic, embodied female subjects as collectivities of difference, is relevant here for a number of reasons. First, she takes seriously the rigorous work of Donna Haraway on the problems of science, technology and the sex–gender nexus, looking both at 'how fiction (the imagination) and science (logos) can be recombined in a new unity'[17] and what form sexed subjectivity might then take. Citing Haraway's cyborgs and her use of the idea of 'figuration', Braidotti suggests that these insights help us to reconceive the multiple connections between women, biological science and technology.[18] Additionally, Braidotti draws a conceptual link between the work of Haraway and the insights of Gilles Deleuze on the question of creative theory and subjectivity posed as figuration:

> I see the cyborg, as a feminist figuration, to be an illuminating example of the intersection between feminist theory and Deleuzian lines of thought, in their common attempt to come to terms with the posthumanist world. Feminist figurations refer to the many, heterogeneous images feminists use to define the project of becoming-subject of women, a view of feminist subjectivity as multiplicity and process, as well as the kind of texts feminists produce.[19]

It is worth noting that Braidotti strategically deploys the phrase 'becoming-subject of women' rather than adopting the more common Deleuzian configuration 'becoming-woman'. For feminist critics, the logic of 'becoming', as developed in the work of Deleuze, has been a point of contention. Braidotti's use of Deleuze is a critical intervention; she mobilises becoming to move beyond the static dualism of subject over object, but insists upon the material conditions which define emergent subjects. In this sense, she, like other feminists now thinking through this mobile paradigm, insists that every becoming is concrete and has material ramifications for particular subjects in the world. Neither Braidotti nor Haraway cast multiple and mobile feminist subjectivity as beyond materialism, historical processes or political dynamics and, in thinking about the effects of women's art, I would reiterate this decisive link to the particularities of historical location.

The other element to note in Braidotti's critical engagement of Deleuze is her elaboration of the logic of 'rhizomatics' as a feminist, transdisciplinary movement of thought:

> I think that the term 'transdisciplinary' is a rather adequate one in describing the new rhizomatic mode in feminism. It means going in between different discursive fields, passing through diverse spheres of intellectual discourse.[20]

This rhizomatic mode of moving between and passing through discursive fields links becoming, as mobile and emergent experimental thought, with the development of concepts as heterogeneous collectivities of difference, or as Deleuze and Guattari described it:

> . . . a concept also has a *becoming* that involves its relationship with concepts situated on the same plane. Here concepts link up with one another, support one another, coordinate their contours, articulate their respective problems, and belong to the same philosophy, even if they have different histories.[21]

The 'machinic' logic of multiple and varied connections, constantly in flux, yet located, materially specific and able to effect both intellectual and social change, is fundamental to Braidotti's emphasis upon figuration as a feminist politics of female subjectivity. Stressing figuration along with images and texts, the activity of assemblage and the priority of fiction, creativity and imagination, further implies that art-making might play an important and particular role in the materialisation of a composite, nomadic female subject. Even if this is only an implication residing within loaded terminology, I would like to mobilise it here as a positive point and argue that women's art can and did construct particular figurations of female subjectivity at the interstices of disciplinary and conceptual boundaries. Art offers unique opportunities to re-examine the potential of the feminist figuration as a mode of visual and material becoming-subject. More-over, as Braidotti's eloquent reference to the kind of texts feminists produce reminds us, the interactions between art, criticism and knowledge are equally machinic – I am myself implicated and bodied forth in the constellations of images, ideas and meanings which I produce. As Gail Weiss put it, 'To trace the process of becoming that forms the subject is itself a transformative enterprise.'[22]

These points are of particular interest in the case of Maria Sybilla Merian, as her work can at once be seen to have figured a creative female subject poised between the languages of science and art and an artist-entomologist negotiating her position as a woman with and between the conditions of colonial domination. These positions have multiple and conflicting ramifications and have proven a vexed subject for later biographers who have an investment in her 'proto-feminism'. However, the issue is not whether Merian's work is 'feminist' in our terms, but how this work gave voice to women's multiple, yet particular, situations within the dynamics of colonialism. *Metamorphosis* figures 'woman' as a complex historical assemblage, negotiated within the gender-specific conditions of colonial power, slavery and scientific investigation; Merian's relationships with other women within this structure are not paradoxical and inexplicable, they are multiple and shifting.

So, for instance, Merian drew on the knowledge of local women, both indigenous and African slaves, and she cited these discussions extensively in *Metamorphosis*. She took their knowledge seriously – from information about the preparation of food such as cassava to a famous discussion of the *flos pavonis*, a plant used by female slaves as an abortifacient to ensure that they did not bear children into slavery.[23] This fact differentiates Merian's work from that of most of her male contemporaries who used local knowledge without any reference to its source and who all but ignored the customs particular to women in their scientific work. However, Merian never noted the names of any of these women in her text, never

shied away from using the labour of slaves and, indeed, took an 'Indian' woman, as an anonymous help-mate, back to Amsterdam with her when she left South America. Hence, the fact that Merian was a female artist-entomologist does emerge within the figurations of texts and images of *Metamorphosis*, yet these do not configure a unified 'woman-essence', linked transhistorically to all other women. These figurations posit 'woman' in all its complexity, becoming-subject in the contradictions of specific material conditions and their political ramifications. Feminist figurations as constellations of difference are neither abstract nor apolitical; indeed, they often mark strategic interventions into histories of inequality and domination. In seventeenth-century Europe, the conjunction between colonial expansion, science, technology, art, analogy and knowledge enabled powerful female intellectual subjects to emerge in complex figurations. In our own historical moment, with the very definition of the subject under scrutiny and the virtual technologies of the 'global', digital age threatening a-political disincarnation, the feminist challenge to recorporealise theory and embody subject-positions has become all the more vital.

Figuring the body in the virtual machine

The 'new' technologies of genetic in(ter)vention, cyber-space and 'virtual reality' are among the most recent group of scientific developments to have had a massive impact on social life and ideas. Digital technologies especially have moved swiftly to encompass a mass, western audience and have become part of the daily routine of communication, information gathering and distribution, providing entertainment and sources of knowledge about the world and our relation to it. However, as I write these lines in the midst of US and British bombing raids on Afghanistan, it is telling that a report in *The Sunday Times* listing the percentages of the population with Internet access in seventeen North African and Middle Eastern countries ranges from 'negligible' in Iraq, Bahrain and Qatar to a minimal 6.3 per cent in Lebanon.[24] The digital realm is neither beyond the power politics of the old 'analog' nation-states, nor the structures of class, wealth and access in the global economy.

Nor can digital technology be divorced from the historical legacy of iniquitous gender and race relations and to celebrate the appearance of a virtual subject, beyond the limits of class, race and sexual difference, is premature. As Keith Ansell Pearson warns:

> . . . this vision of neg-entropic destinies, in which the human plays the role of a mere conduit in the inhuman process of complexification, can only provide simple options that are not options at all, such as a retreat into a new ethical purism . . ., futile Ludditism, or vacuous cyber-celebrationism.[25]

Yet it is clear that advances in media and communication technologies can provide extraordinarily powerful tools with which to re-envisage relations in the world in new and positive ways. Doing so means producing figurations which engage the

technology as both embodied and embedded in histories and the languages of difference.

Australian artist Anna Munster has been exploring the problematic of 'digital embodiment' through just such a multi-stranded figuration in her *Wundernet* (http://wundernet.cofa.unsw.edu.au/), uploaded in 2000. The site is transitional in many senses. It is, for example, a preliminary experiment within a larger project to produce a multi-media CD-ROM designed to incorporate an even more sophisticated form of interactivity and image base. The structure of *Wundernet* is also transitional, taking viewers through changes of scale, form, media and, most suggestively, site, as it hyperlinks participants to other locations as part of its operating logic. But I would like to press the concept of transition even further and suggest that *Wundernet* is premised upon a form of transitional agency, linked to Munster's broader, feminist approach to digital practice and echoing Braidotti's comment that the 'feminist theoretician today can only be "in transit", moving on, passing through, creating connections where things were previously disconnected or seemed unrelated, where there seemed to be "nothing to see" '.[26]

Wundernet creates diverse connections in transit, making visible correspondences between texts, moving images and a range of extra-site links. The connections across these varied elements are machinic (multiple, heterogeneous and temporary), rather than linear or teleological, yet they are not random, circulating in and around the politics of the body, virtuality and display. In one sense, then, the 'content' of *Wundernet* concerns digital embodiment and much of the material on the site (and links from it) are suggestive of the multi-layered corporeality which inhabits our 'clean', virtual experience of the world. For example, Munster's visuals are a combination of the visceral (motifs of cellular forms vie with human flesh and bone), the valuable (shells, gems and other typically collectible objects) and the virtual (mathematical symbols, graphs and diagrams). These motifs play with and against historical and contemporary texts reflecting on the intertwining of art and science, bodies and machines, DNA and digital code, power, knowledge and subjectivity. Hyperlinks take us anywhere from 'Artactivists', artists for responsible genetics, to sites exploring the curiosities of biological nomenclature, glossaries of correct terms, digital enthusiasts' mailing lists and the web-pages of many other artists working in 'new' and traditional media.

But the 'content' of *Wundernet* is not the whole story; its transitional connections materialise virtual corporeality as an effect of machinic agency. Exploring digital embodiment as a process rather than an object links Munster's project with a rapidly expanding feminist discourse on the place of women and 'woman' within the realm of virtual reality.[27] *Wundernet*'s strategic transitions deconstruct a key fiction of ungendered, virtual disembodiment – the seeming infinity of random information hurtling through the ether to the disinterested 'surfer' as passive consumer. You can exhaust the material and the hyperlinks of *Wundernet*, but the ideas which might be composed from this finite content are open to innumerable permutations. This forces users to realise the systemic constraints of the site[28] and the corporeal limits of the virtual itself, while we are made active as knowers, configuring and re-configuring the elements in and around the problem

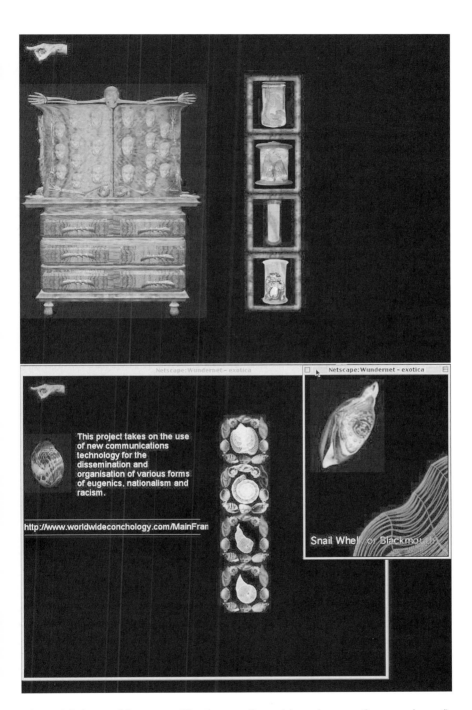

Figure 6.3 Anna Munster, *Wundernet* (http://wundernet.cofa.unsw.edu.au/), uploaded in 2000, courtesy of Anna Munster

of bodies, machines, knowledge and power. It is a double play of digital embodiment and one which reiterates the significance of analogy to subjectivity. As Barbara Stafford put it:

> [I]nformation is not intelligence, and awareness is not a response to a set of logical instructions. . . . Analogy's efficacy consists not simply in communicating what already exists but, like consciousness, in visibly bringing forth what, in fact, it communicates.[29]

Wundernet's self-reflexive figuration brings forth the digital embodiment it communicates, privileging intelligence and awareness over the passive consumption of random, seemingly-infinite information. But *Wundernet* is also a strategic intervention into histories and intentionality. Based on the *Wunderkammer*, its visual tropes, structural logic and reliance upon collection and display as navigational propositions, are from the first a knowing projection of the past into the present. However, the connections between the digital *Wundernet* and the *Wunderkammer* are meant to produce a gap, an interval, through which their constitutive difference enables us to make experimental, conceptual leaps in thinking. This has radical ramifications for the kinds of subjectivity which emerge in exchange with the digital, and in conceiving embodiment. As Munster wrote:

> As opposed to an idea of an informational universe in which everything and everyone is ultimately connected or connectable, differential relations, particularly those that structure the matter and technologies of both the Baroque and the digital, produce unassimilable, if infinitesimal, differences as the derivative of their interconnections. . . . They always operate through and produce a gap, a difference, a remainder that remains outside of or heterogeneous to their connectivity. . . . This different space can help us to rethink contemporary questions of subjectivity. It is this space that is produced again, albeit in radically different ways, through living in digital times. The Baroque, under these terms, cannot be considered the genesis or history of the digital. Rather, I have positioned digital aesthetic experience and its conceptualisation as a reverberation of Baroque matter, technics and spatialisation.[30]

Using an 'old' trope to jam the machinery of the 'new' is a strategy closely allied with re-thinking female subjectivity as composite and composing at once – as machinic, yet embodied. The incorporation of the past as part of the living present stresses the located, bodily roots of agency or, as Mieke Bal argued, '. . . such a paradigm entails engagement, changeability and mutuality . . . The term, rather, is *entanglement*.'[31] Entanglement emphasises that processes of thinking are both corporeal and enveloped by the coevality between the material effects and conditions of the past and those of the present. When we are entangled by quotational works of art, intentionality is reformed; agency is manifest not as some kind of

origin in an invention from nothingness (like a disembodied becoming), but as an intervention in the present, which simultaneously re-makes the past.[32]

The epistemology of the *Wunderkammer* was quintessentially one of connection-in-difference, stressing the work of the viewer as intervention, rather than invention.[33] The point of the *Wunderkammer* was not that 'everything' could be collected, catalogued and thereby 'known', but rather, that knowledge itself was an act of creative composition using limited but disparate and wonderful artifacts. Connecting these insights with digital systems, *Wundernet* performs a machinic correspondence, inscribing materiality and interestedness on the digital while charging the *Wunderkammer* with contemporary significance. The four sections of *Wundernet*, 'Historica', 'Machina', 'Transgenica' and 'Exotica', take this entanglement a step further, reiterating the political interests which are inscribed by the historical and conceptual correspondences between the early modern *Wunderkammer* and our contemporary digital technology.

The economic and ideological interests underlying connections between global exploration and the development of technology, genetics and trade in non-western artifacts, also played a part in rendering 'others' as the objects of knowledge, power, display and commodification. We would be unwise to forget the fascination with which monstrous births and human 'freaks' have been met as scientific specimens, objects of curiosity or portents of doom. It would be equally naïve to occlude the historical links between women, maternity and such 'monsters', not to mention the intimate connections between visuality, 'race' and sexualised 'others'. *Wundernet* does not occlude these histories or their material ramifications. From its images of display cabinets, seashells, bones and test-tubes replete with aestheticised cells, to links with an anti-racist search engine, a site on eugenics and 'Bindigirl', the eroticised, 'exotic' other, *Wundernet* places the virtual squarely within the material legacy of power, politics and pleasure, so demonstrably configured within the *Wunderkammer*.

What I find fascinating in this entanglement is precisely that subjects are interpellated through complex, conflicting and difficult exchanges. Neither a one-sided critique, damning the iniquitous past and its legacy in our present, nor a simplistic celebration of our brave, new, disembodied world, *Wundernet* places the body back into the machine, finding a location from which to configure transitional, composite subjects whose differences answer back. Munster's intervention is a powerful feminist figuration, but is not a singular, intentional, source of meaning. Instead, the logic of entanglement mobilises the particular potential of the digital such that Munster's intention is produced as the effect of an exchange between individual and collective difference/agency, a relay between the figuration she provided in *Wundernet* and participatory re-figurations of the past and present. It is at the point of this transitional relay that I want to turn to the work of Elizabeth King which, while very different in form, similarly tests the limits of machinic subjectivity and embodiment.

Transindividuality and the loop of becoming

Elizabeth King makes fascinating sculptural objects, yet neither the 'art', nor the ideas evoked by her practice, inhere within objects themselves. For instance, the book *Attention's Loop: A Sculptor's Reverie on the Coexistence of Substance and Spirit* (1999), and the multi-media installation piece, *The Sizes of Things in the Mind's Eye* (2000), each centre upon an exquisite, one-half life-size, articulated self-portrait sculpture entitled *Pupil*, yet *Pupil* is only an axis for these works, drawing diverse materials together in far more elaborate figurations.[34] *Pupil* is both a focal point and, as King puts it, 'an instrument',[35] in a practice materialised through analogy and assemblage. In this sense, King's work epitomises the logic of figuration: it is mutable, operates by creating correspondences between heterogeneous objects, images and concepts, and joins them through multiple affinities which neither destroy nor assimilate their differences.

Attention's Loop created particular correspondences between the arts, sciences, history and myth through a dynamic relay of perception and cognition. King's work put into practice a mode of becoming-subject, revealing the mechanisms by which agency might emerge as an exchange between individuality and collectivity, rather than be fixed to either pole. While there are a number of interconnected strands within King's practice which might be isolated temporarily for discussion and suggestion in this context, I want to look more closely at just one of these, examining its connective valences in light of my own machinic assemblage around subjectivity and figuration. I would suggest that the exchange between wonder and knowledge, so compellingly configured in *Attention's Loop*, is an especially useful way to ask *how* art forms analogous figurations in difference.

Attention's Loop locates the connection between wonder and knowledge as an historical and contemporary problem of cognition and empathy, setting these into motion through visual, material and theoretical correspondences. *Pupil* itself realises this problematic in its physical presence: the head, and the eyes particularly, are astoundingly life-like, while the neck, arms, hands and upper torso are stylised and machinic. This combination of the 'hyper-real' with the 'demonstrably false' fills us with wonder and knowledge at once, as we recognise the artifice of the made object while engaging with its astonishing 'reality'. *Pupil* catches viewers in its logic of modulating exchange – from animate to inanimate, life-size to its appearance, substance to spirit. Indeed, the last of these is the central theme of *Attention's Loop* and again can only be conceived as an exchange in process, refusing an 'either/or' choice in favour of a transitional 'and': 'I am propelled by fright and amazement at the coexistence of substance and spirit.'[36]

This coexistence sets up an analogous mechanism by which, for instance, historical information about reproduction and the *homunculus*, the story of Tom Thumb and the legend of the *Golem*, are brought into contact with the technological histories of automata, early experiments in anatomy and the art-historical traditions of portraiture. Connecting wondrous objects, like automata, with anatomical specimens, artworks and scientific instruments was the work of the *Wunderkammer* and it is not surprising that King's 'cognitive collections' parallel

this phenomenon or that elements of her work draw upon the Baroque. I would suggest that the impulses which attend King's aesthetic and intellectual combinations are productive of wonder and knowledge in a way which echoes Mieke Bal's fascinating assessment of 'a baroque vision, a vision that can be characterised as a vacillation between the subject and object of that vision and which changes the status of both'.[37]

One striking example of the vacillation between subject and object brought to bear as a play of differing modes of attention, understanding and astonishment occurs across pages 26 and 27 of *Attention's Loop*, where the photograph of *Pupil*[38] looking at a tiny, imagined object held between thumb and forefinger is paired with the following text:

> One day my father, a physicist, told me about a copper crystal he had inherited from a scientist at Oak Ridge. It was grown in the lab to be structurally perfect, having only 3,000 dislocations per cubic centimeter instead of the normal 10,000,000. If you held it between your thumb and forefinger and squeezed it even slightly, you'd ruin it. Dad was wondering how he could slice a thin wafer (only a few molecules thick), off this crystal, so he

Figure 6.4 Elizabeth King, *Pupil*, 1987–90; photograph, *Pupil: pose 7*, 1997 by Katherine Wetzel. Photograph appears on page 26 of *Attention's Loop: A Sculptor's Reverie on the Coexistence of Substance and Spirit*, Elizabeth King, NY: Harry N. Abrams, 1999.

could examine it with the neutron beam: 'What if I just drape a thread over it, and put each end of the thread in an acid, so that it will slowly cut through the copper without exerting any pressure?'

None of the elements of this complex figuration can be reduced to any other – the delicate gesture of the self-portrait, the hypothetical scientific experiment, the childhood memory – yet they combine as a wonderful knowing, a knowing which enfolds us in our embodiment. We are interpellated as corporeal agents in a modulation between and within the individual and the collective; the tale is utterly personal and social at once, the sculptural gesture is simultaneously particular and universal. This figuration works through the aesthetic, indeed kinaesthetic, becoming-subject. As Barbara Stafford wrote: 'We become aware of thinking only in those kinaesthetic moments when we actively bind the sights, savours, sounds, tastes and textures swirling around us to our inmost, feeling flesh.'[39]

The figurations in *Attention's Loop* invite a kinaesthetic exchange between subject and object, unity and diversity, mutability and concrete emergence materialised through proprioception. Proprioception, our 'sixth' sense, is that convergence of the disparate senses into a mobile combination which enables us to take our place in the world – literally and figuratively. Taking this literally, it is the indivisible connection within ourselves of both subject- and object-positions which enables us to move/act in space. Proprioception is the perpetual relay in our attentive cognition which reiterates our enworlded, connected subjectivity. In this sense, proprioception is a figurative mechanism as well, providing an aesthetic parallel for the interconnectedness of individuality and collectivity in a machinic conception of subjectivity.

This shares a fascinating affinity with the work of Moira Gatens and Genevieve Lloyd on selfhood, identity and the philosophy of Benedict de Spinoza.[40] Like Stafford, Deleuze and Bal, Gatens and Lloyd have explored Baroque philosophy in order to think through some of the vexing questions of the present: collective responsibility, the role of imagination in consciousness and a non-dualist conception of subjectivity. Their project thus corresponds historically and conceptually with the wider material under discussion in this chapter and their insights into 'transindividuality'[41] are extraordinarily resonant here. First, they assert the impossibility of thinking the individual in opposition to the collective and describe a relay of cognition between modes:

> For human individuality, this means a movement of thought between the individual and wider collectivities through which the power of Substance is mediated. Individual selfhood is not possible in isolation . . .[42]

Later, this is expanded in terms of difference, embodiment and imagination in ways which emphasise change and movement. In this figuration of identity, we have a veritable model of the nomadic feminist figuration of the machinic assemblage:

We have argued further that ways of knowing oneself and one's context are reflected in embodied ways of being. What we know, imagine and believe is constitutive of our identities and these identities are processual, rather than fixed, because they are formed and re-formed through our participation in larger transindividual wholes.[43]

Attention's Loop is not conceived as a linear narrative or a tale of fixed identities or meanings. Working through the figure of the 'loop', King's volume spirals forward and back, posits concentric convergences and tangential connections across objects, images, events and ideas. The 'loop' is not a simple or singular round-trip, returning us inevitably to the point of origin, but an invitation to enter and emerge from the journey at any point. It is akin to Weiss's assessment of becoming as 'a disparate series of backward and forward movements in which the subject repetitively, reflexively, turns back upon itself'.[44] I would suggest, following the trajectories of assemblage, becoming and the Baroque which have circulated throughout this chapter, that King's work materialises the logic of the fold as an aesthetics of becoming-subject, enfolding, unfolding and forming collectivities, not as multiples of the same, but as the manifold.[45] An aesthetics of the fold, as Yve Lomax argued, refutes binary opposition through the logic of inclusion, implication, analogy and relation:

> Here things are continually wrapped with something else. One relation always involving another. One time always implicating another. Multiplicities, I may say then, are made of becomings and bring with them the work – indeed art – of implication. Folding. The difference between things isn't so clear-cut, the same and the other do not stand opposite each other.[46]

The art of implication is mobilised strikingly in a telling passage from *Attention's Loop*, wherein making and thinking are intertwined around *Pupil* such that proprioception turns identity back upon itself:

> I put the figure in different positions and stand back to look at them. A few degrees of shift in the axis of the head to the torso can turn an attentive gesture into an introspective one, or signal a trace of suspicion, or resignation. . . . I notice that in posing the figure I often seek to have it perform eye-hand actions in which the fingers are articulating some difficult task . . . Or the figure scrutinizes its own hand. It occurs to me that I am having the self-portrait duplicate the same motions I performed in making it.[47]

This text is paired with a photograph of the artist's hands performing the actions which produce the mirroring sculptural gesture; from macro to micro and back again, hands enfold and unfold the gestural, embodied, exchange which configures identity as processual and yet concrete (see cover image). The inter-relationship between making, thinking and becoming materialises transindividual exchange in *Attention's Loop*, emphasising the experimental nature of the self,

constantly negotiating its own parameters within the world. The logic of becoming which sees it as mobile, invested and enworlded has powerful ramifications for reconceiving female subjectivity in process without resorting to apolitical abstractions or utopian configurations beyond difference. In seeking a more sophisticated model of the creative subject's embeddedness within the material conditions of histories, Gen Doy wrote:

> We need a theory of the historically situated subject, individual and at the same time part of a social totality, who consciously and unconsciously engages with a contradictory and changing reality to create new representations, not passive reflections, of his/her material and psychic existence.[48]

I would argue that feminist figurations, as mobile collectivities of difference, articulating the subject as always both individual and part of a social totality, go some way toward answering this need. The shift from an aesthetics premised upon passive reflection, toward the materialisation of visual analogy and 'transindividuality', will not define female subjectivity once and for all as a monolithic object, available as a representation, but rather permit its productive reconfiguration in new ways in the future.

Part III
Aesthetics

Introduction

It seems almost too obvious to say that women making art negotiate the field of aesthetics, since any art-making by necessity must. But women's engagement with aesthetics is far more intriguing than it first appears. Since the use of the term as we now know it emerged during the course of the late eighteenth century, philosophies of art, standards for evaluating artworks and our understanding of the sensory basis of knowledge itself, have carried with them the gender-biases of their historical frame. Conventionally, the disciplinary delineation of aesthetics has been particularly debilitating to women's art practice, since its internal logic privileged masculine-normative concepts of art-making, value and knowledge.

In its looser, more connotative definitions, aesthetics referred to philosophies of art and systems by which a wide variety of artworks might be evaluated, 'good' from 'bad'. The canonical tradition of art history was upheld by a range of aesthetic theories which operated in this way so that, for example, the qualities typical of Classical sculpture and High Renaissance painting, were itemised, lionised and taught to a generation of artists, patrons and connoisseurs who reanimated them in the elite form of History Painting. While I am in no way suggesting that aesthetics in this sense ever became fully hegemonic and am very much aware that philosophies of art and their corollary concepts such as beauty, pleasure, the sublime and the grotesque, competed for dominance in the history of ideas, nonetheless, a relatively stable canon of high art was able to emerge by the end of the eighteenth century in part through the dissemination of aesthetics.

The features of canonical art and the aesthetic theories which underpinned these were not gender-neutral. For instance, the sublime was valued over the picturesque and the transcendent universal form over the particular, the detail or the decorative. The former term in each of these key pairings was critically associated with masculine creative genius and the latter with feminine artifice; while masculine and feminine are not strictly linked to men and women, women who made art frequently found themselves aligned with the denigrated term. Hence art critics commonly assumed an evaluative stance with regard to women's art which took for granted that certain features would appear in their practice, such as delicacy of handling, facility with colour, decorative rendering and an inability to move from the particular to the universal.

Historically, women artists had an ambivalent relationship with categories of

feminine and masculine production. In some cases, they embraced the idea of a feminine aesthetic, using this as an effective strategy by which to promulgate their work in an artworld dominated by men; in other instances, they acclaimed their masculine creative power, flying in the face of gender norms. By the first half of the twentieth century, the gendered nature of creativity and aesthetics were, in themselves, rarely challenged, but women's tactical deployment of the categories indicates the seriousness with which they took these terms and the high stakes of choosing, or being defined by, the 'wrong' trope.

During the period of 'second generation' feminism of the 1960s and 1970s, the issue of a feminine aesthetic took a new turn. Feminists were frequently divided on the validity and usefulness of such gender-specific concepts of creativity and art practice; those against noted the historical production of these categories and argued that their existence was yet another feature of a male-dominated social form, namely art and the artworld. Others, however, sought to reclaim an empowered feminine aesthetic and to define this as the key feature of women's radical art practice. Probably the most deliberate expression of this project was the development of what has come to be known as 'central-core' imagery, or 'cunt art'. Working against what were seen to be phallic modes of representation, central core work stressed an imagery derived from the bodily imaginary of women, organised around vaginal symbolism. Not all of the proponents of central core work saw this as an intrinsic element of women's art practice; some saw it as a strategic mobilisation of sexual difference in the face of a long history of the objectification of woman in western art.

However, the more pervasive delineation of a feminine aesthetic focused on features which were argued to be common across all women's art, irrespective of historical, material or geographical differences between women. Some of the features identified as a feminine aesthetic in this sense are familiar – a tendency to invoke central core imagery, to use forms of overall patterning or decoration and a more dispersed compositional structure. The problem here is obvious; differences between women are ignored in favour of an homogenising logic which can thus only be premised upon some form of (biological) essentialism. Obliterating the complex and multifaceted histories of women making art does those women artists a great disservice and is an inadequate method by which to explore the various and significant encounters between women and aesthetics.

A number of feminist artists and critics eschewed the concept of a *feminine* aesthetic in favour of a *feminist* aesthetic. Arguing against what was seen as the biological essentialism of the former position, proponents of a feminist aesthetic sought to define a mode of practice or form of representation which could mobilise the political potential of art for women. This was a more productive agenda in terms of aesthetics and was one of the reasons why feminist conceptual art, installation and performance flourished from the 1970s onward. However, a feminist aesthetic, cast in the singular, also suffers from the occlusion of difference and in practice, tended to foster an uncomfortable orthodoxy by which women's art, historical and contemporary, was judged. Obviously, the search for an ideal feminist aesthetic, a mode of art making and representation which could never be

appropriated against the interests of women, was wrong-footed. At its most punitive, this quest also meant that many practices and subjects, most notably figurative painting and an engagement with the nude female body, were deemed anti-feminist and excluded from consideration.

However, those exploring the extraordinary potential of art to further feminist theory and politics did not linger long in search of a singular feminist aesthetic, but moved toward a more radical exploration of feminist aesthetics. In so doing, artists, critics, historians and theorists turned their attention to the philosophical and artistic traditions themselves, questioning the development of aesthetics more broadly and negotiating positions within and through its structures for the articulation of female subjectivity.

A crucial feature of this analysis was the recognition of aesthetics as a legitimate form of knowledge in which the senses and the body play a key role. Historically, the corporeal base of aesthetics was used to distinguish it from reason or rational epistemologies whose claims for authority negated the body in favour of the mind. Feminist theorists eager to move beyond the mind–body opposition, with its association of the masculine with the privileged position of rational transcendence and the feminine with corporeal immanence, embraced aesthetics. This was not done such that the terms of the opposition were merely reversed and the binary logic remained intact, rather, the significance of the body and the senses in knowledge production was used to deconstruct the dualist paradigm itself.

Acknowledging the significance of embodiment, materiality and process to the formation of subjects in the world, feminist theory has been able to develop challenging positions on history, philosophy and cultural identity. The insights of feminisms provide a critical counterpoint to many of the prevailing discursive structures which marginalise or negate difference; re-visiting aesthetics as a field intrinsically concerned with the body, the senses and the interaction between perceptual and conceptual understanding, has been an invaluable facet of feminist scholarly work. Moreover, feminist explorations of aesthetics take art seriously as a site for the articulation of difference, and art-making has been as significant in the development of ideas around corporeality, process and alterity as text-based theory.

The following three chapters, which constitute the third and final section of this book, 'Aesthetics', also take art seriously and attempt to engage its theoretical and historical interventions productively. In making art, women have developed an astounding range of aesthetic devices to address difference without simply objectifying 'others' and have countered many of the conventional hierarchies within aesthetics which would marginalise their insights. Each of the following chapters is structured around a central problem in aesthetics – pleasure and knowledge, the text–image dichotomy and temporality. In no way are these themes meant to exhaust the subject, yet, as they follow the contours of contemporary debates in aesthetics and art practice, they touch upon vital and persistent issues. As the chapters unfold it is made clear that women's art has real potential to interrogate epistemologies, reconceive theory and demonstrate novel perspectives for the future.

The question of sensual pleasure and its relationship to knowledge has a long and vexed history. The seventh chapter investigates the hierarchy of the senses and explores the possibility that the primacy of vision, and claims for objective, distanced observation, might be reworked by multi-sensory aesthetic interventions. The chapter examines these issues by looking at filmic work by contemporary North African and Middle Eastern women artists which challenge both the colonial scopic regimes characterised by 'orientalism' and the cinematic production of pleasure through the objectification of woman. In positing alternative constructions of the sensorium and its knowledges, these filmic works counter both the racism and sexism typical of instrumental vision, yet do not simply reject the power of sensual pleasure in articulating female subjectivity and knowledge.

Turning to the polarised relationship between text and image, the eighth chapter seeks to move beyond the dualist logic which divides these two terms so to counter the denigration of visual and material practices in relation to their text-based counterparts. The corporeal locus of word and text is reinstated and the resultant insights enable the effaced matter, matrix and materiality of languages and ideas to emerge. The artworks discussed in this chapter play a vital role in recorporealising text and, specifically, in rethinking the book as a cartographic instrument, mapping new territories and communicating across seemingly fixed borders and boundaries. Transgressing such boundaries, addressing difference and reinstating the corporeality of theory has radical implications for women making art and their negotiation of the text–image paradigm is politically as well as aesthetically apt.

The final chapter of the volume explores time and temporality in Australian women's art and critical theory. The historical and geographic significance of Australia to this theme is noteworthy; as the chapter delineates further, it has been imperative to the decolonising projects of Australian feminist philosophers to conceive subjects and histories in process. The work of these scholars has its parallel in the fascinating practices of women artists in Australia, as they seek to move beyond an idea of time as defined by space (as an object or a 'thing') and toward a more open-ended, fluid evocation of temporality. This art instantiates an ontology of becoming rather than being and engenders the potential of art to think futurity as a modality of difference.

The cases discussed in these chapters are not general, but specific and limited to particular times, places and material practices. This is a determined strategy and one which posits the detail in opposition to the meta-narrative, bringing our attention in close to expand the horizons beyond. As the chapters show, women's art has much to contribute to the renewed field of aesthetics as we come to understand the role of corporeality, materiality and process in the making of histories and subjects in the world.

7 Pleasure and knowledge: 'Orientalism' and filmic vision

> 'Sensual abandon' is a phrase of Enlightenment subjectivity, implying that the senses (except maybe vision, and possibly hearing) dull the powers of the intellect. It implies that Orientalist desire for the sense experience of other cultures is in part a desire to stop thinking, as though sensory knowledge is radically opposed to intellectual knowledge. . . . [However] stirring up the hierarchy of the senses is not a chance to play dumb; in fact it's quite exhausting.
>
> (Laura U. Marks)[1]

In this succinct and eloquent passage, Marks connects a number of key facets of conventional Enlightenment thinking on aesthetics: pleasure, sensory hierarchies, colonial power and knowledge. But the development of aesthetics was, like colonial domination of the 'Orient' itself,[2] a multi-layered, uneven and contested process. Despite the repetitious and over-determined practices, discourses and debates which were intended to achieve the complete cultural and political dominance of the 'West' over the 'East', and the 'rational' over the 'sensual', hegemony was never attained in either sphere. That is not to say that the material and ideological practices which constituted 'Orientalism' were anything less than iniquitous and exploitative, it is simply to argue that resistance and exchange were always also part of the relationship. So too, the traditional sensory hierarchies, and the epistemological order which they signalled within aesthetics and beyond, were never undisputed. Indeed, exploring the radical potential of aesthetics to 're-orient' subjects through pleasure, knowledge and multi-sensory encounters with difference is still possible and pertinent, if exhausting.

As Terry Eagleton put it, during the eighteenth century, aesthetics came to be seen as the 'feminine analogue' of reason.[3] The corollaries of this logic are now well rehearsed in feminist critiques: aesthetics and sensuality are associated with seduction, pleasure and woman (as an object of masculine, heterosexual desire) and opposed to rational, disembodied, universal knowing. Within this system, rational masculinity is able to transcend to the position of universal subject/self at the expense of 'woman', cast as the object/other, and confined to the negative, immanent pole of the binary pair. It is but a small step to associate cultural

difference and political 'otherness' with woman/object – hence the logic which feminised the 'Orient' as an exotic object of desire, unable to transcend its too bodily, too sensuous, state.

Many scholars have noted that the projection of the exotic upon non-European people and places was the obverse of Enlightenment political theory and aesthetics. As G.S. Rousseau and Roy Porter argued in the introduction to *Exoticism in the Enlightenment*, the exotic was shorthand for anything transgressing the borders of an ostensibly 'christian, civilised, rational Europe'.[4] Orientalist exoticism was particularly indebted to visual tropes, most commonly figured in and through sexual difference. The veiled woman and the harem came to signify the exotic and desirable 'East' and brought together the two key modes of instrumental vision which constituted the dominance of the colonising gaze: sexual voyeurism and scientific scopophilia.[5] Exoticising veiled women in the space of the harem established the power of the penetrating gaze to unveil, know and possess the other. The use of the harem/veiled woman as a trope of the 'Orient' was extensive and profound – it both signified and determined European responses to the varied cultures of North Africa and the Middle East for generations. Significantly, it also affected the development of visual culture within colonised regions, so that the ubiquitous forms of gendered, instrumental vision were also the forms most thoroughly challenged, resisted and reconceived toward new and productive ends.

Author and filmmaker Assia Djebar, well known for her evocative studies of women's lives in post-liberation Algeria, described what she felt to be the complete evacuation of subjecthood from people living within colonial Arab, African and Far Eastern scopic economies: 'Thus, for about a century and a half, as in the days of pagan magic, people were "possessed" – both in the sense of being dominated and of being tricked – by the annexation of their image in an operation in which they took no part.'[6] Citing examples of colonial European visual culture from Orientalist painting to erotic postcards, ethnographic photodocumentary and the so-called 'colonial cinema', Djebar argues that this legacy left its mark on contemporary Arab filmmaking which takes 'what it means to be scrutinized by others' as a key theme.[7]

Fine art, photography and film, as they developed in the European colonies of the Arab world, were certainly the products of an attempt to centre a masculine, hegemonic gaze in visual culture. Criticism of what has been termed 'ocularcentrism' [even 'phallocularcentrism' or 'the monocular penis'[8]] is now well known, so it will suffice here simply to reiterate that instrumental vision, sensory hierarchies and the pleasures attained from specular domination of 'others' were connected intimately in this regime.[9] Yet, while the pervasive presence of masculine-normative ocularcentrism in the colonised regions of North Africa and the Middle East made this scopic economy seem hegemonic, its effects never were. Certainly Djebar never assumed that decolonised subjects, particularly women, were powerless to negotiate an authoritative speaking and looking position. Rather, she asserted a number of strategic devices by which such a position might be attained, never ignoring the histories of colonial interaction or the specificity of gender difference.

Underlying such strategic interventions is the insight that painting, photography and film were precarious constructions formed within specific socio-political regimes. Specular control of colonial subjects had to be won through force, coercion and, as Gen Doy compellingly argued in *Women and Visual Culture in France 1800–1852*, practice:

> Many photographs taken in North Africa in the 1850s embody the difficulties the French photographers had in fixing racial 'types', and in successfully fitting the people who posed for them into established genres of photographic practice. . . . However, by the late nineteenth and early twentieth centuries, North African women were posed in the same soft-pornographic manner as French studio photographs.[10]

Colonised subjects learned to become the objects of these voyeuristic or ethnographic visual technologies, but, crucially, they also learned to use film and photography for themselves. Indeed, native practitioners frequently trained in cities within the ruling nations, such as Paris, Berlin and London.[11] The influence of cinematic technologies has never been unidirectional; in fact, as Rey Chow made clear in the case of China, the effects of film and photography could be most profound in cultures with radically different visual and aesthetic histories, since these responded to, and inflected, the new scopic modes in widely various ways.[12] In her work on Arab cinema, Violet Shafik amplified this point, describing the ambivalences between the imperialist and indigenous traditions of the medium, still attended by debates concerning acculturation, alienation and authenticity.[13]

Laura Marks further argued that simplistic centre/periphery paradigms are not relevant to intercultural cinematic practice, since work emerging at the interstices of multiple cultural exchanges actually reorganises the sensorium to articulate mobile subject-positions: '. . . intercultural cinema bears witness to the reorganisation of the senses that takes place, and the new kinds of sense knowledges that become possible, when people move between cultures'.[14] She, like other theorists of 'interstitial' film or 'Third Cinema', such as Hamid Naficy and Paul Willemen, have gone beyond the binary logic which simply pits this cinema against mainstream western conventions as oppositional, 'anti-aesthetic' or even worse, 'authentic'. These critics explore the more complex engagement and critique produced by interstitial work which is thoroughly immersed within mainstream international film production and aesthetics, yet different from them.[15]

In this chapter, I want to focus upon three particular instances of such intercultural filmic practice by women: the 1988 video piece *Measures of Distance* by Mona Hatoum, the first of a trilogy of sound and video installations by Shirin Neshat, *Turbulent* (1998) and the full-length, popular feature film, *Silences of the Palace* (1994) written and directed by Moufida Tlatli. These works are each the product of elaborate cross-cultural exchanges which make a nonsense of fixed borders between the First and Third Worlds, 'West' and 'East', fine art and popular cinema or pleasurable and oppositional aesthetics. The artists use 'western'

technologies of film and video, they undertook at least part of their artistic training in European and US cities (Hatoum in London, Neshat in Los Angeles and Tlatli in Paris) and they move between international centres in financing, making and showing their work.

Additionally, Hatoum, Neshat and Tlatli have all experienced, in their own lives, dramatic changes in the political boundaries and cultural climate of the places in which they were raised. Hatoum was born in Beirut to an exiled Palestinian family with British identity papers, moved to London to study art and was herself exiled when civil war erupted in Lebanon in the 1980s. Neshat was born in Iran, went to California as a teenager, studied art at Berkeley and, like Hatoum, found herself distanced by the political turmoil in her homeland when the Ayatollah Khomeini's fundamentalist regime came to power – she made her first journey back over a decade later in 1990. Tlatli witnessed Tunisian liberation from French colonial rule as a young girl, was in Paris as a film student at IDHEC in time to experience the radical social and political tumult of 1968 and returned to Tunisia in the 1970s to work as an editor in the film industry. These biographical details, however, are not meant to 'explain' the work; I am no more interested in a reductive biographical reading of their practices than I am in asserting a unified identity politics for all women. Rather, the references to their biographies reiterate the significance of thinking critically about the 'inter' – of international, intercultural and interstitial – as a productive space between, not an empty transition from, one locus to another.[16]

The three works all refer to the intercultural spaces inhabit(ed) by the artists, but what is even more striking is their insistent deployment of the very trope which links colonial aesthetics with the production of pleasure in narrative cinema – namely, the figure of the 'Eastern' woman. Hatoum, Neshat and Tlatli made extraordinarily sensual video and film works by confronting directly the problematic of the 'Arab/Muslim' woman as both a cipher of masculine scopophilic desire *and* as the potential site of female embodied pleasure, subjectivity and the articulation of difference.[17] The filmic aesthetics of these women artists demonstrate the productive embeddedness of their practices and the ability these have to refashion knowledge against the grain of a masculine, objectifying gaze without simply negating pleasure and desire.

Measures of Distance, *Turbulent* and *Silences of the Palace* bring together the intercultural and the intersubjective dynamics of enworlded, embodied female subjects casting pleasure as more than the satisfaction of lack or the domination of difference. What is fascinating is that they also recognise the very different social, political and ideological frameworks which have encoded female subjects, desire, aesthetics and the sensorium; the works are not a unified body of practice bearing an essential meaning or using a singular aesthetic strategy. These dynamic strategies are addressed in the rest of this chapter as processes of engagement with the work and its pleasures. From investing aurality with power to embodying the eye through proprioceptive, haptic[18] techniques, the works open an 'inter' space, fully sensory and productive of knowledge, political critique and pleasure in difference.

Aesthetics: pleasure and the voice

Hearing and voice are highly significant within the sensorium[19] of North African and Middle Eastern countries and, as Assia Djebar argued in relation to Arab women's filmmaking, claiming a speaking position is as crucial as moving beyond a colonising gaze: 'Can it be simply by chance that most films created by women give as much importance to sound, to music, to the timbre of voices recorded or captured unawares, as they do to the image itself?'[20] The sophisticated interplay of sound, music, vocal timbre and silence which establishes women's place within social and cultural life in the Arab world is not static; cultural, political and religious variations locate women and men differentially within the conventions of pleasure, power and knowledge. Thus it is that a long-established tradition of women's poetry throughout the Muslim world granted women a respectable forum for speaking and developing exceptional recitation skills, yet, as Marnia Lazreg argued in *The Eloquence of Silence*, women in ordinary life often muted their voices in the presence of men and colonial Europeans.[21]

Throughout the Maghreb and Mashreq, traditions of vocal interpretation have played a key role in the production of meaning.[22] The privileged place of aurality stems both from the long history of poetic intonation, in which women played a crucial role, and the legacy of Islam. The Qu'ran is a heard rather than read text; skilled recitation is highly prized as is knowledge of Qu'ranic verse, demonstrated by the ability of the speaker to intone it with emphasis, bringing the text to life in the listener. This state of enrapt listening has been characterised as *Tarab* or 'enchantment' and implies an intersubjective state, rather than a diametric split between an active speaker and passive listener. *Tarab* can extend to describe the interaction between a great vocal artist and her audience, moved bodily by the performance, as evinced by responses to Umm Khulthum's famous first Thursday concerts.[23] Khultum, known as the 'voice of Egypt', was the best-known and best-loved singer in the Maghreb for fifty years and her concerts were widely broadcast by radio from the 1930s to the 1960s. In the context of cinematic musicals too, Khultum was a pioneer and it is still common in Arab films for song and voice to assume a primary role in driving the narrative and developing characters or meanings.[24]

In *Silences of the Palace*, *Measures of Distance* and *Turbulent*, interplays of sound, song and silence are featured as key aesthetic strategies to voice female subjectivity through collective enunciation and the enchanted space of engaged intersubjectivity.[25] *Silences of the Palace* most obviously depends upon the dynamic interplay between silence and song as its primary form of alternative aesthetic pleasure. The film is centred around the story of a young singer, Alia, who, in flashback sequences, revisits her childhood as the daughter of a servant in the palace of the Beys just before the liberation of Tunisia. Maintaining a knowing silence was crucial to the lives of women who served the Beys and the injunction to remain silent is repeated often within the film, forming a bond between the women. Yet silence is also used to mark the most traumatic disruption of the loving connection between Alia and her mother Khedija; when the daughter

witnesses the rape of her mother, the camera pans to a close-up image of her face as she emits a silent scream at the locked gates of the palace. The shot acts as a forceful comment on the disintegration of female subjectivity through imposed silence and the fateful connection between female silence and masculine control.

By contrast, when the female servants are together, beyond the intrusion of men or any upper-class female family members, their collective pleasure and control is signalled by sound – they ululate, gossip, laugh and sing. The sound of these woman-to-woman spaces, where pleasurable collective enunciation enables female subjectivity to emerge, contrasts markedly with the stifled iteration of women in the company of men or in the controlled atmosphere of formal social events within the film. It is important to note that the women's collectivity does not reside in homogeneity, but in bonding across differences of age, origin and outlook. Indeed, throughout the film much is made of the servants' differing roles within the household and their very different responses to the political unrest of the period.

Alia's voice itself is formed and nurtured through the bonds that she shares with her mother and the other women who serve the Beys, such as the elder Khalti Hada'a. Arguably, for North African viewers of the film, Alia's singing is also formed by a fictional relationship to Umm Khultum, who rose from humble origins to become an icon of nationalist liberation, and whose presence haunted the script at every turn.[26] Throughout *Silences of the Palace*, Alia's voice evokes *Tarab*; she is herself transfixed by singing and those who hear her break off from

Figure 7.1 Moufida Tlatli, still from *Silences of the Palace*, 1994, copyright Moufida Tlatli; photograph, British Film Institute

ordinary activities, caught in the enchantment of the moment. This should not be underestimated as a formal quality of the filmic aesthetics in *Silences*, since, as Shafik argued, most modern Arab films sacrificed *Tarab* for more westernised forms of temporal continuity.[27] Here instead, it is Alia's voice, and its enchantment, which produce the dramatic climax to the film as Alia takes her fascinated wealthy audience on a journey from sheer delight in her beautifully sung melody through to knowledge of their certain downfall as she intones a Tunisian nationalist anthem.

Significantly, it is not the nationalist song which ends the film, but the conjunction of song, sound, silence and voice-over crossing through the final scenes. These complex aural aesthetics articulate the empowerment of Alia as a female subject through her bond with other women, especially her mother. The political events of liberation are described through the collective enunciation of female subjects, in their pleasure, pain and knowledge. As Alia remembers, in flashback, the night she sang of her nation's liberation and left the palace forever with the young radical teacher Lotfi, she also understands, finally, the circumstances of her mother's tragic death during an attempted abortion. The elaborate intonation of the liberatory song merges with the cries of the women's mourning and brings the flashback to an end. Alia is left in the present with the aged Khalti Hada'a and asks once more for confirmation of her father's identity – the ostensible reason for her return to the palace. This is answered, as always, with an absolute insistence upon silence.

However, in a first-person voice-over, directed to her late mother as she walks alone in the courtyard of the palace, Alia is empowered specifically through voicing her connectedness with other women. The use of the voice-over is rare in Arab filmmaking and tends to be a radical device of self-revelation, deployed politically to give voice to collective concerns.[28] Tlatli's final scene stages this powerfully, contrasting the climactic nationalist song with silence, knowledge and self-articulation in the voice of a woman. Alia's words are chosen carefully; ceasing the search for self-verification in the name of the father, she enters into the knowing silence of women, yet asserts her renewed bond with her mother. She attests to her independence from Lotfi and from the whole system of patrilineage (and the patronym) by vowing to have a child on her own and, significantly, to give her the name of her mother, Khedija. Crucially, Alia links her new-found empowerment with her voice: since losing the community of women she had loved, her songs were, as she puts it, 'stillborn'.

In *Measures of Distance*, Mona Hatoum also layered voices with and against sound to express the bond between a mother and a daughter, in this instance, separated by political circumstances beyond their control. Just under fifteen minutes long, the video develops a concise narrative and eloquent aural aesthetics by combining a voice-over of Hatoum reading translations of her mother's letters to her from Beirut with a recording of herself and her mother chatting and laughing together in Arabic. The top-notes are provided by the letters, which are spoken very clearly in English (the work was first made and shown in an Anglophone context) and describe shared, familial bonds, the increasing tensions and violence

during the civil war in Lebanon and the mother's sadness at being separated from her beloved daughter. The soundtrack of their happy dialogue, by contrast, suggests the intimacy of their bond without any particular narrative content. Even for an Arabic-speaking audience, the text of this recording is not fully intelligible as it is heard within the video and instead, it transmits a physical, sensual intonation, resounding with pleasure, laughter and closeness.

These two soundtracks evoke the complex state of proximity and distance characteristic of the mother–daughter bond, yet delineate this with reference to a particular relationship, caught in the real space of international conflict. This aural tension delineates female agency and desire as constitutive of socio-political knowledge. That is, we as listeners come to know of the political circumstances as they are articulated through the personal relationship between two women and, more significantly, as both a distanced, spoken narrative of events and as sensual, aural proximity, pleasure and painful longing. There is no simple separation between what we know rationally, in our minds, and what we know through our bodies in this multi-layered aesthetics of sound. *Measures of Distance* makes the political struggles in Lebanon an integral part of the most intimate woman-to-woman relationship, rather than a blank 'context' for the piece, and thus is all the more effective in its critique.

This is a sensory form of coextensivity, where differences in tone, modulation, and narrative emphasis are not subsumed into one, but set with and against one

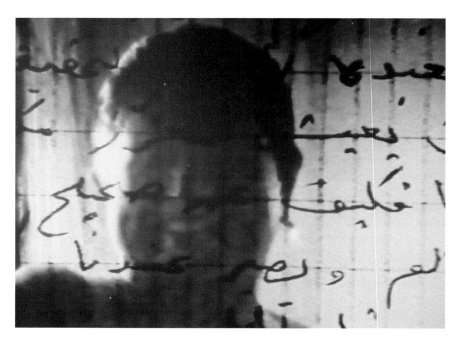

Figure 7.2 Mona Hatoum, still from *Measures of Distance*, 1988, copyright Mona Hatoum; photograph, Tate Modern, London

another to provide productive resonance and knowledge. I would argue that an aesthetic strategy which enables coextensive differences to emerge, is an empowering tactic for the articulation of female subjectivity since assimilative monologues simply render it mute. Moreover, such coextensivity can suggest a more productive model of the mother–daughter relationship, based upon simultaneous identification and individuation rather than a choice between pleasurable absorption or violent separation. In *Measures of Distance*, the literal narrative further reinforces this alternative coextensivity, stressing the desire, agency and pleasure of *both* the mother and the daughter, rather than one forming at the expense of the other.[29] The mother and daughter are collaborators within the pleasurable spaces they create. While photos Hatoum took of her mother in the shower during a visit in 1981 form the main visual content of the video, the letters describe the collective nature of this photo-session, including the intense bond that Hatoum's mother felt with her daughter while they talked together and made pictures, her permission to use the images in a work on public view and her desire to collaborate with her daughter in the future. The power of collective enunciation sustains and develops the creativity of both the mother and the daughter.

The creation of an enchanting, yet politically challenging, aesthetic space through a woman's vocal intonation links *Silences of the Palace* and *Measures of Distance* with Shirin Neshat's *Turbulent*. *Turbulent* is a sound and video installation of ten minutes' duration which poses the question of female subjectivity through song/voice, space and performance. There is a semi-narrative element to the work, effected through two facing screens and two simple, yet connected, sound and visual passages. The video opens on one screen with a man (Shoja Azari) taking the stage to sing a love-song by Rumi, the thirteenth-century Iranian mystic, before a large audience of other men. Although they appear to enjoy the performance, his back is to them throughout and he sings rather to 'us', as the viewers of the piece, and to the opposing screen in the space. On this other screen is a silent woman in *chador*, with her back to the male singer, his audience and the viewers of the piece in the gallery. She stands on a stage in an empty theatre, waiting. As the man's song ends, the woman comes to voice and the camera pans around to face her and provide her an audience. Her 'song' answers his, but is of an entirely different order.

This is no simple lyric put to melody; the woman intones a fantastic collection of vocal elaborations from reverberating breath to mesmerising recitation, passionate harmonics and powerful, full-voice calls. The gallery fills with this voice which resounds, literally, in viewers' bodies in the space, and the men appearing on the facing screen become transfixed by the woman's song. Although the man had sung with a full audience, it is the woman's voice and passionate gestures, 'alone' on stage, which create the pleasurable, enchanted aesthetic space in which we and the actors are enfolded. Female embodiment and collective enunciation are combined in this performance as the sheer physicality of the woman's voice evokes centuries of women's recitation and sacred intonation. But the collective voice summoned to this space is more than that of an ancient female tradition, it is

part of the very technological processes Neshat deployed with her sound collaborator, Susan Deyhim (the singer on screen). Deyhim used electronic and digital means to repeat, amplify and multiply her voice, which literally becomes collective through the recording.

I would argue that these making processes are integral to the meaning and not merely incidental. The fact that Neshat's sound and video installations are collaborative, multi-sensory works, utilising complex strategic devices to explore female subjectivity counters any essentialist rendering of woman. That is, we are not being offered the veiled woman as a singular object to be known or as a universal signifier of 'authentic' identity or passive womanhood. Rather, Neshat poses the problem of female agency as one of competing material and discursive constructions and therefore makes the reorganisation of the senses a political issue. *Turbulent* has, for example, something to say about the loss of power and pleasure (for both men and women) in post-revolutionary Iran where women's public performance is curtailed and sex segregation is enforced. However, even in Iran, this is a complex arrangement, by no means fixed and Neshat also counters commonplace Euro-US constructions of women 'under the veil' as passive, oppressed and homogeneous.[30] She uses sophisticated installation techniques to develop pleasure as a means of knowing in the body and addressing the particular questions raised for female subjectivity in aesthetics.

Aesthetics: pleasure and the embodied eye

While *Turbulent* used sound in specific ways, it is impossible to separate clearly the sensory elements of the work. The effect of voice and sound were enhanced and reiterated by the structure of the visuals which encouraged a more bodily response to the piece as a whole. Indeed, what Neshat's installations offer is a more holistic, phenomenological encounter with cinema where spectators act less as voyeurs, using a mastering gaze to reinforce a sharp subject–object split between the viewer and the viewed, and more as participants, intertwined as embodied subjects within the multiple sensory knowledges produced in the space. Neshat's installations produce unusually sensual spaces in which any simple call to disembodied, instrumental vision, not to mention to the equation of the transcendent 'eye/I' discussed earlier in this chapter, are rendered futile. As Hamid Naficy argued, one result of this multi-sensory vision is characteristic of interstitial cinema's collective look: 'Contrary to much of Western cinema and feminist film theory, the gaze in Neshat's films is not personal but social.'[31]

Vivian Sobchack has written eloquently of a phenomenological approach to cinema which takes intersubjectivity and embodied spectatorship as its keynotes.[32] Sobchack argued that our cultural dependence upon instrumental vision makes us view our bodies as images or objects rather than experience them as multi-sensory, proprioceptive instruments making 'sense in and of the world'.[33] This leads to destructive forms of 'epidermalization', which evict subjects from the empowering place of their embodiment. That is, subjects who lose the sense of living in and through their bodies, gauging their very existence as a function of

Figure 7.3 Shirin Neshat, *Turbulent*, 1998, video stills copyright Shirin Neshat;
photograph, Barbara Gladstone Gallery, New York

'being seen', lose the cornerstone of subjectivity itself. Following the work of Audre Lorde and Charles Johnson on racist vision, Sobchack explored 'epidermalization' as an interaction between the social and the psychological. Racism, for example, brutally alienates subjects from within as they learn to recognise themselves as despised others through the debilitating vision of bigotry.

It is more useful, however, to think of an exchange between proprioception and epidermalisation than it is simply to reverse the terms from 'being seen' to 'seeing'. Experiencing one's own body as subject *and* object can be envisioned as a productive modulation and one which is also an intrinsic element of art-making. To draw, for example, requires an interaction between these two forms of attention as you work through the body and monitor its actions in quick succession.[34] As Sobchack suggested, challenging objectification and singular identification with the skin-surface does not entail rejecting all forms of imaging, but rather, 'that we recognise vision as embodied and representable not only in its objective dimensions as the visible skin of things, but also in those subjective dimensions that give visual gravity to us'.[35] Strategies which enable these subjective dimensions to emerge have a particularly significant role to play for those subjects who, historically, have been most determinedly defined as objects of the instrumental gaze – women, gay men and lesbians, and racialised others. It is also part of any strategy to produce visual art, since moving between subject and object positions characterises the experience of making. Thus, calling upon aesthetics to evoke pleasure through non-mastering visuality and addressing the subject-status of 'Oriental' women, is clearly ingenious and effective.

Additionally, it connects the articulation of difference with situated knowledge. Just as there is no essentialised 'veiled woman' delineated by Neshat's work, there is no monolithic, 'correct' or 'authentic' interpretation; interpretations are processes, formed at the point where embodied spectators and their located knowledges meet the articulation of pleasure and difference in the work. Neshat made this clear by differentiating between her western (primarily US and European) audiences and those within the Islamic nations of the Middle East. Significantly, she acknowledged both that they may read slightly different things into the work and that they are perfectly justified in so doing.[36] Similarly, Tlatli recognised that women in North African and Middle Eastern nations enjoyed *Silences of the Palace* for reasons determined by their historic relationship to Islam,[37] yet, in an interview with Laura Mulvey, discussed the possibility that a 'woman's gaze' was present in the film.[38] Using this terminology in discussion with Mulvey demonstrated that Tlatli was aware of western feminist film criticism and could envisage her work crossing cultural borders with ease.

Multiple and shifting contexts were crucial to *Measures of Distance* as well, concerned as it was with materialising distant political events in and through relationships between particular, situated subjects. The war in Lebanon, and by extension on-going conflict in the Middle East, are not simply figured as peripheral global events, disconnected from viewers in the gallery. Rather, Hatoum's work addressed international political crises through cross-cultural perspectives on gender, sexuality and female embodiment. The work emphasised the bodily

basis of knowledge by maintaining productive tensions between competing discourses of 'East' and 'West', subject and object, within the piece. For example, the work is intimate and autobiographical, yet never disconnected from the wider frame of history and politics, the focus on maternal agency refutes the banal massification of Arab women typical of western media coverage, yet, casting the mother as a nude bather does not deny the conventional iconography of Orientalism. These tensions typify the embeddedness of interstitial cinema and refute either a simple call to the 'authenticity' of the work or any singular oppositional position.

Significantly, some western feminist critics reacted negatively to the piece when it was first shown, arguing that Hatoum had merely objectified her mother and any image of a naked woman was an invitation to a masculine, mastering gaze. However, this argument replicates the subject–object logic of the gaze and misses the more subtle visual strategies of *Measures of Distance*. In *Measures*, Hatoum constructed viewing as a fully sensory experience using still photographs of her mother bathing in various visual structures: extreme close-up, framing distance, both at once and all made thick through the layering of Arabic calligraphy (from the mother's letters) on the surface. This tactile vision has been termed a 'haptic' aesthetics[39] and counters the subject–object logic of the gaze through an embodied process of looking.[40] The strategic ambivalence between the mother's body as desired object and as embodied subject allows no resolution of the 'Arab woman' as knowable, readable or containable. Just as the piece places a number of different constructions of 'woman' into dialogue across cultural, political, aesthetic and generational lines, so too it interpellates viewing subjects as hybrid, embodied and embedded within the processes of interpreting or 'knowing'. The work calls into question the very premise upon which representations and images might be judged as 'positive' or 'negative' once and for all.

Neither politics nor philosophy are abstract entities; as they move across times and places they change, respond and develop materially and conceptually. Similarly, interpretation and criticism are not a grid through which artworks are sieved, but processes of engagement or, to borrow Edward Said's term, modes of 'travelling theory'.[41] Neshat's installation and Hatoum's video draw on pleasurable, haptic aesthetics to shift the viewing relationship from instrumental to embodied, thereby reinstating the significance of corporeality to knowledge. Corporeal theory, bearing the material traces of travels from place to place, does not resolve as a unity. The specificity of sexual difference, as the trace of particular bodies and embodiment (not 'the body'), leaves its mark on aesthetic practices giving them the potential to reorder sensory hierarchies and materialise the 'inter' or in-between. Materialising this 'inter' space has radical ramifications for both the articulation of female subjectivity and for the interpellation of subjects-in-process.

Aesthetics: pleasure and 'inter' space of corporeal theory

There is an important temporal aspect to thinking of subjects, knowledges and aesthetic pleasures as corporeal processes. Mieke Bal particularly connected temporality to the embodiment of vision engendered by works of art:

> The mobilized body, conjured into participation qua body, is the same body whose eyes are doing the looking. Hence, in contrast to the disembodied gaze we have learned to cast on images, the gaze that is a-temporal and does not even know it has a body let alone a body involved in looking, this other mode of looking imposed itself. It was not only a desirable gaze for this work but also the only possible one the only one that leads to seeing.[42]

In *Silences of the Palace*, *Turbulent* and *Measures of Distance*, the temporality of embodied looking creates particular kinds of pleasurable aesthetic spaces – spaces we might not 'see' in the a-temporal frame of the gaze. Using time strategically, the 'inter' is materialised as a productive locus for looking, making and knowing. This is especially significant in thinking about the ways in which Tlatli, Neshat and Hatoum reorder pleasure and the sensorium to envisage female subjectivity which might otherwise remain unseen. This other mode of looking might well be the only one that leads to seeing the radical potential of such 'inter' spaces as the international frame of politics and art, the intercultural crossings of 'East' and 'West', interstitial cinematic practices and the intersubjective, corporeal engagement with the world.

US critics of *Silences of the Palace* frequently remark on its 'sluggishness',[43] unaccustomed to the timing usual in Arab and African filmmaking. However, the 'slowness' of Tlatli's film was more than just a typical feature of Tunisian cinema. The pace of the film is an aesthetic strategy designed to produce an in-between which connects pleasure with agency. The film as a whole operates in this mode through the device of the flashback, framed by brief periods in the diegetic 'present'. The shifts from the narrative present to the past occur through temporal gaps created, in nearly every sequence, by some corporeal memory trigger, such as Alia touching her necklace, strumming a lute or feeling the weave of linen. Time is thus fashioned as much through corporeal pleasure and memory as by any distinct reference to diegetic or extra-diegetic events.

This bodily time characterises the visual logic of the film as well, making the 'palace' into an in-between, 'inter' spatio-temporal zone. The visuals of the film construct both detailed 'accurate' accounts of the period and reverie-inducing, voluptuous spaces. The flashback sequences occur during the period after Egypt has been liberated but before the French are forced out of Tunisia, or between 1954 and 1956, and the diegetical present is ten years after this. That temporal specificity is mirrored by the careful delineation of the social order maintained between family and servants in the palace and the visual details of fashion and interiors (even electrical appliances) which locate the narrative. However, time stops when Alia sings, or in the scene where she and her young friend are

mesmerised by the beauty of her mother dancing, or as she rushes into the court-yard to spin and spin until she faints in the sun.

Hence, the 'palace' is a realistic historical location for the action of the film and much more at once. It is a rich space of memory and desire, the limits of the 'world' for those who never leave its grounds and a space defined by a temporal logic incongruous with the socio-political upheaval of colonial revolt. When the incommensurate spaces and times converge at the nexus of the 'palace' it becomes an in-between place. Female agency emerges in this 'inter' zone, as a hybrid and contradictory collection of ambivalent forces. For example, in a fascinating scene of explosive contrasts, the pubescent Alia and her closest friend Sarra (legitimate daughter of one of the Bey princes), spy on Alia's mother dancing for a private party of the Beys. The scene is entirely carried by the sound of the music, the dance and exchanges of looks – there is no dialogue. The mother's dance inspires lust and desire on the part of the men who watch, jealousy and envy from their wives, but, crucially, absolute fascination from the young girls. The girls' rapt attention gives way, in Alia's case, to a scene of kinaesthetic mimesis in which she dresses up and begins, tentatively, to move as the womanly mother. Clearly, the scene is wrought through the contradictory elements of power and pleasure; the sensual dancing woman is the object of masculine desire and their possession (literally), she is a recognisable trope of the colonial exoticism of the orient and she lives in silence. However, even that overdetermined image can be re-cast through the active pleasure of the girls, transfixed by the performance and the connections it makes with their bodies.

The 'inter' space of the palace is thus productive of knowledge through the senses, arguably the only kind of knowing which can bring hybrid female subjects into view without negating the discontinuous and iniquitous processes through which they emerge. Similarly, the enfolding of viewers and the viewed in Neshat's *Turbulent*, materialises the 'inter' as the very locus of proprioception and critique; as Farzaneh Milani put it, 'Neshat creates a space in-between.'[44] The dual screens reference the rigid lines of demarcation between gendered spaces in contemporary Muslim fundamentalism, yet the interaction between these spheres continually disrupts their boundaries and creates new and unexpected pleasures. As Fatima Mernisi suggested, women, Islam and feminism interact dynamically around space, sexuality and power in contemporary Muslim culture and it would be mistaken to see relationships between men and women as static or eternal.[45] Moreover, they do not simply replicate the male–female dynamics prevalent in the west. Neshat's installation enables a participatory experience of the 'inter' she is exploring; we are enworlded with other subjects and our knowledges of sexual and cultural difference are revealed to be partial, perspectival and located rather than universal. The in-between mobilises pleasure as the encounter with differ-ence, rather than an illusion of complete, mastering knowledge.

Measures of Distance also invokes an 'inter' spatio-temporal zone through the conjunction of disparate times and places. Close physical proximity to the naked body of the mother suggests the intimacy of infancy and undifferentiated desire, as well as the inevitable stages of individuation. The bathing scene too evokes

multiple encodings as a personal space devoted to the pleasurable care of the self, a site of archetypal 'orientalist' desire for woman as exotic other and an historically significant space in Arab culture where women meet, speak freely and develop a sense of 'self' in and with other women.[46] Of course, in *Measures of Distance*, all of these times and spaces are interconnected and modulated by the specificity of the historical moment and the autobiographic narrative frame. Again, female subjectivity is conceived at the nexus of multiple boundaries and practices, as embodied and in process.

As Homi K. Bhabha argued,

> . . . we should remember that it is the 'inter' – the cutting edge of translation and negotiation, the *in-between* . . . – that carries the burden of the meaning of culture. . . . It is in this space that we will find those words with which we can speak of Ourselves and Others. And by exploring this hybridity, this 'Third Space', we may elude the politics of polarity and emerge as the others of our selves.[47]

By negotiating the many 'inter' zones which locate the 'Arab woman' and the practices of women's film- and art-making as they cross national, cultural and social divides, Hatoum, Tlatli and Neshat demonstrate the power of these 'Third Spaces'. It is here that women's agency and aesthetics collide to rework the stagnant sensory hierarchies around instrumental vision and to formulate female subjectivity through pleasure as well as critical thinking. The aesthetic intervals materialised by these works do not provide a final resolution between differences or translate one culture into the terms of another, but they enable us to explore our embodiment and location as crucial factors in making knowledge.

8 The word and the flesh: text/image re-made

> The self-images of knowledges have always been and remain today, bereft of an understanding of their own (textual) corporeality. They misrecognise themselves as interior, merely ideas, thoughts and concepts, forgetting or repressing their own corporeal genealogies and processes of production. Knowledge is an activity; it is a *practice* and not a contemplative reflection. It *does things.*
>
> (Elizabeth Grosz)[1]

To conceive of knowledge as a practice challenges the legacy of western dualism, in which rationality is seen as abstract, 'interior, merely ideas', and is set above and against sensual, embodied understanding. This self-same logic underpins other key oppositions which enable the conceit of a disembodied, universal episteme to flourish: form over matter, masculine over feminine and, significantly, word over flesh. Structurally, such binary oppositions marginalise aesthetics by implying that knowledges gained through the fleshly senses are secondary to, and even possibly in need of 'correction' by, those articulated by the disembodied, rational word.

It is not coincidental that Grosz referred above to '(textual) corporeality'. This phrase in particular invites us to rethink the opposition between word (text) and flesh (image/object). Grosz's parenthetical phrasing signalled the primary role which text has played in disguising the connections between thought and the body such that linear, progressive narratives of universal truth, unencumbered by their material origins and vested interests, could be seen as stable and natural. The sacrifice of the flesh in favour of the word has a long history, connecting classical western philosophy with the Christian opposition between body and soul. In more recent history, words have been decorporealised through both processes of production and consumption – through technologies of print and practices of reading which evolved over a lengthy period to effect a 'transparency' of the word.

As Barbara Stafford argued, text-based knowledge systems came to prominence through the slow but certain denigration of imagery, reaching a high point in the wake of the Enlightenment.[2] For Stafford, the connection between an increasing reliance upon truths carried by transparent text and the corresponding negation of the 'mere spectacle' of visual and material culture is profound; the triumph of

rationalism over aesthetics carried moral, political and epistemological weight. Even conceiving meaning in terms of legibility and, to a slightly lesser extent, visibility ('oh, I see' rather than 'yes, I touch'), reiterates the dominance of text over matter and, of course, our current relationship to the arts, the senses and visuality have been formed by this unequal partnership.

In *The Visible Word*, Joanna Drucker took up the problem of textual transparency as a theoretical stumbling block for those who sought to explore the development of typography. Arguing strongly for an analytic method which would take the materiality of text seriously, Drucker wrote:

> The notion of linguistic transparency implies *immateriality*, . . . [that] nothing of linguistic value is contributed by the form of the written inscription which serves merely to offer up the 'words' in as pure and unmediated a form as possible. The act of repression on which this act depends is monumental, really, since it requires continual negation of the very evident fact of the existence of what is immediately before the eyes in the name of its signified value.[3]

Drucker is here working through both the troubled relationship between text and image, exacerbated in the case of avant-garde experimental typography, and the historical phenomenon of the transparency of text. Significantly, she points out how nineteenth-century breakthroughs in deciphering 'dead' languages actually increased the sense that the real meaning of text lay in its system of signifieds, not its signifiers. Christopher Collins has suggested that a similar disjunction between the physical qualities of text and visual imagination became more acute after the invention of movable type and standardised print:

> In an age before standardized print, the chirographic peculiarities of the text could distract the visual centers of the brain from the imaginal signifieds to the graphic signifiers; illuminated manuscripts, not to mention pattern poems, forcefully drew attention to the written surface of an object . . . [with some] exceptions notwithstanding, standardized print since the late sixteenth century increased the transparency of graphemic signifiers and enhanced the production of imaginal signifieds.[4]

The development of so-called 'print culture' in early-modern Europe has been the subject of much scholarly debate. Elizabeth Eisenstein's classic work on the subject, *The Printing Press as an Agent of Change*, detailed the intimate connections between the development of a fixed canon of authoritative texts and the formation of increasingly stable knowledge systems during the Renaissance and Reformation.[5] In his recent work on printed text and developments in the natural sciences, Adrian Johns also acknowledged the importance of the seeming transparency of printed text to the history of science while arguing strongly that this was in no way an intrinsic feature of print. Importantly, he argues just the opposite; the experience of the transparency of text, through which we

assure the veracity and fixity of our transmitted knowledge systems, is contingent:

> . . . the very identity of print itself has had to be *made*. It came to be as we now experience it only by virtue of hard work, exercised over generations and across nations. That labor has long been overlooked, and is not now evident. But its very obscurity is revealing. It was dedicated to effacing its own traces and necessarily so . . . A reappraisal of print in the making can contribute to our historical understanding of the conditions of knowledge itself.[6]

What is effaced when we read *through* printed type, forgetting the corporeal processes by which it came to be made, is the matrix – literally and figuratively. In printing, the matrix is the block from which letters, words or images are pressed; it physically substantiates the negative of words and images. 'Matrix', of course, comes from the Latin for 'womb' and shares a root with 'matter', the term commonly opposed to 'form' in dualist thinking. When we suppress the matrix then, we negate a surfeit of terms associated with corporeality: matter, mother, woman and the sensuous base of knowledge through the flesh.

Textual transparency also ensured the historical production of a gender-neutral reader. For example, during the Reformation, when printed books became more readily available, many women had their writing published as a means by which to voice alternative political, religious and social opinions.[7] These texts were premised upon the specificity of their author's position and their dissenting strategy emphasised that these were women who were speaking from a particular, not universal, situation. Their use of the book was fully corporeal and frequently oppositional.[8] Not surprisingly, censorship laws were quickly introduced to quell such thriving adverse dialogue. Even more insidiously, printed books became the realm of a far more limited group of authors who assumed impersonal voices and universal speaking positions. The disembodiment of the author enhanced the transparency of the text itself and the interpellation of the gender-neutral reader – both of which led to the textual disenfranchisement of women and other subjects speaking with alternative or dissenting voices. The assimilative strategy of effacing corporeal genealogy in the body of the text silenced difference.

If printed text can efface matter fully and be rendered transparent in itself, then form will be transmitted uncontaminated by its corporeal genealogy. Or so knowledge systems based upon binary logic would have us accede. But this conventional denigration of flesh by word is untenable if we take seriously the challenge to move toward thinking knowledges as practices and explore the materiality of theory. Words and texts do not simply transmit ideas, they materialise them or, as Maurice Merleau-Ponty said, '. . . speech, in the speaker, does not translate ready-made thought, but accomplishes it'.[9] Alphonso Lingis argued still further that one's word is honoured by, formed through and formative of the body; to distinguish the corporeal speaker from performative speech is to misunderstand the foundation of agency.[10] For women making art, and for feminist

art historians and critics, a formulation of the text–image relation which does not negate body, matter or matrix has powerful ramifications.

These ramifications can be made explicit by turning to particular instances in which women artists have adopted printed text as matter in making art. Both Ann Hamilton and Svetlana Kopystiansky have used books and printed text as materials within object- and performance-based installations. Their work articulates the very corporeal genealogies which were so forcibly 'forgotten' to remove the flesh from the word. They use aesthetic strategies which return both books and reading to the body and make knowledges part of a fully sensual encounter with text. Reworking text/image paradigms in aesthetic configurations, Hamilton and Kopystiansky demonstrate both how text can *matter*, in the widest sense, and how the book can be thought more productively as a process, enabling different subjects to communicate without sacrificing their corporeal specificity.

Reading matter

During 1993 and 1994, the US artist Ann Hamilton produced two major installations, *tropos* (Dia Center, New York, 1993) and *lineament* (Ruth Bloom Gallery, Santa Monica, 1994). A key feature of many of Hamilton's installations is the presence of the artist and/or attendants performing a repetitive gesture which forms a focal point in the space – the repetitive gesture of both *tropos* and *lineament* was the reading of printed books.[11] Significantly, the act was not simply to read *through* transparent texts, but to have gestures return the body to the book by reinstating reading as a fully physical, multi-sensory act. In his astute assessment of Hamilton's altered book works, Buzz Spector referred to the ways in which the artist's 'procedures concretize the behaviors of writing into the presentness of art'.[12] Hamilton's reinstatement of the physicality of writing/reading in these performance spaces refuses to efface the labour of printed text and thus speaks eloquently of the practices of knowledge.

In *tropos*, the reader (sometimes male, sometimes female) was located in a huge open space, the floor of which was inclined slightly and strewn with horsehair. The transparent windows were replaced with frosted glass so that the light source became more muted, just as the spectators' footfalls were made strange by the organic matting. The scent of the horsehair permeated the space and was joined by a burning smell – as the book was heard aloud in a recording, its text was charred with a precision burnishing tool by the silent reader, working at the speed of the hand, not just the eye. The sound of the words being formed[13] thus merged with the repetitive task of the burnishing, evoking the lived experience of reading and memories of hearing the read word as spoken.[14] *tropos* thus centralised reading as a practice, invoked through all of the senses[15], which refuses to delineate the printed word as a mere vehicle of ideas. Indeed, the title of the installation, derived from 'tropism', the instinctual response of sentient beings to environmental stimulants, such as light and heat, tied the act of reading even more intimately to the full, sensory corporeality of the reader and the participant spectator in the installation.

lineament placed the figure of the woman reader as the central performance gesture of the installation, but here Hamilton's 'reading' was a materially productive act. In *lineament*, the reading gesture 'unwound' books and recomposed them as 'bookballs', or, as Hamilton began to think of them during the course of the installation, 'bodies'.[16] Books were carefully pre-sliced so that the lines on each page formed a continuous strand of physical text, a 'narrative thread' made material. In performance, Hamilton and attendants extracted each of these filaments from the books, unwinding their narratives, and re-winding them as a ball of printed thread. Hamilton thus enacted women as resisting and recovering readers, rejecting gender-neutral paradigms. Feminist literary scholars have also countered the concept of the gender-neutral reader by pointing to the ways in which women negotiate the ostensible universality of texts through their situated knowing, recovering the eccentric, marginal meanings inscribed in even the most canonical works.[17] When *lineament* deconstructed the conventions of disembodied, gender-neutral reading, it re-made the very matter of the text.

Each 'bookball' made during the installation was put onto a large table-top, through a slot in a semi-transparent screen separating the reader from the table, so that the cumulative effect was an encounter with a collection of stories, worked by the reader/artist into delicate narrative-thread objects. The material connections between the objects on the table suggest a dialogic context for the work; histories are never complete or whole in and of themselves, but make meanings in their interaction. Hamilton's titles themselves participate in this logic, always spelt in lower-case like the poetry of the imagists who saw their verse as segments from a larger universe of ideas. The title *lineament*, specifically, was taken from 'The Planet on the Table', a poem by Wallace Stevens which centres on the intimate connections between poetry and the world:

> It was not important that they [the poems] survive.
> What mattered was that they should bear
> Some lineament or character,
> Some affluence, if only half-perceived,
> In the poverty of their words,
> Of the planet of which they were part.[18]

Hamilton's 'bookballs' are planets on the table, the gigantic in the miniature. These texts, read, touched, un-made and re-made, bear their connection with the world in their material form. These planets are invested with bodily memory through aesthetic praxis, or as Hamilton put it: 'The work part of it, for me, is a way of understanding something in a way that isn't thinking it.'[19]

This juxtaposition between 'understanding' and 'thinking' suggests a mode of corporeal knowing, where the 'work' of the body through its senses and agency is crucial to thought. In Hamilton's own suggestive phrase, this is a 'tactile knowledge', demonstrating knowledge as a practice to move beyond dualism rather than simply reverse its privileged terms.[20] Describing Hamilton's installation work, Joan Simon argued that it 'always focuses on the way a body of knowledge

Figure 8.1 Ann Hamilton, *lineament*, detail, balls of wound text, 1994, copyright Ann Hamilton; photograph Robert Wedemeyer, courtesy of Sean Kelly Gallery, New York

is generated, contained, perceived, absorbed'.[21] The balls of wound text resulting from the installation *lineament*, provide a useful locus for thinking more critically about how aesthetics can corporealise knowledges, by focusing on processes of generation and perception.

Both the installation *lineament* and its untitled 'objects', balls of wound text, join agency and matter as practices of textuality, so that the gestural processes and their resultant objects are intertwined, rather than autonomous. The 'bookballs' have not been produced by a transcendent subject's disembodied thought, but by the material engagement of the subject in the world. Spectators thus encounter in this work a parallel to the cognitive problem of reading itself, in the sense that reading is performed more easily when the materiality of the text itself recedes from view. In each ball of wound text the physical practice of reading is continually re-enacted as a part of an aesthetics; we cannot render the corporeal processes and practices of knowledge which have formed these objects transparent. Thus the transformation of base matter through formulary words is here reinscribed as an interactive, generative process through which textual objects are reconnected with their materiality.

The acts through which Hamilton reconnects books with their corporeal genealogies are never random; she revisits the effacement of the feminine by the masculine, matter by form, and counters its monolithic logic. Hamilton's own career was caught up in the gendered languages of art practice and her

negotiation of these parameters demonstrated her ability to connect text and text-based theory with materiality and 'women's work'. For example, the reading figure who winds thread in *lineament* is a reminder of the earliest visual icon of women's textile practice – the woman spinning. This icon has personal and political significance; after studying geology and literature, Hamilton turned to textiles, pursuing a degree at the University of Kansas. When she undertook postgraduate work at Yale, however, she felt an implicit pressure to reject her long association with domestic or craft activity: 'Everyone is making big steel stuff, so you don't really feel like knitting. It's all very unspoken.'[22]

The negation of domestic work was in part embodied by these contrasting materials – steel as opposed to knitted fabric – but also in part by the academic environment itself, in which intellectual practice, or 'theory', can be conceived as a purely abstract field of enquiry. In such an environment, books, as symbolic containers of masculine, transcendent knowledge, are empowered over knitted textiles, or any other product of women's traditional craft work. Hamilton's combination of monumental installation spaces with the materials and activities associated with domestic labour, reworked the terms of this dichotomy and *lineament*'s return of printed books to matter through 'spinning' posed an explicit intervention into the gendered division of art from theory.

Like Hamilton, Svetlana Kopystiansky used performance and installation to re-examine the corporeal locus of printed matter, but her explorations were framed by a very different set of historical parameters. As Dan Cameron suggested, Kopystiansky's work provides 'an extended meditation on the cultural identity of The Book',[23] yet it would be mistaken to imagine the book as a unified or monolithic signifier within her practice. While books are ubiquitous in Kopystiansky's work, they never signify in the same way and instead provide eloquent insights into the corporeal genealogies of contested spheres of knowledge.

Kopystiansky's early forays into scripto-visual practice during the 1980s resulted mainly in a body of written landscapes; pictorial renderings of mountains, valleys and plains composed of line after line of tightly scripted text, some darker, some lighter, used to form the image. She swiftly moved from hand-written, gestural pieces to the use of printed books in performances and object-making, but retained her fascination with the unequal relationship between art and text, arguing that 'literary models have too much weight over art'.[24] Using her work to undermine the domination of art by text, Kopystiansky was also staging an intervention into the canonical traditions of Russian literary culture, which had reached its pinnacle of privilege over the visual arts during the nineteenth century.[25] In large part, this privilege was attained through the separation of elite literature and high culture from the manual skills and requirements of both the visual arts and everyday material culture.

By contrast, the Russian avant-garde of the 1920s, which both Svetlana Kopystiansky and her husband Igor note as an important influence, stressed the interconnectedness of art and life and the significance of art as a means to change the very conditions of knowledge and understanding for a mass, international audience.[26] In 1990, Kopystiansky produced the performance piece *The Ironed Books*,

in which she carefully ironed the pages of printed texts and then left them, fanned open as beautiful objects, on the ironing board. Like Hamilton's 'bookballs', the object and the process are not simply separable, but entwined as the practice of making meanings. *The Ironed Books* brought the most banal, everyday, domestic chore into direct and immediate contact with high literary culture and transformed the objects into a work of art. This act confounds any simple separation of text from matter and process and performs a sophisticated intervention into the histories of the Russian cultural *milieu*.

But the interventions Kopystiansky made with her book objects and performances were by no means singular or simply the response of a young dissident artist to Russian high culture. Significantly, the Kopystianskys were a generation younger than the best-known dissident artists of the pre-Perestroika period such as Ilya Kabakov, and did not originate from Moscow (Svetlana came from Voronezh and Igor from Lvov), though the city became their home. In this sense, both Svetlana and Igor maintained some distance and independence from the dissident art scene as well as from the official delineation of Soviet cultural life. Their interest in the international modernist avant-garde and Russian absurdism, in addition to their active engagement with, rather than rejection of, the tropes of elite culture (for Svetlana, books and libraries, for Igor, painting and museums), encoded their work multiply. Moreover, Svetlana Kopystiansky, as a woman artist who worked first tangentially within the pre-Perestroika dissident art scene and now participates in the contemporary, 'global' art market, using New York as her base, confounds both a simplistic Cold War and after, 'oppressed' vs. 'free', artistic divide and a linear narrative of women in the arts.

The Ironed Books referenced these diverse histories of production, consumption, meaning and power, bringing together the powerful legacy of Russian literature and the oppositional stance of constructivism, the oppressive censorship of 'official' culture under autocratic governments and the absurdism of Dada readymades, the intellectual conventions of conceptual art and the banal repetitive labour of women in the home. The work thus engaged with history itself as a material practice, utilising past histories to create new narrative spaces in the present.

There is not a clear divide between the form or the content of the books Kopystiansky uses in her work and she does not find in the book a singular symbol, either of culture, censorship or the historical record. Kopystiansky's work enables us instead to think of books as complex aesthetic processes in the making, what Deleuze and Guattari have described as 'a little machine'.[27] The artist herself drew on Borges to articulate this:

> A serious book has many meanings, and the combination of several serious books creates a network of complicated correlations of meanings . . . Borges said: 'A book isn't a closed essence, but a relation or more precisely an axis of endless relations.'[28]

There are further resonances here with Ulises S. Carrion's radical conception of

books which go beyond being 'accidental containers of words' and become 'autonomous space-time sequences'[29] and with Deleuze again, when he argued that writing 'has nothing to do with signifying. It has to do with surveying, mapping, even realms that are yet to come.'[30]

Once the book is opened to these radical formations, it ceases to be a transparent carrier of universal (read masculine) ideas and becomes a fully corporeal element in a system of meaning-making, open to difference and specificity. Aesthetic strategies, like those of Hamilton and Kopystiansky, which reconnect the bodily, performative effects of reading and making with the matter of books, offer an opportunity to think of printed text in more dynamic, relational ways. But thinking books as 'autonomous space-time sequences', 'little machines' for 'mapping and surveying' or an 'axis of endless relations', is not necessarily straightforward. In the first place, such conceptions of the book might work

Figure 8.2 Svetlana Kopystiansky, *The Ironed Books*, 1990, courtesy of Svetlana Kopystiansky

against the reinstatement of the corporeal and toward a new kind of dematerialised textuality, one which encourages endless configurations of autonomous, free-floating signs. Additionally, it is difficult even to imagine experiencing the book in a way commensurate with these theoretical positions: how might this work in practice? Still, the importance of experimenting with the potential of the re-corporealised book as a space-time sequence should not be underestimated. Indeed, it is here that I would argue most strongly that the combination of processual aesthetics, feminist politics and the articulation of difference might operate to surmount both the traditional binary dead-end of word against flesh and the threat of empty, a-historical becomings.

The book in the expanded field

It is not coincidental that thinking the book as a process leads to repeated references to cartography and to conceptions of the book as spatialised and relational. Space and process can be brought together through the trope of mapping to explore the book as a social forum, open to diverse readers/subjects, engaging materially and dialogically with ideas. However, working with this dynamic concept of mapping rejects the more commonplace idea of maps as fixed and correct descriptions of spaces beyond the particularities of histories and bodies. Cartographic projects premised upon disembodied knowledge of the world and its contours are not relevant to the spaces we wish to describe through textual corporeality, since such maps assimilate all differences into a monolithic system. Instead, I am arguing here that the spaces of books as processes might be explored more effectively through aesthetics; embodied and sensory models which emphasise the act of mapping, and the situation of the subject who maps, are more pertinent to the book as a space through which difference can be articulated. Here we can see the radical connection between feminist ethics and aesthetics very clearly in the relationship between locus, creative agency and political engagement. This model does not deny the significance of the map – that subjects are located by the contingencies of specific histories, material conditions and circumstances beyond their individual control – yet neither does it deny the possibility of changing those maps.

In 1991, shortly after moving to Berlin, Kopystiansky produced two site-specific, mapping projects which used books as a means by which to address the transitional moment of reunification. In the Humboldt University Library, in what had been East Berlin, she folded books backward to partially expose their texts as spines and replaced them on the shelves of the collection, which was being re-stocked to suit the changed political climate. Readers encountered these suggestive objects in amidst the rest of the books as they searched for titles. In a very subtle shift of emphasis, the books resisted their readers' familiar and naturalised scanning for meaning, they stopped being transparent and they began to trouble the space of the library, and of course the very concept of the University, as a unified system of knowledge. This opened the space to dispute, discussion and debate forcing the readers to re-map the library itself.

The resonances between the transformed Humboldt Library and the trans-formations which Berlin was experiencing during the process of re-unification are obvious. Berlin's Humboldt University was the model upon which many of the national European universities were founded, with its emphasis upon the human-ities as the basis of an established, unified national culture. This concept of cul-ture, while still desired by many, was certainly not uncontested in the period following the Second World War and the utter devastation of the Holocaust. Berlin itself, as the former capital and divided city, was the symbolic centre-piece of unity, but also a city inscribed by its turbulent, traumatic and fragmented past. There were not just two sides in re-unification and the discussions were never simple or fully transparent. Re-unification as a political action implied a process of re-mapping, both literally and figuratively. These new maps needed to work with, in and through the many complex overlayed histories and material conditions of the past and present in order to make a future. It was a cartographic problem of participation, since the new maps needed not only to determine the possible interactions between subjects, but to invite them into new communities.

Kopystiansky's 1991 Berlin book installation *Café Einstein*, was one such dynamic and participatory space. The Café Einstein is located on the Kurfürsten-strasse in the western suburb of Schöneberg, the development of which, during the inter-war years, was seen to be a distinct sign of economic prosperity and technological innovation. Schöneberg was linked to the centre of the city by the new urban railway and quickly became a cultural district, full of artists' studios, galleries, shops and of course, cafés. Kopystiansky worked with the site, using only subtle strategies to exacerbate tensions and readings at the point of reunification. Significantly, she worked her transformation of the space through the book.

Café Einstein was defined simply; on each dining table, there were four place-settings, one facing pair were set with ordinary plates, glasses and utensils while in the other facing pair open books replaced the plates. Juxtaposing the activity of dining with that of reading articulated the room through a host of resonant, yet divergent, historical motifs. These played the city's capitalist success against its powerful communist heritage and made reference to both the freedoms Berlin has granted its citizens and their suppression. For example, the negative sugges-tion of the greedy consumption of commodified knowledge in capitalist culture is countered by the suggestion that books feed the spirit; the work refuses an easy accommodation of the mind-body split. The social activity of dining out is held in tension with the highly individualised experience of reading a book, the corporeal pleasure obtained in the space being entwined with the intellectual.[31] These refer-ences re-animate Berlin as the zenith of modern Europe's underground nightlife as well as the home of extraordinary scholars, as the turbulent site of the Weimar Republic's capital, replete with pitched battles between communists and fascists, and a city brutally divided after defeat in war. Berlin's past and present are con-joined in this space as they would have to be in re-unification – corporeally, partially and insolubly.

Without providing answers to the problems which faced Berlin and the whole of Germany on the eve of re-unification, *Café Einstein* did invite dialogue centred

around the book as 'an axis of endless relations'. The use of books to articulate space in *Café Einstein* reiterates the fact that re-unification, and indeed any international negotiation, goes far beyond the re-mapping of territory to the very possibility of cross-cultural narrative and communication. Paul Ricoeur's thinking on narrative as a cross-cultural praxis, imply that the assimilation of difference in 'translation' negates dialogue.[32] Ricoeur's position emphasises the significance of corporeal specificity as a prerequisite of exchange and communication across differences. His insights suggest that meta-narrative will not produce dialogue; a genuinely international political sphere can only be formed through genuinely new modes of communication. Mapping is such communication, and books, conceived as open-ended mapping processes, entail the very dialogue with location needed for international change.

While I would not want to suggest that the re-unification process was wholly positive, let alone utopian, I am interested in the kinds of spaces, both political and aesthetic, which began to be mapped by artists, intellectuals and politicians who tried to think creatively about that moment and the wider problems of cross-cultural dialogue. It is not surprising to me that a woman artist, committed to international dialogue, addressed new narratives of difference through a strategy which corporealised books as cartographic spaces. Women, coming into contact with teleological conventions of narrative, translation and assimilative universal norms, by needs must find spaces which negotiate their situations and knowledges across static boundaries, re-mapping them and their positions in the process.

Figure 8.3 Svetlana Kopystiansky, *Untitled (installation in the Café Einstein, Berlin)* 1991, courtesy of Svetlana Kopstiansky

Indeed Schöneberg and the west of the city had a particularly important role in the life of Germany's 'new women' in the years following the First World War for just these reasons. This region of the urban centre developed in parallel with women's increased access to the public sphere and was mapped by their participation in the social life of the community. The shops, cafés, offices and houses of the area played host to the young, independent women of the period; even the train line was noted for enabling women to move freely throughout Berlin. Women artists, such as Lotte Laserstein, quickly moved to studios in the suburb, making it a professional space of women's culture [*Frauenkultur*] as well as a commercial district. *Café Einstein* was set in the charged space of the present, formed by a relationship to women and culture of the past and mobilised by a woman artist, new to the city, yet entangled in its changing story.

In 1999, Ann Hamilton also mapped a politically charged space when she represented the United States in the Venice Biennale with the installation *myein*. This installation demonstrates the powerful socio-political potential of re-corporealised text when it articulates a heterogeneous space. *myein* did not so much place printed text into the constructs of an installation, as materialise the space within the US pavilion as a textual, narrative process. In this way, the space can be conceived more as an event and the installation itself as a multi-sensory experience of textuality. Mobilising the physical presence of printed matter or corporealised text as part of the space, rather than its (transparent) explanatory label, provides an especially useful way to think the book in the expanded field, literally and figuratively. Hamilton's own assessment of the work's structure is fascinating in this context:

> It's a piece that links itself, or is experienced, in the same way that you read: you read across a line of text as if you are moving in time and space. . . . I came away thinking that my question for the next ten years is, 'What does it mean to be a reader?'.[33]

Hamilton's comments are instructive; the installation space itself is a corporeal book, mapping a relationship between readers' bodies and the materiality of history without occluding their differences.

There were three main elements to *myein*: a wall of glass panes outside the entrance through which the front of the federal-style pavilion building is seen, distorted, by spectators before they walk in; an altar-like table, also outside the pavilion, to which numerous white cloths were knotted; the interior sound and textural texts. The aesthetic textual interior is the section which principally concerns me, but the entrance elements are crucial to the play with and against the federal, neo-classical narrative of the building which entangles spectators within. On the walls of the pavilion's interior were large-scale embossed Braille texts taken from Charles Reznikoff's book, *Testimony: The US, 1885–1915 (Recitative)*,[34] a pivotal revisionist account of the violence and dissent which characterised the period during which the United States developed as a 'unified' and empowered nation. The Braille was picked out by a fine pink chroma which

leaked, slowly, from the top of the wall where it joined the ceiling. Abraham Lincoln's Second Inaugural Address, read aloud in international code ('alpha, bravo, charlie . . .') was heard in this chroma-soaked space.

The United States pavilion itself is a site of narrative. First, it is a federal-style structure, referencing the eighteenth-century neo-classicism which dominates civic building throughout the United States. This style is linked to both a notion of democratic citizenship and the ideal of the body politic. It represents a fairly limited revival of classicism, used to produce a unified national narrative of democracy. The federal style of the building also signifies the Enlightenment liberalism which formed the basis of US political, social and moral development. Indeed, as John Gray argues, the United States is the archetype of the legacy of universalising Enlightenment political theory, in both its best and worst aspects.[35] The narrative represented by the building and its Enlightenment roots, especially

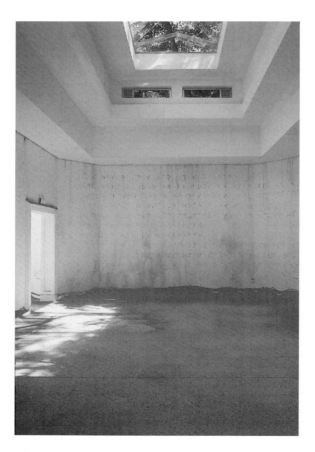

Figure 8.4 Ann Hamilton, interior view, *myein*, 1999, copyright Ann Hamilton; photograph Thibault Jeanson, courtesy of Sean Kelly Gallery, New York

as a national pavilion representing US culture and art in a foreign city, is distinct and monolithic. It embodies the assimilation of difference into a universal civic policy; 'all men are created equal . . .'.

Arguably, for women, the indigenous population of the Americas and those who settled the colonies as slaves, the assimilative logic of liberalism has been particularly damaging. 'All men' only extended to those who conformed to the normative concept of the ideal citizen and all others were excluded from the rights and liberties this guaranteed. As US feminists have found to their cost, the logic of equality and liberal political rights cannot address the needs of 'all women' without falsely effacing their diversity with regard, for example, to such factors as class, race, age and sexual orientation. Acceding to the liberal vision of assimilation has very little to offer women as they struggle to articulate themselves as heterogeneous subjects.

Hamilton's installation resisted this singular assimilative narrative by an active reconstitution of the space and a bodily recuperation of the manifold voices which have been effaced to attain the one. Spatially, a two-fold process was enacted; the internal inconsistencies of the space were first exacerbated and then re-envisaged through strategies of corporeal textuality. The federal architecture of the US pavilion is deceptive. As Hamilton said, it is 'every bank in Iowa. This is an American form . . . And yet the building is almost a scale model. When you get in, the façade is not fulfilled by the experience and the volume of the inside.'[36] The mismatch between interior and exterior is a physical embodiment of the inability of hegemonic narratives to fulfil their promises of totality. The completion of the assimilative federal discourse is bound to be marked by ruptures and schisms, but these are precisely the spaces through which alterity might be voiced.

In a similar sense, Hamilton's architectural reinscription of the pavilion opened these spaces of rupture to vision and voice. The glass wall through which spectators first see and revise the frontage of the federal-style façade acted to corporealise the transparent text of the building. The wall of imperfect, hand-crafted glass refused any illusion of clarity, emphasising that it was both an object to be seen and one which was seen through. Like bringing the body back to the text, these glass panes reinstated the complex material processes of looking/reading *at* and *through* at once. Hence, the transparency of the federal narrative was disrupted by the bodily engagement of the spectator with aesthetic processes before they even entered the pavilion.[37]

Once inside, the seamless links between classicism, the *polis* and United States federalism were shattered by associating the space with a temple of the Mysteries. The title of the installation, *myein*, refers obliquely to these cults and their initiation rituals, in which you closed your eyes and mouth to know through your body; such Dionysian features of classical culture were relegated to the underside of the Enlightenment, along with those artistic manifestations of classicism later considered 'obscene' by nineteenth-century commentators.[38] Additionally, there is now thought to be a close relationship between matriarchal religious traditions and the Mystery cults, including evidence that almost all of those chosen to be initiated into the Mysteries were women.[39] The relegation of Dionysian culture to

the realm of the obscene therefore, forced both the corporeal lineage of classicism and the significance of women to the religious and spiritual life of the *polis*, to the margins. With this title, Hamilton invited us to reconsider the more diverse traces of the classical past which might linger within the architecture of the site and the very political paradigms of liberalism.

The powerful, physical histories of the site, and the democratic discourses it enshrined, were not ignored by Hamilton in this installation. She did not challenge the space by forgetting its corporeal genealogy and writing a new history from 'beyond'. What is fascinating here is the precise way in which the very material histories which construct the singular surface narrative are used to deconstruct its teleology while creating a new narrative space, open to dialogue and contestation from alternative positions. In this sense, the space was an event, rather than a fixed map or object. It was materialised at the point of bodily engagement, rather than pre-determined and merely displayed for effect. Hamilton's own comment on the strategic use of texts in *myein* suggests a similar way of thinking about the installation as an event: 'There was a more literal, historic content than in other projects, with a sense of looking back to what needs to be brought forward. It's not about literal texts so much as how they come together and what happens when they do.'[40]

What did happen in this space? Texts articulated the interior of the building as a multi-sensory, poly-vocal event. Reznikoff's words in Braille, privileged signifiers of tactile reading, were picked out visually, by a deeply coloured powder, itself also having a strong, atmospheric presence in the space. Audible letters spelt Lincoln's words, but these were only able to be completed through acts of bodily memory. That is, Lincoln's address had to be reconstituted either by writing each heard letter down and reading it back, or by remembering the letters and 'reading' them as an internal, mnemonic process. The Reznikoff and Lincoln texts themselves explored some of the social and political debates and disruptions through which the United States came to define itself as a nation, most especially the racial violence against African-Americans and the ethnic tensions between competing groups of new immigrants. These corporeal genealogies of nationhood were then doubled-back through the aesthetic intertwining of bodies and texts in the space. The corporeal engagement through which these texts came to be known invited difference and dialogue. Spectators even began to write back, using the chroma which spilled onto the floor as 'ink', rubbing their own graffiti onto the walls. This act strangely mirrored behaviour in classical temples, where many different visitors would leave their own inscription in the space, diversifying the voices and the stories which could be told by the body politic.

In a fascinating sense, Hamilton produced a space in which the invitation to voice was actually taken up. I would suggest that this was because, not in spite of, the fact that the space was realised through a corporeal interaction between texts, histories and subjects, such that differences were not assimilated into a linear narrative, but allowed to proliferate as part of a dynamic process. In this sense, *myein* referenced yet another shade of meaning around the book, namely the shared root of 'folio' and 'fold'. The concept of the fold as a process of

differentiation is important to thinking the book as an aesthetic space. Folding holds out the potential to diversify endlessly without falling into the logic of binary opposition. This sense of the fold thinks matter as doubling back upon itself to make endless new points of connection between diverse elements. Embedding the texts of democracy within material histories as practices, Hamilton enworlded the subjects who entered the space, permitting their diversity to be 'legible' rather than 'translated' or simply left unread. This is the action of the fold, as it entwines subject and object, situated, embodied and articulate. Kopystiansky's mapped books in the expanded field of the installation also inter-twined histories, corporeal practices and diverse subjects. It is here that process and practice overtake the object, differences can find a voice and aesthetics comes into its own as a full mode of knowing. It also questions the development of a corporeal textual space as an event and even as a configuration of embodied temporality.

9 The place of time: Australian feminist art and theory

> It's not as if one says 'here is the future, a blueprint', but rather by questioning past practices and by revaluing present practices, one causes a shift or a tremor in the web.
>
> (Moira Gatens)[1]

The tremor in the web which Gatens described is that active intervention into history which yields a future as yet unknown. However, this open-ended futurity is neither a function of abstractions nor of utopian dreams, but the emergent potential arising from working through the past and present as practices and not as fixed histories or static objects – as 'blueprints', already provided. Working in this way questions the place of time in history and subjectivity, seeing their interaction as located, material and aesthetic, rather than pre-determined and simply representative.

I have chosen to use the phrase 'the place of time' to describe the reconceived space–time nexus discussed throughout this chapter for two, specific reasons. First, unlike the models of spatialised time, typified by mechanistic chronology or 'Chronos', the place of time references difference, embodiment and the connections between time and situation. The place of time neither forgets the critical function of mapping temporal practices nor seeks to universalise or standardise this activity. Second, the place of time questions the role (place) of time within an aesthetics of difference operating against the conventions of representation. Place, in this second sense, remembers to explore the significance or aptness of time in making aesthetic interventions into history.

The ontology of Chronos reduces time to a function of space, rather than proposing the spatio-temporal axis as a dynamic interface, a process or an event. In a model of time reduced to space, time is seen as 'thingly', measurable, quantifiable and beyond the activities of subjects in the world. Chronos underpins linear, narrative histories, in which progress and the logic of succession are inevitable. Moreover, this assimilative logic defeats genuine newness or futurity. The emergent future, pre-determined as the mere consequence of the known past and present, is rendered impotent. This structure is dramatically envisaged in the

myth of Chronos, where Time/Chronos devours his own son – the future, seen as the product of male autogenesis, is inevitably and violently assimilated into the sameness of the now. However, this conception of time is not a truth, despite its naturalisation as such. It is a construction of knowledge, an episteme, derived from a convergence of historical events and material practices which can be challenged and recast.

It was in the period between the late seventeenth and early eighteenth centuries that the ontology of time as a spatialised, measurable quantity reached its zenith. Arguably, this instituted a shift in the conventions of temporality (from cyclical to linear, from the computus to progressive history) so fundamental that it overturned 1400 years of thinking on the subject.[2] It was not accidental that this temporality became dominant during the historical moment in which precision clock-making and the mechanical measurement of time underscored the scientific discoveries, industrialisation and imperial expansion intrinsic to the rise of the modern, western nation-state. Navigation, map-making and Enlightenment experimentation in the natural sciences converged around quantifiable time-keeping; simply, we got the time we deserved.

However, I am not arguing that this conception of time is merely useless, corrupt or completely outmoded. Obviously, global travel, telecommunications and many productive developments in the human sciences could not have occurred without the ability to keep time as an accurate quantity and zone the world through its force. But that fact neither suggests that spatialised time has been wholly beneficial in its effects nor that it is beyond critique and revision. What it does imply is that critique cannot reside elsewhere; in order to effect a tremor in the web, the practices of the past and present through which the web has come into being simply cannot be ignored or reversed. The former strategy suggests that there is a utopian space beyond history in which subjects might change the world and the latter maintains the very logic it seeks to move beyond. To relocate our temporal maps so that difference can emerge means expanding the limits of mechanistic time.

What Chronos does not entertain is an open-ended future; as an assimilative logic, mechanistic temporality ensures the dominance of an ontology of being, rather than becoming, and guarantees representation rather than articulation. That is, the future is asserted as already known and differences are rendered recognisable by being written into (or represented within) a monolithic system, already in force.[3] In this sense the action of the present strives toward changes as *things*, causally determined in advance, rather than setting up conditions for change whose outcomes cannot be defined. That closes the future to difference and practice/agency at once. As Elizabeth Grosz put it, the challenge now is to 'conceptualize temporality and futurity, in all their richness, as modalities of difference'.[4] Articulating difference and imagining a temporality which can accommodate the emergence of the wholly new and unrecognisable move toward an experimental strategy of becoming. It is important to remember that such a strategy might yield inconsequential or dangerous effects as well as produce 'positive' changes. Yet to argue that the future might bring an infinite variety of

possibilities, unable to be determined in advance, is neither to suggest that anything can happen, nor that anything goes.

Cognisant of feminist arguments against formations of 'becoming' which might be a-historical, depoliticising and unable to account for gender and sexual difference, Claire Colebrook suggested thinking of feminist becomings in terms of genealogy and geology: 'both an affirmation of its position as position (and not as the innocent manifestation of essence, ground, horizon, "beyond" or absence) and a question directed to itself as an event of style'.[5] Her modulation between event and position offers a way to think of temporality which neither solidifies it as an object, nor rejects its corporeal history. Rather, she queries the place of time. This reasserts the significance of embodiment and situation to becoming, recognising that while the possible combinations of subjects, ideas, materials and meanings might be infinite, the elements of these machinic formations are historically and corporeally located and each becoming is concrete. This accords with Grosz's later thinking on emergence as being neither free nor determined, but rather constrained and undecidable at once.[6]

In her extraordinary article, 'Can Ethologists Practice Genealogy?', Moira Gatens connected the subject in process with situation in order to think female subjectivity against the grain.[7] Gatens argued strongly for a notion of the subject in terms of what it can do (ethology), rather than what it is – for articulation and becoming, rather than representation and being. In order to explore capacity, 'doing', however, Gatens emphasised the corporeal specificity of the subject and the material locus of histories (genealogy) as the web which constrained, but could never contain, the subject in process. Significantly, to work through these ideas, Gatens turned to a complex analysis of temporality. It is not enough to reject the limitations of Chronos, since this is the historical frame of the subject and must be negotiated for change to occur, nor is it adequate to substitute Chronos with 'Aeon' or the event outside linear time, since this has little historical effect. Instead, Gatens posited the time of 'Kairos' – opportunity, crisis point, moment of change, timing, praxis – to think the modulation which permits an acknowledgement of corporeal specificity and yet the potential for the new to emerge. Kairos is not simply the reversal of the dualist logic of Chronos/Aeon, nor is it a concept of temporality derived from some utopian space outside the 'web' of histories and material conditions. It is a modulating temporality, connected to the processes and practices of specific historical formations, yet not beyond change and the potential of the 'new'.

Moreover, Kairos, as timing and praxis, invites aesthetics and creative agency into historical processes. This does not suggest aestheticising history, but intervening in ways which acknowledge materiality and the bodily locus of knowledge. It moves from a linear, causal mode of historical explanation to a set of strategic practices designed to engage with historical processes as open-ended and creatively enacted in the present. It is not surprising that feminist reconceptions of subjectivity, agency and history have produced processual and embodied models of temporality, since mechanistic time has both effaced sexual difference and been unable to account for change.

It is at this point that I would like to introduce the 'coincidence' which occupies me for the rest of this chapter. I am using coincidence here in the stronger, more resonant sense of the term, as events concurrent in both space and time, fluctuating at their nexus and never reduced one to the other. One of the elements of my coincidence has already been introduced above at some length, namely, the body of work produced by Australian feminist philosophers and theorists which mooted new temporal cartographies in order to explore the articulation of female subjectivity and sexual difference in process. The internal coincidence within this work is the conjunction of feminism, articulate women scholars, an Australian academic and political framework and a real concern with thinking embodiment.[8] But the coincidence which first made me question the place of time more generally was between the feminist philosophers and Australian women artists who, simultaneously, had been developing a sophisticated body of practice which also explored time, vision and the body as modalities of difference.

The conjunction of these two coincidental elements is powerful and asks the feminist critic to locate the place of time without replicating the logic of linear, causal explanation or assimilative reduction. That is, I am not concerned with asking why this body of work emerged in this place and time and then effecting a *post facto* explanation of the origins and causes of its production as if its creative intervention was inevitable. Similarly, I do not wish to reproduce an assimilative strategy, accounting for the art as a function of the theory or vice versa. Instead, I want to work with the coincidence itself, as a spatio-temporal event which has ramifications for thinking productively about sexed subjectivity, aesthetics, histories and the articulation of difference in the future. The rest of this chapter suggests modes of temporality which might be offered by creative configurations of theories, practices, texts, images and objects as they circulate in the here and now, using the materials of the past to set up conditions for the future. I am interested in how women's art and feminist aesthetics, as embodied approaches to the problems of historical agency, might help us get the time we deserve.

A glance at (ec)centric histories

In 1994, Janet Laurence, working in collaboration with Fiona Foley, completed the commission from the Historic Houses Trust of New South Wales to design and produce *Edge of the Trees*, a sculptural installation outside the new Museum of Sydney on the site of First Government House.[9] The work deals with this site as a place defined by contestation and dialogue, by 'first contact' and the continued debates which orchestrate Australia's multicultural history and future. The final piece consists of twenty-nine timber, steel and sandstone pillars, variously inscribed with textual fragments and names, stained by oxides, incised and reworked to contain shells, bones, hair, honey, seeds and ash. There is an important sound element to the work and it is lit, so that it provides an environment for viewers by both day and night. Since its unveiling in January 1995, *Edge of the Trees* has become one of the most popular and lauded public sculptural works in

Australia, winning, for example, the Lloyd Rees Award of the Royal Australian Institute of Architects in 1995.

When it was first decided to erect a museum on the site of Governor Arthur Phillip's First Government House in 1988 (the bicentennial year), the plans were nothing so integrated or forward-looking as *Edge of the Trees* might suggest. Denton Corker Marshall, the architectural firm who won the bid to develop the site overall (including a huge office block and public square), planned to mark the significance of this space with a large-scale sculptural representation of Governor Phillip himself, the First Fleet 'Founding Father' of the nation. Commemorating the establishment of colonial rule in Australia in this way reinforces the connections between spatialised time, representation and the assimilative logic of the same. It privileges founder narratives and the idea of *terra nullius*, that conception of the continent which was invoked to slaughter and disenfranchise generations of indigenous Australians.[10] The mechanised time-keeping which enabled colonial exploration of the southern hemisphere during the eighteenth century defined Captain Cook's 1770 landing in Australia as the 'founding' of the region and, concomitantly, as the beginning of 'history' there. The establishment of the colony in 1788 merely reconfirmed that history (and time) had come to this empty, timeless territory.

The origin myth of the founding father, *terra nullius* and the genesis of history is fragile. In order to maintain such an untruth as the central narrative of nation, the many competing voices and stories must be forced to the margins or eliminated altogether. Not only must the indigenous population be seen as a- or pre-historical, they must also be homogeneous and eternal. As an unchanging (or unable to adapt) collective, Australian indigenous peoples occupied the space of the precursors to settler history, literally and figuratively 'out of time'.[11] It was not possible to write the diversity of Aboriginal cultures into the narrative without acknowledging their long and extraordinary history and the evidence of their continual adaptation to change and contact. Similarly, regional differences and class conflict among the settlers tended to be nullified in the founding myth, not to mention the important role of settler women in cultivating the land and ensuring the survival of the Euro-Australian population through their skill and ingenuity.[12] Difference, within and against the founding myth, was silenced.

When Peter Emmett, the Senior Curator of the Museum of Sydney, put together the concept brief for the final commission in 1993, he worked with a very different model of the site and its histories. His concept was to create a metaphor of place for this site – to address the highly charged and contested narratives through which first contact might be seen as a 'turning-point' or 'edge', rather than the origin of an inevitable progressive logic.[13] This plan implies the production of a 'tremor in the web' rather than the representation of a unified narrative. Emmett's concept brief was the beginning of the collaborative dialogue between artists, architects, historians and curators which enabled *Edge of the Trees* to emerge.

In terms of the 'coincidental' encounter which I am seeking to cultivate in this chapter, it is significant that of the final artists included in the short-list, only one

Figure 9.1 Janet Laurence in collaboration with Fiona Foley and Denton Corker Marshall Architects, *Edge of the Trees*, 1994, courtesy of the Museum of Sydney

was a man.[14] I am not suggesting that there was a biological imperative at work here, but rather that many women making art in Australia during the 1990s were concerned with difference, embodiment and situation and that attention to materiality, place and negotiated histories neatly coincided with their practices. Indeed, Laurence and Foley were invited to work as a collaborative team precisely because they shared interests in making meaning through material transformation, constructing histories by drawing on bodily memory and creating a challenge to fixed ideas of identity, 'race' and nation. At the same time, they staged their collaboration as a dialogue between culture and difference in Australia, drawing on their own perspectives as women from diverse backgrounds. Foley, a descendent of the Badtjala group from Fraser Island off the coast of Queensland, had long been working with the complexities of Aboriginal Australian identity through a diverse art practice engaged with ethnography, museology and counters to colonial myths (not least the stories of the Frasers who gave their name to Foley's ancestral region). Laurence, of settler descent, had similar interests in museums as makers of cultural identity, but was also engaged with feminist and ecological politics. Their collaboration worked as an on-going process, never assuming that their 'indigenous/settler' dialogue represented an essential set of perspectives. Indeed, Laurence and Foley demonstrated in *Edge of the Trees* that the complex conceptual structure of Emmett's brief could be materialised as an

installation precisely by interrogating the place of time through dialogues with difference.

The installation did not represent first contact, the history of Sydney or the Eora peoples who had inhabited the area in 1788; rather, *Edge of the Trees* articulated the event of history through engagement with strategic, temporal aesthetic devices. In order to make the site into a place of exchange and dialogue, Laurence and Foley set into play multiple temporal cartographies. The histories of the site itself, charged with the ramifications of first contact and the competing narratives of colonial power, settlement and brutal displacement, coincide in *Edge of the Trees* as 'Kairos', an emphatic crisis point signalling the possibility of change. As an integral part of the Museum of Sydney, the installation also participated in the processes of cultural exchange involved in the historical evaluation of art and artifacts in Australia. In so doing, *Edge of the Trees* invoked a powerful quotational temporality which moved beyond objectification. Finally, the work's physical presence sets up a perceptual time map, enacted by participants as they glance or glimpse the ever-new.

The title, *Edge of the Trees* came from a passage in Rhys Jones' essay 'Ordering the Landscape' in which he invoked the moment of first contact:

> . . . the discoverers, struggling through the surf were met on the beaches by other people looking at them from the edges of the trees. Thus the same landscape perceived by the newcomers as alien, hostile or having no coherent form, was to the indigenous people their home, a familiar place, the inspiration of dreams.[15]

In this text, the place of contact is shown from the first to be multi-faceted; familiar and unformed, the inspiration of dreams and an alien, hostile territory. Figuring these contrasts as the 'edge' which mobilises *Edge of the Trees* emphasises the incomplete and dialogic event of colonisation, neither negating the very real material conditions and conflicts by which imperial domination was attained nor denying the potential for change in the future.

The twenty-nine poles coincide with a ground map of the Sydney region from the early nineteenth century on which the twenty-nine Eora language-group clans who used to inhabit the territory were mapped. The Eora are further sited in *Edge of the Trees* through another form of non-representational cartography, namely a 'sound map', a recording of the Eora words for places in and around the region.[16] Crucially, there is no attempt to represent the Eora or literally image the devastation they suffered as their numbers went from some 40,000 to 6,000 in the first eighty years after contact. Rather, the evocative mapping itself suggests the losses incurred through colonial force. These two maps interact with the outline of the absent First Government House, excavated between 1983 and 1989, marked onto the square. Hence, mobile mapping constructs the primary tension of the site – the outline of First Government House, disrupted by the poles and sounds marking out an alternative geography that contests the edges of this place.

Naming and language encounters in the work set out a similar dynamic

interplay. The Latin and Eora names for the local flora and fauna both appear as burnished texts on the wooden poles, zinc plates embedded in timbers carry the signatures of the First Fleeters against the names of important Eora warriors appearing elsewhere in the installation. Some sandstone pillars are carved with text from the *Dawes Notebooks*, the record of Lieutenant William Dawes's travels around the harbour with an Eora woman as he recorded their different words for places and things – an early, if very limited, attempt at translation and understanding across language barriers. These physical texts compete for the space and for cultural authority, yet this competition is never won and they continue as a polylogue. For example, the signatures of the First Fleeters reveal the divisions of class and education in their hand and local words for places and objects sometimes overcame Latinate or anglophone renaming through force of use.

But nowhere does *Edge of the Trees* set up a more effective point of change through praxis than in its evocative use of materials. Materials were chosen for their multi-layered resonance with the site, the ecology of the region at first contact, and the diverse historical, ritual and corporeal meanings they can carry. So, for example, the wooden poles are reclaimed timber from the McWilliams winery, levelled while the installation was in progress. The winery's beams came from trees living in the area at the time of first contact and their recycling at this site recalls both the mercantile development of the city and the ecological change/damage which this has wrought. Moreover, the carving of the wooden poles harkens to the indigenous use of wood for tools and its symbolic significance within that economy. Similarly, the sandstone is local to New South Wales, was widely used as a building material by settlers and, traditionally, was carved by the Eora; here, its use further emphasises the growth of this city, since many of Bridge Street's buildings are sandstone structures, including the Museum of Sydney itself. The oyster shells harboured within niches in some of the poles are also doubly-encoded, linking the indigenous reliance on 'middens' (an important and abundant source of protein), with the settler use of these shells, burned and ground, to produce lime needed for building work. Ash, oxides and hair have powerful ritual ramifications for indigenous Australians while their potential to activate sensory and bodily memory can include a much broader audience in their physical effects. At every crossing of material and meaning, the work offers a dynamic point and counterpoint between history, corporeality, aesthetic knowledge and the future.

Edge of the Trees uses aesthetic strategies to reconfigure the legacy of colonial interaction as dynamic, changing and open-ended. The articulation of the site as a moment of encounter and change suggests that histories are past practices in which we can intervene, rather than static truths which we must simply uncover. Moreover, as a key element in the conceptual development of the Museum of Sydney, the installation was also an aesthetic intervention into the strategies which informed contemporary museology. Working through quotation, *Edge of the Trees* interrogated the activities of cultural change and development in opposition to the reification of the objects of the past.[17]

The Museum of Sydney on the site of First Government House was designed to

be 'an exhibition/performance' rather than a fixed archive of objects.[18] Described by Emmett as 'frighteningly temporary', it is made to house changing configurations of displays and events which provide a locus for discussion about the nature of a volatile history rather than a definitive narrative of its course.[19] This is a dialogic conception of the museum and the changed paradigm reflected both the strategic commission of *Edge of the Trees* as an intrinsic element of the Museum's meaning and the diverse committee of the Historic Houses Trust who oversaw the submissions. The committee had representation from a very wide constituency in the arts, including Joan Kerr, an academic art historian known for her pioneering research into women's art in Australia, and Hetti Perkins, a founding member of the important Boomalli Artists Cooperative. As a group, their perspectives were as multi-faceted as the place itself and their comments on the project demonstrate this variation – especially with regard to the quotation of indigenous sources.

The poles of *Edge of the Trees* are not grave posts and, as Peter Emmett emphatically stated in the concept brief, 'So too this place should not be represented solely as a generalised Aboriginal cultural "site". It is totally inappropriate to have Arnhemland poles on the (Sydney/Eora) site.'[20] Emmett was, of course, opposing any attempt to fix indigenous culture within the mythic state of eternal

Figure 9.2 Janet Laurence in collaboration with Fiona Foley and Denton Corker Marshall Architects, detail, *Edge of the Trees*, 1994, courtesy of the Museum of Sydney

homogeneity. However, as David Prosser, the Curator of Aboriginal Studies, wrote in his later comments on the work, '. . . it is suggestive of *pukumani* grave posts, which indicate sacredness in the eyes of Indigenous Australians'.[21] In *Edge of the Trees*, Laurence, working with Foley, was able to make a vital statement on museums and their place as mediating mechanisms of display and meaning in a multicultural Australia through the use of this powerful quotational device.

The work does 'suggest' *pukumani* grave posts and, for some viewers, two particular set of poles: the famous *Pukumani Grave Posts* commissioned for the Art Gallery of New South Wales (AGNSW) by Tony Tuckson in 1958. This was the first major commission of contemporary Aboriginal work made by a Euro-centred Australian museum and the *Pukumani Grave Posts* have continued to play a central role in the changes wrought upon the definition of 'Australian' art by the impact of post- and anti-colonial debates since the 1950s. The work, brought from Melville Island in 1959, was reinvested with significance as a central display in the AGNSW in 1973 when the Sydney Opera House opened and again, when the new Yiribana Gallery, dedicated to Aboriginal art, was added to the AGNSW nearly two decades later. The changing significance of the piece mirrors and reinforces the changing relationships between indigenous and settler art and culture. *Edge of the Trees* also quotes another, highly contentious set of grave posts, the *Aboriginal Memorial* (now in the National Gallery of Australia, Canberra), made by the Ramingining community in 1988, with 200 grave posts to commemorate the indigenous dead for each year of the bicentennial.

I am in no way arguing that *Edge of the Trees'* poles are grave posts; indeed, the Eora did not honour their dead in this way and to have appropriated that indigenous convention would have been to misinterpret, at a fundamental level, the very point of the Museum of Sydney commission. However, the visual 'suggestion' of these two powerful icons of Aboriginal art and resistance, revisits the dialogue between ethnography and art, ritual and practice, tradition and change which reside at the core of contemporary debates in Australian art practice and museology. Again, it sets up a tremor in the web, using the highly charged material practices of the present to open the future to change. I have been arguing that *Edge of the Trees* is not so much a representation of history as it is a mode of doing history; the exchanges it sets up between ideas, objects and materials connect time, place and the body in strategic encounters with difference. So too, the physical encounter with the installation does not picture time or the future, but enables its unfolding in the place of the present.

Crucial to *Edge of the Trees* is the fact that visitors are located within the piece and therefore become participants instead of viewers/spectators in the physical encounter with the work. As the original brief stated, the work is 'not something to look at in architectural space, but something to enter/engage'.[22] Visitors to the site describe the work as 'inviting you to touch or embrace it' and say that there are 'new details to discover on each visit'.[23] Standing within the work is akin to being within a grove and not seeing the wood for the trees; the installation cannot be perceived as an object but is experienced as a series of partial, located encounters in an immensely inviting physical space. The edge, as a metaphor for

sensory experience, perspective and a point of exchange, is glimpsed anew at each moment, rather than contained within a unifying visual field.

Edward Casey, in an essay on the temporal effect of the glance, argued that the glance connected open-ended futurity with embodied perception and marginality. The glance is ec-centric viewing, glimpses caught at the edges or peripheries, and however brief these breaks from conventional temporal sequencing might be, they change the subject forever.[24] The glance brings with it the absolutely new – we do not send out a question when we glance and we cannot pre-determine an outcome when something catches our eye. Significantly, peripheral vision most readily recognises movement[25], change and process and multiple encounters with peripheral vision characterise the viewing experience in *Edge of the Trees*. The installation mobilises the mechanism of the glance to see movement at the margins – the Eora at the edges of the trees, the material processes of historical change, the heterogeneous subjects exiled from normative concepts of nation in colonial progress narratives.

The logic of the glance makes each encounter with *Edge of the Trees*, and by extension, the Museum of Sydney, the charged site of First Government House and the continued negotiations between differing constructions of identity in Australia, new. The work, the museum and the debates will continue to change in the future, not become rarefied artifacts of the past.[26] There is not one privileged viewpoint on ec-centric histories and, as feminist explorations of difference have demonstrated so well, there is no point in simply reversing the logic to make central what was once marginal. That approach merely reiterates a system of dualist thinking and ultimately reinforces the power of the centre itself. For feminist scholars, the challenge has been to find ways to articulate ec-centric subject-positions in and through change. The temporal aesthetics which cast this loaded site as an event rather than a representation iterate the power of emergent histories as they open to the future. Their culmination in the bodily encounter with movement at the margins pushes us toward another coincidence in the stronger sense, namely, the place of time in thinking difference and the emergent subject.

Hesitation, elaboration and the emergent subject

There are many parallels between *Edge of the Trees* and Joan Brassil's 1978 installation *Can It Be that the Everlasting is Everchanging*. Brassil's installation consisted of two overlayed temporal maps: ochred saplings, configured to correspond with an Aboriginal Dreamtime constellation, placed in conjunction with Geiger tubes connected to a series of light-emitting diodes, operated randomly by circuits responding to meteor showers in space. These coincidental maps link the heavens with the earth and chart the mutability of time and space. By describing this connection through both Dreamings and Chronos (as figured by the high-tech measuring devices), Brassil reiterated the interaction between competing narratives of space and time in a colonised land. The work conveys both their resonance and dissonance as the unresolved tensions of dynamic interplay. Indeed, their discontinuity speaks of deterritorialised space and the final failure of

any singular logic to own or define with certitude a place in which differences coalesce.

Can It Be that the Everlasting is Everchanging demonstrates an explicit concern with temporality and cartography, yet it does not literally represent either. This is in keeping with Brassil's later assessment of her work shifting 'from object to process' during the 1970s and 1980s.[27] By moving in this direction, Brassil imbued her works with a temporal sensibility which is neither contained by the time-based technologies she deployed nor by any direct references to time-keeping, such as the hourglass, which sometimes appear in her spaces. The temporal aesthetics of the works are produced more as a 'machine', a 'collectivity of heterogeneities' in the Deleuzian sense.[28]

Can It Be that the Everlasting is Everchanging is typical of Brassil's later, process-based installation practices which combine diverse and divergent materials and sources. Brassil frequently configures advanced technologies with organic matter, memories and myths with specific histories of places and events, and scientific knowledges with(in) poetic texts. In this sense, the artist makes connections where there had been none, the better to see what had remained unseen and hear what had previously been unheard. The emergence of the unseen and unheard is in fact closely paralleled by one of Brassil's earliest installation trilogies, *Light beyond seeing, Sound beyond hearing* and *Memory beyond recall* (1970–74). But making connections does not end at the level of the objects and ideas within the space. Rather, Brassil's machinic constellations implicate the sensorial subject within the practice, with 'process, object and viewer becoming the work of art'.[29]

In a fascinating coincidence of ideas, Elizabeth Grosz wrote what could well be a critical evaluation of Brassil's installation work:

> . . . they make clear that something links the life of planets and universes to the life of organisms and their histories, and to the 'life' of nonorganic or chemical beings, and this something is the endless unfolding of the new, restless transformation, upheaval, redirection and digression, which ensures the impossibility of the same even through the modes of repetition . . . central to the surprise and unpredictability of difference.[30]

Grosz, however, was discussing convergences in the work of Darwin, Nietzsche, Bergson and Deleuze which, she argues, make them key sources for a project which takes time, futurity and difference seriously. Without suggesting that these scholars held any unified intellectual position, or indeed that they represent any sort of origin point, Grosz made connections between them so to materialise an epistemology which can encourage emergence, change and the new. One of her most pertinent points is that this way of thinking by needs must explore chance or randomness. I would argue that it is coincidental in the strongest sense that the random forms a crucial focus for both Grosz and Brassil in thinking about the connections between subjectivity, difference and time.

If *Can It Be that the Everlasting is Everchanging* made the random an element

Figure 9.3 Joan Brassil, *Can It Be that the Everlasting is Everchanging*, 1978 (on the back wall: *Light beyond seeing*, *Sound beyond hearing* and *Memory beyond recall*, 1970–74), courtesy of Joan Brassil

in its configuration of competing temporal cartographies, *Randomly Now and Then* (1990) took chance as its organising principle. *Randomly Now and Then* consists of eight primal samples of diorite, each set to resonate at its own frequency, recorded visually and sonically in the gallery space as inscribed waves and 'an unheard song of place'.[31] Yet again, Brassil used advanced technical instruments to materialise the unheard in the most ordinary, local materials. Here, time figures through the random as the possibility of the emergent new in the commonplace. This is neither spatialised time made manifest in the the gallery, nor is it an indication of linear causality. Rather, it is a multi-sensory opening to the kind of time described by Grosz 'as an open-ended and fundamentally active force – a materializing if not material – force whose movements and operations have an inherent element of surprise, unpredictability or newness'.[32]

What does it mean to materialise randomness in a work of art? The random does not emerge in a vacuum, it emerges from the resonances between combinations of materials, ideas, objects and subjects – from the entanglement of subject and object within an aesthetic event.[33] The subject who is interpellated and entangled by the temporal logic of Brassil's installations is in process, open to change and the new. Subjectivity here becomes the effect of striving toward the random, rather than aiming for a pre-determined endpoint. Hence, Brassil's work

materialises an oppositional paradigm of the temporal frame of subjectivity as an interval, a place of *hesitation* as Bergson wrote:

> . . . the living being essentially has duration; it has duration precisely because it is continuously elaborating what is new and because there is no elaboration without searching, no searching without groping. Time is this very hesitation.[34]

Brassil's work is not *about* time; time is not represented or mapped. The materialising effect of time in opening the future and the subject to modalities of difference finds a form in the aesthetic strategies of Brassil's installations, just as feminist philosophers are making use of similar strategies to think change and emergence. Hesitation, as the struggle to think and make the new, places subjectivity at the heart of temporal strategies of difference and in the final part of this chapter, I want to reconnect the hesitant subject with creative agency to explore the role of aesthetics in new formations of time.

Brassil's œuvre is a complex and shifting entity, making use of internal cross-connections and external links to set up an engaging temporal dialogue of elaboration. The mechanisms of elaboration, as a temporal dynamic of creative agency unfolding difference and multiplicity, suggest the significance of aesthetics in thinking and making the new. It similarly reconnects the subject with an aesthetics of emergence. To cite Grosz again: 'elaboration is time's mode of acting, but an elaboration that frees up, undetermines, interrupts, and deflects rather than causes.'[35]

To characterise the seemingly contradictory connections within Brassil's praxis, Zoë Sofia coined the fascinating phrase 'technoscientific poeisis'.[36] Sofia explored the double meaning of *techne* as science *and* art, arguing that Brassil's aesthetic use of technical devices produces creative acts beyond the simple division of the two spheres. Sofia also explored the original sense of *poeisis* as bringing forth through human hands, or 'making', as a means by which to connect art, science and agency as corporeal enterprises within the practice. The interrelationship between hard science and poetics in Brassil's work is one of its key features and one which reconceives both science/technology and aesthetics as modes of temporal elaboration.

Brassil's installations make use of sophisticated technologies and she often works collaboratively with scientists to produce subtle interfaces between her materials and the spaces she articulates. In this sense, Brassil's work presages many of the techno-art practices which came to prominence in Australia during the 1980s and 1990s. Yet as Martin Thomas astutely noted, her work has never used technology simply as an end in itself.[37] Brassil's experimentation with technologies, while innovative, is but a small element within a larger process of exploring the connections between mobile subjectivity and technological change. It could be argued that Brassil is able to take this wider view on technology and change because she came to art in her fifties, after a long career as a teacher and has, in her own lifetime, experienced extensive shifts in the technologies of everyday life. Her

ability to move through a wide variety of technical processes demonstrates her own fluent adaptability to those mechanisms which change the way we experience the world. However, while Brassil's attitude to technology may be due in part to her lived experience of technological change, it is also determined by her artistic and intellectual orientation.

Brassil spoke of both science and poetics together as 'elegant' ways of conceiving the world anew.[38] Poetics and *poeisis* are significant to Brassil's project (indeed, she wrote her DCA thesis on poetics) because they emphasise creative agency and the articulation of the subject through a mode of address which goes beyond linear narrative. So too science, in the experimental and exploratory manner in which Brassil uses it, is a creative mode of perceiving the world. This way of understanding science is not commonplace, but experimental scientists themselves recognise the creative force and the play of the random which Brassil sets into motion in her work, as demonstrated by the comments made by one of her scientific collaborators, the astronomer Brian Robinson:

> Art and science share a sense of form and structure, of wonder, of elegant simplicity – and also share curiosity. . . . There are similarities between Joan's creative process and my own as an astronomer. There is a common link in sharp observation, imaginative interpretation, leaps beyond established dogma.[39]

The space of the scientific/poetic installation is intersubjective; both *Can It Be that the Everlasting is Everchanging* and *Randomly Now and Then* elaborate difference and set into place the conditions for the emergent subject to grasp the new and make a leap beyond established dogma.

In many ways, *Randomly Now and Then* can be seen to have continued to develop the concerns of *Can It Be that the Everlasting is Everchanging*. Separated by twelve years, the two works set up a temporal dialogue within the wider body of Brassil's practice which again questions the place of time as an experimental elaboration of emergent histories and subjects-in-process. Brassil frequently cross-references her own work, re-animating themes in new ways, connecting diverse installations within trilogies, re-using tactics and material strategies across a wide range of practices. Indeed, the earlier installation had another answer/echo in a 1997 work, *Where Yesterday May be Tomorrow*, the first part of the *Cosmic Trilogy*.[40] This is another form of elaboration – a corporeal praxis in which works are not seen as closed or complete in themselves, but as forms of exploration, open-ended and subject to reiteration in the present and future.

In the project statement for *Where Yesterday May be Tomorrow*, Brassil said that 'the challenge of constant change and husbandry presents itself in the delicate balance between that which is already there in existence with desire and development in Time'.[41] This balance between change and 'husbandry' resonates powerfully with an aesthetics of emergent subjectivity as being poised between becoming (the absolutely new) and embodiment (the situated, material locus of agency). Colebrook questioned these connections in thinking about feminist

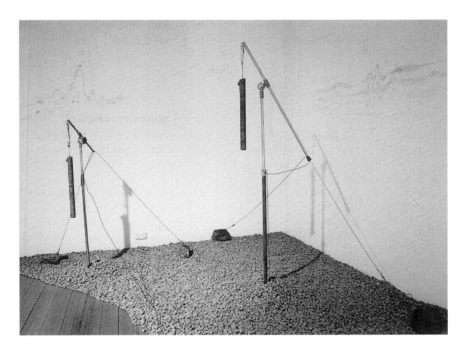

Figure 9.4 Joan Brassil, *Randomly Now and Then*, 1990, courtesy of Joan Brassil

becoming and subjectivity. Specifically, she argued for a move from causality to futurity, asking not 'What is it that causes my being?' but 'What sort of self will I be if . . . ?'[42] In so doing, there is little relevance in positing a teleology of the subject-in-process, since that closes the future as a representation of the already known (if not possessed). That is, there is little value in aiming toward becoming a particular kind of feminist subject, rather: 'A feminist genealogy would be both a critical procedure – connecting the subject in general with the forces and techne that have made it possible – and an active becoming, through this encounter affirming the specific value of other techne and other values.'[43]

The link with techne, in thinking of futurity, subjectivity and difference, is powerful. Modes of imaginative thinking and exploration, are constitutive of subjectivity; the subject is the effect of these hesitations and elaborations of difference. Constant change and the future's randomness are affirmed as the very possibility of emergence, but they are not conceived as beyond the world. Indeed, emphasising the significance of aesthetics reconnects the corporeal with the emergent; the place of time is where the subject-in-process is enworlded, constrained but never contained.

The work of Australian feminist philosophers has turned to time so to conceive of an open future which does not simply forget the past or occlude difference, corporeal specificity or the material histories from which it emerges. As Penelope

Deutscher argued, there has been an important shift in Australian feminist philosophy 'from what is overtly said in philosophical texts about women and femininity, or men and masculinity, to what is said about the passions and emotions, embodiment, the private sphere, the imaginary, and the poetic'.[44] To this, I would add time. The powerful anti-colonial perspectives on time, subjects-in-process and aesthetics demonstrated by both the art and scholarly textual work discussed in this chapter, remind us that feminism remains a vital force for change in the future. While we cannot determine in advance the directions this might take, we can prepare the ground and work through the practices and processes to hand to be ready for what may emerge.

Afterword – on wonder

This book was intended, originally, to end with a formal conclusion, demonstrating again the significance of women artists and their work in redressing exclusive versions of history, reconceiving female subjectivity in and through difference and renegotiating the very limits of aesthetics. This conclusion would have reiterated the aptness of the three key themes of the volume and the usefulness of the chosen case studies in drawing out their crisis points and delineating the new epistemes materialised by women's art.

But the development of research and thinking is organic, and as I come to conclude this volume I am forced to acknowledge that such a static revision of the work would be counterproductive, even stultifying, especially following the arguments of the final chapter considering time, futurity and emergent becomings. So, in keeping with those insights, I want to end with a short tale and wise words which are not my own.

In February of 2002, I had the great privilege to visit the artist Joan Brassil and spend a day in her 'bush studio' in Wedderburn, New South Wales. Now an octogenarian, Brassil came to practise professionally as an artist in her fifties, yet she is one of the liveliest and most forward-looking artists – people – I have ever had the pleasure to meet. Over a cup of tea on the back porch of her studio, overlooking great gum trees in a ravine which had emerged from the recent bushfires all but unscathed, we spoke of what it is that compels an artist to continue to make work and, on my part, an art historian to continue to try to engage with art in ever more productive ways. It is Brassil's comment which has stayed with me since: 'we are pursuing wonder, celebrating wonder'.

If I am able to conclude this volume in any way, it is with that thought and the open-ended futurity it entails. The project of coming to explore and engage with women making art is not over, it has hardly begun. Yet, as we continue to do this work and as women continue to make art which challenges, delights and fills us with wonder, we are writing the past and present so as to pursue and celebrate the future, a future in which women's great contributions to the artistic, intellectual and cultural life of our society will not go unseen, unrecognised or under-valued.

Notes

Introduction: women making art

1 Linda Nochlin, 'Memoirs of an *Ad Hoc* Art Historian', in *Representing Women* (NY and London: Thames and Hudson, 1999), pp. 7–33 (quote, p. 33).

2 *Spirit of an Age: Nineteenth Century German Painting from the Nationalgalerie Berlin* (2000–02, touring), organised in conjunction with the National Galleries of Art in Washington, DC, and London, had no works by women artists, despite the fact that Germany, during the nineteenth century, was one of the best places for women artists to practise professionally and Berlin saw the establishment of a major women's art organisation (still operative), the *Verein der Berliner Künstlerinnen*. The show was absolutely pioneering in its choice of work, save for this astounding exclusion, making the absence of work by women all the more tragic.

3 I asked this question, to the mild embarrassment of the represented curators, in London during a preview of the show. It was not a curator, but another scholar of German art who pointed out how many pictures were *of* women and that Caspar David Friedrich was a feminine painter, so I had no need to complain.

4 There was a very extreme response to the nominations for the Turner Prize (Britain's most media-covered art prize) in 1997 when four women (Christine Borland, Angela Bulloch, Cornelia Parker and Gillian Wearing) and no men were short-listed. Responses included both the argument that the nominations had been rigged and that the state of contemporary art was declining. No such commentary arose when in 2001, only men were nominated, or indeed, in the numerous cases before 1997, when no women made the shortlist.

5 Griselda Pollock, *Differencing the Canon: Feminist Desire and the Writing of Art's Histories* (London and NY: Routledge, 1999), p. 33. I find it very interesting that this text was published in the same year as Nochlin's *Representing Women* (op. cit.) and Rosalind Krauss's *Bachelors* (Cambridge, MA: MIT Press, 1999). Although Pollock, Nochlin and Krauss address the problem of 'women artists' differently, the very appearance of three texts in the same year by such eminent art historians engaging with the category of 'women artists', suggests that it is time to explore this in more detail.

6 Ian Buchanan, 'Deleuze and Cultural Studies', in *A Deleuzian Century?*, edited by Ian Buchanan (Durham, NC and London: Duke University Press, 1999), pp. 103–17, p. 103.

7 Ibid., p. 114.

8 Ibid., p. 21.

9 Elizabeth Grosz, 'Sexual Signatures: Feminism After the Death of the Author', in *Space, Time and Perversion: Essays on the Politics of Bodies* (NY and London: Routledge, 1995), pp. 9–24, p. 18.

10 Mieke Bal, *Quoting Caravaggio: Contemporary Art, Preposterous History* (Chicago: University of Chicago Press, 1999), p. 3.
11 I took this point up at length in the article, 'In Mind and Body: Feminist Criticism Beyond the Theory/Practice Divide', *Make: The Magazine of Women's Art*, March/May, 1998, pp. 3–8.

1 Exiled histories: Holocaust and *Heimat*

1 Deborah Lefkowitz, 'On Silence and Other Disruptions', in *Feminism and Documentary*, edited by Diane Waldman and Janet Walker (Minneapolis, MN: University of Minnesota Press, 1999), pp. 244–66, pp. 256–7.
2 Rebecca Horn, 'The Colonies of Bees Undermining the Moles' Subversive Efforts through Time', *Concert for Buchenwald* (Zurich, Berlin, NY: Scalo, 1999), pp. 23–6, p. 23.
3 Habermas's comment on 'conventional' histories was cited by Eric L. Santner in discussing the *Historiker-Streit* in *Stranded Objects: Mourning, Memory and Film in Postwar Germany* (Ithaca, NY and London: Cornell University Press, 1990), p. 50.
4 Geoffrey Hartman, *The Longest Shadow: In the Aftermath of the Holocaust* (Indianapolis, IN: Indiana University Press, 1996), p. 104.
5 Hamid Naficy (ed.), 'Introduction', in *Home, Exile, Homeland: Film, Media and the Politics of Place* (London and NY: Routledge, 1999), p. 4.
6 Ronnie S. Landau, 'The Nazi Holocaust: Its Moral, Historical and Educational Significance', in *After Auschwitz: Responses to the Holocaust in Contemporary Art*, edited by Monica Bohm-Duchen (Sunderland: Northern Centre for Contemporary Art, in association with Lund Humphries, 1995), pp. 17–24, p. 18.
7 For an excellent account of the problem of anamnesis (following Lyotard), the occlusion of difference and the role of monuments and memorials in coming to think about the Holocaust, see Andreas Huyssen, 'Monument and Memory in a Postmodern Age', in *Holocaust Memorials: The Art of Memory in History*, edited by James E. Young (Munich and NY: Prestel-Verlag, 1994), pp. 9–17.
8 Hartman, op. cit., p. 32.
9 Lefkowitz, 'On Silence and Other Disruptions', op. cit., p. 246.
10 See the excellent work of Joan Ringelheim on this topic, including 'Thoughts about Women and the Holocaust' in *Thinking the Unthinkable*, edited by Roger S. Gottlieb (NY and Mahwah, NJ: Paulist Press, 1990), pp. 141–9, p. 145.
11 There is now some excellent work on women and the Holocaust of which the following are a few sources: Carol Rittner and John K. Roth (eds), *Different Voices: Women and the Holocaust* (NY: Paragon House, 1993); Dalia Ofer and Lenore J. Weitzman (eds), *Women in the Holocaust* (New Haven, CT: Yale University Press, 1998).
12 Itka Zygmuntowicz, cited by Sara R. Horowitz in 'Women in Holocaust Literature: Engendering Trauma Memory', in *Women in the Holocaust*, op. cit., pp. 364–77, p. 370.
13 Vivian Sobchack, '"Is Any Body Home?" Embodied Imagination and Visible Evictions', in Naficy, op. cit., pp. 45–61.
14 Myrna Goldberg, 'Different Horrors, Same Hell: Women Remembering the Holocaust', in Gottlieb, op. cit., pp. 150–66.
15 James E. Young, 'The Art of Memory: Holocaust Memorials in History', in Young, op. cit., pp. 19–38, p. 20.
16 Lefkowitz herself used the phrase 'uneasy ambivalence' to describe her relationship to German history and contemporary culture. See Deborah Lefkowitz, 'Editing from Life', in *Women in German Yearbook 8: Feminist Studies in German*

Literature and Culture, edited by Jeanette Clausen and Sarah Friedrichsmeyer (Lincoln, NB, and London: University of Nebraska Press, 1993), pp. 199–215.

17 All film quotes are taken directly from the subtitles, translated and excerpted by Lefkowitz.

18 Matthew Bernstein, 'Review of *Intervals of Silence: Being Jewish in Germany*', *Film Quarterly*, vol. 47, no. 4 (Summer 1994), pp. 29–35.

19 Deborah Lefkowitz, in the artist's statement from *Illuminations from a Moment Past*, exhibition catalogue (Rancho Cucamonga, CA: Wignall Museum/Gallery, Chaffey College, 1998), no page numbers.

20 Lefkowitz, 'Editing from Life', op. cit., p. 206.

21 Griselda Pollock, 'Gleaning in History or Coming after/behind the Reapers: The Feminine, the Stranger and the Matrix in the Work and Theory of Bracha Lichtenberg Ettinger', in *Generations and Geographies in the Visual Arts: Feminist Readings* (London and NY: Routledge, 1996), pp. 266–88.

22 Ibid., p. 285.

23 In my own correspondence with Lefkowitz about the idea of covenant and the mother- and daughter-in-law relation, she noted that while her mother-in-law was not interviewed for the film, her image appears twice – as the woman cleaning the window and laying flowers on a grave. These appearances are both critical junctures in the film and reinforce the complexity of remembrance in creating covenants across difference.

24 In a long exchange, Lefkowitz was kind enough to describe the choices (both included and excluded) from this final scene as well as her multi-layered working methods. I felt that the negotiations with materials – visual, aural, textual – that she made were both sophisticated and meaningful and I hope that sense has been conveyed in the text.

25 Kitty Klaidman's artist statement in Bohm-Duchen, op. cit., p. 150.

26 There are a number of critics who have pointed to this feature of Horn's practice. See, for example: Mina Ronstayi, 'Getting Under the Skin: Rebecca Horn's Sensibility Machine', *Arts Magazine*, vol. 63, pt. 9 (May 1989), pp. 58–68 and Holland Cotter, 'Rebecca Horn: Delicacy and Danger', *Art in America*, vol. 81, pt. 12 (December 1993), pp. 58–67.

27 Irit Rogoff made this connection in a fascinating essay on the occlusion of gender difference within Israel's European-dominated Jewish cultural tradition. See Irit Rogoff, 'Daughters of Sunshine: Diasporic Impulses and Gendered Identities', in *Diaspora and Visual Culture: Representing Africans and Jews*, edited by Nicholas Mirzoeff (London and NY: Routledge, 2000), pp. 163–78, p. 175.

28 Martin Mosebach, 'Concert for Buchenwald' in Horn, *Concert for Buchenwald*, op. cit., pp. 11–16, p. 15.

29 Unlike a number of Whiteread's sculptures, the *Holocaust Memorial* is not a direct cast from an actual building, but a construction derived from casts Whiteread had been making of library shelves.

30 Lisa G. Corrin, Patrick Elliot and Andrea Schlieker, *Rachel Whiteread*, exhibition catalogue (Edinburgh and London: Scottish National Gallery and Serpentine, 2001), p. 60.

31 Interestingly, the German artist Grethe Jürgens, who spent the war years in 'inner exile', produced a small book in 1944 entitled *Das Atelier*. The volume moved through the spaces of the studio, connecting these with stories of the artist's activities and thoughts, to produce a profound self-portrait *sans* figurative likeness as the performance of female exilic subjectivity in memory. See M. Meskimmon, '*Das Atelier*: Spatiality and Self-Portraiture in the Work of Grethe Jürgens', *Woman's Art Journal*, vol. 21, no. 1 (Spring/Summer 2000), pp. 22–6, 64.

32 Suzi Gablik, 'Connective Aesthetics: Art After Individualism', in *New Genre Public Art*, edited by Suzanne Lacy (Seattle: Bay Press, 1995), pp. 74–87, p. 78.

33 Hartman, op. cit., p. 7.

34 See, for example, Doris von Drathen, 'Les Délices des Evêques and other scenes of the crime', in *Rebecca Horn: The Glance of Infinity*, edited by Carl Haenlein (Zurich, Berlin, NY: Scalo Verlag and Hanover: The Kestner Gesellschaft, 1997), pp. 338–41, p. 339.

35 Ronstayi, op. cit., p. 65.

36 Bruce W. Ferguson, 'Rebecca Horn: Really Dangerous Liaisons', in *Rebecca Horn: Driving Through Buster's Bedroom*, exhibition catalogue (Los Angeles Museum of Contemporary Art, and Milan: Fabbri Editori, 1990), pp. 19–27, p. 19.

37 For the German context especially, see M. Meskimmon, *We Weren't Modern Enough: Women Artists and the Limits of German Modernism* (Berkeley, CA and London: University of California and I.B. Tauris, 1999).

38 Horn, 'The Colonies of Bees', op. cit., p. 26.

39 Gablik, 'Connective Aesthetics', op. cit., p. 86.

40 Griselda Pollock, 'Is Feminism to Judaism as Modernity is to Tradition?: Critical Questions on Jewishness, Femininity and Art', in *Rubies and Rebels: Jewish Female Identity in Contemporary British Art*, edited by Monica Bohm-Duchen and Vera Grodzinski (London: Lund Humphries, 1996), pp. 15–27, p. 17.

2 Corporeal cartography: women artists of the anglophone African diaspora

1 Ringgold, cited in Moira Roth, 'Of Cotton and Sunflower Fields: The Makings of *The French* and *The American Collection*', in Dan Cameron *et al.*, *Dancing at the Louvre: Faith Ringgold's French Collection and Other Story Quilts* (NY: New Museum of Contemporary Art and Berkeley, CA: University of California Press, 1998), p. 61. This volume contains excellent reproductions of the series in colour and I would suggest that readers interested in the plays between the various quilts and their visual motifs consult this source.

2 Camp, cited in Wendy Belcher, 'An Interview with Sokari Douglas Camp', in *Echoes of the Kalabari: Sculpture by Sokari Douglas Camp* (Washington, DC: National Museum of African Art, Smithsonian Institution, 1989), pp. 9–23, p. 15.

3 Marcia Tucker, 'Foreword', in Cameron *et al.*, op. cit., p. ix.

4 In this chapter, I am using African, African-American, African-diasporan to designate the geo-cultural locus of artists/works, but the more politicised term 'black' to indicate subjects interpellated through the iniquitous power structures of racism across the 'First' and 'Third' Worlds.

5 Camp, cited in Wendy Belcher, 'An Interview with Sokari Douglas Camp', op. cit., pp. 9, 20.

6 Stuart Hall, 'Cultural Identity and Diaspora', reprinted in *Diaspora and Visual Culture*, op. cit., pp. 21–33, p. 24.

7 There is a great deal of excellent work on the tendency of white liberal feminists to homogenise 'woman' and the problems which such colour-blindness and implicit heterosexism entails for subjects inscribed as 'other' to the already 'othered'– one of the best early examples is the collection of essays entitled *All the Women are White, All the Blacks are Men, But Some of Us are Brave*, edited by Gloria T. Hull, Patricia Bell Scott and Barbara Smith (Old Westbury, NY: The Feminist Press, 1982).

8 Lubaina Himid, 'Mapping: A Decade of Black Women Artists', in *Passion: Discourses on Blackwomen's Creativity*, edited and introduced by Maud Sulter (Hebden Bridge: Urban Fox Press, 1990), pp. 63–72, p. 68.

9 Adrian Piper, 'The Triple Negation of Colored Women Artists', reprinted in *Next*

Generation: Southern Black Aesthetic, exhibition catalogue (Winston-Salem, NC: Southeastern Center for Contemporary Art, 1990), pp. 15–22.

10 Quote taken from Frieda High W. Tesfagiorgis, 'In Search of a Discourse and Critique/s that Center the Art of Black Women Artists', in *Gendered Visions: The Art of Contemporary African Women Artists*, edited by Salah M. Hassan (Trenton, NJ and Asmara, Eritrea: African World Press, 1997), pp. 73–92, p. 73. Tesfagiorgis also coined 'Afrofemcentrism' in 'Afrofemcentrism and its fruition in the art of Elizabeth Catlett and Faith Ringgold', *SAGE*, vol. iv (Spring 1987), pp. 25–32 and Mark A. Reid used the term 'Black womanism' in 'Dialogic Modes of Representing Africa(s): Womanist Film', in Michael T. Martin (ed.), *Cinemas of the Black Diaspora: Diversity, Dependence and Oppositionality* (Detroit: Wayne State University Press, 1995).

11 Michele Wallace, 'Variations on Negation and the Heresy of Black Feminist Creativity', *Heresies*, vol. 6, pt. 4 (1989), pp. 69–75, p. 69.

12 Audre Lorde, 'The Master's Tools Will Never Dismantle the Master's House', in *Sister Outsider: Poems and Speeches by Audre Lorde* (Freedom, CA: The Crossing Press, 1984), pp. 110–13.

13 As I write this, a new book is forthcoming from Rutgers University Press by Lisa Gail Collins, *The Art of History: African-American Women Artists Engage the Past* (February 2002). I anxiously await what looks to be a more lengthy study of some of the diverse ways in which African-American women artists consistently reinscribe histories by making art.

14 In the case of performance art, this potential was described very clearly by Amelia Jones in *Body Art: Performing the Subject* (Minneapolis and London: Minnesota University Press, 1998).

15 Ntozake Shange, in the preface to *for colored girls who have considered suicide/when the rainbow is enuf* and *spell 7* (London: Methuen Drama, 1990), p. xiii.

16 A fascinating collection of essays on the theme of dance and knowledge (and one which takes sexuality, gender, 'race' and cultural difference seriously), is *Corporealities: Dancing Knowledge, Culture and Power*, edited by Susan Leigh Foster (London and NY: Routledge, 1996).

17 Lowery Stokes Sims, 'Aspects of Performance in the Work of Black American Women Artists', in *Feminist Art Criticism: An Anthology*, edited by Arlene Raven *et al.* (UMI, 1988), pp. 207–25, p. 210.

18 Michele Wallace, 'The French Collection: Momma Jones, Mommy Fay and Me', in Cameron *et al.*, op. cit., pp. 14–25, p. 21.

19 See Chapter 1, especially the discussion of Frida Kahlo, in *The Art of Reflection: Women Artists' Self-Portraiture in the Twentieth Century* (London: Scarlet Press and NY: Columbia University Press, 1996).

20 Piper, 'The Triple Negation', op. cit., p. 16.

21 Michele Wallace, 'The French Collection: Momma Jones, Mommy Fay and Me', in Cameron *et al.*, op. cit., pp. 14–25, pp. 14–15.

22 Ringgold, cited in Roth, 'Of Cotton and Sunflower Fields', op. cit., p. 60.

23 Roth, ibid., p. 51.

24 The point need hardly be made of the significance of the subject-matter of women dancers to male modernist artists from Degas onward.

25 Geoffrey Hartman, *The Longest Shadow*, op. cit., pp. 107–8.

26 Moira Roth noted the significance of the quilt as a redress to a modernist, masculinist painterly tradition in 'Of Cotton and Sunflower Fields', op. cit., p. 55.

27 Toni Morrison, *Playing in the Dark: Whiteness and the Literary Imagination* (Cambridge, MA: Harvard University Press, 1992), p. 21.

28 The text has been reprinted many times; Alice Walker, 'In Search of Our Mothers' Gardens', *Imagining Women*, edited by Frances Bonner *et al.* (Cambridge: Polity and Open University Press, 1992), pp. 321–8.

29 The relationship delineated between Willia Marie and Marlena is not simple, however, and raises important question concerning women, creative freedom and maternal legacy.

30 Nicholas Serota and Gavin Jantjes wrote of Camp and the other artists in the show *From Two Worlds* that their work represented a 'fusion of European and non-European visions', see Serota and Jantjes, 'Introduction', in *From Two Worlds*, exhibition catalogue (London: Whitechapel, 1986), pp. 5–8, p. 5.

31 For a good quality reproduction of this work *in situ* (prior to it sustaining water damage), see Mary Jane Jacobs, *Places with a Past: New Site-Specific Art at Charleston's Spoleto Festival* (New York: Rizzoli International Publications, 1991).

32 Estella Conwill Májozo, 'To Search for the Good and Make It Matter', in *New Genre Public Art*, edited by Suzanne Lacy (Seattle: Bay Press, 1995), pp. 88–93, p. 91.

33 Camp, cited in Wendy Belcher, 'An Interview with Sokari Douglas Camp', op. cit., pp. 23, 10.

34 Camp, cited in Fran Cottell and Marian Schoettle, *Conceptual Clothing*, exhibition catalogue (Birmingham: Ikon Gallery, 1987), p. 25.

35 Camp, cited in Helen Karikari, 'Out of Africa', *Artists and Illustrators*, no. 110 (November 1995), pp. 55–8, p. 58.

36 Camp, cited in Wendy Belcher, 'An Interview with Sokari Douglas Camp', op. cit., p. 16.

37 Charmaine Nelson has recently completed a PhD on the topic of race, neo-classicism and the representation of black female figures at Manchester University. A version of this work, *The Colour of Stone: Sculpting Black Female Subjects in Nineteenth-Century American Neo-Classicism*, will be published by Manchester University Press and I am happy to have been able to read this proposal.

3 Re-inscibing histories: Viet Nam and representation

1 Trinh T. Minh-ha with Pratibha Parmar, 'Between Theory and Poetry' (interview, 1990), reprinted in Trinh T. Minh-ha, *Framer Framed* (London and NY: Routledge, 1992), pp. 151–8, p. 158.

2 Maya Lin, interviewed by Elizabeth Hess in 'A Tale of Two Memorials', *Art in America*, vol. 71, pt. 4 (April 1983), pp. 120–7, p. 123.

3 While the *Vietnam Veterans Memorial* is centred upon US involvement in Viet Nam, *Surname Viet Given Name Nam* addresses the longer period of decolonisation, from rejecting French rule to developing a socialist state. I do not wish to continue the tendency to see Viet Nam as merely an episode in US history.

4 Benedict Anderson, *Imagined Communities: Reflections on the Origin and Spread of Nationalism* (London and NY: Verso, 1991), p.6.

5 These variations in definition can be found in the *Oxford English Dictionary*.

6 Trinh has frequently invoked the difficulties of speaking as/for/about, see: 'Jumping into the Void', interview with Bérénice Reynaud, in *Cinema Interval* (London and NY: Routledge, 1999), pp. 51–73; 'Speaking Nearby', interview with Nancy Chen (1994), also reprinted in *Cinema Interval*, pp. 209–25; 'Outside In Inside Out', in Trinh T. Minh-ha, *The Moon Waxes Red* (London and NY: Routledge, 1991), pp. 65–78.

7 The name is still a subject of some controversy – in this chapter, I adhere to recent thinking on transliteration and use the two-word 'Viet Nam', except when citing titles of works which themselves used 'Vietnam', common in French and US sources. For a discussion of these conventions, see Carol A. Wells, 'Viet Nam[3]' in Track 16 Gallery and the Center for the Study of Political Graphics, *Decade of Protest: Political Posters from the United States, Viet Nam and Cuba* (Santa Monica, CA: Smart Art Press, 1996), pp. 15–23, p. 23, footnote 1.

8 Trinh T. Minh-ha with Deb Verhoeven, 'A Scenography of Love' (1997), reprinted in *Cinema Interval*, op. cit., pp. 3–15, p. 4.

9 Sources vary on the exact number – the original proposal mentioned 57,692 dead and 2,457 missing in action; 57,709 were first read aloud at the memorial service (see Shirley Neilsen Blum, 'The National Vietnam War Memorial', *Arts Magazine*, vol. 59, pt. 4 (Dec. 1984), pp. 124–8) and one source referred to 58,132 names (see Marita Sturken, 'The Wall, The Screen and the Image: The Vietnam Veterans Memorial', *Representations* 35 (Summer 1991), pp. 118–142).

10 In an incisive comment on the wall of names, Lin noted that their presence is like a public billboard, yet reading them, like reading a book, engenders an intimate, private space. See Tom Finkelpearl, 'The Anti-Monumental Work of Maya Lin', *Public Art Review*, issue 15, vol. 8, no. 1 (Fall/Winter 1996), pp. 5–9, p. 8.

11 Interview with Elizabeth Hess, op. cit.

12 Judith E. Stein makes the point that there were important precedents for Lin's work in earlier women artists' site-specific sculpture. See 'Space and Place', *Art in America*, vol. 82, pt. 12 (December 1994), pp. 66–71, 117.

13 *Surname Viet Given Name Nam*, film script reprinted in *Framer Framed*, op. cit., pp. 49–91, p. 88.

14 *Surname Viet Given Name Nam*, film script, op. cit., p. 88.

15 Carlo McCormick, 'Make Posters not War: Art as Artifact of the Viet Nam Era', in Track 16 Gallery, *Decade of Protest*, op. cit., pp. 27–33, p. 32.

16 Hugh Lunn, *Vietnam: A Reporter's War* (St Lucia: University of Queensland Press, 1985), p. 74.

17 See Francis Frascina, *Art, Politics and Dissent: Aspects of the Art Left in Sixties America* (Manchester: Manchester University Press, 1999), pp. 122–4.

18 May Stevens interviewed in *As Seen by Both Sides: American and Vietnamese Artists Look at the War*, edited by C. David Thomas (Boston, MA: Indochina Arts Project and the William Joiner Foundation, 1991), p. 64.

19 Benjamin Buchloh, 'An Interview with Martha Rosler', in *Martha Rosler: Positions in the Life World*, edited by Catherine de Zegher (Cambridge, MA: MIT Press, 1998), pp. 23–55, pp. 23, 29.

20 Alexander Alberro, 'The Dialectics of Everyday Life: Martha Rosler and the Strategy of the Decoy', in de Zegher, op. cit., pp. 73–112, p. 78.

21 Frascina, *Art, Politics and Dissent*, op. cit, p. 172.

22 Fifteen of the montages go under the heading *Bringing the War Home: House Beautiful* and five, *Bringing the War Home: In Vietnam*.

23 I am borrowing this useful phrase from Rosemary Betterton who characterised female embodied art-making with it: see R. Betterton, *An Intimate Distance: Women Artists and the Body* (London and NY: Routledge, 1996).

24 In his article 'Questioning Documentary', Brian Wallis argued that contemporary women artists had begun to challenge the very discourse of documentary as a stylistic and institutionalised set of conventions designed to promote particular constructions of subjectivity and identity. He interestingly mentions both Rosler and Trinh in this text, but does not specifically link any of their works: *Aperture*, vol. 112 (1998), pp. 60–71, p. 60.

25 Trinh interviewed by Isaac Julien and Laura Mulvey, in ' "Who Is Speaking?": Of Nation, Community and First Person Interviews' (1989), reprinted in *Framer Framed*, op. cit., pp. 191–210, pp. 191–2.

26 Bhabha, 'Painted Power', in *Cinema Interval*, op. cit., pp. 17–31, p. 22.

27 *Surname Viet given Name Nam* script, op. cit., p. 83.

28 Trinh, 'Totalising Quest of Meaning', in *When the Moon Waxes Red*, op. cit., pp. 29–50, p. 41.

29 Michael Renov, 'New Subjectivities: Documentary and Self-Representation', in

Feminism and Documentary, edited by Diane Waldman and Janet Walker (Minneapolis, MN: University of Minnesota Press), 1999, pp. 84–94, p. 91.

30 Victoria White, 'Whose Memorial Is This?', *Public Art Review*, vol. 7, pt. 2 (Spring/Summer 1996), pp. 14–17, p. 15.

31 Carhart is cited in Nicholas Capasso, *The National Vietnam Veterans Memorial in Context: Commemorative Public Art in America 1960–1997*, PhD dissertation (New Brunswick, NJ: Rutgers University, 1998), p. 170.

32 Hess, 'Tale of Two Memorials', op. cit., pp. 125, 126.

33 Ibid., p. 124.

34 Cited in Capasso, op. cit., p. 172.

35 Hess, 'A Tale of Two Memorials', op. cit., p. 123.

36 Sturken, op. cit., pp. 123, 126.

37 Nicholas Mirzoeff, *Bodyscape: Art, Modernity and the Ideal Figure* (London and NY: Routledge, 1995), p. 95.

38 Moira Gatens, 'Corporeal Representation in/of the Body Politic', in *Cartographies: Poststructuralism and the Mapping of Bodies and Spaces*, edited by Rosalyn Diprose and Robyn Ferrell (Sydney: Allen and Unwin, 1991), pp. 79–87, pp. 81–2.

39 Ibid., p. 79.

40 There are many sources which confirm the disproportion of ethnic/racial distribution among those who served and also the fact that most soldiers were working or lower-middle class, see Sturken, op. cit., p. 127.

41 D.S. Friedman, 'Public Things in the Atopic City: Late Notes on *Tilted Arc* and the *Vietnam Veterans Memorial*', *Art Criticism*, vol. 10, pt. 1 (1995), pp. 66–104, p. 75.

42 See Sturken, op. cit., for a fuller account of this, p. 131.

43 Therese O'Malley, '"A Public Museum of Trees": Mid-Nineteenth Century Plans for the Mall', in *The Mall in Washington, 1791–1991*, edited by Richard Longstreth (Washington, DC: The National Gallery of Art, 1991), pp. 61–76.

44 Interestingly, Catlett was raised in Washington, DC, and attended Howard University where Edmonia Lewis's *Forever Free* is housed.

45 Gatens, op. cit., p. 84.

46 Sturken, op. cit., p. 118.

4 Embodiment: space and situated knowledge

1 Deborah Cherry, *Beyond the Frame: Feminism and Visual Culture, Britain 1850–1900* (London and NY: Routledge, 2000), p. 28. Women artists in Victorian England have been the subject of excellent work for some time now, see, for instance, Pamela Gerrish Nunn, *Victorian Women Artists* (London: Women's Press, 1987) and Cherry's *Painting Women: Victorian Women Artists* (London and NY: Routledge, 1993). Here, I am particularly indebted to the brilliant account of *Nameless and Friendless* from *Beyond the Frame* which connects bodies, spaces and the politics of feminism/feminist texts in ways which have proven very useful in my attempt to think women's art, embodiment and situation.

2 Significantly, Rosemary Betterton invoked the concept of embodiment, rather than 'bodies' or 'body types' to discuss women's art and corporeality in her book *An Intimate Distance: Women Artists and the Body* (London and NY: Routledge, 1996).

3 Donna Haraway, 'Situated Knowledges: The Science Question in Feminism and the Privilege of Partial Perspective', in *Simians, Cyborgs and Women: The Reinvention of Nature* (London: Free Association of Books, 1991), pp. 183–201, p. 193.

4 Gail Weiss, *Body Images: Embodiment as Intercorporeality* (London and NY: Routledge, 1999), p. 5.

5 Pamela Gerrish Nunn, speaking at *Mirror, Mirror*, a day conference on women's self-portraiture, National Portrait Gallery, London, November 2001. NB - Nunn did not argue the point I am making about embodiment when she described the work as a 'generic self-portrait' and I am not just assuming that she holds this position.

6 Young wrote a number of well-known articles on this subject – I am here thinking mainly of 'Throwing Like a Girl' and its companion, 'Throwing Like a Girl – Twenty Years On', reprinted in *Body and Flesh: A Philosophical Reader*, edited by Donn Welton (Oxford: Blackwell, 1998), pp. 259–73 and 286–90, respectively.

7 Cherry expands upon her use of the frame as a structuring device and upon the intertextual and implicated processes by which sexuality, visual culture and social life intersected in the period in the Introduction to *Beyond the Frame*, op. cit., especially p. 5.

8 Judith Butler, 'Sex and Gender in Simone de Beauvoir's *Second Sex*', in Elizabeth Fallaize (ed.), *Simone de Beauvoir: A Critical Reader* (London and NY: Routledge, 1998), pp. 29–42, p. 38.

9 Rosalyn Diprose, *The Bodies of Women: Ethics, Embodiment and Sexual Difference* (NY and London: Routledge, 1994), p. 19 [italics in original].

10 Haraway, op. cit., pp. 190, 188.

11 This was not only the case in the late nineteenth century; this continued well into the 1920s. I have discussed this in relation to German modernism in M. Meskimmon, *We Weren't Modern Enough: Women Artists and the Limits of German Modernism* (London and Berkeley: I.B. Tauris and University of California Press, 1999).

12 Haraway, op. cit., p. 188.

13 Ibid., p. 193.

14 Elizabeth Grosz, 'Bodies and Knowledges', in *Space, Time and Perversion: Essays on the Politics of Bodies* (London: Routledge, 1995), pp. 25–44, p. 28.

15 Weiss, op. cit., p. 55.

16 Simon Sadler, *The Situationist City* (Cambridge, MA: MIT Press, 1998).

17 I want to thank Carol Richardson for providing me with this insight into the studio/studium connection in the Renaissance.

18 Svetlana Alpers, 'The Studio, The Laboratory and the Vexations of Art', in *Picturing Science, Producing Art*, Caroline Jones and Peter Galison (eds) (NY and London: Routledge, 1998), pp. 401–17.

19 Ibid., pp. 415–16.

20 Ibid., p. 407.

21 Maurice Merleau-Ponty, 'The Chiasmus – The Intertwining', in *The Visible and the Invisible*, edited by Claude Lefort, translated by Alphonso Lingis (Evanston, IL: Northwestern University Press, 1968), p. 263.

22 Ibid., p. 134.

23 Jacques Lassaigne and Guy Wheelen, *Vieira da Silva* (NY: Rizzoli, 1979), p. 14.

24 John Rewald, *Vieira da Silva: Paintings 1967–1971* (NY: M. Knoedler and Co, 1971), p. 5.

25 Serge Guilbaut, 'The Taming of the Saccadic Eye: The Work of Vieira da Silva in Paris', in *Inside the Visible: An Elliptical Traverse of the 20th Century, in, of and from the Feminine*, M. Catherine de Zegher (ed.) (Cambridge, MA and London: MIT Press, 1996), pp. 319–29, p. 327.

26 Martine Arnault, 'Dans la solitude des territoires', *Cimaise*, vol. 35, no. 137 (November/December 1988), pp. 121–4, p. 124.

27 Haraway, op. cit., p. 198.

28 Serge Guilbaut, op. cit., p. 323.

29 Weiss, op. cit., p. 119 – I am indebted to Weiss for her discussion of the micro and macro of reversibility and to Amelia Jones's excellent work on the Chiasmus in

Body Art: Performing the Subject (Indianapolis, IN: University of Indiana Press), 1998.

30 Haraway, op. cit., p. 201.

31 Sara Ahmed and Jackie Stacey, 'Introduction – Dermographies', in *Thinking Through the Skin*, S. Ahmed and J. Stacey (eds) (London and NY: Routledge, 2001), pp. 1–18, 2, 1.

32 Ibid., p. 2.

33 See, for example, the early collection by Cherríe Moraga and Gloria Anzaldúa (eds), *This Bridge Called My Back: Writings by Radical Women of Color* (Watertown, MA: Persephone Press, 1981). Specifically, the exploration of borderlands and the new *mestiza*, an extremely important feminist contribution to theories of radical difference, comes from Gloria Anzaldúa, *Borderlands/La Frontera* (San Francisco: Aunt Lute Press, 1987).

34 Anzaldúa made the salient comment that 'border *mestizo* culture' is not a fact, but a 'fiction' – one in which she and other artists of the border are heavily invested. This acknowledges that speaking of the new *mestiza* is not about imagining that there are essential 'mestizas', but that this concept is about the processes of engaging the border. See Gloria Anzaldúa, 'Border Arte: Neplanta, El Lugar de la Frontera', in *La Frontera/The Border: Art About the Mexico/US Border Experience*, edited by Patricio Chavez and Madeleine Grynsztejn (San Diego, CA: Centro Cultural de la Raza and the Museum of Contemporary Art, 1993), pp. 107–14, p. 111.

35 Amalia Mesa-Bains, 'El Mundo Femenino: Chicana Artists of the Movement – A Commentary on Development and Production', in *Chicano Art: Resistance, Affirmation, 1965–85*, edited by Richard Griswold del Castillo, Teresa McKenna and Yvonne Yarbro-Bejaran (Los Angeles, CA: UCLA, Wright Art Gallery, 1991), pp. 131–40, p. 131.

36 Amalia Mesa-Bains quoted by Trisha Ziff, 'Identity/Hybridity: Ideas Behind this Project', in *Distant Relations: Chicano, Irish, Mexican Art and Critical Writing* T. Ziff (ed.) (NY: Smart Art Press, 1996), pp. 25–44, p. 34.

37 She developed the term in writing about another Chicana artist, Patssi Valdez, see Meredith Tromble, 'A Conversation with Amalia Mesa-Bains', *Artweek*, 8 October 1992.

38 A pivotal article on this phenomenon is 'Rasquachismo: A Chicano Sensibility' by Tomás Ybarra-Frausto, in Richard Griswold del Castillo *et al.*, op. cit., pp. 155–62.

39 Amalia Mesa-Bains, quoted in Meredith Tromble, op. cit., p. 27.

40 Amalia Mesa-Bains, '*Domesticana*: The Sensibility of Chicana *Rasquache*', in T. Ziff, op. cit., pp. 156–63, p. 157.

41 Ibid., p. 162.

42 Jennifer A. Gonzáles, 'Rhetoric of the Object: Material Memory and the Artwork of Amalia Mesa-Bains', *Visual Anthropology Review*, vol. 9, no. 1 (Spring 1993), pp. 82–91, p. 82.

43 Ibid., p. 90.

44 For an excellent essay on Sor Juana which refuses an anachronistic reclamation of her as a contemporary feminist, yet asserts her woman-centred views, see Stephanie Merrim, 'Toward a Feminist Reading of Sor Juana Inés de la Cruz: Past, Present and Future Directions in Sor Juana Criticism', in *Feminist Perspectives on Sor Juana*, Stephanie Merrim (ed.) (Detroit: Wayne State University Press, 1991), pp. 11–37, p. 17.

45 Mesa-Bains described her own experience of coded language and accessibility in Anne Barclay Morgan, 'Interview: Amalia Mesa-Bains', *Art Papers*, vol. 19, no. 2 (1995), pp. 24–9, 25–6.

5 Performativity: desire and the inscribed body

1 Alex Hughes and Kate Ince, *French Erotic Fiction: Women's Desiring Writing, 1880–1990* (Oxford and Washington, DC: Berg, 1996), p. 3.

2 Though it is well known that Cahun and Moore were involved with the Resistance in Nazi-occupied Jersey and that they were imprisoned, sentenced to death and only saved when the island was liberated, Cahun is frequently discussed with little sense of her being a politicised artist. Gen Doy's work is particularly useful in reconnecting politics to Cahun's practice. See Doy, *Materializing Art History* (Oxford and NY: Berg, 1998), ch. 4. I would make the further point that Cahun's choice to publish *Aveux* with Willi Munzenberg's Éditions du Carrefour is significant and reiterates the connections between her left politics and her views on sexuality and aesthetics.

3 Cottingham, Lasalle and Solomon-Godeau take slightly different positions on the use of the term 'lesbian' in relation to Cahun and the historical moment, but I very much affirm their insistence that her work should not be subsumed within a generalised idea of unitary 'womanhood'. See Laura Cottingham, 'Betrachtungen zu Claude Cahun', in H. Ander and D. Snauwert (eds), *Claude Cahun: Bilder* (Munich: Schirmer/Mosel, 1997), pp. XIX–XXX and Honor Lasalle and Abigail Solomon-Godeau, 'Surrealist Confession: Claude Cahun's Photomontages', *Afterimage*, vol. 19, pt. 8 (March 1992), pp. 10–13.

4 Elizabeth Meese, *(Sem)Erotics: Theorizing Lesbian Writing* (New York and London: New York University Press, 1992), p. 3.

5 Judith Butler, 'Critically Queer', in J. Butler, *Bodies That Matter: On the Discursive Limits of 'Sex'* (London and New York: Routledge, 1993), pp. 223–42, 225.

6 Jeffner Allen, *Sinuosities: Lesbian Poetic Politics* (Indianapolis, IN: Indiana University Press, 1996), pp. 74, 76.

7 Since the early 1990s, a small but very good body of literature has appeared on Cahun – I am particularly indebted to the work of Abigail Solomon-Godeau, Honor Lasalle, Whitney Chadwick, Gen Doy, Laura Cottingham, Peter Weibel and Francoise Leperlier. It is Lasalle and Solomon-Godeau who argued for the translation 'null and void', and noted that the term was used in legal jargon; see 'Surrealist Confession', op. cit., p. 10.

8 I am using Judith Butler's phrase here. See 'Imitation and Gender Insubordination', in *Inside/Out: Lesbian Theories, Gay Theories*, Diana Fuss (ed.) (London and NY: Routledge, 1991), pp. 13–31.

9 Rosalind Krauss, *Bachelors* (Cambridge, MA: MIT Press, 1999), p. 42.

10 Elizabeth Grosz, 'Refiguring Lesbian Desire', in *Space, Time and Perversion*, op. cit., pp. 173–85, p. 175.

11 Butler, 'Bodies that Matter', in Butler, op. cit., pp. 27–55, p. 32.

12 Doy, op. cit., p. 119.

13 These works have been shown in numerous exhibitions over the past decade and are frequently reproduced. However, even the many which have now become familiar are but a small proportion of the number actually made – many were destroyed by the Nazis when they occupied the Channel Islands and imprisoned Cahun and Moore for their work with the Resistance.

14 Such a 'private' circulation network, particularly between women in the arts, should not be underestimated. I am very much indebted to my colleague Elaine Hobby who pointed out to me how important private publication amongst women in the early-modern period had been which made me re-examine this aspect of Cahun's work.

15 Although this project was never completed, the essays have been reprinted in English in *Inverted Odysseys: Claude Cahun, Maya Deren, Cindy Sherman*, edited by Shelley Rice (Cambridge, MA: MIT Press, 1999).

16 Butler, 'Imitation and Gender Insubordination', in Butler, op. cit., pp. 16–17.

17 I am using graphemic here deliberately, since I want to invoke the range of meanings implied by the term 'graph' – from writing to drawing – in addition to the way in which 'grapheme' indicates a point between spoken and written language.

18 The translation of Ellis ('La Femme dans la société, I. L'Hygiene sociale') and the comment on the Allan trial ['La *Salomé* d'Oscar Wilde. Le procès Billing et les 47000 perverts du Livre noir'] both appeared in *Mercure de France*, 1929 and 1918 respectively. The oft-cited *Amitié* quote is from 1925: 'My viewpoint on homosexuality and homosexuals is the same as my opinion on heterosexuality and heterosexuals: it all depends on the individuals and their situation. I support general moral freedom' (my translation), cited in Heike Ander and Dirk Snauwert (eds), *Claude Cahun: Bilder* (Munich: Schirmer/Mosel, 1997), p. XLIII. On the Maud Allan case, see Lucy Bland, 'Trial by Sexology?: Maud Allan, *Salome* and the "Cult of the Clitoris" Case', in *Sexology in Culture: Labelling Bodies and Desires*, edited by Lucy Bland and Laura Doan (Chicago: University of Chicago Press, 1998), pp. 183–98.

19 Alison Oram, 'Sex is an Accident: Feminism, Science and the Radical Sexual Theory of *Urania*, 1915–40', in L. Bland and L. Doan, op. cit., pp. 214–30.

20 This montage has sometimes been cited incorrectly as 'III'; it is twice labelled as the second ('II') montage in *Aveux non Avenus*, Paris: Éditions du Carrefour, 1930 – at page 23 and in the English table of sections at the back of the volume 'II Moi-même – (self-love)', no page number.

21 I am thinking, for instance, of the well-known work by John Berger, *Ways of Seeing* (London: BBC and Penguin, 1972) and Laura Mulvey, in *Visual and Other Pleasures* (Basingstoke: Macmillan, 1989).

22 See Lynda Nead, *The Female Nude: Art, Obscenity, Sexuality* (London and NY: Routledge, 1992).

23 The first image is comprised of a series of snapshots taken from head to foot of the artist's body and the second is a single snap – the 'lo-tech' nature of phototherapy is important and obvious in the visuals.

24 This work has been discussed elsewhere, see especially, Rosy Martin's own article in which she connects her personal experience of coming-out with the hostile political climate of the period: 'Don't say cheese, say lesbian', in *Stolen Glances*, Jean Fraser and Tessa Boffin (eds) (London: Pandora, 1991), pp. 94–105.

25 In discussion with Martin, she did lament the fact that the first image was often shown without its pair, thus leading some critics to imply that the work was only concerned with the negative force of words.

26 For an excellent discussion of the politics of inside/out, see Diana Fuss, op. cit., p. 2.

27 Eve Kosofsky Sedgwick, *Epistemology of the Closet* (New York: Harvester Wheatsheaf, 1991).

28 Tamsin Wilton, *Lesbian Studies: Setting an Agenda* (London and NY: Routledge, 1995). This is also the line which Butler takes, describing provisional naming and is akin to the concept of 'strategic essentialism' proposed by Teresa de Lauretis and others.

29 This sense of liberating the 'real' body is reinforced by the fact that the first part is more decidedly 'constructed' through the montage of the photos and the second part more 'complete' in one picture.

30 Phototherapy has been discussed at length by both Martin and Spence and I would suggest that readers unfamiliar with this pivotal intervention into images and psychic constructions of the self see Rosy Martin and Jo Spence, 'Phototherapy – psychic realism as a healing art?', *Ten 8*, No. 30 (1988), pp. 2–17 and Rosy Martin, 'Unwind the ties that bind' in *Family Snaps*, Jo Spence and Pat Holland (eds) (London: Virago, 1991), pp. 209–21.

31 Text from David Reuben, *Everything You Always Wanted to Know About Sex, But were Afraid to Ask* (New York: McKay, 1969).
32 Text from Barbara Walker, *The Women's Encyclopedia: Myths and Secrets* (London: Harper and Row, 1983).
33 Elizabeth Meese, *(Sem)Erotics*, op. cit., p. 132.
34 Text taken from Elizabeth Grosz, *Volatile Bodies: Toward a Corporeal Feminism* (Indiana IN: Indiana University Press), 1994.
35 Text taken from Sigmund Freud, 'The Disposition to Obsessional Neurosis', 1913.
36 In a forthcoming text on *Outrageous Agers*, Martin discusses the image paired with the Butler text as referencing the Venus and stresses the fist in the Freud text-image pair. See Martin, 'Challenging Invisibility: Outrageous Agers', in *Gender Issues in Art Therapy*, Susan Hogan (ed.), forthcoming (London: Jessica Kingsley, 2002).
37 Joanna Frueh, *Monster/Beauty: Building the Body of Love* (Berkeley, CA: University of California Press, 2001), p. 11.
38 Audre Lorde, 'Uses of the Erotic: The Erotic as Power', *Sister Outsider: Essays and Speeches by Audre Lorde* (Freedom, CA: The Crossing Press, 1984), pp. 53–9.
39 Grosz, *Space, Time and Perversion*, op. cit., p. 181.
40 The first two comments come from an interview with Andrew Renton in *Flash Art*, 'Velvet Sex Trap', vol. 154 (October 1990), pp. 144–5, p. 145; the third is from an interview with Louisa Buck in *Tate: The Art Magazine*, no. 12 (1997), pp. 60–5, p. 60.
41 Roland Barthes, *The Pleasure of the Text*, translated by Richard Miller (NY: Hill and Wang, 1975).
42 Ibid., p. 42.
43 Some excellent work on surface/depth and feminist art practice appears in the work of Mira Schor – see, for example, *Wet: On Painting, Feminism and Art Culture* (Durham, NC: Duke University Press, 1997).
44 I'd like to note the fascinating ideas Paul Melia has been exploring in his work on queering the image and the subject in the early work of David Hockney. He linked performativity to the emphasis on surface in Hockney's student paintings in ways which really moved my thinking on. The paper I heard is being published as: 'David Hockney: A Different Kind of Beginning', in *David Hockney: A Retrospective*, ed. Kay Heymer (Bonn: Kunst- und Ausstellungshalle, 2001).
45 Alphonso Lingis, *Excesses: Eros and Culture* (NY: State University of New York Press, 1984), p. 34.
46 Andrew Renton, op. cit., p. 145.
47 See Emmanuel Levinas, *Totality and Infinity*, translated by Alphonso Lingis (Pittsburgh: Duquesne University Press, 1969), p. 34 and Luce Irigaray, 'The Fecundity of the Caress: A Reading of Levinas', *Totality and Infinity* section IV, B, "The Phenomenology of Eros"', in *Face to Face with Levinas*, edited by Richard Cohen (NY: State University of New York Press, 1986), pp. 231–58, p. 236.
48 Alphonso Lingis, *Libido: The French Existential Theories* (Bloomington IN: Indiana University Press, 1985), p. 62.
49 Krauss, *Bachelors*, op. cit., p. 37.

6 Becoming: individuals, collectives and wondrous machines

1 William T. Stearn documented the citations Linnaeus took from Merian in Maria Sybilla Merian, *The Wondrous Transformation of Caterpillars: Fifty Engravings Selected from Erucarum Ortus (1718)*, with an introduction by William T. Stearn (London: Scolar, 1978), p. 18.
2 The Labadists were followers of Jean de Labadie, a French Jesuit-turned-

Protestant who espoused a form of Quietism associated with communal living, the renunciation of worldly goods and intensive, personal prayer. See Trevor J. Saxby, *The Quest for the New Jerusalem: Jean de Labadie and the Labadists, 1610–1744* (Dordrecht: M. Nijhoff Publishers, 1987).

3 Merian did not write on theology, *per se*, but, as Natalie Zemon Davis points out in her biographical account of the artist, there are strong indications that her spiritual life was in accord with the teachings of the Labadists in some ways. For further detail, see Natalie Zemon Davis, *Women on the Margins: Three Seventeenth-Century Lives* (Cambridge, MA: Harvard University Press, 1995).

4 There are a number of accounts of Ruysch's famous cabinet and its eventual acquisition, nearly complete, by Peter the Great, but I would refer the reader to Rosamond Wolff Purcell and Stephen Jay Gould, *Finders, Keepers: Eight Collectors* (London: Pimlico, 1993), for astounding photographs of some of the embalmed displays by Rosamond Wolff Purcell.

5 Merian and Ruysch were not the only women – many others also flourished as allegorical flower-painters or as illustrators of flora and fauna for the burgeoning field of scientific publication in the period. For example, both Clara Regina Imhoff and Dorothea Maria Auerin were successful flower painters in Germany and Barbara Regina Dietzsch, a generation younger than Merian, made her name in Nuremburg by producing a volume on endangered bird species. In Amsterdam, Maria van Oosterwijk was already well established as a flower painter when Ruysch began her career and of the many women illustrating flora and fauna, two were employed at the Botanical Garden – Maria Moninckx (one of the producers of *The Moninckx Atlas*) and Johanna Helena Herolt, Merian's older daughter.

6 This is a classic trope used to explain away women's wide participation in culture – some exciting work on this was done by Mary D. Sheriff, *The Exceptional Woman: Elisabeth Vigee-Lebrun and the Cultural Politics of Art* (Chicago: University of Chicago Press, 1996).

7 Marianne Berardi, 'Science into Art: Rachel Ruysch's Early Development as a Still-Life Painter' (University of Pittsburgh, 1998). This is an excellent PhD thesis and will make an invaluable contribution to this subject when published.

8 There is much high calibre feminist work on re-thinking the sciences, historically and structurally – the works to which I am here referring are two key examples of this body of criticism: Sandra Harding, *The Science Question in Feminism* (Ithaca, NY, and London: Cornell University Press, 1986) and Evelyn Fox Keller, *Reflections on Gender and Science* (New Haven, CT: Yale University Press, 1985), p. 4.

9 Barbara Stafford, *Visual Analogy: Consciousness as the Art of Connecting* (Cambridge, MA: MIT Press, 1999), p. xvi.

10 Ibid., p. 9.

11 It is also interesting that Leibniz's thinking on combination was influenced by yet another woman who has since been marginalised in the history of philosophy, Ann Finch, Viscountess of Conway.

12 Natalie Zemon Davis, op. cit., p. 151.

13 Ibid., p. 181

14 Marianne Berardi, op. cit., pp. 358–9, p. 311.

15 Borzello discussed this at length at the conference *Mirror, Mirror*, held at the National Portrait Gallery in London, November 2001 and in her book *Seeing Ourselves* (London: Phaidon, 1998).

16 Rosi Braidotti, 'Toward a New Nomadism: Feminist Deleuzian Tracks; or, Metaphysics and Metabolism', in *Gilles Deleuze and the Theater of Philosophy*, C.V. Boundas and D. Olkowski (eds) (New York and London: Routledge, 1994), pp. 159–85, p. 159.

17 Rosi Braidotti, 'Re-figuring the Subject', in *Nomadic Subjects: Embodiment and Sexual Difference in Contemporary Feminist Theory* (NY: Columbia University Press, 1994), pp. 95–110, p. 109.

18 Rosi Braidotti, 'Mothers, Monsters and Machines', in *Nomadic Subjects*, op. cit., pp. 75–94, p. 75.

19 Braidotti, 'Toward a New Nomadism', op. cit., pp. 180–1.

20 Ibid., p. 177.

21 Gilles Deleuze and Félix Guattari, *What is Philosophy?*, translated by Hugh Tomlinson and Graham Burchill (London: Verso, 1984), p. 18.

22 Gail Weiss, *Body Images: Embodiment as Intercorporeality* (NY and London: Routledge, 1999), p. 120.

23 Londa Schiebinger, 'Lost Knowledge, Bodies of Ignorance, and the Poverty of Taxonomy as Illustrated by the Curious Fate of the *Flos Pavonis*, An Abortifacient', in *Picturing Science, Producing Art*, edited by Caroline Jones and Peter Galison (London and NY: Routledge, 1998), pp. 125–44. Also note, we are now certain that many male biologists of the period also used local knowledge to find and gain access to sources; the difference is that they excised these encounters from their methodical scientific texts as mere 'anecdotes'.

24 *The Sunday Times*, 14 October 2001, section 4, p. 2.

25 Keith Ansell Pearson, 'Viroid Life: On Machines, Technics and Evolution', in *Deleuze and Philosophy: The Difference Engineer* (London and NY: Routledge, 1997), pp. 180–210, p. 202.

26 Braidotti, 'Toward a New Nomadism', op. cit., p. 177.

27 Here we might not only think of Donna Haraway's famous 'Manifesto for Cyborgs', in *Simians, Cyborgs and Women*, op. cit., pp. 149–82, but also the work of Sadie Plant on historical and cognitive links between women, networked thinking and the dynamics of computer technology or artists such as Linda Dement who have sought to enflesh new media. See Plant, *Zeros and Ones: Digital Women and the New Technoculture* (London: Fourth Estate, 1997).

28 Munster's plans for the CD-ROM will actually enhance this element; as she puts it: 'The idea, however, is that the collector/user is initially unaware of both [their own] behavioural attributes and system constraints, becoming cognisant of these only as a result of interactivity.' In unpublished CD-ROM specification, made available to me by the artist.

29 Stafford, op. cit., p. 175.

30 Anna Munster, 'Machinic Disturbants: Genealogies of the Digital', PhD thesis (University of New South Wales, December 2000), pp. 4–5.

31 Mieke Bal, *Quoting Caravaggio: Contemporary Art, Preposterous History* (Chicago: University of Chicago Press, 1999), p. 25.

32 Bal discusses the vexed issue of intentionality as a way to re-think art historical methods which over-determine meaning through biography. See *Quoting Caravaggio*, pp. 10–11.

33 John V. Pickstone, *Ways of Knowing: A New History of Science, Technology and Medicine* (Manchester: Manchester University Press, 2000) – see especially Chapter 3, 'Natural History'.

34 It is important to note that *Pupil* has also provided the focal point for video work and multi-media installations.

35 Elizabeth King, *Attention's Loop: A Sculptor's Reverie on the Coexistence of Substance and Spirit* (New York: Harry N. Abrams, 1999), p. 7.

36 Ibid., p. 66.

37 Bal, op. cit., p. 7.

38 The photographs of *Pupil* for the volume were taken by Katherine Wetzel; they are integral to the work and to the more multiple form of authorship which it implies.

39 Stafford, op. cit., p. 58.

40 Moira Gatens and Genevieve Lloyd, *Collective Imaginings: Spinoza, Past and Present* (London and NY: Routledge, 1999).
41 Gatens and Lloyd credit Etienne Balibar with this term, which he used to describe Spinoza's conception of the connected individual, ibid., p. 121.
42 Ibid., p. 65.
43 Ibid., p. 127.
44 Weiss, op. cit., p. 120.
45 The classic philosophical text on the fold is Gilles Deleuze's study of Leibniz and the Baroque – *The Fold: Leibniz and the Baroque*, foreword and translation by Tom Conley (Minneapolis, MN: Minnesota University Press, 1993).
46 Yve Lomax, 'Folds in the Photograph', *Third Text*, vol. 32 (Autumn 1995), pp. 43–58, p. 46.
47 King, op. cit., p. 50.
48 Gen Doy, *Materializing Art History*, ibid., p. 109.

7 Pleasure and knowledge: 'Orientalism' and filmic vision

1 Laura U. Marks, *Skin of the Film: Intercultural Cinema, Embodiment, and the Senses* (Durham, NC: Duke University Press, 2000), pp. 118–19.
2 I am using the terms 'Orient', 'East' and 'West' here purposely to invoke their heavily laden ideological significance in colonial and imperial fantasies of place – not as words which simply indicate any exact or actual locations. When I refer to geographical regions or nation-states, I will do so specifically in order to distinguish these from the homogenising logic of 'orientalism'. Additionally, the conventions of 'orientalism' point foremost toward the Ottoman, Muslim regions of North Africa and the Middle East and not to China, Southeast Asia and Japan as the word 'Orient' is more commonly used today, especially in the United States.
3 Terry Eagleton, 'The Ideology of the Aesthetic', in *The Politics of Pleasure: Aesthetics and Cultural Theory*, edited by Stephen Regan (Milton Keynes: Open University Press, 1992), pp. 17–31, p. 17.
4 G. S. Rousseau and R. Porter (eds), *Exoticism in the Enlightenment* (Manchester: Manchester University Press, 1990), p. 5. The best-known work on this theme is, of course, Edward Said, *Orientalism* (London: Routledge and Kegan Paul, 1978) and a famous polemic on the gendered nature of orientalist discourse can be found in Rana Kabbani, *Imperial Fictions: Europe's Myths of Orient* (London: Pandora, 1986).
5 Susan Rodin Pucci, 'The Discrete Charms of the Exotic: Fictions of the Harem in Eighteenth-century France', in Rousseau and Porter (eds), op. cit., pp. 145–74.
6 Assia Djebar, 'Behind the Veil: Women on Both Sides of the Camera', *Unesco Courier* (October 1989), pp. 34–7, p. 36.
7 Ibid., p. 35.
8 Mira Schor coined the term 'monocular penis' to describe a form of monolithic, masculine vision in her 'Erotics of Viewing', in *Wet: On Painting, Feminism and Art Culture*, op. cit., pp. 165–9, p. 169.
9 Irvin Cemil Schick in 'The Women of Turkey as Sexual Personae: Images from Western Literature', in *Deconstructing Images of 'The Turkish Woman'*, Zehra F. Arat (ed.) (London and NY: Macmillan, 1998), pp. 83–100 (p. 91), makes the salient point that one of the most negative critical conflations in western discourses on the Ottoman empire was between '*ars erotica*' and '*scientia sexualis*', a key underpinning to sexualising the scientific, objective look.
10 Gen Doy, *Women and Visual Culture in 19th Century France: 1800–1852* (London: Leicester University Press, 1998), p. 232.

11 Lizbeth Malkmus and Roy Armes, *Arab and African Film Making* (London and New Jersey: Zed Books, 1991) (on training in the colonies).
12 See Rey Chow, *Primitive Passions: Visuality, Sexuality, Ethnography, and Contemporary Chinese Art* (New York: Columbia University Press, 1995).
13 Violet Shafik, *Arab Cinema: History and Cultural Identity* (Cairo, Egypt: The American University in Cairo Press, 1998), pp. 4 and ff.
14 Marks, op. cit., p. xii.
15 This shift from anti- to authentic to interstitial and negotiated was hard won. See Hamid Naficy, 'Between Rocks and Hard Places: The Interstitial Mode of Production', in *Home, Exile, Homeland*, edited by Hamid Naficy, op. cit., pp. 125–47 and Paul Willemen, 'The Third Cinema Question: Notes and Reflections', in *Questions of Third Cinema*, edited by Jim Pines and Paul Willemen (London: BFI Publishing, 1989), pp. 1–29.
16 It is also worth remembering that these artists were impelled to train as artists in western metropolitan centres, precisely because of the legacy of imperialism; the 'international' is not an homogenous zone, but one marked by power differentials between nation-states.
17 Reina Lewis, 'Cross-Cultural Reiterations: Demetra Vaka-Brown and the Performance of Racialized Female Beauty', in *Performing the Body, Performing the Text*, edited by Amelia Jones and Andrew Stephenson (London and NY: Routledge, 1999), pp. 56–75, described very well the complex and risky practices in which women writers of the mid-twentieth century engaged when they worked across similar cultural boundaries and tropes. This risk is exactly what interests me – the difficult territory of pleasure, the 'East' and 'woman', inscribed by women who might be reappropriated within the stereotypes themselves, yet avert this danger.
18 Haptic is a term increasingly used in aesthetics to denote a multi-sensory, and especially a tactile, emphasis in works of art; it is often described against a distancing ocularcentrism. I will be discussing this at great length later in this chapter and am indebted to the work of Jen Fisher, 'Relational Sense: Toward a Haptic Aesthetics', *Parachute*, no. 87 (1997), pp. 4–11.
19 Sensorium is the term used in anthropology to delineate a culture's field of sensory expectation and evaluation – e.g., which sights, sounds, smells, tastes or tactile encounters are usual/unusual, pleasant/unpleasant, valued/devalued, etc. See Kit Griffin, 'Notes on the Moroccan Sensorium', *Anthropologica*, XXXII (1990), pp. 107–11.
20 Djebar, op. cit., p. 37
21 Marnia Lazreg, *The Eloquence of Silence: Algerian Women in Question* (London: Routledge, 1994), p. 107.
22 See Shafik, op. cit., pp. 108–9.
23 Virginia Danielson, *The Voice of Egypt: Umm Khulthum, Arabic Song, and Egyptian Society in the 20th Century* (Chicago: University of Chicago Press, 1997), pp. 10–11.
24 Lizbeth Malkmus and Roy Armes, *Arab and African Film Making* (London and New Jersey: Zed Books, 1991).
25 I am borrowing the term 'collective enunciation' from Hamid Naficy, who used it differently when he described the role of language in interstitial cinema (see Naficy, 'Between Rocks and Hard Places', op. cit., p. 131.) However, his argument is resonant with mine and the term can 'travel'.
26 The character of Alia even sings along to Khulthum on the radio.
27 Shafik, op. cit., p. 113.
28 Malkmus, op. cit., p. 140
29 Renee Baert's 'Desiring Daughters', in Katy Deepwell (ed.), *Women Artists and Modernism* (Manchester: Manchester University Press, 1998), pp. 175–88 makes

this point and demonstrates how this runs counter to negative, Freudian concepts of the mother–daughter bond.

30 Significantly, this film was produced in New York and Neshat's collaborators for the work, Deyhim, Azari and the director of phototography Ghasem Ibrahimian, are also Iranian expatriates. The work is both collective and exilic; it is cross-cultural in its very production and in its emphasis. As Neshat put it: 'One of the main challenges for me is figuring out how an artist who comes from and remains interested in the resources of another culture can make work that contributes to a broader dialogue. I'm not satisfied with just explaining my culture. I don't want to be an ethnographic artist. – It's a very delicate balance to maintain.' Neshat in Leslie Camhi, 'Lifting the Veil', *Art News* (February 2000), pp. 148–51, p. 151.

31 Hamid Naficy, 'Parallel Worlds', in *Shirin Neshat*, exhibition catalogue (Vienna: Kunsthalle and London: Serpentine, 2000), pp. 42–53, p. 51.

32 See Sobchack, *The Address of the Eye: A Phenomenology of Film Experience* (Princeton, NJ: Princeton University Press, 1992).

33 Vivian Sobchack, ' "Is Anybody Home?"': Embodied Imagination and Visible Evictions', in Hamid Naficy (ed.), *Home, Exile, Homeland*, op. cit., pp. 45–61, p. 48.

34 George Whale, a Research Fellow at Loughborough University, has been exploring the cognitive features of drawing in ways which explore some of these dynamics and my thinking on this topic was first piqued by one of his seminars (Spring 2001).

35 Sobchack, 'Is Anybody Home?', op. cit., p. 60.

36 See Gerald Matt, 'In Conversation with Shirin Neshat', in *Shirin Neshat*, exhibition catalogue (Vienna: Kunsthalle and London: Serpentine, 2000), pp. 10–29, p. 11.

37 See Judy Stone on Tlatli winning the Satyajit Ray award in ' "Silences of the Palace" Has Everybody Talking', *San Francisco Chronicle*, 23 April 1995: http://www.sfgate.com/cgi-bin/article.cgi?file=/chronicle/archive/1995/PK45698.DTL

38 Laura Mulvey, 'Moving Bodies: Interview with Moufida Tlatli', *Sight and Sound* (March 1995), pp. 18–20, p. 20.

39 Laura Marks used *Measures of Distance* as a touchstone throughout *Skin of the Film*, because of its evocative sense of vision and followed Jen Fisher in arguing for the significance of such 'haptic' aesthetics.

40 E. Ann Kaplan makes this distinction between gaze and look in *Looking for the Other: Feminism, Film and the Imperial Gaze* (London: Routledge, 1997), p. xviii.

41 Edward Said, 'Traveling Theory', in *The World, the Text and the Critic* (Cambridge, MA: Harvard University Press, 1983).

42 Mieke Bal, 'Visual Narrativity', published in the conference book for *Visual-Narrative Matrix: Interdisciplinary Collisions and Collusions Conference* (Southampton: Southampton Institute, 1999), no page numbers.

43 Edward Guthmann, ' "Silence" is a Cry for Freedom', *San Francisco Chronicle*, 1 September 1995: http://www.sfgate.com/cgi-bin/article.cgi?file=/chronicle/archive/1995/DD34528.DTL

44 Farzaneh Milani, 'The Visual Poetry of Shirin Neshat', in *Shirin Neshat* (Milan: Edizioni Charta, 2001), pp. 6–13, p. 12.

45 Fatima Mernisi, *Beyond the Veil: Male-Female Dynamics in Modern Muslim Society* (1975), revised edition (London: A. L. Saqi Books, 1985). See especially pp. 89, 137–147.

46 Much has been written on the significance of the baths or *hammam* for women in Islamic cultures. See Mildred Mortimer, 'Assia Djebar's *Algerian Quartet*: A Study in Fragmented Autobiography', *Research in African Literature*, vol. 28, pt. 2 (1997), pp. 102–17, p. 108.

47 Homi K. Bhabha, 'The Commitment to Theory', in Pines and Willemen, op. cit., pp. 111–31, p. 131.

8 The word and the flesh: text/image re-made

1 Elizabeth Grosz, *Space, Time and Perversion*, op. cit., p. 37.
2 Barbara Stafford, *Good Looking: Essays on the Virtue of Images* (Cambridge, MA: MIT Press, 1996), p. 45.
3 Johanna Drucker, *The Visible Word: Experimental Typography and Modern Art, 1909–1923* (Chicago: University of Chicago Press, 1994), p. 14.
4 Christopher Collins, 'Writing and the Nature of the Supernatural Image, or Why Ghosts Float', in *Languages of Visuality: Crossings Beyond Science, Art, Politics and Literature*, edited by Beate Allert (Detroit: Wayne State University Press, 1996), pp. 242–61, p. 246.
5 Elizabeth Eisenstein, *The Printing Press as an Agent of Change: Communications and Cultural Transformations in Early-Modern Europe* (Cambridge: Cambridge University Press, 1979), pp. 84–8.
6 Adrian Johns, *The Nature of the Book: Print and Knowledge in the Making* (Chicago: University of Chicago Press, 1998), pp. 2, 6.
7 Ibid., pp. 180, 414.
8 Women's writing in the seventeenth century continued this oppositional stance from a bodily locus – see, for a pointed instance, Elaine Hobby's fascinating work on women and midwifery manuals: Jane Sharp (1671), *The Midwives Book or The Whole Art of Midwifery Discovered*, edited by Elaine Hobby (Oxford: Oxford University Press, 1999).
9 Maurice Merleau-Ponty, *The Phenomenology of Perception*, translated by Colin Smith (London: Routledge and Kegan Paul, 1962), p. 178.
10 Alphonso Lingis, 'Word of Honour', in Davies and M. Meskimmon, *Reconceptions: New Ecologies of Knowledge* (London: I.B. Tauris, forthcoming, 2002). Lingis argues in a fully corporeal textual mode, against simplistic dualist logic.
11 Hamilton has 'read' in other installations and has had others perform gestures in the space linked to reading (such as winding typewriter ribbon hand to hand like yarn, dropping balls to the ground), but these two installations are of most interest to me in thinking about reading as a multi-sensorial act.
12 Buzz Spector, 'Residual Readings: The Altered Books of Ann Hamilton', *Print Collectors' Newsletter*, vol. 26, no. 2 (May–June 1995), pp. 55–6, p. 56.
13 The reader Hamilton engaged for the recording was a man who had undergone a severe stroke at an early age and whose ability to speak the words he read was impaired so that what was heard was the difficult entry of the body into speech, rather than the seamless translation of text into voice.
14 Dave Hickey, in 'In the Shelter of the Word: Ann Hamilton's *tropos*', *Ann Hamilton, tropos* (NY: DIA Center, 1995), pp. 117–43, pp. 124–5, refers to the artist's stories of her grandmother reading to her as they did household chores.
15 In describing the temporal effects of *tropos*, Hamilton mentioned to me that the smoke produced by burning the texts eventually permeated the horsehair and thus became part of the smell and taste of the work – it was ingested. This return to the body was especially subtle, yet definitive.
16 Hamilton, in correspondence with the author.
17 Carol H. Cantrell, 'Analogy as Destiny: Cartesian Man and the Woman Reader', *Hypatia* Special Issue on Feminist Aesthetics, edited by Hilde Hein and Carolyn Korsmeyer, vol. 5, no. 2 (Summer 1990), pp. 7–19.
18 Wallace Stevens, 'The Planet on the Table', in *The Collected Poems of Wallace Stevens* (London: Faber and Faber Ltd, 1955), pp. 532–3.
19 Ann Hamilton quoted in 'It Ain't Needlepoint' by Hunter Drohojowska-Philp, *LA Times, Calendar*, Sunday 19 June 1994, pp. 4, 79–80, p. 4.
20 Hamilton in conversation with Helaine Posner, cited in *19 Projects: Artists-in-*

Residence at the MIT List Visual Arts Center (Cambridge, MA: MIT Press, 1996), pp. 194–202, p. 199.

21 Joan Simon, 'Ann Hamilton: Inscribing Place', *Art in America*, vol. 87, no. 6 (June 1999), pp. 76–85.

22 Ibid., p. 79.

23 Dan Cameron, 'In The Tradition', in *Igor and Svetlana Kopystiansky*, exhibition catalogue with texts from Joachim Sartorius, Dan Cameron and Christine Tacke (Berlin: Berlinische Galerie, 1991), pp. 90–92, p. 90.

24 Svetlana Kopystiansky quoted in *The Library* exhibition catalogue with an introductory conversation between Doreet Levitte-Harten and Jürgen Harten (Düsseldorf: Kunsthalle, 1994), p. 79.

25 David Jackson has described this privilege and its effects upon fine art at the end of the nineteenth century in *The Wanderers*, forthcoming (Manchester: Manchester University Press).

26 Svetlana and Igor maintain their own separate practices, but frequently show work together so to play across their shared themes. In some ways, their working processes are thus strongly collaborative and dialogic.

27 Gilles Deleuze and Félix Guattari, *A Thousand Plateaus: Capitalism and Schizophrenia*, translated and foreword by Brian Massumi (Minneapolis, MN: University of Minnesota Press, 1987), p. 4.

28 Gavin Jantjes (ed.), *A Fruitful Incoherence: Dialogues with Artists on Internationalism* (London: Institute of International Visual Arts, 1998), pp. 71–2.

29 Ulises S. Carrion, *On Books* (Geneva: Heros Limite, 1997), p. 31.

30 Deleuze, op. cit., p. 4.

31 As a colleague of mine reminded me recently, these intellectual and corporeal pleasures are also combined as lone diners eat and read at once.

32 Paul Ricoeur, *History and Truth*, translated by Charles A. Kelbley (Evanston, IL: Northwestern University Press, 1965), p. 278.

33 Ann Hamilton, cited in Mary Katherine Coffey, 'Histories that Haunt: A Conversation with Ann Hamilton', *Art Journal*, vol. 60, no. 3 (Fall 2001), pp. 11–23, p. 14.

34 Charles Reznikoff, *Testimony: The US, 1885–1915 (Recitative)* (Santa Barbara: Black Sparrow Press, 1978).

35 John Gray, *Enlightenment's Wake: Politics and Culture at the Close of the Modern Age* (London: Routledge, 1995). See especially pp. 144–5.

36 Hamilton in Coffey, op. cit., p. 11.

37 And, as a double-sided distorting lens, the view back out from the pavilion, into Venice and the Biennale, was also rendered problematic rather than transparent.

38 See G. S. Rousseau and R. Porter (eds), *Exoticism in the Enlightenment* (Manchester: Manchester University Press, 1990). I am also indebted to the excellent work of Lynda Nead on nineteenth-century responses to the sexual artifacts of Pompeii, which I first heard in a paper she delivered to the *Come to Your Senses* conference, Amsterdam School of Cultural Analysis, May 1998.

39 I am indebted to John Grace of the OU for this information – very little detailed material exists on the Mysteries and therefore much is speculative.

40 Ann Hamilton, interviewed by Libby Anson, 'Deep Pink Solace', *Make: the magazine of women's art*, no. 85 (September–November 1999), pp. 16–19, p. 18.

9 The place of time: Australian feminist art and theory

1 Moira Gatens, cited in Steven Maras and Teresa Rizzo, 'On Becoming: An Interview with Moira Gatens', *Southern Review*, vol. 28 (March 1995), pp. 53–68, p. 65.

2　See Arno Borst, *The Ordering of Time: From the Ancient Computus to the Modern Computer*, trans. Andrew Winnard (Cambridge: Polity Press, 1993).

3　Deleuze is taken to argue that thinking is experimental and emergent, while recognition reproduces the already known – see D. N. Rodowick, 'The Memory of Resistance', in *A Deleuzian Century?*, edited by Ian Buchanan (Durham, NC and London: Duke University Press), 1999, pp. 37–57.

4　Elizabeth Grosz, 'Thinking the New: Of Futures Yet Unthought', in Grosz (ed.), *Becomings: Explorations in Time, Memory and Futures* (Ithaca, NY: Cornell University Press, 1999), pp. 15–28, p. 16.

5　Claire Colebrook, 'A Grammar of Becoming: Strategy, Subjectivism and Style', in Grosz (ed.), *Becomings*, op. cit., pp. 117–40.

6　Grosz, 'Thinking the New', in *Becomings*, op. cit., p. 19.

7　Moira Gatens, 'Sex, Gender, Sexuality: Can Ethologists Practice Genealogy?', *The Southern Journal of Philosophy*, vol. XXXV, Supplement (1996), pp. 1–19.

8　For an excellent introduction to Australian feminist philosophy, see the special edition of *Hypatia*, 'Going Australian: Reconfiguring Feminism and Philosophy', vol. 15, no. 2 (Spring 2000), edited by Christine Battersby, Catherine Constable, Rachel Jones and Judy Purdom. In relation to the particular strategies and ideas introduced into feminist philosophy by Australian scholars, see Christine Battersby's Introduction to the Special Issue, 'Learning to Think Intercontinentally: Finding Australian Routes', pp. 1–17.

9　The full name of the Museum of Sydney includes the epithet 'on the site of First Government House' to keep the charged space in view.

10　1992 saw the legal end of this concept when *terra nullius* was finally overruled in the famous Mabo case.

11　Genevieve Lloyd made the point that, although *terra nullius* was always treated with scepticism, it actually underpinned ideas of the indigenous population as a 'doomed race', a concept considered more credible. See 'No One's Land: Australia and the Philosophical Imagination', *Hypatia*, vol. 15, no. 2 (Spring 2000), pp. 26–39.

12　On the significance of women to settlement, and their diversity, see Deborah Oxley, *Convict Maids: The Forced Migration of Women to Australia* (Cambridge: Cambridge University Press, 1996).

13　Peter Emmett's brief, cited in *Edge of the Trees: A Sculptural Installation by Janet Laurence and Fiona Foley* [from the concept by Peter Emmett], edited by Dinah Dysart (Sydney: Historic Houses Trust of New South Wales, 2000), pp. 26–39.

14　The other artists invited to submit proposals were: Alison Clouston, Narelle Jubelin, Rea (*Gamilaroi/Wailwan*) and Ken Unsworth.

15　Rhys Jones, 'Ordering the Landscape', in I. and T. Donaldson, *Seeing the First Australians* (Sydney: Allen and Unwin, 1985), p. 185.

16　Jakelin Troy, 'Naming Languages and People in the Sydney Area', in Dysart, op. cit., p. 108.

17　For more detailed discussion of the significance of quotational histories, see: Mieke Bal, *Quoting Caravaggio: Contemporary Art, Preposterous History* (Chicago: University of Chicago Press, 1999).

18　See Emmett's project brief, in Dysart, op. cit., p. 34.

19　Peter Emmett cited in an interview with Peta Landman, *Sydney Review*, December 1994. Clipping from the archives at Museum of Sydney.

20　Emmett's project brief, op. cit., p. 36.

21　Prosser cited in Dysart, op. cit., p. 97.

22　Emmett's project brief, op. cit., p. 35.

23　These comments are taken from letters to the Museum kept in their archive.

24　Edward Casey, 'The Time of the Glance: Toward Becoming Otherwise', in Grosz, *Becomings*, op. cit., pp. 79–97.

25 Significantly, Sue Best signalled movement in response to this work with the phrase 'mobile engagement' – see Sue Best, 'Immersion and Distraction in the Environmental Works of Janet Laurence', *Art and Australia*, vol. 38, no. 1 (2000), pp. 84–91, p. 88.

26 See 'Conservation', in Dysart, op. cit., p. 109.

27 In Anna Voigt, *New Visions, New Perspectives: Voices of Contemporary Australian Women Artists* (Sydney: Craftsman House, 1996), p. 62.

28 On Deleuzian machines and collectivities, see Manuel de Landa, 'Deleuze, Diagrams and the Open-Ended Becoming of the World', in Grosz, *Becomings*, op. cit., pp. 29–41.

29 In Voigt, op. cit., p. 62.

30 Elizabeth Grosz, 'Becoming . . . An Introduction', in Grosz, *Becomings*, op. cit., pp. 1–11, p. 5.

31 In Voigt, op. cit., p. 60.

32 Elizabeth Grosz, 'Becoming . . . An Introduction', op. cit., pp. 4–5.

33 Bal, *Quoting Caravaggio*, op. cit., p. 25.

34 Henri Bergson, *The Creative Mind: An Introduction to Metaphysics*, trans. Mabell L. Andison (NY: Citadell Press, 1992), p. 93.

35 Grosz, 'Thinking the New', in *Becomings*, op. cit., p. 28.

36 Zoe Sofia, 'Technoscientific Poeisis: Joan Brassil, Joyce Hinterding, Sarah Waterson', *Continuum*, vol. 8, pt. 1 (1994), pp. 364–75.

37 Martin Thomas, 'Technology of Perception: The Installations of Joan Brassil', *Art and Australia* (1993), pp. 68–76.

38 In Jutta Feddersen, *Soft Sculpture and Beyond: An International Perspective* (G + B Arts International) (Sydney: Craftsman House, 1993), p. 63.

39 Brian Robinson, 'Joan Brassil: A Link Between Art and Science' from *metis*, pp. 45–6 (from archival material in Campbelltown Art Gallery).

40 In the original project statement, this work was envisaged as the second part of a trilogy with *Randomly Now and Then*, but this altered as Brassil began to work and found that new materials and concerns were being established in the piece. In discussing this with the artist, she also directed me toward the poem which is part of the second piece in the *Cosmic Trilogy*, *In The Sublime Flux* (1999) and beautifully connects with the concerns of this chapter: 'We/ may be/ sensor shadows/ where energies meet/ to echo and reflect/ astral songs/ of chance/ yet/ again/ to change/ in passing thru/ harmonic shiftings/ or diatronic drifts to/ random rhythms/ within/ Songs and Sands/ of Time'.

41 Project statement, in the archives of Campbelltown Gallery.

42 Colebrook, op. cit., p. 124.

43 Ibid., p. 127.

44 Penelope Deutscher, 'Imperfect Discretion: Interventions into the History of Philosophy by Twentieth-Century French Women Philosophers', in *Hypatia*, op. cit., pp. 160–80, p. 173.

Bibliography

Ahmed, Sara and Jackie Stacey (eds), *Thinking Through the Skin*. London and NY: Routledge, 2001.

Allen, Jeffner, *Sinuosities: Lesbian Poetic Politics*. Indianapolis, IN: Indiana University Press, 1996.

Allen, Jeffner and Iris Marion Young (eds), *The Thinking Muse: Feminism and Modern French Philosophy*. Indiana, IN: Indiana University Press, 1989.

Allert, Beate (ed.), *Languages of Visuality: Crossings Between Science, Art, Politics and Literature*. Detroit: Wayne State University Press, 1996.

Ander, Heike and Dirk Snauwert (eds), *Claude Cahun: Bilder*. Munich: Schirmer/Mosel, 1997.

Anderson, Benedict. *Imagined Communities: Reflections on the Origin and Spread of Nationalism*. London and NY: Verso, 1991.

Ann Hamilton: tropos, exhibition catalogue. NY: Dia Center, 1995.

Anson, Libby, 'Deep Pink Solace', *Make: the magazine of women's art*, no. 85, September–November 1999, pp. 16–19.

Antoni, Janine, 'Mona Hatoum' (interview), *Bomb*, vol. 63, Spring 1998, pp. 54–61.

Anzaldúa, Gloria, *Borderlands/La Frontera*. San Francisco, CA: Aunt Lute Books, 1987 (second edition 1999).

Arat, Zehra F. (ed.), *Deconstructing Images of 'The Turkish Woman'*. London and NY: Macmillan, 1998.

Archer, Michael, Guy Brett and Catherine de Zegher, *Mona Hatoum*. London: Phaidon, 1997.

Arnault, Martine, 'Dans la solitude des territoires', *Cimaise*, vol. 35, no. 137, November/December 1988, pp. 121–4.

Art and Australia, vol. 32, no. 3, 1995 [special issue on women's art].

Ashburn, Elizabeth, *Lesbian Art: An Encounter with Power*. Sydney: Craftsman House, 1996.

Atherton, Margaret (ed. and intro), *Women Philosophers of the Early Modern Period*. Indianapolis and Cambridge: Hackett Publishing Co., 1994.

Baert, Renee, 'Desiring Daughters', in Katy Deepwell (ed.), *Women Artists and Modernism*. Manchester: Manchester University Press, 1998, pp. 175–88.

Bal, Mieke, *Quoting Caravaggio: Contemporary Art, Preposterous History*. Chicago: University of Chicago Press, 1999.

Bandt, Ros, 'Sculpting Sounds: An Introduction to Sound Sculpture in Australia', *Art and Australia*, vol. 32, no. 4, 1995, pp. 536–47.

Barnwell, Andrea D. (ed.), *The Walter O. Evans Collection of African American Art.* Seattle, WA: University of Washington Press, 1999.

Barthes, Roland, *The Pleasure of the Text*, translated by Richard Miller. NY: Hill and Wang, 1975.

Barwell, Ismay, 'Feminine Perspectives and Narrative Points of View', *Hypatia*, special issue 'Feminism and Aesthetics', edited by Hilde Hein and Carolyn Korsmeyer, vol. 5, no. 2, Summer 1990, pp. 63–75.

Battersby, Christine and Catherin Constable, Rachel Jones, Judy Purdom (eds), 'Going Australian: Reconfiguring Feminism and Philosophy', special issue of *Hypatia*, vol. 15, no. 2, Spring 2000.

Behdad, Ali, *Belated Travelers: Orientalism in the Age of Colonial Dissolution.* Cork: University of Cork Press, 1994.

Bell, Diane, *et al.* (eds), *Gendered Fields: Women, Men and Ethnography.* London: Routledge, 1993.

Berardi, Marianne, 'Science into Art: Rachel Ruysch's Early Development as a Still-Life Painter', PhD. University of Pittsburgh, 1998.

Berger, John, *Ways of Seeing.* London: BBC and Penguin, 1972.

Bernstein, Matthew, 'Review of *Intervals of Silence: Being Jewish in Germany*', *Film Quarterly*, vol. 47, no. 4, Summer 1994, pp. 29–35.

Bernstein, Matthew and Gaylun Studlar (eds), *Visions of the East: Orientalism and Film.* London: I.B. Tauris, 1997.

Bertucci, Lina, 'Shirin Neshat: Eastern Values', *Flash Art*, vol. 30, no. 197, Nov.–Dec. 1997, pp. 84–7.

Best, Sue, 'Immersion and Distraction in the Environmental Works of Janet Laurence', *Art and Australia*, vol. 38, no. 1, 2000, pp. 84–91.

Betterton, Rosemary, *An Intimate Distance: Women Artists and the Body.* London and NY: Routledge, 1996.

Between Distance and Proximity: Images and Texts from the Film 'Intervals of Silence: Being Jewish in Germany', exhibition catalogue. Berlin: Galerie am Scheunenviertel, 1994.

Bland, Lucy and Laura Doan (eds), *Sexology in Culture: Labelling Bodies and Desires.* Chicago: University of Chicago Press, 1998.

Blatter, James and Sybil Milton (eds), *Art of the Holocaust.* London: Pan Books Ltd, 1982.

Blum, Shirley Neilsen, 'The National Vietnam War Memorial', *Arts Magazine*, vol. 59, pt. 4, Dec. 1984, pp. 124–8.

Bobo, Jacqueline (ed.), *Black Women Film and Video Artists.* London and NY: Routledge, 1998.

Bohm-Duchen, Monica (ed.), *After Auschwitz: Responses to the Holocaust in Contemporary Art.* Sunderland: Northern Centre for Contemporary Art, in association with Lund Humphries, 1995

Bohm-Duchen, Monica and Vera Grodzinski (eds), *Rubies and Rebels: Jewish Female Identity in Contemporary British Art.* London: Lund Humphries, 1996.

Bontemps, Arna Alexander and Jacqueline Fonvielle-Bontemps, 'African–American Women Artists: An Historical Perspective', *SAGE*, vol. IV, no. 1, Spring 1987, pp. 17–24.

Borst, Arno, *The Ordering of Time: From the Ancient Computus to the Modern Computer*, trans. Andrew Winnard. Cambridge: Polity Press, 1993.

Boundas, C.V. and Dorothea Olkowski (eds), *Gilles Deleuze and the Theater of Philosophy*. New York and London: Routledge, 1994.

Braidotti, Rosi, *Nomadic Subjects: Embodiment and Sexual Difference in Contemporary Feminist Theory*. NY: Columbia University Press, 1994.

Broinowski, Alison, *The Yellow Lady: Australian Impressions of Asia*. Melbourne and Oxford: Oxford University Press, 1992.

Buchanan, Ian (ed.), *A Deleuzian Century?* Durham, NC and London: Duke University Press, 1999.

Büchler, Pavel, 'Avoided Objects', *Creative Camera*, no. 350, February/March 1998, pp. 36–7.

Buck, Louisa, interview with Cathy de Monchaux, in *Tate: The Art Magazine*, no. 12, 1997, pp. 60–65.

Butler, Judith, *Bodies That Matter: On the Discursive Limits of 'Sex'*. London and New York: Routledge, 1993.

Cahun, Claude, *Aveux non Avenus*. Paris: Éditions Carrefour, 1930.

Cameron, Dan, *et al.*, *Dancing at the Louvre: Faith Ringgold's French Collection and Other Story Quilts*. NY: New Museum of Contemporary Art and Berkeley, CA: University of California Press, 1998.

Camhi, Leslie, 'Lifting the Veil', *Art News*, February 2000, pp. 148–51.

Cantrell, Carol H., 'Analogy as Destiny: Cartesian Man and the Woman Reader', *Hypatia* special issue on Feminist Aesthetics, edited by Hilde Hein and Carolyn Korsmeyer, vol. 5, no. 2, Summer 1990, pp. 7–19.

Capasso, Nicholas, 'Constructing the Past: Contemporary Commemorative Sculpture', *Sculpture*, November/December 1990, pp. 56–63.

Capasso, Nicholas. *The National Vietnam Veterans Memorial in Context: Commemorative Public Art in America 1960–1997*, PhD. Rutgers University, 1998.

Castillo del, Richard Griswold, Teresa McKenna and Yvonne Yarbro-Bejaran (eds), *Chicano Art: Resistance, Affirmation, 1965–85*. Los Angeles, CA: UCLA, Wright Art Gallery, 1991.

Carrion, Ulises S., *On Books*. Geneva: Heros Limite, 1997.

Cathy de Monchaux, exhibition catalogue. London: Whitechapel, 1997.

Chadwick, Whitney (ed.), *Mirror Images: Women, Surrealism, and Self-Representation*. Cambridge, MA: MIT Press, 1998.

Chanter, Tina, *Ethics of Eros: Irigaray's Rewriting of the Philosophers*. London and NY: Routledge, 1995.

Chavez, Patricio and Madeleine Grynsztejn (eds), *La Frontera/The Border: Art About the Mexico/US Border Experience*. San Diego, CA: Centro Cultural de la Raza and the Museum of Contemporary Art, 1993.

Cherry, Deborah, *Painting Women: Victorian Women Artists*. London and NY: Routledge, 1993.

Cherry, Deborah, *Beyond the Frame: Feminism and Visual Culture, Britain 1850–1900*. London and NY: Routledge, 2000.

Chow, Rey, *Primitive Passions: Visuality, Sexuality, Ethnography, and Contemporary Chinese Art*. New York: Columbia University Press, 1995.

Cohen, Richard (ed.), *Face to Face with Levinas*. NY: State University of New York Press, 1986.

Cornelia Parker: Avoided Object, exhibition catalogue. Cardiff: Chapter, 1996.

Corrin, Lisa G., Patrick Elliot and Andrea Schlieker, *Rachel Whiteread*, exhibition

catalogue. Edinburgh and London: Scottish National Gallery and Serpentine, 2001.

Cottell, Fran and Marian Schoettle, *Conceptual Clothing*, exhibition catalogue. Birmingham: Ikon Gallery, 1987.

Cotter, Holland, 'Rebecca Horn: Delicacy and Danger', *Art in America*, vol. 81, pt. 12, December 1993, pp. 58–67.

Cottingham, Laura, 'Ann Hamilton: A Sense of Imposition', *Parkett*, no. 30, 1991, pp. 130–8.

Craw, Robert, 'Anthropophagy of the Other: The Problematic of Biculturalism and the Art of Appropriation', *Art and Asia Pacific*, September 1993, pp. 10–15.

Culbert, David, *Film and Propaganda in America: A Documentary History*. NY: Greenwood Press, 1990.

Danielson, Virginia, *The Voice of Egypt: Umm Kulthum, Arabic Song, and Egyptian Society in the 20th Century*. Chicago: University of Chicago Press, 1997.

Davis, Natalie Zemon, *Women on the Margins: Three Seventeenth-Century Lives*. Cambridge, MA: Harvard University Press, 1995.

Deepwell, Katy, 'Inside Mona Hatoum', *Tate: The Art Magazine*, vol. 6, Summer 1995, pp. 32–5.

Deleuze, Gilles, *The Fold: Leibniz and the Baroque*, foreword and translation by Tom Conley. Minneapolis, MN: Minnesota University Press, 1993.

Deleuze, Gilles and Félix Guattari, *What is Philosophy?*, translated by Hugh Tomlinson and Graham Burchill. London: Verso, 1984.

Deleuze, Gilles and Félix Guattari, *A Thousand Plateaus: Capitalism and Schizophrenia*, translated and foreword by Brian Massumi. Minneapolis, MN: University of Minnesota Press, 1987.

Diamond, Sara, 'Performance: An Interview with Mona Hatoum', *Fuse*, vol. 10, pt. 5, April 1987, pp. 46–52.

Diprose, Rosalyn, *The Bodies of Women: Ethics, Embodiment and Sexual Difference*. NY and London: Routledge, 1994.

Diprose, Rosalyn and Robyn Ferrell (eds), *Cartographies: Poststructuralism and the Mapping of Bodies and Spaces*. Sydney: Allen and Unwin, 1991.

Djebar, Assia, 'Behind the Veil: Women on Both Sides of the Camera', *Unesco Courier*, October 1989, pp. 34–7.

Doy, Gen, *Materializing Art History*. Oxford and NY: Berg, 1998a.

Doy, Gen, *Women and Visual Culture in 19th Century France: 1800–1852*. London: Leicester University Press, 1998b.

Doy, Gen, *Black Visual Culture: Modernity and Postmodernity*. London: I.B. Tauris, 2000.

Drake, Nicholas, 'In the Wake of Places: The Social, Political and Cultural Impact of "Places with a Past" on Charleston, South Carolina', *Art Papers*, vol. 21, no. 3, May–June 1997, pp. 27–9.

Drathen, Doris von, 'Gespeicherte Zeit, Gespeichertes Tun', *Kunstforum International*, no. 147, September/November 1999, pp. 288–97.

Driskell, David C. (ed.), *African American Visual Aesthetics: A Postmodernist View*. Washington, DC: Smithsonian Institution Press, 1995.

Drohojowska-Philp, Hunter, 'It Ain't Needlepoint' by *LA Times, Calendar*, Sunday 19 June 1994, pp. 4, 79–80.

Drucker, Johanna, *The Visible Word: Experimental Typography and Modern Art, 1909–1923*. Chicago: University of Chicago Press, 1994.

Drury, Nevill, *New Sculpture: Profiles in Contemporary Australian Sculpture*. Sydney, Craftsman House, 1993.

Duerden, Dennis, 'Sokari Douglas Camp', *African Arts*, Summer 1995, pp. 64–9.

Dyer, Richard, *White*. London and NY: Routledge, 1997.

Dysart, Dinah (ed.), *Edge of the Trees: A Sculptural Installation by Janet Laurence and Fiona Foley*. Sydney: Historic Houses Trust of New South Wales, 2000.

Earman, John, *World Enough and Space-Time: Absolute versus Relational Theories of Space and Time*. Cambridge, MA: MIT Press, 1989.

Echoes of the Kalabari: Sculpture by Sokari Douglas Camp. Washington, DC: National Museum of African Art, Smithsonian Institution, 1989.

Edelstein, Susan, *Shirin Neshat "Women of Allah"*. Vancouver: Artspeak Gallery, 1997.

Eisenstein, Elizabeth, *The Printing Press as an Agent of Change: Communications and Cultural Transformations in Early-Modern Europe*. Cambridge: Cambridge University Press, 1979.

Fallaize, Elizabeth (ed.), *Simone de Beauvoir: A Critical Reader*. London and NY: Routledge, 1998.

Feddersen, Jutta, *Soft Sculpture and Beyond: An International Perspective* (G + B Arts International). Sydney: Craftsman House, 1993.

Finkelpearl, Tom, 'The Anti-Monumental Work of Maya Lin', *Public Art Review*, issue 15, vol. 8, no. 1, Fall/Winter 1996, pp. 5–9.

Fisher, Jen, 'Relational Sense: Towards a Haptic Aesthetics', *Parachute*, no. 87, 1997, pp. 4–11.

Fiske, John, Bob Hodge and Graeme Turner (eds), *Myths of Oz: Reading Australian Popular Culture*. London and Syney: Allen and Unwin, 1987.

Foster, Susan Leigh (ed.), *Corporealities: Dancing Knowledge, Culture and Power*. London and NY: Routledge, 1996.

Frascina, Francis, *Art, Politics and Dissent: Aspects of the Art Left in Sixties America*. Manchester: Manchester University Press, 1999.

Fraser, J.T. (ed.), *The Voices of Time: A Cooperative Survey of Man's Views of Time as Expressed by the Sciences and the Humanities*. London: Allen Lane, The Penguin Press, 1968.

Friedman, D.S., 'Public Things in the Atopic City: Late Notes on *Tilted Arc* and the *Vietnam Veterans Memorial*', *Art Criticism*, vol. 10, pt. 1, 1995, pp. 66–104.

Frueh, Joanna, *Monster/Beauty: Building the Body of Love*. Berkeley, CA: University of California Press, 2001.

Fuss, Diana (ed.), *Inside/Out: Lesbian Theories, Gay Theories*. London and NY: Routledge, 1991.

Garb, Tamar, 'Mona Hatoum', *Art Monthly*, no. 216, May 1998, pp. 31–2.

Garceau, Anne-Marie, 'Ann Hamilton: experimenter avant de nommer', *Parachute*, no. 92, October–December 1998, pp. 4–13.

Gatens, Moira, 'Sex, Gender, Sexuality: Can Ethologists Practice Genealogy?', *The Southern Journal of Philosophy*, vol. XXXV, Supplement, 1996, pp. 1–19.

Gatens, Moira and Genevieve Lloyd, *Collective Imaginings: Spinoza, Past and Present*. London and NY: Routledge, 1999.

Goldberg, S.L. and F.B. Smith, *Australian Cultural History*. Cambridge: Cambridge University Press, 1988.

Gonzáles, Jennifer A., 'Rhetoric of the Object: Material Memory and the Artwork of Amalia Mesa-Bains', *Visual Anthropology Review*, vol. 9, no. 1, Spring 1993, pp. 82–91.

Gottlieb, Roger S. (ed.), *Thinking the Unthinkable*: NY and Mahwah, NJ: Paulist Press, 1990.

Grant, Colonel Maurice Harold, *Rachel Ruysch 1664–1750*. Leigh-on-Sea: F. Lewis Publishers, Limited, 1956.

Gray, John, *Enlightenment's Wake: Politics and Culture at the Close of the Modern Age*. London: Routledge, 1995. See especially pp. 144–5.

Griffin, Kit, 'Notes on the Moroccan Sensorium', *Anthropologica*, XXXII, 1990, pp. 107–11.

Grosz, Elizabeth, *Volatile Bodies: Toward a Corporeal Feminism*. Indiana, IN: Indiana University Press, 1994.

Grosz, Elizabeth, *Space, Time and Perversion: Essays on the Politics of Bodies*. London: Routledge, 1995.

Grosz, Elizabeth (ed.), *Becomings: Explorations in Time, Memory and Futures*. Ithaca, NY: Cornell University Press, 1999.

Grosz, Elizabeth and Elspeth Probyn (eds), *Sexy Bodies: The Strange Carnalities of Feminism*. London and NY: Routledge, 1995.

Guilbaut, Serge, 'The Taming of the Saccadic Eye: The Work of Vieira da Silva in Paris', in *Inside the Visible: An Elliptical Traverse of the 20th Century, in, of and from the Feminine*, M. Catherine de Zegher (ed.). Cambridge, MA, and London: MIT Press, 1996.

Haenlein, Carl (ed.), *Rebecca Horn: The Glance of Infinity*. Zurich, Berlin, NY: Scalo Verlag and Hanover: The Kestner Gesellschaft, 1997.

Hammond, William M., *Reporting Vietnam: Military and Media at War*. Lawrence, KS: University of Kansas Press, 1998.

Haraway, Donna, *Simians, Cyborgs and Women: The Reinvention of Nature*. London: Free Association of Books, 1991.

Harding, Sandra, *The Science Question in Feminism*. Ithaca, NY, and London: Cornell University Press, 1986.

Hartman, Geoffrey, *The Longest Shadow: In the Aftermath of the Holocaust*. Indianapolis, IN: Indiana University Press, 1996.

Hassan, Salah M. (ed.), *Gendered Visions: The Art of Contemporary Africana Women Artists*. Trenton, NJ, and Asmara, Eritrea: African World Press, 1997.

Haynes, Peter, 'Janet Laurence', *Art and Australia*, vol. 26, pt. 4, 1982, pp. 607–9.

Healy, Chris, *From the Ruins of Colonialism: History as Social Memory*. Cambridge: Cambridge University Press, 1997.

Heath, G. Louis (ed.), *Mutiny Does Not Happen Lightly: The Literature of the Resistance to the Vietnam War*. Metuchen, NJ: Scarecrow Press, 1976.

Hedger, Michael, *Public Sculpture in Australia*. Sydney: Craftsman House, 1995.

Hess, Elizabeth, 'A Tale of Two Memorials', *Art in America*, vol. 71, pt. 4, April 1983, pp. 120–27.

hooks, bell, *Art on My Mind: Visual Politics*. NY: The New Press, 1995.

hooks, bell, *Reel to Real: Race, Sex and Class at the Movies*. London and NY: Routledge, 1996.

Horn, Rebecca, *Concert for Buchenwald*. Zurich, Berlin, NY: Scalo, 1999.

Horne, Peter and Reina Lewis (eds), *Outlooks: Lesbian and Gay Sexualities and Visual Cultures*. London and NY: Routledge, 1996.

Hughes, Alex and Kate Ince, *Women's Erotic Writing in France, 1880–1990*. Oxford and Washington, DC: Berg, 1996.

Hull, Gloria T., Patricia Bell Scott and Barbara Smith (eds), *All the Women are White,*

All the Blacks are Men, But Some of Us are Brave. Old Westbury, NY: The Feminist Press, 1982.

Igor and Svetlana Kopystiansky, exhibition catalogue with texts from Joachim Sartorius, Dan Cameron and Christine Tacke. Berlin: Berlinische Galerie, 1991.

Illuminations from a Moment Past, exhibition catalogue. Rancho Cucamonga, CA: Wignall Museum/Gallery, Chaffey College, 1998.

In Place (Out of Time), exhibition catalogue. Oxford: Museum of Modern Art, 1997.

Isaacs, Jennifer, *Aboriginality: Contemporary Aboriginal Paintings and Prints*. St Lucia, Queensland: Queensland University Press, 1989.

Jacobs, Mary Jane, *Places with a Past: New Site-Specific Art at Charleston's Spoleto Festival*. New York: Rizzoli International Publications, 1991.

Jantjes, Gavin (ed.), *A Fruitful Incoherence: Dialogues with Artists on International- ism*. London: Institute of International Visual Arts, 1998.

Jaques, Elliot, *The Form of Time*. New York: Crane Russak and London: Heinemann, 1982.

Johns, Adrian, *The Nature of the Book: Print and Knowledge in the Making*. Chicago: University of Chicago Press, 1998.

Jones, Amelia, *Body Art: Performing the Subject*. Minneapolis and London: Minnesota University Press, 1998.

Jones, Amelia and Andrew Stephenson (eds), *Performing the Body, Performing the Text*. London and NY: Routledge, 1999.

Jones, Caroline and Peter Galison (eds), *Picturing Science, Producing Art*. NY and London: Routledge, 1998.

Kabbani, Rana, *Imperial Fictions: Europe's Myth of Orient*. London: Pandora, 1986.

Kaplan, E. Ann, *Looking for the Other: Feminism, Film and the Imperial Gaze*. London and NY: Routledge, 1997.

Karikari, Helen, 'Out of Africa', *Artists and Illustrators*, no. 110, November 1995, pp. 55–8.

Kaufman, Debra Renee, 'The Holocaust and Sociological Enquiry: A Feminist Analysis', *Contemporary Jewry*, vol. 17, 1996, pp. 6–17.

Keller, Evelyn Fox, *Reflections on Gender and Science*. New Haven, CT: Yale University Press, 1985.

Kerr, Joan and Jo Holder (eds), *Past Present: The National Women's Art Anthology*. Sydney: Craftsman House, 1999.

King, Elizabeth, *Attention's Loop: A Sculptor's Reverie on the Coexistence of Substance and Spirit*. New York: Harry N. Abrams, 1999.

King-Hammond, Leslie, *Gumbo Ya Ya: Anthology of Contemporary African- American Women Artists*. NY: Midmarch Arts Press, 1995.

Kirby, Sandy, *Sight Lines: Women's Art and Feminist Perspectives in Australia*. Sydney: Craftsman House, 1992.

Kirker, Anne, *New Zealand Women Artists: A Survey of 150 Years*. Sydney: Craftsman House, 1986.

Kopystiansky, Svetlana, *The Library* exhibition catalogue with an introductory conver- sation between Doreet Levitte-Harten and Jürgen Harten. Düsseldorf: Kunsthalle, 1994.

Krauss, Rosalind, *Bachelors*. Cambridge, MA: MIT Press, 1999.

Lacy, Suzanne (ed.), *New Genre Public Art*. Seattle: Bay Press, 1995.

Lasalle, Honor and Abigail Solomon-Godeau, 'Surrealist Confession: Claude Cahun's Photomontages', *Afterimage*, vol. 19, pt. 8, March 1992, pp. 10–13.

Lassiagne, Jacques and Guy Wheelen, *Vieira da Silva*. NY: Rizzoli, 1979.

Lazreg, Marnia, *The Eloquence of Silence: Algerian Women in Question*. London: Routledge, 1994.

Lefkowitz, Deborah, 'Editing from Life', in *Women in German Yearbook 8: Feminist Studies in German Literature and Culture*, edited by Jeanette Clausen and Sarah Friedrichsmeyer. Lincoln, NB and London: University of Nebraska Press, 1993, pp. 199–215.

Lefkowitz, Deborah, 'On Silence and Other Disruptions', in *Feminism and Documentary*, edited by Diane Waldman and Janet Walker. Minneapolis, MN: University of Minnesota Press, 1999, pp. 244–66.

Leperlier, François, *Claude Cahun: L'Ecart et la métamorphose*. Paris: Jean-Michel Place, 1992.

Lester, Robert E. (ed.), *Vietnam, The Media and Public Support for the War*. MD: University Publications of America, 1986.

Levinas, Emmanuel, *Totality and Infinity*, translated by Alphonso Lingis. Pittsburgh: Duquesne University Press, 1969.

Lewis, Reina, *Gendering Orientalism: Race, Femininity and Representation*. London: Routledge, 1996.

Lingis, Alphonso, *Excesses: Eros and Culture*. NY: State University of New York, 1984, p. 34.

Lingis, Alphonso, *Libido: The French Existential Theories*. Bloomington, IN: Indiana University Press, 1985, p. 62.

Lomax, Yve, 'Folds in the Photograph', *Third Text*, vol. 32, Autumn 1995, pp. 43–58.

Longstreth, Richard (ed.), *The Mall in Washington, 1791–1991*. Washington, DC: The National Gallery of Art, 1991.

Lopes, Sal, *The Wall: Images and Offerings for the Vietnam Veterans Memorial*, introduced by Michael Norman. NY: Collins Publishers, 1987.

Lorde, Audre, *Zami: A New Spelling of My Name*. London: Sheba Feminist Publishers, 1982.

Lorde, Audre, *Sister Outsider: Poems and Speeches by Audre Lorde*. Freedom, CA: The Crossing Press, 1984.

Louvre, Alf and Jeffrey Walsh (eds), *Tell Me Lies About Vietnam: Cultural Battles for the Meaning of the War*. Milton Keynes: Open University Press, 1985.

Lunn, Hugh, *Vietnam: A Reporter's War*. St Lucia: University of Queensland Press, 1985.

Mahoney, Elisabeth, 'An Ounce of Gold Around the Globe', *Make: the magazine of women's art*, no. 79, March–May 1998a, pp. 22–3.

Mahoney, Elisabeth, 'Natural Science', *Art Monthly*, no. 214, March 1998b, pp. 33–4.

Malkmus, Lizbeth and Roy Armes, *Arab and African Film Making*. London and New Jersey: Zed Books, 1991.

Maras, Steven and Teresa Rizzo, 'On Becoming: An Interview with Moira Gatens', *Southern Review*, vol. 28, March 1995, pp. 53–68.

Marks, Laura U., 'Sexual Hybrids: from Oriental Exotic to Postcolonial Grotesque', *Parachute*, no. 70, April–June 1993, pp. 22–9.

Marks, Laura U., *Skin of the Film: Intercultural Cinema, Embodiment, and the Senses*. Durham, NC: Duke University Press, 2000.

Martin, Michael T. (ed.), *Cinemas of the Black Diaspora: Diversity, Dependence and Oppositionality*. Detroit: Wayne State University Press, 1995.

Martin, Rosy, 'Don't say Cheese, say Lesbian', in Fraser, Jean and Tessa Boffin (eds), *Stolen Glances*. London: Pandora 1991a.

Martin, Rosy, 'Unwind the Ties that Bind', in Jo Spence and Pat Holland (eds), *Family Snaps*. London: Virago, 1991b.

Martin, Rosy and Jo Spence, 'Phototherapy – psychic realism as a healing art?', *Ten 8*, No. 30, 1988.

McHugh, Siobhan, *Minefields and Miniskirts: Australian Women and the Vietnam War*. Sydney: Doubleday, 1993.

Meese, Elizabeth, *(Sem)Erotics: Theorizing Lesbian Writing*. New York and London: New York University Press, 1992.

Melia, Paul, 'David Hockney: A Different Kind of Beginning', in *David Hockney: A Retrospective*, ed. Kay Heymer. Bonn: Kunst- und Ausstellungshalle, 2001.

Memorable Histories and Historic Memories (exhibition catalogue). Brunswick, Maine: Bowdoin College Museum of Art, 1998.

Mercer, Kobena (guest editor), *ICA Documents 7: Black Film, British Cinema*. London: Institute of Contemporary Art, 1988.

Merian, Maria Sybilla, *The Wondrous Transformation of Caterpillars: Fifty Engravings Selected from Erucarum Ortus (1718)*, with an introduction by William T. Stearn. London: Scolar, 1978.

Merleau-Ponty, Maurice, *The Phenomenology of Perception*, translated by Colin Smith. London: Routledge and Kegan Paul, 1962.

Merleau-Ponty, Maurice. *The Visible and the Invisible* edited by Claude Lefort, translated by Alphonso Lingis. Evanston IL: Northwestern University Press, 1968.

Mernisi, Fatima, *Beyond the Veil: Male-Female Dynamics in Modern Muslim Society* (1975), revised edition. London: A. L. Saqi Books, 1985.

Merrim, Stephanie (ed.), *Feminist Perspectives on Sor Juana Inés de la Cruz*. Detroit, MI: Wayne State University Press, 1991.

Meskimmon, Marsha, *The Art of Reflection: Women Artists' Self-Portraiture in the Twentieth Century*. London: Scarlet Press and NY: Columbia University Press, 1996.

Meskimmon, Marsha, *We Weren't Modern Enough: Women Artists and the Limits of German Modernism*. London and Berkeley, CA: I.B. Tauris and University of California, 1999.

Meskimmon, Marsha, '*Das Atelier*: Spatiality and Self-Portraiture in the Work of Grethe Jürgens', *Woman's Art Journal*, vol. 21, no. 1, Spring/Summer 2000, pp. 22–6, 64.

Midgley, Mary, *Science and Poetry*. London and NY: Routledge, 1994.

Miller, Paul D., 'Motion Capture: Shirin Neshat's *Turbulent*', *Parkett*, vol. 54, 1998–9, pp. 156–64.

Millstein, Barbara Head, *Committed to the Image: Contemporary Black Photographers*. Brooklyn, NY: Brooklyn Museum of Art in assocation with Merrell, 2001.

Mirzoeff, Nicholas, *Bodyscape: Art, Modernity and the Ideal Figure*. London and NY: Routledge, 1995.

Mirzoeff, Nicholas (ed.), *Diaspora and Visual Culture: Representing Africans and Jews*. London and NY: Routledge, 2000.

MIT List Visual Arts Center, *19 Projects: Artists-in-Residence at the MIT List Visual Arts Center*. Cambridge, MA: MIT Press, 1996.

Moi, Toril, *Feminist Theory and Simone de Beauvoir*. London: Basil Blackwell, 1990.

Mona Hatoum (exhibition catalogue). Bristol: Arnolfini, 1993.

Mona Hatoum: The Entire World as a Foreign Land. London: Tate Gallery, 2000.

Moraga, Cherríe and Gloria Anzaldúa (eds), *This Bridge Called My Back: Writings by Radical Women of Color.* Persephone Press, 1981.

Morgan, Anne Barclay, 'Interview: Amalia Mesa-Bains', *Art Papers,* vol. 19, no. 2, 1995, pp. 24–9.

Mortimer, Mildred, 'Assia Djebar's *Algerian Quartet*: A Study in Fragmented Autobiography', *Research in African Literature,* vol. 28, pt. 2, 1997, pp. 102–17.

Moore, Catriona (ed.), *Dissonance: Feminism and the Arts 1970–1990.* St Leonards, NSW: Allen and Unwin, 1994.

Mulvey, Laura, *Visual and Other Pleasures.* Basingstoke: Macmillan, 1989.

Mulvey, Laura, 'Moving Bodies: Interview with Moufida Tlatli', *Sight and Sound,* March 1995, pp. 18–20.

Munster, Anna, *Machinic Disturbants: Genealogies of the Digital,* PhD thesis. University of New South Wales, 2000.

Naficy, Hamid (ed.), *Home, Exile, Homeland: Film, Media and the Politics of Place.* London and NY: Routledge 1999.

Nead, Lynda, *The Female Nude: Art, Obscenity, Sexuality.* London and NY: Routledge, 1992.

Neale, Margo, *Yiribana: An Introduction to the Aboriginal and Torres Strait Islander Collection.* Sydney: The Art Gallery of New South Wales, 1993.

Nunn, Pamela Gerrish, *Victorian Women Artists.* London: Women's Press, 1987.

Ofer, Dalia and Lenore J. Weitzman (eds), *Women in the Holocaust.* New Haven, CT: Yale University Press, 1998.

Oguibe, Olu, 'Medium and Memory in the Art of Fiona Foley', *Third Text,* no. 33, Winter 1995–6, pp. 51–60.

Olkowski, Dorothea, *Gilles Deleuze and the Ruin of Representation.* Berkeley, CA: University of California Press, 1999.

Oxley, Deborah, *Convict Maids: The Forced Migration of Women to Australia.* Cambridge: Cambridge University Press, 1996.

Papastergiadis, Nikos, *Dialogues in the Diasporas: Essays and Conversations on Cultural Identity.* London and New York: Rivers Oram Press, 1998.

Patton, Paul (ed.), *Deleuze: A Critical Reader.* Oxford: Blackwell, 1996.

Patton, Sharon F., *African-American Art.* Oxford: Oxford University Press, 1998.

Paz, Octavio, *Sor Juana or, The Traps of Faith* (trans. by Margaret Sayers Peden). Cambridge, MA: The Belknap Press of Harvard University Press, 1988.

Pearson, Keith Ansell, *Deleuze and Philosophy: The Difference Engineer.* London and NY: Routledge, 1997.

Phelan, Shane (ed.), *Playing with Fire: Queer Politics, Queer Theories.* London and NY: Routledge, 1997.

Philippi, Desa, 'Mona Hatoum: The Witness Beside Herself', *Parachute,* no. 58, April–June 1990, pp. 10–15.

Pickstone, John V., *Ways of Knowing: A New History of Science, Technology and Medicine.* Manchester: Manchester University Press, 2000.

Pietropaolo, Laura and Ada Testaferri (eds), *Feminisms in the Cinema.* Indianapolis: Indiana University Press, 1995.

Pines, Jim and Paul Willemen (eds), *Questions of Third Cinema.* London: BFI Publishing, 1989.

Piper, Adrian, 'The Triple Negation of Colored Women Artists', reprinted in *Next*

Generation: Southern Black Aesthetic, exhibition catalogue. Winston-Salem, NC: Southeastern Center for Contemporary Art, 1990, pp. 15–22.

Plant, Sadie, *Zeros and Ones: Digital Women and the New Technolculture*. London: Fourth Estate, 1997.

Pollock, Griselda, *Generations and Geographies in the Visual Arts: Feminist Readings*. London and NY: Routledge, 1996.

Purcell, Rosamond Wolff and Stephen Jay Gould, *Finders, Keepers: Eight Collectors*. London: Pimlico, 1993.

Rebecca Horn: Driving Through Buster's Bedroom, exhibition catalogue. Los Angeles: Los Angeles Museum of Contemporary Art and Milan: Fabbri Editori, 1990.

Regan, Stephen (ed.), *The Politics of Pleasure: Aesthetics and Cultural Theory*. Milton Keynes: Open University Press, 1992.

Renton, Andrew, 'Velvet Sex Trap', *Flash Art*, vol. 154, October 1990, pp. 144–5.

Rewald, John, *Vieira da Silva: Paintings 1967–1971*. NY: M. Knoedler and Co, 1971.

Rice, Shelley (ed.), *Inverted Odysseys: Claude Cahun, Maya Deren, Cindy Sherman*. Cambridge, MA: MIT Press, 1999.

Ringgold, Faith, *We Flew Over the Bridge: The Memoirs of Faith Ringgold*. Boston: Little Brown, 1995.

Rittner, Carol and John K. Roth (eds), *Different Voices: Women and the Holocaust*. NY: Paragon House, 1993.

Robinson, Arthur, *Early Thematic Mapping in the History of Cartography*. Chicago: University of Chicago Press, 1982.

Ronstayi, Mina, 'Getting Under the Skin: Rebecca Horn's Sensibility Machine', *Arts Magazine*, vol. 63, pt. 9, May 1989, pp. 58–68.

Rosen, Miriam. 'The Uprooted Cinema: Arab Filmmakers Abroad', *Middle East Report*, July–Aug 1989, pp. 34–7.

Rousseau, G.S. and Roy Porter (eds), *Exoticism in the Enlightenment*. Manchester: Manchester University Press, 1990.

Rovit, Rebecca and Alvin Goldfarb (eds), *Theatrical Performance During the Holocaust: Texts, Documents, Memoirs*. Baltimore, MD and London: Johns Hopkins University Press, 1999.

Rücker, Elisabeth, *Maria Sybilla Merian*, Nürnberg: Germanisches Nationalmuseum, 1967.

Sadler, Simon, *The Situationist City*. Cambridge, MA: MIT Press, 1998.

Said, Edward, *Orientalism*. London: Routledge and Kegan Paul, 1978.

Santner, Eric L., *Stranded Objects: Mourning, Memory and Film in Postwar Germany*. Ithaca, NY, and London: Cornell University Press, 1990.

Saxby, Trevor J., *The Quest for the New Jerusalem: Jean de Labadie and the Labadists, 1610–1744*. Dordrecht: M. Nijhoff Publishers, 1987.

Scarlett, Ken, *Contemporary Sculpture in Australian Gardens* (G + B International). Sydney: Craftsman House, 1993.

Schor, Mira, *Wet: On Painting, Feminism and Art Culture*. Durham, NC: Duke University Press, 1997.

Sedgwick, Eve Kosofsky, *Epistemology of the Closet*. New York: Harvester Wheatsheaf, 1991.

Serota, Nicholas and Gavin Jantjes, *From Two Worlds*, exhibition catalogue. London: Whitechapel, 1986.

Shafik, Violet, *Arab Cinema: History and Cultural Identity*. Cairo, Egypt: The American University in Cairo Press, 1998.

Shange, Ntozake, *for colored girls who have considered suicide/when the rainbow is enuf* and *spell 7*. London: Methuen Drama, 1990.

Sheriff, Mary D., *The Exceptional Woman: Elisabeth Vigee-Lebrun and the Cultural Politics of Art*. Chicago: University of Chicago Press, 1996.

Shirin Neshat, exhibition catalogue. Vienna: Kunsthalle and London: Serpentine, 2000.

Shirin Neshat, Milan: Edizioni Charta, 2001.

Simon, Joan, 'Ann Hamilton: Inscribing Place', *Art in America*, vol. 87, no. 6, June 1999, pp. 76–85.

Skelton, R.A., *Maps: A Historical Survey of Their Study and Collecting*. Chicago and London: University of Chicago Press, 1972.

Sobchack, Vivian, *The Address of the Eye: A Phenomenology of Film Experience*. Princeton, NJ: Princeton University Press, 1992.

Sofia, Zoe, 'Technoscientific Poeisis: Joan Brassil, Joyce Hinterding, Sarah Waterson', *Continuum*, vol. 8, pt. 1, 1994, pp. 364–75.

'Sokari Douglas Camp', *Revue Noire*, no. 30, Sept.–Nov. 1998, pp. 40–1.

Spector, Buzz, 'Residual Readings: The Altered Books of Ann Hamilton', *Print Collectors' Newsletter*, vol. 26, no. 2, May–June 1995, pp. 55–6.

Stafford, Barbara, *Good Looking: Essays on the Virtue of Images*. Cambridge, MA: MIT Press, 1996.

Stafford, Barbara, *Visual Analogy: Consciousness as the Art of Connecting*. Cambridge, MA: MIT Press, 1999.

Stein, Judith E., 'Space and Place', *Art in America*, vol. 82, pt. 12, December 1994, pp. 66–71, 117.

Stevens, Wallace, *The Collected Poems of Wallace Stevens*. London: Faber and Faber Ltd, 1955.

Sturken, Marita, 'The Wall, The Screen and the Image: The Vietnam Veterans Memorial', *Representations* 35, Summer 1991, pp. 118–142.

Sulter, Maud (ed.), *Passion: Discourses on Blackwomen's Creativity*. Hebden Bridge: Urban Fox Press, 1990.

Tesfagiorgis, Frieda High W., 'Afrofemcentrism and its Fruition in the Art of Elizabeth Catlett and Faith Ringgold', *SAGE*, vol. iv, Spring 1987, pp. 25–32.

Thomas, C. David (ed.), *As Seen by Both Sides: American and Vietnamese Artists Look at the War*. Boston, MA: Indochina Arts Project and the William Joiner Foundation, 1991.

Thomas, Martin, 'Technology of Perception: The Installations of Joan Brassil', *Art and Australia*, 1993, pp. 68–76.

Thomas, Nicholas, *Possessions: Indigenous Art/Colonial Culture*. London: Thames and Hudson, 1999.

Topliss, Helen, *Modernism and Feminism: Australian Women Artists 1900–40*. Sydney: Craftsman House, 1996.

Track 16 Gallery and The Center for the Study of Political Graphics, *Decade of Protest: Political Posters from the United States, Viet Nam and Cuba*. Santa Monica, CA: Smart Art Press, 1996.

Trinh T. Minh-ha, *The Moon Waxes Red*. London and NY: Routledge, 1991.

Trinh T. Minh-ha, *Framer Framed*. London and NY: Routledge, 1992.

Trinh T. Minh-ha, *Cinema Interval*. London and NY: Routledge, 1999.

Tromble, Meredith, 'A Conversation with Amalia Mesa-Bains', *Artweek*, 8 October 1992.

Vigano, E., 'Shirin Neshat', *Zoom* [Italy], vol. 26, March–June 1998, pp. 58–63.

Voigt, Anna, *New Visions, New Perspectives: Voices of Contemporary Australian Women Artists.* Sydney: Craftsman House, 1996.

Waldman, Diane and Janet Walker (eds), *Feminism and Documentary.* Minneapolis, MN: University of Minnesota Press, 1999.

Wallace, Michele, 'Variations on Negation and the Heresy of Black Feminist Creativity', *Heresies*, vol. 6, pt. 4, 1989, pp. 69–75.

Wallis, Brian, 'Questioning Documentary', *Aperture*, vol. 112, 1998, pp. 60–71.

Watson, Sophie (ed.), *Playing the State: Australian Feminist Interventions.* London: Verso, 1990.

Weintraub, Linda, *Art on the Edge and Over: Searching for Art's Meaning in Contemporary Society 1970s–1990s.* Litchfield, CN: Art Insights Inc., 1996.

Weiss, Gail, *Body Images: Embodiment as Intercorporeality.* London and NY: Routledge, 1999.

Welton, Donn (ed.), *Body and Flesh: A Philosophical Reader.* Oxford: Blackwell, 1998.

White, Victoria, 'Whose Memorial Is This?', *Public Art Review*, vol. 7, pt. 2, Spring/Summer 1996, pp. 14–17.

Willis-Thomas, Deborah, *An Illustrated Bio-bibliography of Black Photographers, 1940–1988.* NY and London: Garland Publishing, 1989.

Wilton, Tamsin, *Lesbian Studies: Setting an Agenda.* London and NY: Routledge, 1995.

Winterson, Jeanette, *Written on the Body*, London: Vintage, 1996.

Wittig, Monique, *The Lesbian Body*, translated by David Le Vay, British edition. London: Peter Owen, 1975.

Wittig, Monique, *The Straight Mind and Other Essays*, with a foreword by Louise Turcotte. Hemel Hempstead: Harvester Wheatsheaf, 1992.

Women 150 (eds), *150 Victorian Women Artists.* Melbourne, Victoria, 1985.

Young, James E. (ed.), *Holocaust Memorials: The Art of Memory in History.* Munich and NY: Prestel-Verlag, 1994.

Zabel, Igor, *Shirin Neshat* (exhibition catalogue). Ljubljana: Moderna Galerija, 1997.

Zaya, Octavio, 'Shirin Neshat', *Flash Art*, vol. 27, no. 179, Nov.–Dec. 1994, p. 85.

Zaya, Octavio, 'Women of Allah' (interview with Shirin Neshat), *Creative Camera*, no. 342, Oct.–Nov. 1996, pp. 18–23.

Zegher, Catherine de (ed.), *Inside the Visible: An Elliptical Traverse through Twentieth Century Art, in, of and from the Feminine.* Cambridge, MA: MIT Press, 1996.

Zegher, Catherine de (ed.), *Martha Rosler: Positions in the Life World.* Cambridge, MA: MIT Press, 1998.

Ziff, Trisha, *Distant Relations: Chicano, Irish, Mexican Art and Critical Writing.* NY: Smart Art Press, 1996.

Index